ZADIG & VOLTAIRE

ZADIG & VOLTAIRE

**ESTABLISHED 1997
IN PARIS**

New York · Paris · London · Milan

CHÂTEAU VOLTAIRE
Hôtel
55-57, RUE SAINT-ROCH
PARIS I ER ARR.

life is not
a straight Road
ups and downs
but its my way

THIERRY GILLIER NAMED HIS FASHION BRAND ZADIG&VOLTAIRE AFTER A BELOVED BOOK FROM HIS YOUTH. ZADIG WAS THE MAIN CHARACTER IN A FABLE BY THE EIGHTEENTH-CENTURY FRENCH PHILOSOPHER, VOLTAIRE. YOU COULD SAY, HOWEVER, THAT HE OWES A DEBT TO ELVIS.

TEXT BY NICOLE PHELPS

In the late 1990s, early days of Zadig & Voltaire, Gillier began putting the King of Rock 'n' Roll's name on cashmere sweaters. The sweaters themselves were something special. Now that cashmere is so ubiquitous, it's hard to remember, but in the late '90s it hadn't yet shed its stuffy, bourgeois connotations—Gillier was the man and Zadig & Voltaire was the brand that would do that. A great-great nephew of the cofounder of Lacoste, Gillier grew up in the textile business, which gave him a unique advantage. "I knew knit very well," he admits. "And the fashion world didn't know about it at all in the '90s. They were always doing the same thing."

Up until that point, sweaters knit from cashmere yarn had been thick, heavy, and expensive. A born rule-breaker, Gillier made Zadig & Voltaire's featherweight cashmeres with raw, unfinished edges; eventually, he'd discover a way to knit them with strategically placed pre-made holes, as if they'd been in your wardrobe, well-loved and much-worn (but not moth-eaten!) for years. But it was Elvis's name as an intarsia across the back of the sweaters, that earned the brand its early buzz. "Elvis for me—it was poetry," Gillier remembers. "Elvis was freedom."

Iggy Pop deserves some credit, too. The musician wore a Zadig & Voltaire cashmere sweater with the words "Art is Truth" on the back for an appearance on a French television program—only he wore it back-to-front, cementing the brand's rock 'n' roll credentials. That's when the crowds started coming. "I came up with something new and I knew it. People waited in line to get in," Gillier says.

Not all of Zadig's customers have had to queue, of course. The Rolling Stones once asked the brand to close the store in Brussels, when they were on tour there, so they could shop in private. And the company has locked the doors so Kate Moss could do the same thing with her daughter Lila Grace. Moss collaborated with the company in 2019, partnering on a 1970s-inspired handbag collection that earned the discerning Lila Grace's approval. "At first, when I told her, 'I've designed some bags,' she was like, 'whatever'—like daughters can be," Moss told *Vogue* at the time of the launch. "But then she picked one up and said, 'Oh, Mummy, I like that, can I borrow it?' I told her it was my Zadig & Voltaire one and she was like, 'Ooh, I like it!' I was quite happy about that," Moss went on. "After all, it's for young girls—and older girls, like me."

Gillier is proud of the way Zadig & Voltaire resonates with young people, but its audience spans generations. First Lady Dr. Jill Biden wore a Zadig & Voltaire jacket on the campaign trail with husband Joe Biden in 2019, and re-wore it at the G7 summit in England in 2021. For that occasion, she had it embellished with the word LOVE picked out in crystals on the back. Speaking to reporters, Dr. Biden said, "We're bringing love from America. This is a global conference, and we're trying to bring unity across the globe. I think it's needed right now, that people feel a sense of unity from all the countries and feel a sense of hope after this year of the pandemic." If you visit Zadig & Voltaire's website today, you'll find sweaters spelling out the same block-letter message in both English and French.

Zadig & Voltaire was born in 1997. "It was the era of the *créateur*," Gillier says. But he's never been interested in being a front man—not then and not now. And that explains the name he gave his brand: "Zadig is a character that Voltaire invented," Gillier says. "He goes through life and things happen bad and good. Life is not a straight line, but in the end he is successful."

The first Zadig & Voltaire store was situated on the rue du Pré-aux-Clercs in Saint-Germain-des-Prés. When it opened, Gillier decided against a big campaign announcing the store's arrival, a counterintuitive move if ever there were one, believing the products in the windows would speak for themselves. Inside, the atmosphere was fresh, too. In the '90s, cashmere was behind the counter in plastic bags at most boutiques—precious, prim, and out of reach without the help of a sales assistant. At Zadig & Voltaire, shoppers could walk amongst the low-slung tables and shelves, and help themselves. "Like a supermarket," Gillier laughs. Indeed, the brand's stores started popping up all over Paris, weaving themselves into the fiber of city life. Today, there are eighteen Zadig & Voltaire boutiques on both sides of the Seine, plus shop-in-shops, with the flagship perched on the rue François-Ier, opposite the Dior store on the Avenue Montaigne.

"The simpleness of the interior design, it was such a shock, so clear, so efficient, and the fragrance that was diffused, that was so new," remembers Cecilia Bönström, the label's current artistic director and Gillier's former wife for many years (they share a child together). But what really made an impression on Bönström was the cashmere: "The candy colors and the way you were supposed to wear it directly on your skin—no one had done that before."

Funnily enough, Gillier himself has always worn black. In the brand's first years, it wasn't just Zadig & Voltaire merchandise on offer in its stores. "I put things together that made sense," Gillier says, pointing out that he sold Helmut Lang denim, "because he changed the way we wore jeans." The Austrian minimalist and master tailor Helmut Lang was Gillier's design icon. Both Lang and Gillier upended the way the industry did business—only from different angles. Where Lang made the subversive elegant, elevating T-shirts, jeans, and army parkas to the level of high fashion and splicing his lean suiting with bondage references, Gillier made the elegant subversive, releasing cashmere from its stuffy past, and democratizing and modernizing the experience of shopping for it in the process.

Conventional wisdom in fashion has always had it that trends trickle down from the runways. Backstage at their shows, designers name-check long-dead couturiers, pin screen grabs of Renaissance paintings (or whatever their reference) to their mood boards, and spin complicated backstories about their collection's origins. Gillier has never seen it that way. He always has his eye on the street. "I've always been an outsider," he says.

But if he is an outsider, Zadig & Voltaire has had an outsize influence on shaping the look of French fashion. Bönström credits Gillier with creating the "eternally youthful," rock 'n' roll

attitude that has come to be synonymous with Parisian style. "I really admire Thierry for his vision of French fashion," she says. "He created a vision that keeps women youthful—cool without being too trendy *or* too sophisticated."

Bönström is Swedish, a biographical detail she brings up often to emphasize Zadig & Voltaire's international reach. "It's not important where you come from," she says, "it's about style and fashion that fits women everywhere in the world." The "codes" of the brand, in industry parlance, are masculine/feminine, chic but nonchalant, timeless, and day-to-night. Fabrics, naturally, are important to Bönström. As a brand built on cashmere, Zadig & Voltaire's materials must be soft and noble.

Again, it's hard to remember, given just how global the Zadig & Voltaire brand of "French girl style" has become—the blazer, the slouchy tee or camisole, the kicky boots and jeans—but before the 1990s, Paris wasn't known for its casual fashion. Gillier's generation shook off the couture salon excesses of its predecessors and built brands that put chic simplicity at their core. "Today," says Bönström, who honed the brand's recognizable silhouette, "we call it effortless luxury. Thierry's obsession was to create a sweater and make it look like it had already lived, as if the sweater was a kind of love story, a lucky charm, something important."

Gillier put it this way in the *New York Times*: "We have a style that fits into daily routines, although we make the clothes a little bit more sexy." That goes for women's clothes and for men's, which he prefers to be more alike than different. The brand's raw-edged T-shirts were a case in point. "Now you see them everywhere, but they actually started as a mistake," Gillier says. "The factory sent me a T-shirt and it was awful. I said, 'stop the production,' but they were already produced. I cut the necklines, and I put them in our shop and I forgot about them. And later I was out for drinks with an actor and I said, 'Wow, your T-shirt is really nice.' I asked, 'What is it?' And he said, 'It's Zadig.' You know," Gillier continues, "I love product. I don't like fashion. I tell my staff, don't get into fashion, get into product. The product has to have a meaning by itself, like a good painting. After that T-shirt, we cut the edge on everything."

Gillier studied painting as a student at Bard College in Upstate New York—"we were hippies, we didn't wear shoes to class," he remembers, though he was interested in clothes, dyeing T-shirts and deconstructing jeans. He was kicked out of school for a time for being "too wild," he told *W* magazine, but went on to graduate with a film degree. Today he's an enthusiastic art collector. There are Picassos and Twomblys in his Paris home, as well as pieces by Jean-Michel Basquiat and Christopher Wool, so he knows of what he speaks when he talks about good paintings. At Zadig & Voltaire, he's made a practice of collaborating with undiscovered and under-recognized artistic talents, enlisting the likes of Venezuelan "Graffiti Queen" Jormi Graterol, Brooklyn tattoo artist Virginia Elwood, and young painter and printmaker Khalif Tahir Thompson, for different projects over the years.

As Zadig & Voltaire expanded and grew, so did Gillier's thinking about marketing, though he maintained a firm grip on his trademark irreverence. In 2008, the brand produced an ad featuring a model on a motorbike wearing nothing but a helmet and a pair of underwear. "This is Zadig!" it declared. Freedom was the message, and there was no ignoring the campaign when it started appearing in Paris.

In 2012, Gillier had another change of heart and opted to put Zadig & Voltaire on the runway. He was in the midst of construction on a would-be boutique hotel in the seventh arrondissement and decided to do an event in the raw space. The show was a chance for Bönström to evolve the Zadig & Voltaire aesthetic beyond weekend leisure chic. "I'm trying to help active women to quickly dress in the morning, whether she has a date or a job interview, lunch with her in-laws, or she's bringing the kids to school," she says. Having developed an audience in Paris and throughout Europe, in 2017, on the occasion of the brand's twentieth anniversary, Bönström brought the collection to New York Fashion Week. She hired the then little-known model Bella Hadid to open the show. "We like to stay a step ahead," the designer says.

For Gillier, the runway provided an opportunity to prove that the Zadig & Voltaire way of doing things belonged in the fashion week mix. There's a generation of design talent in Paris that has spent their careers propping up old names and heritage labels, reaping fabulous returns for their holding companies. What Gillier had to offer was something new, with none of the baggage that comes with the famous labels from the past. That's at least partly why its audience skews young—Zadig & Voltaire is not your parents' or your grandparents' brand.

In Los Angeles, a recently opened Rodeo Drive boutique was the site of a twenty-fifth birthday bash for the label that drew a young Hollywood crowd, including *Pretty Little Liars: Original Sin* stars Malia Pyles and Jordan Gonzalez, and musicians Chase Hudson and Jacob Sartorius. The brand's U.S. expansion is ongoing. After reopening on Madison Avenue last year, where its neighbor across the street is fellow French import Ladurée, the brand has a new TriBeCa location.

"If you think, 'okay, I'm successful,' it's very boring," Gillier says. "There is no end. The end is at the end and then bye-bye." Like his brand's namesake, he's a man in perpetual motion, even on the weekends. The worst day of the week for him is Sunday because on Sundays nobody makes deals. "I love to do deals, but it's not an action of power, it's the magic of doing deals. There is an art to it. But then, I don't need anything, either. That's why I love Helmut Lang—he retired to his house in the middle of the woods on Long Island."

Gillier's latest project is the Château Voltaire, a boutique hotel on the rue Saint-Roch halfway between the Louvre and the Opéra Garnier, in "le coeur de Paris." When it opened in 2022 in a trio of buildings dating to the sixteenth, seventeenth, and eighteenth centuries that once functioned as the brand's headquarters, it quickly became a fashion hotspot. Franck Durand, the artistic director of *Holiday* magazine, led the reinvention with Charlotte de Tonnac and

Hugo Sauzay of Festen Architecture, who are known for imbuing the spaces they work on with homey, yet chic vibes. "I think my best value is to have chosen the right people around me," Gillier says, likening the Zadig & Voltaire staff to a family. "I love to work with others. When you are surrounded by people who have good ideas, it's great."

A quarter century after its beginnings, Zadig & Voltaire's greatest success is that so much of fashion has adopted its philosophies and found inspiration in the kind of effortless luxury that it sells. Knits are a foundational part of many luxury labels for their easy-wearing sophistication, and never before have women's and men's offerings been more closely linked, to say nothing of the genderless collections that are emerging all over the world. "Now the luxury brands, I think they are doing what I did in the past," Gillier says. He's got that right.

"NOW THE LUX
I THINK THEY A
WHAT I DID IN
GILLIER SAYS.
THAT RIGHT.

JRY BRANDS,
RE DOING
THE PAST,"
HE'S GOT

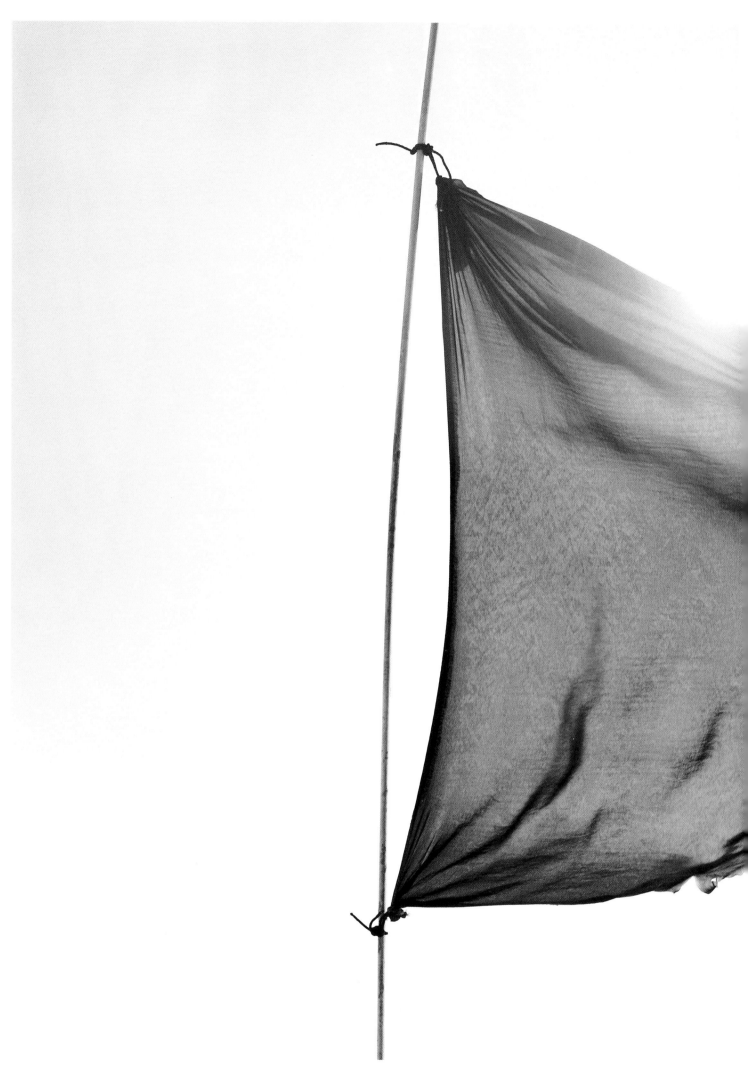

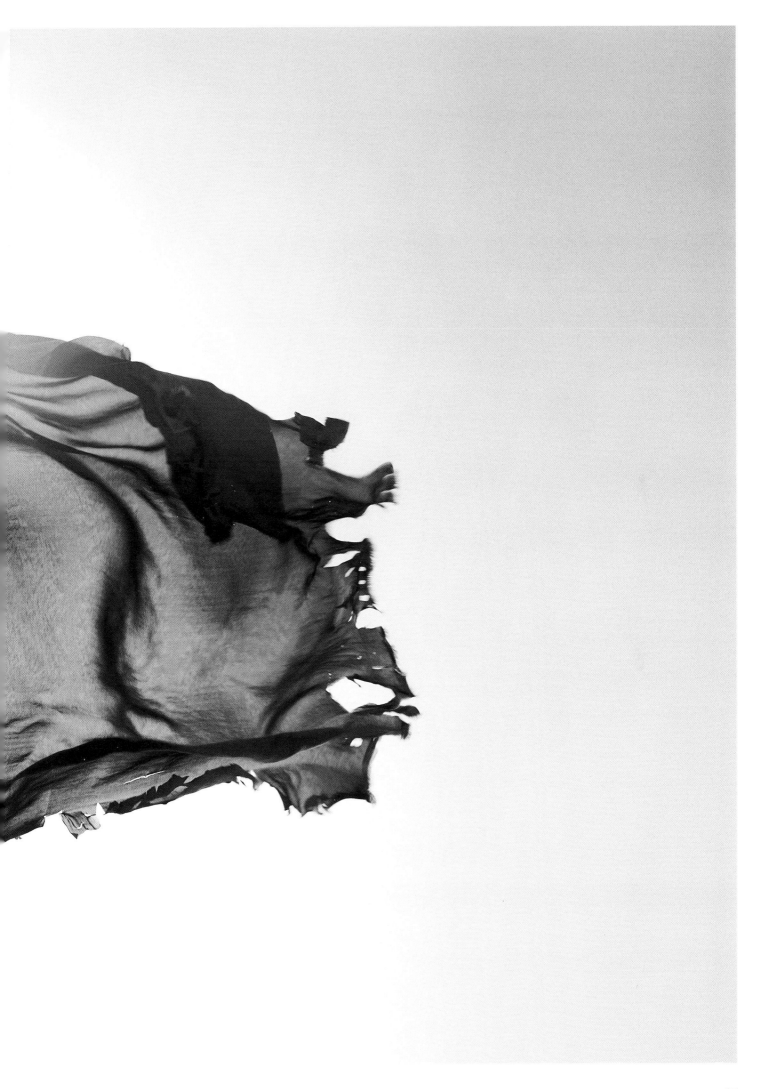

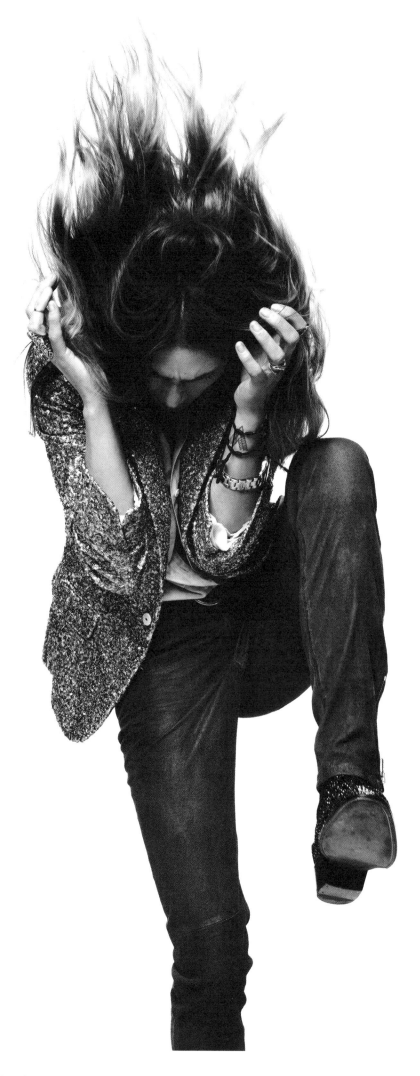

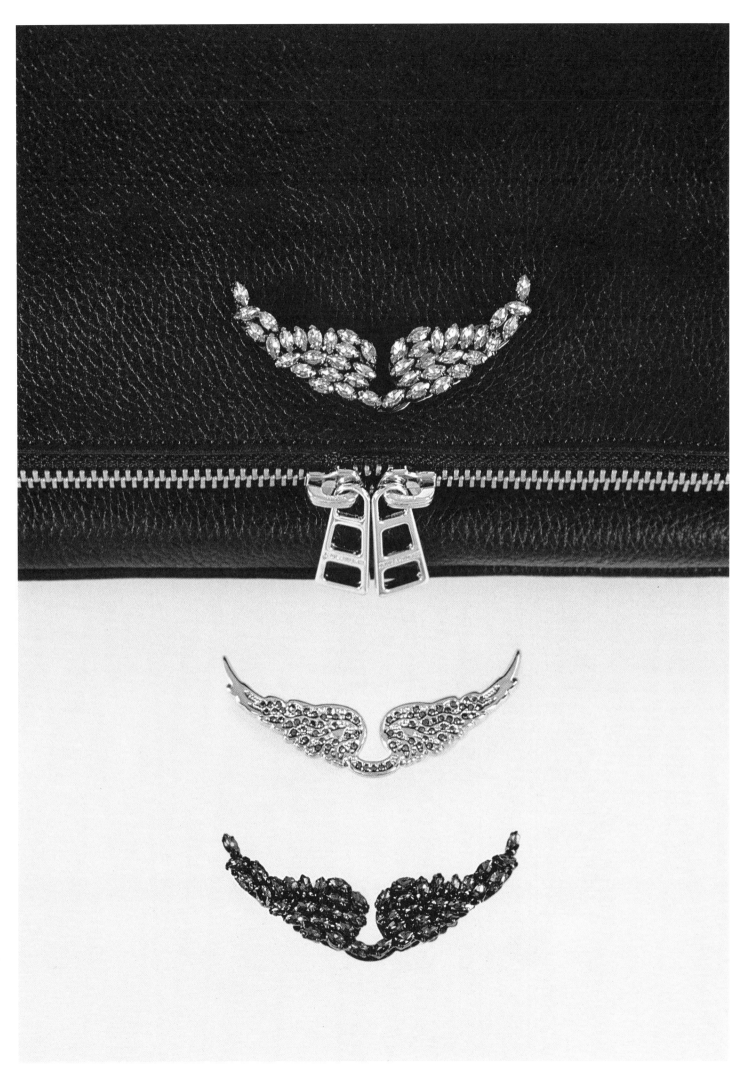

ROCK CLUTCH, ICONIC PIECE

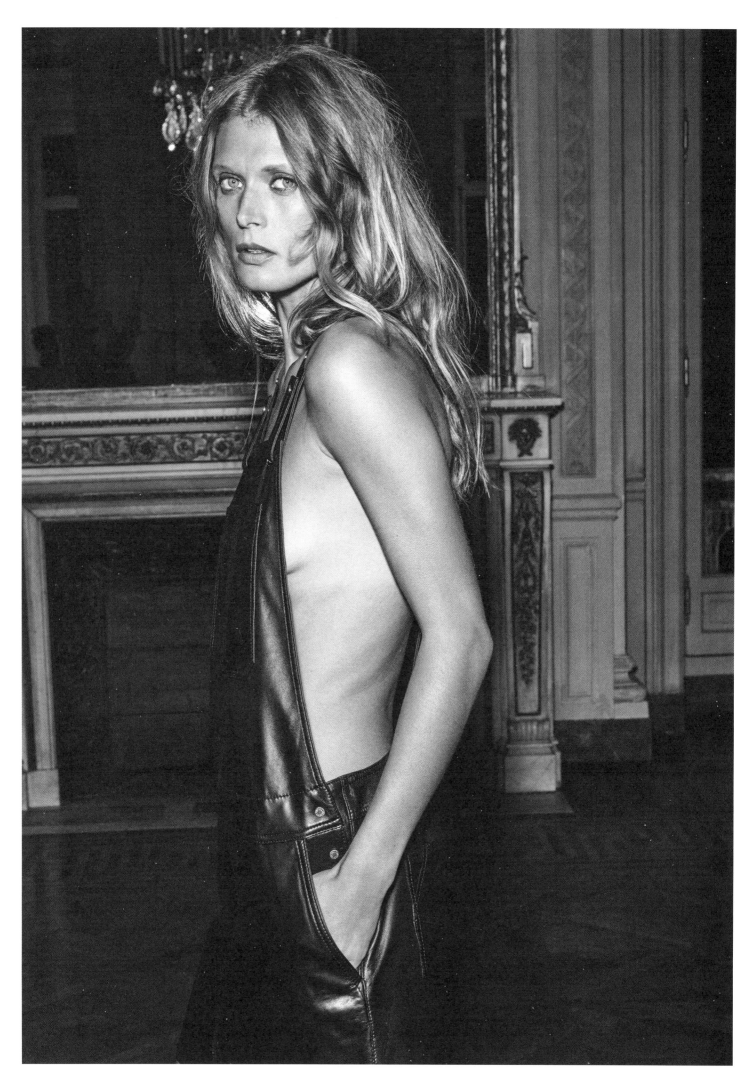

18 SPRING-SUMMER 2016 AD CAMPAIGN

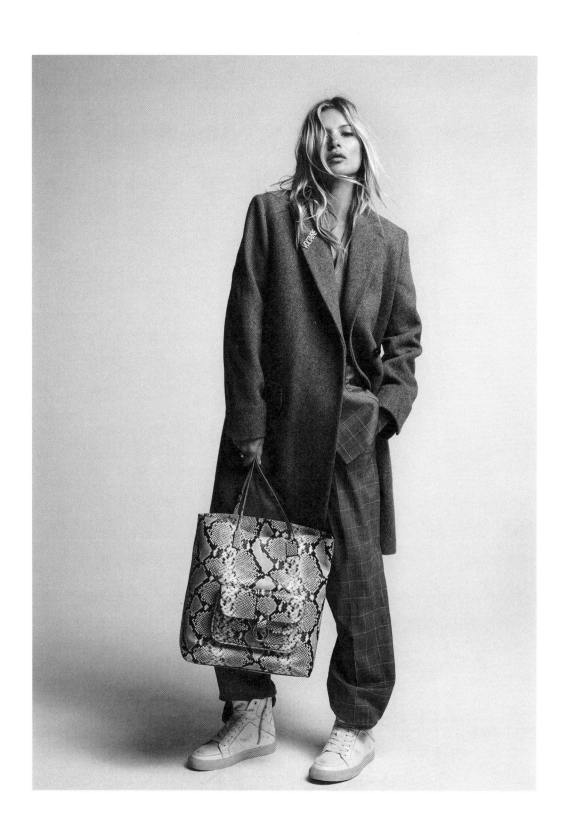

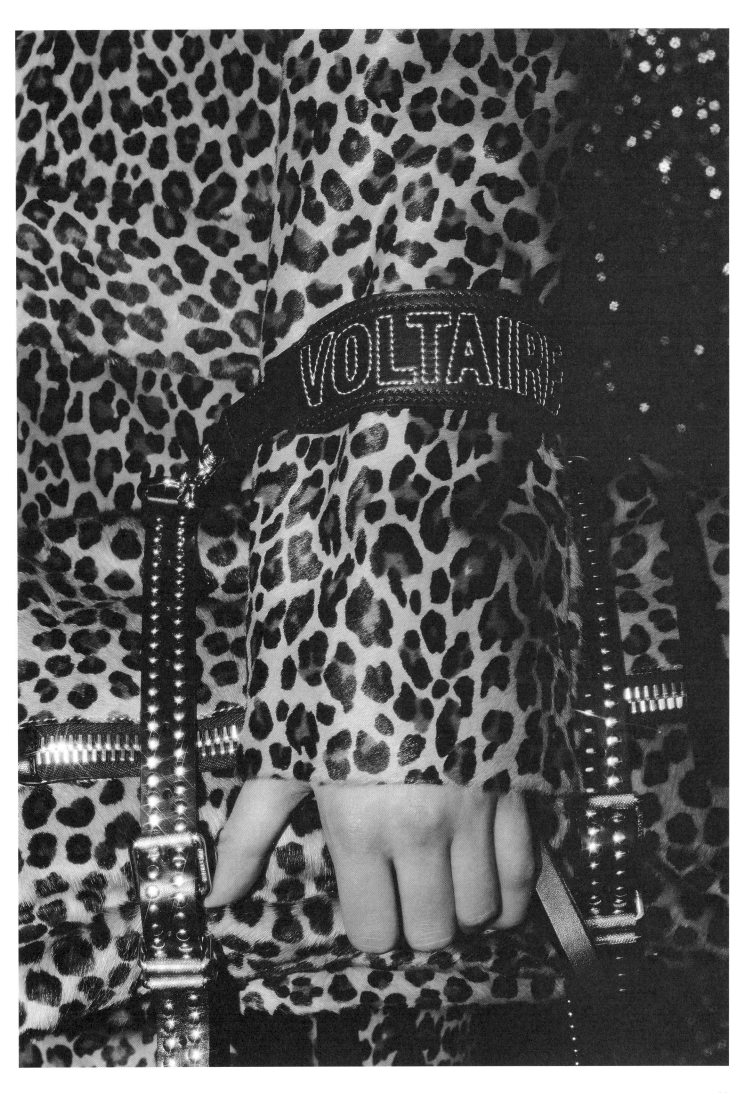

BACKSTAGE, FALL-WINTER 2019 SHOW, NEW YORK

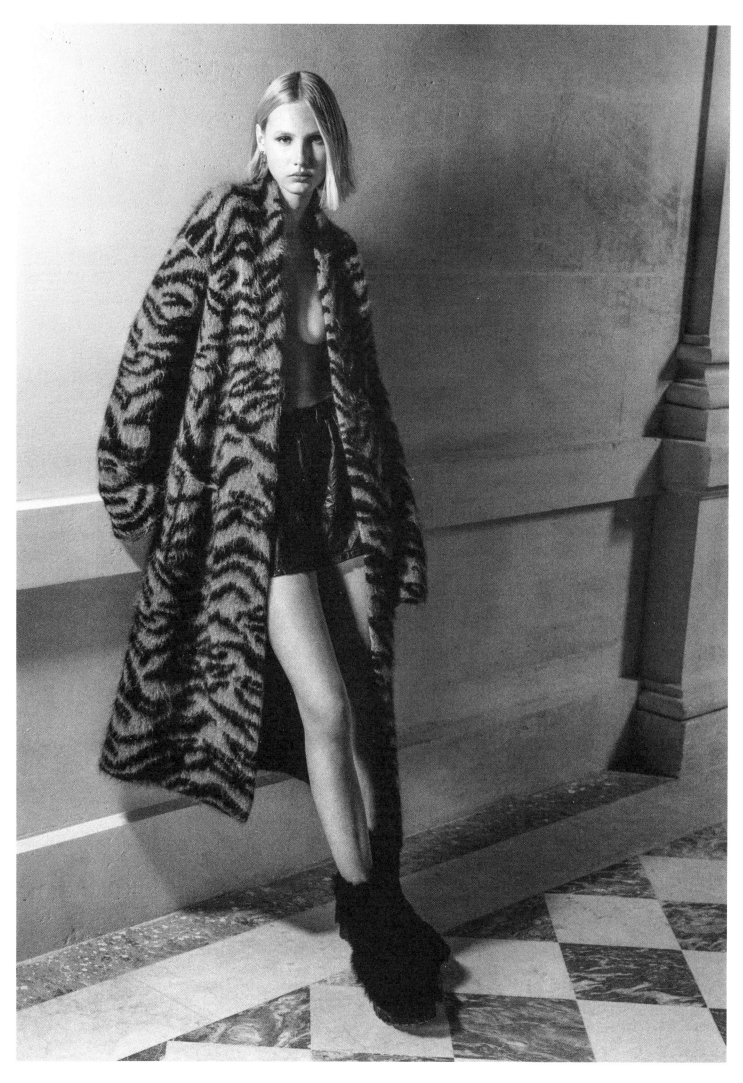

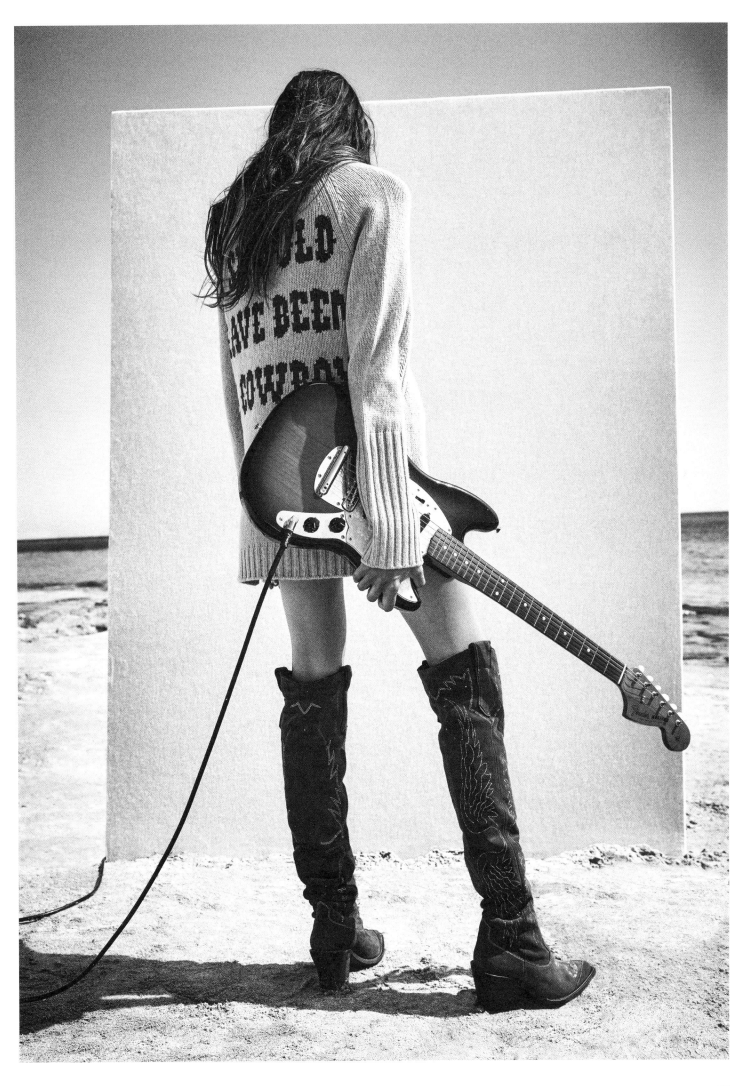

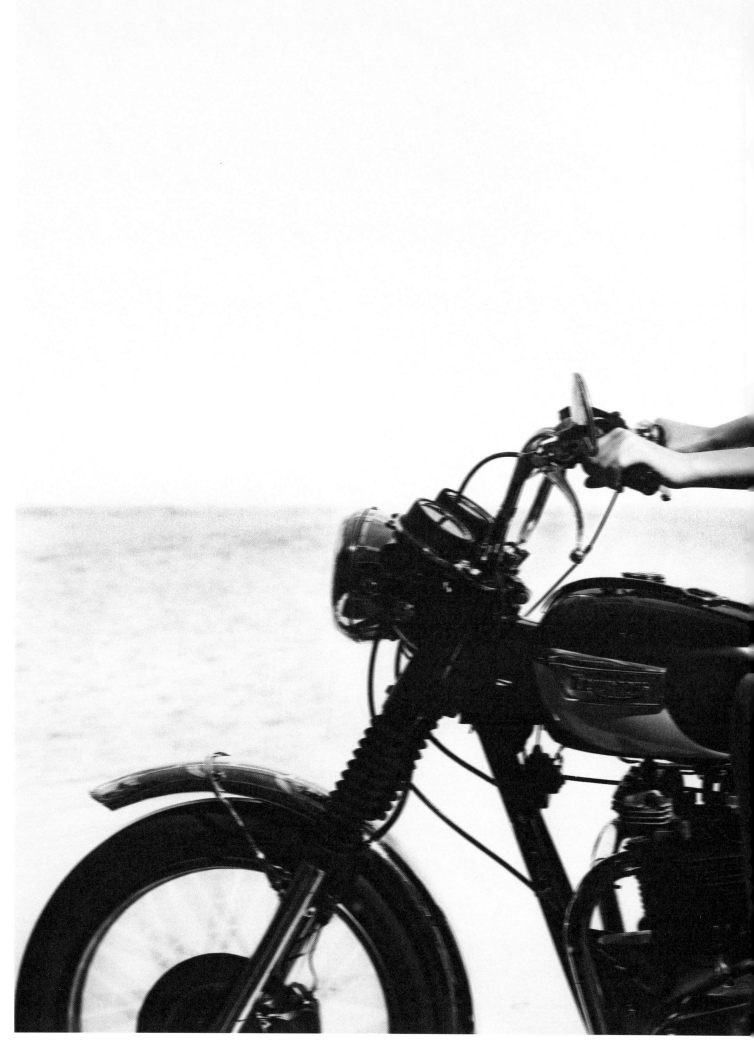

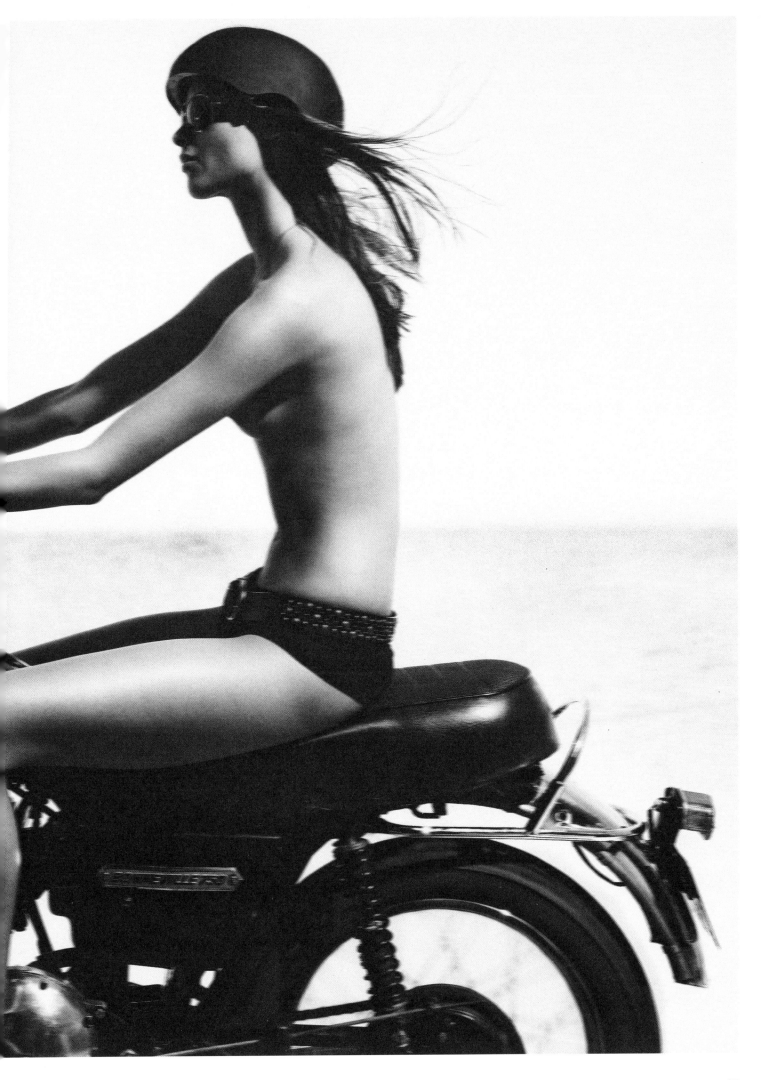

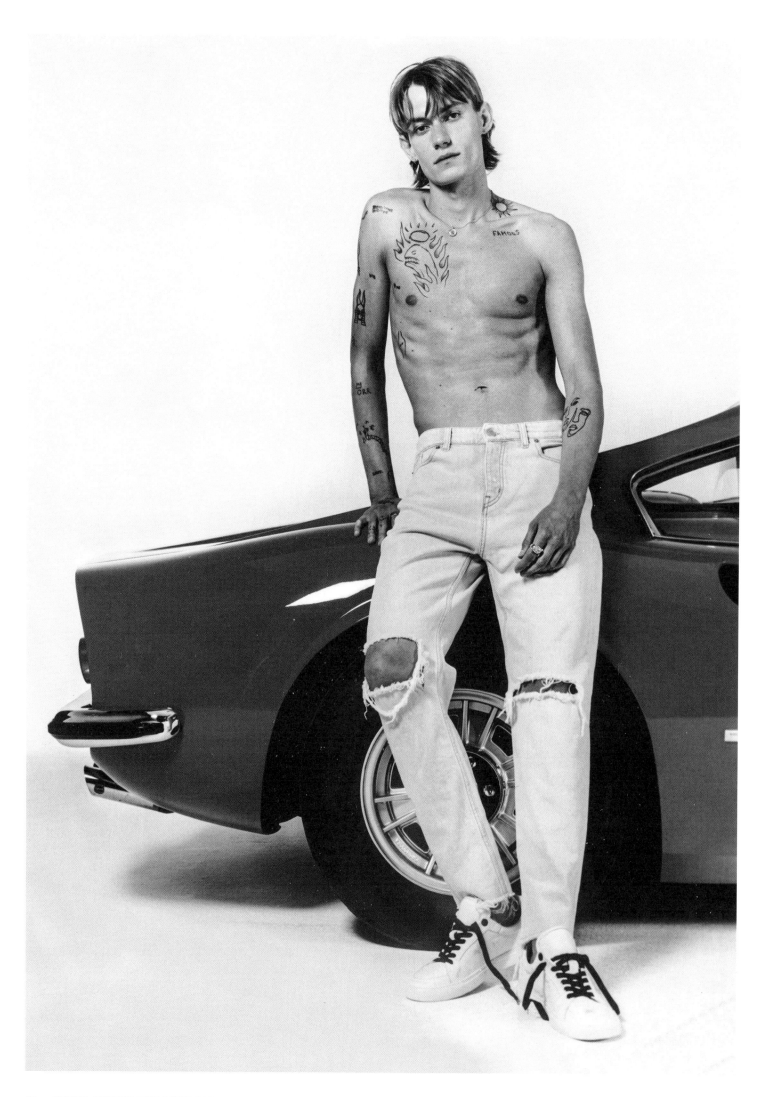

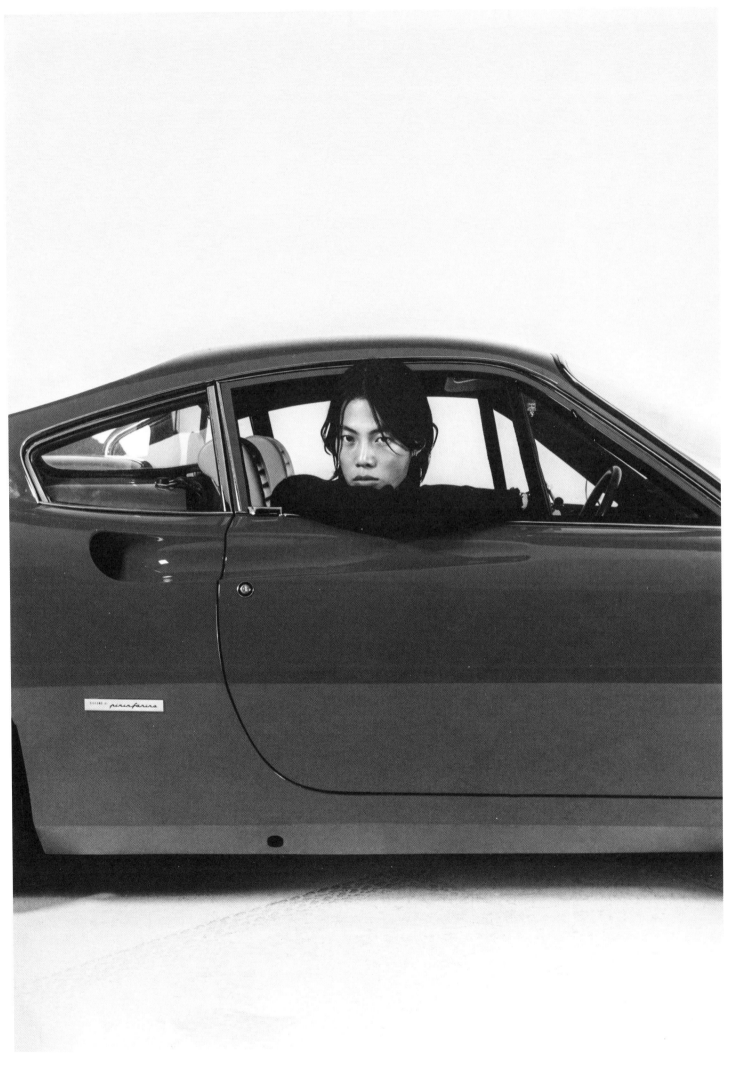

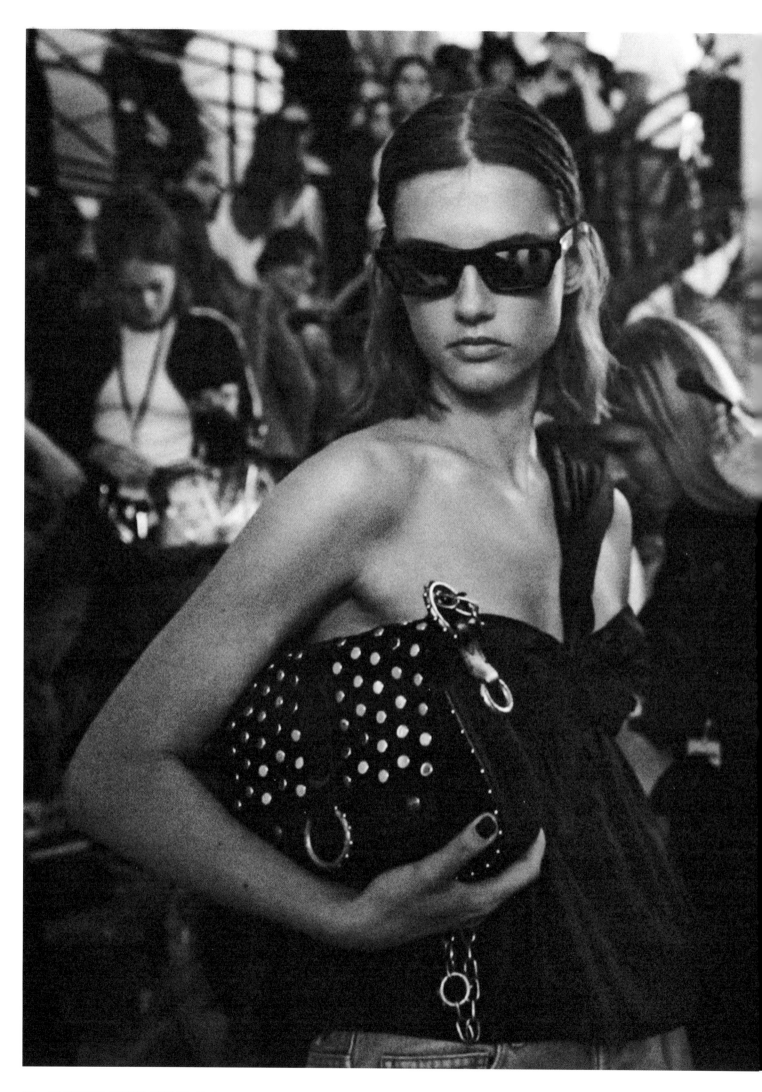

28 BACKSTAGE, SPRING-SUMMER 2020 SHOW, RITZ, PARIS

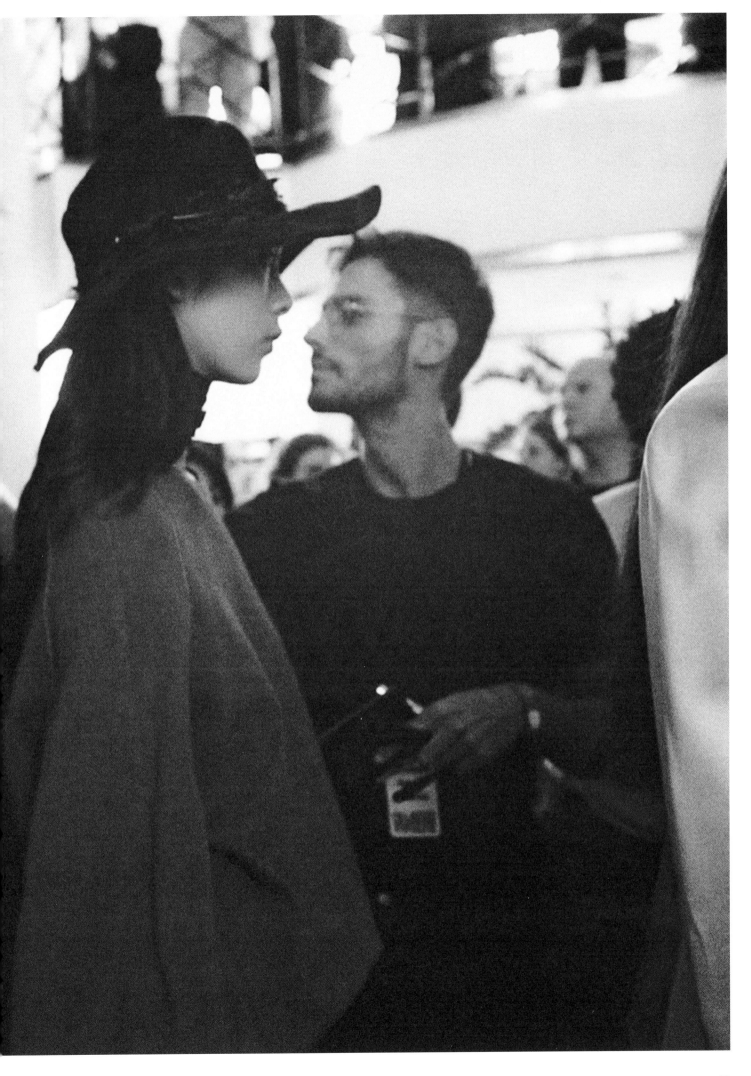

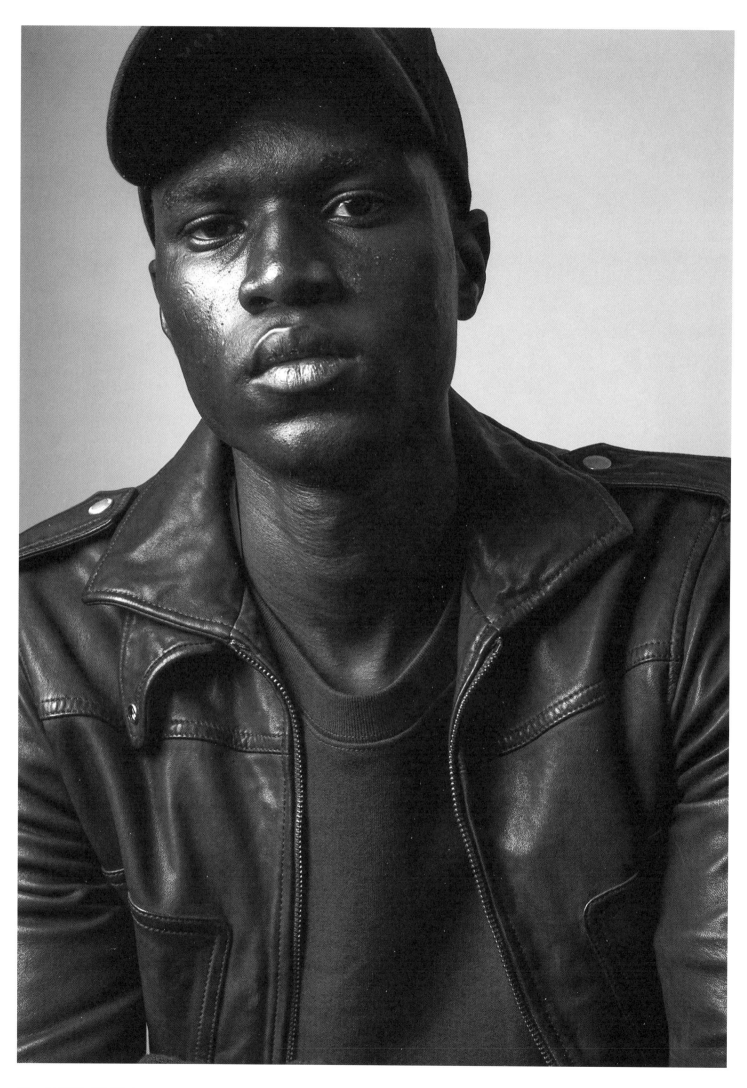

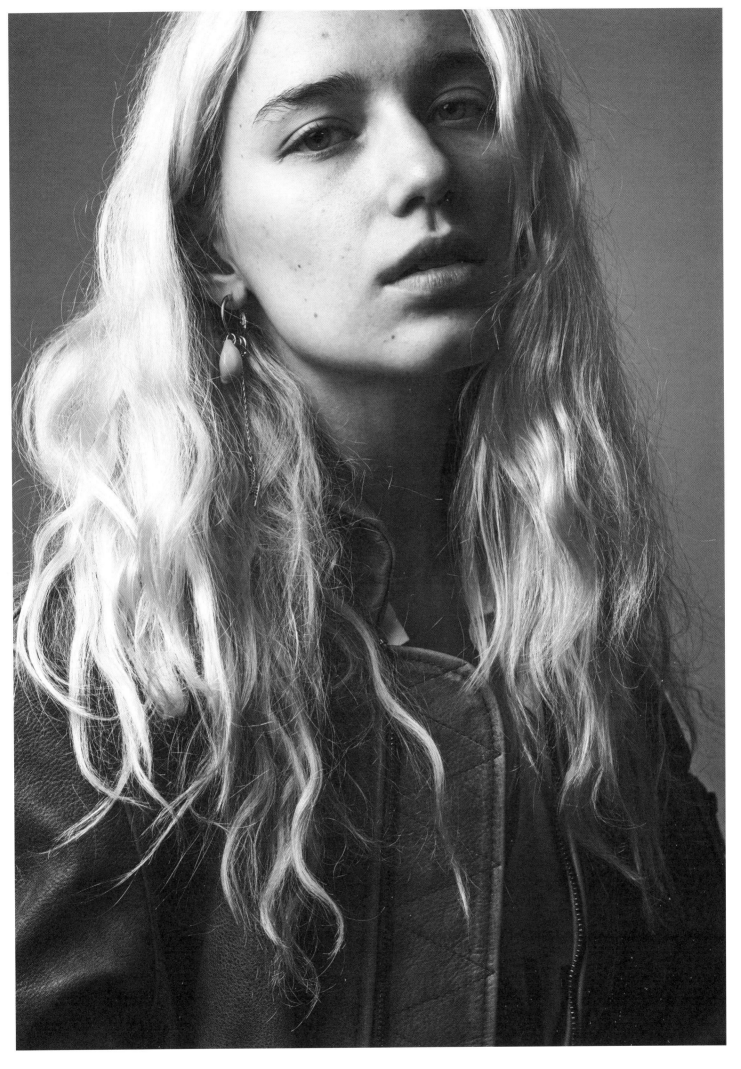

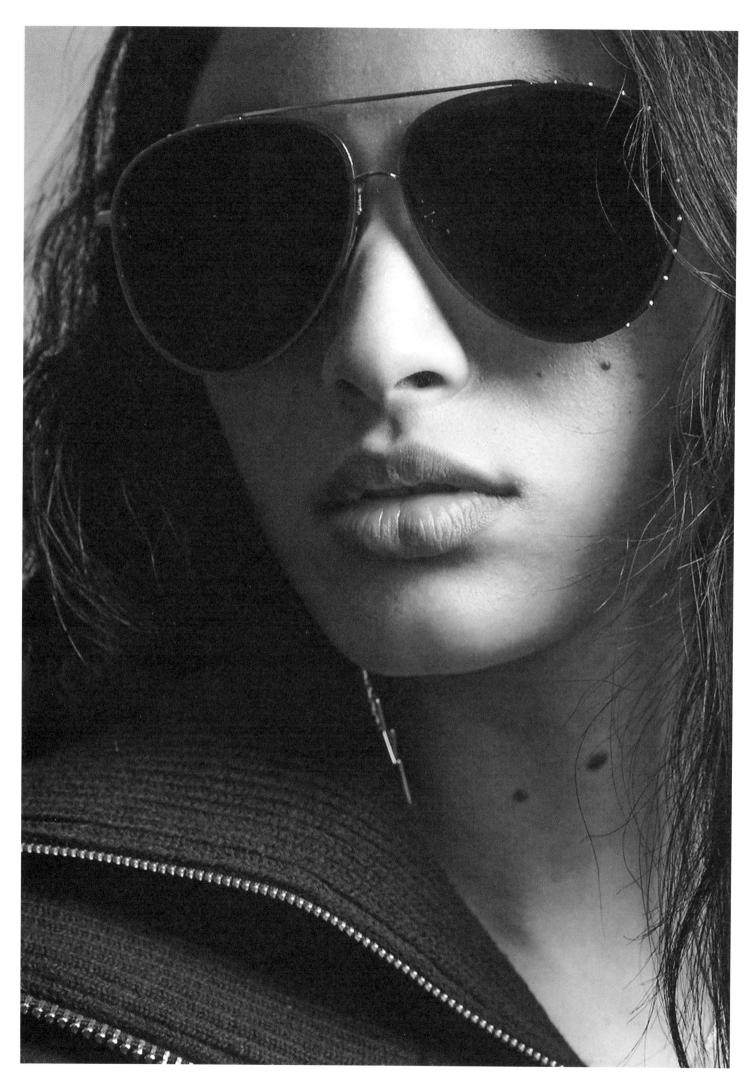

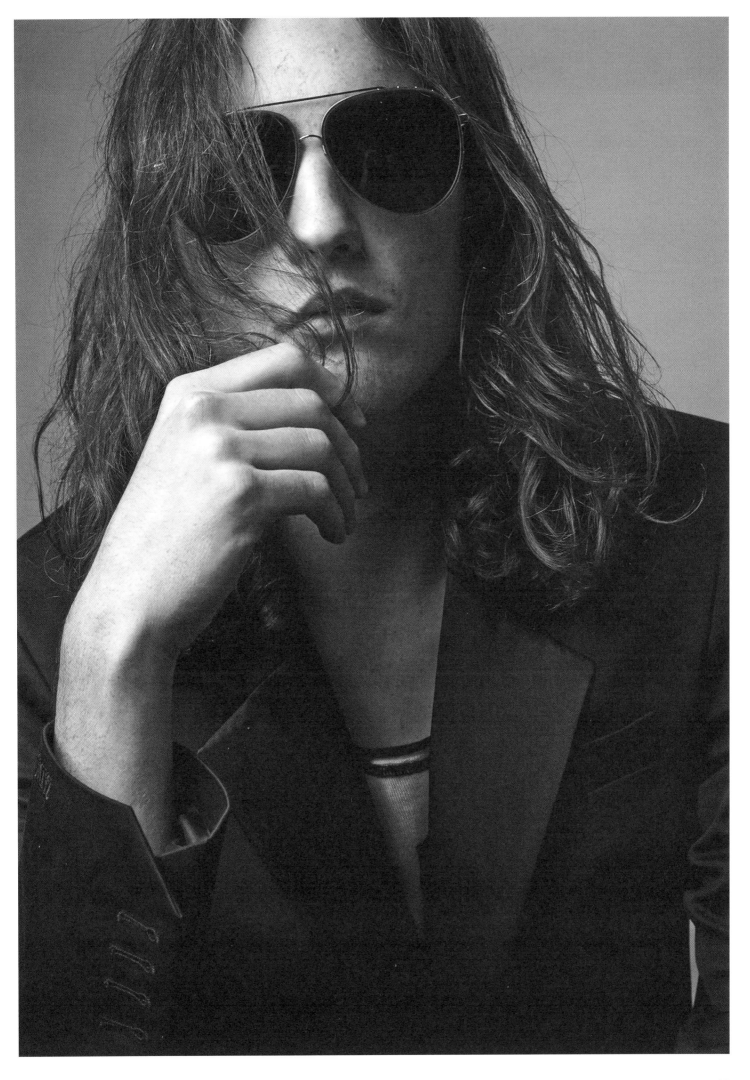

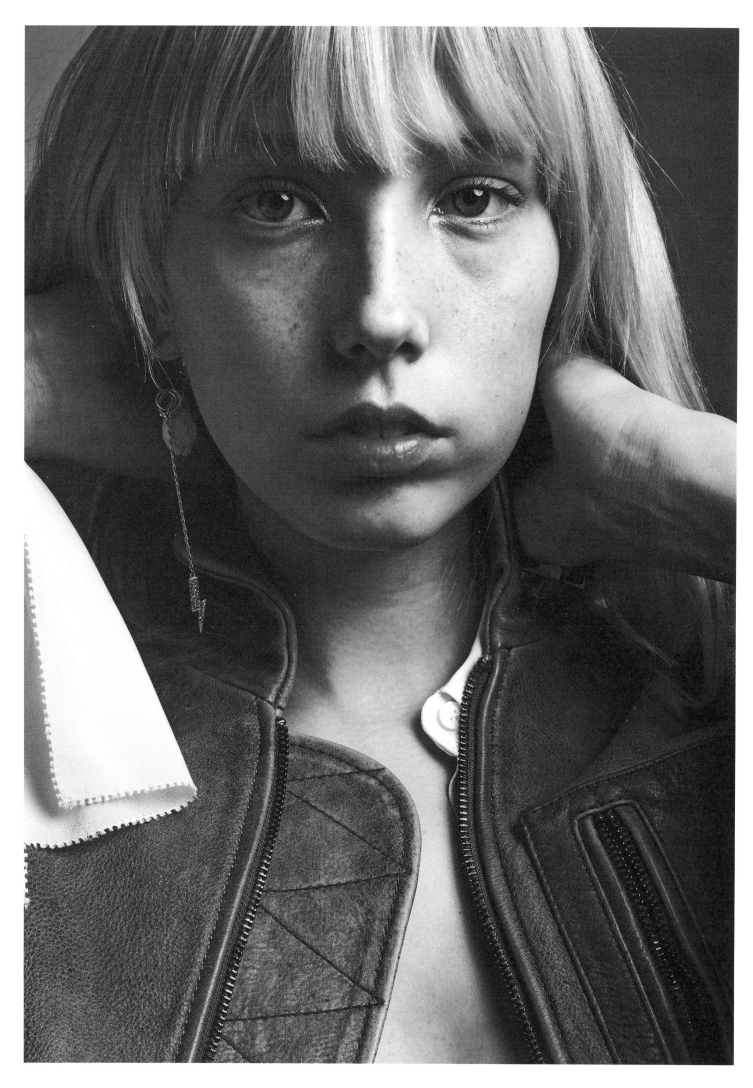

34 CASTING, SPRING-SUMMER 2019 SHOW, PARIS

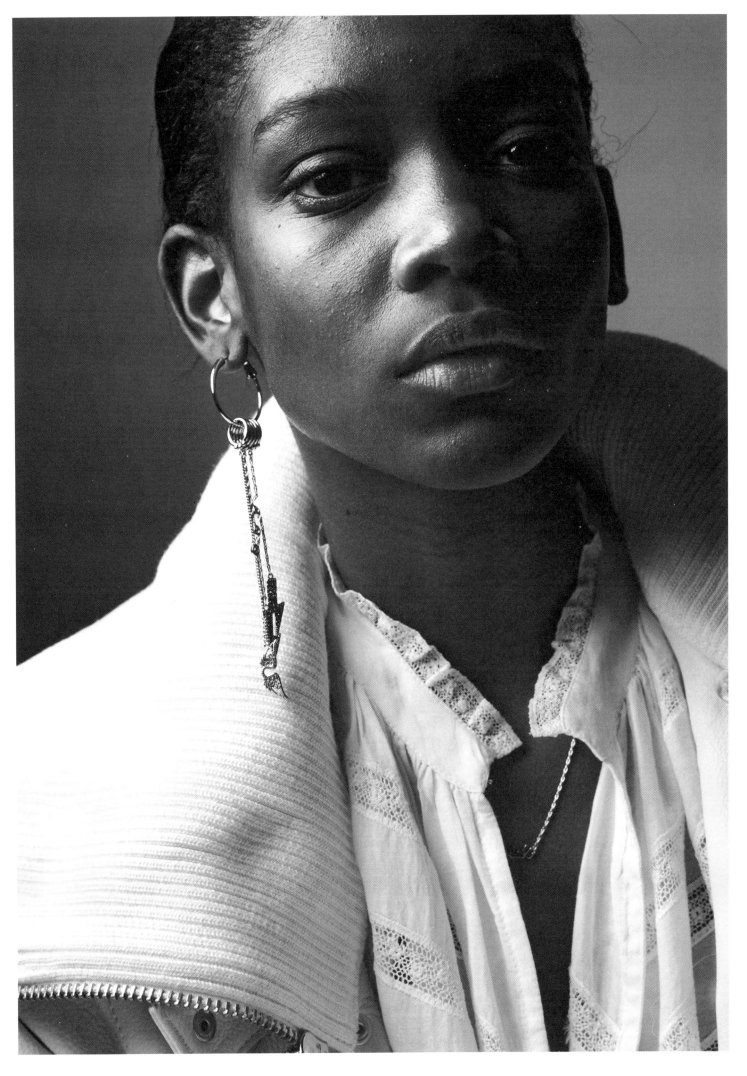

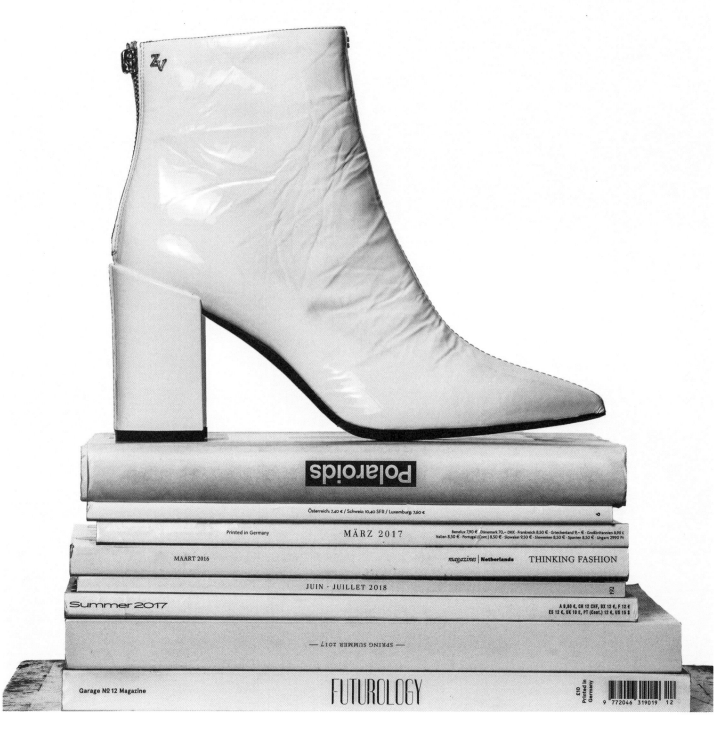

36 SPRING-SUMMER 2017 LOOKBOOK

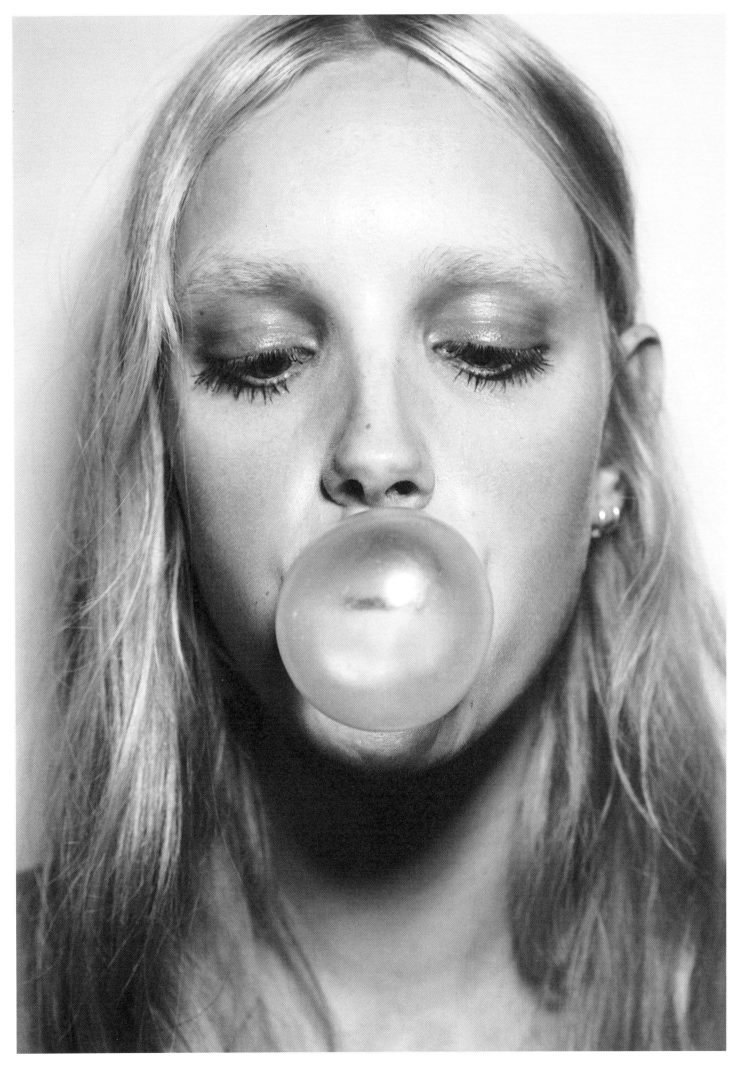

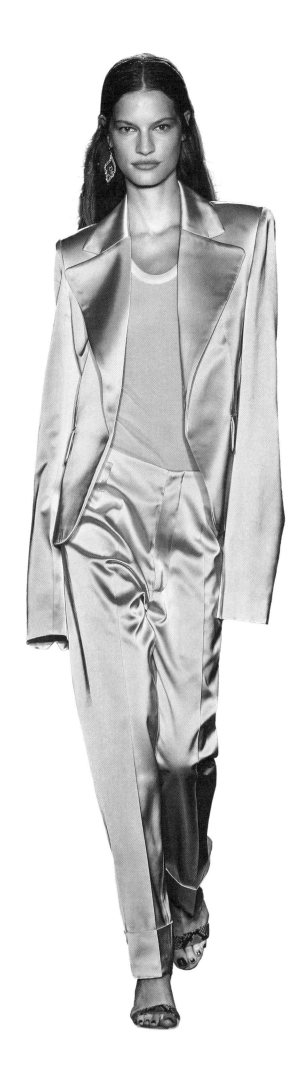

38 SPRING-SUMMER 2020 SHOW, PARIS

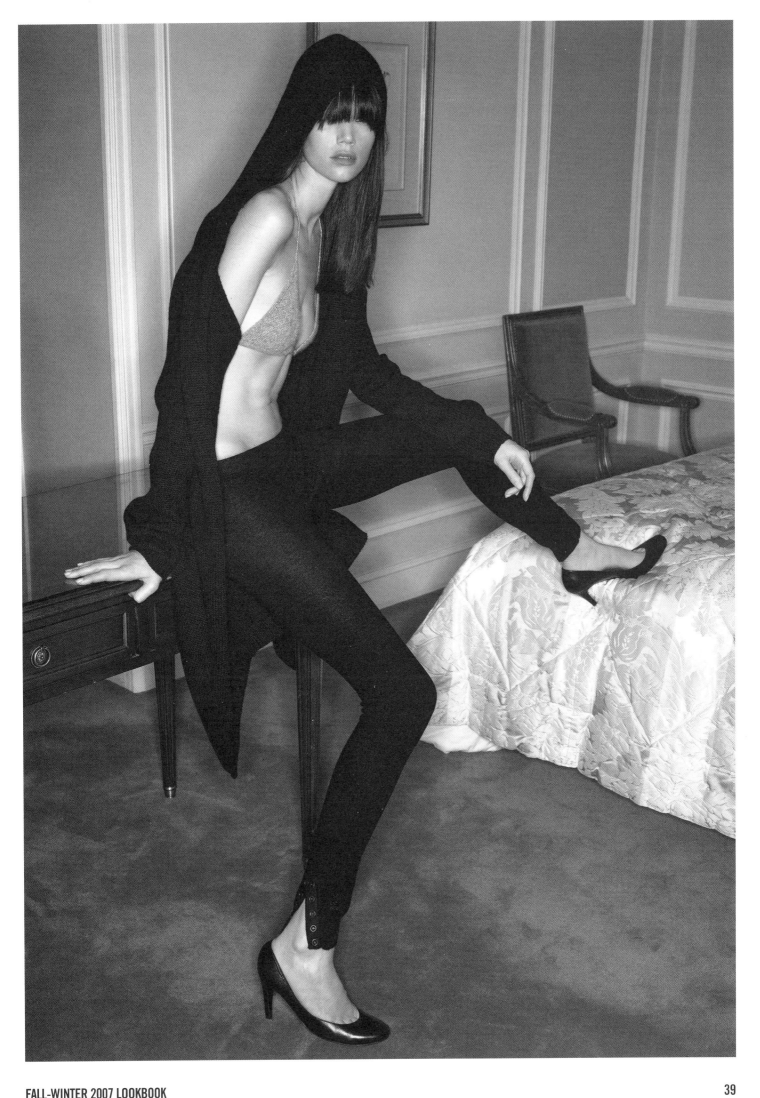
FALL-WINTER 2007 LOOKBOOK

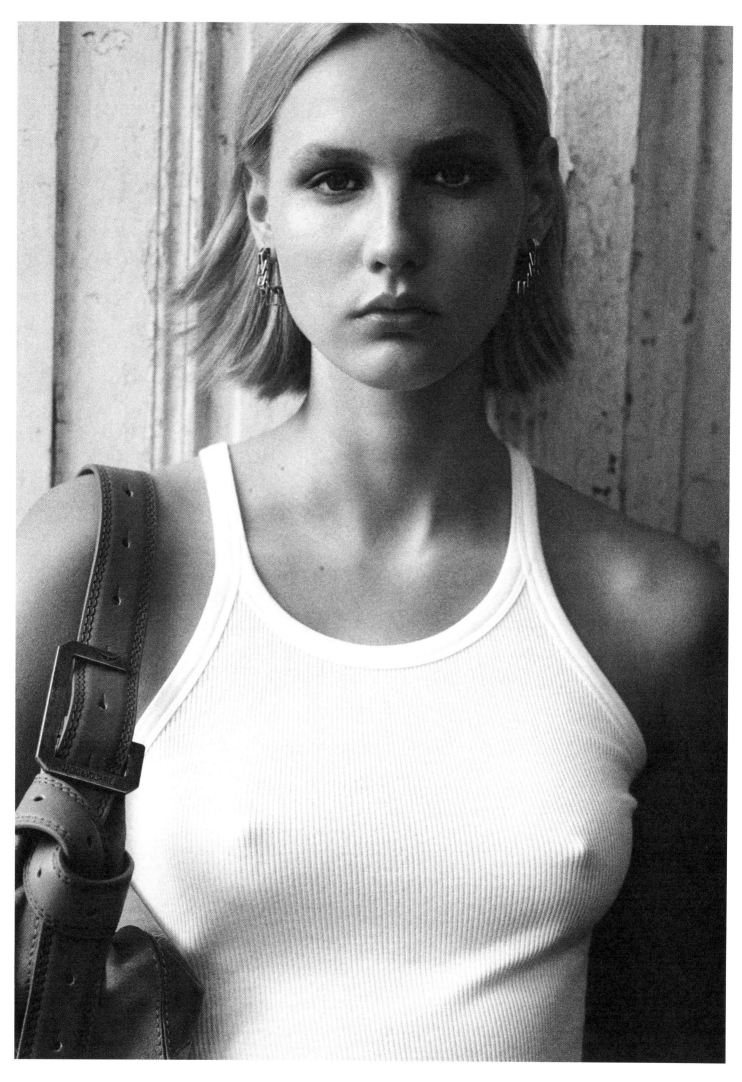

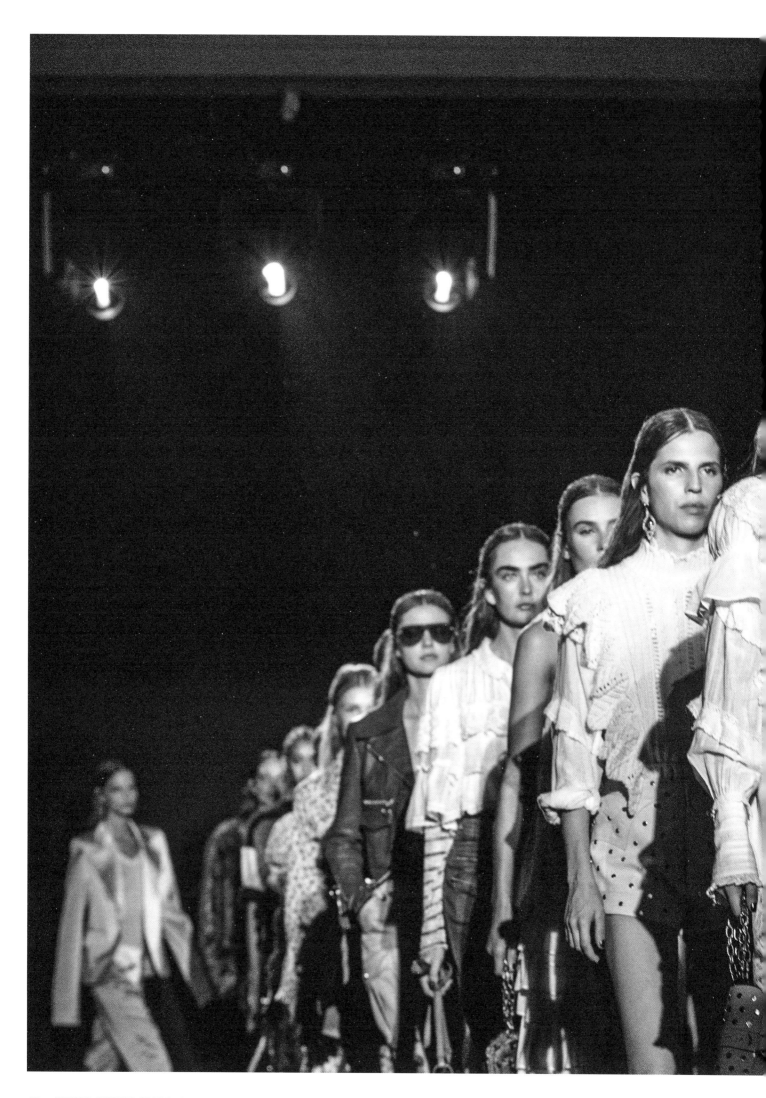

SPRING-SUMMER 2020 SHOW, RITZ, PARIS

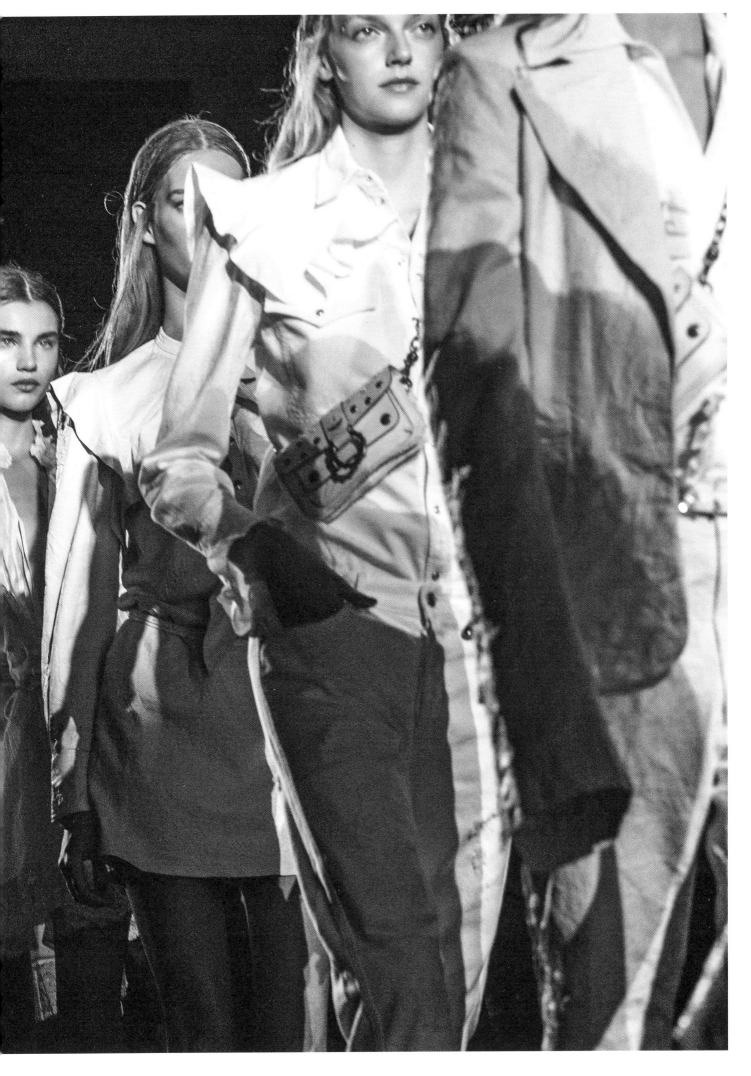

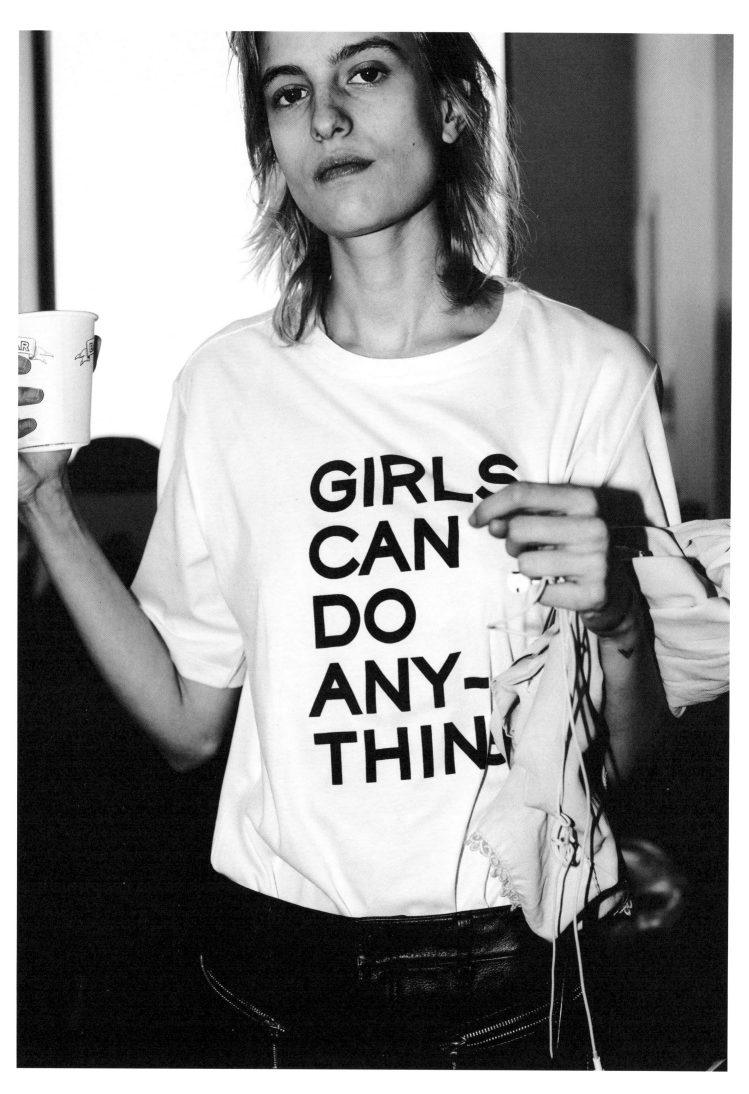

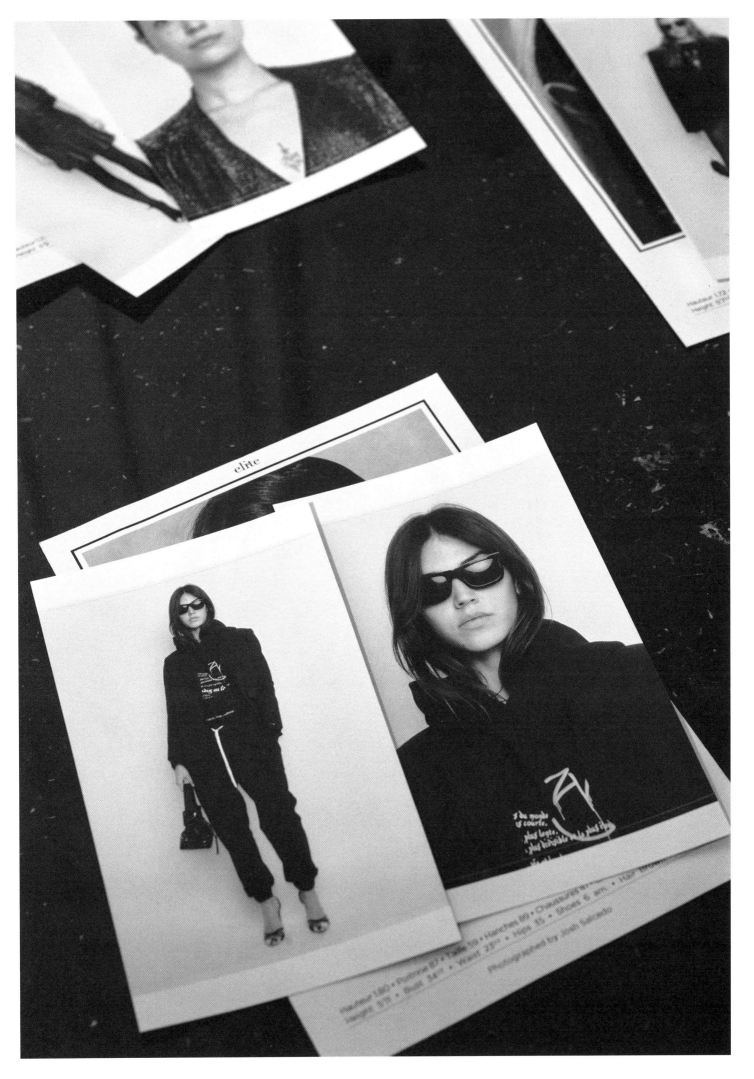

CASTING, FALL-WINTER 2021 SHOW, PARIS

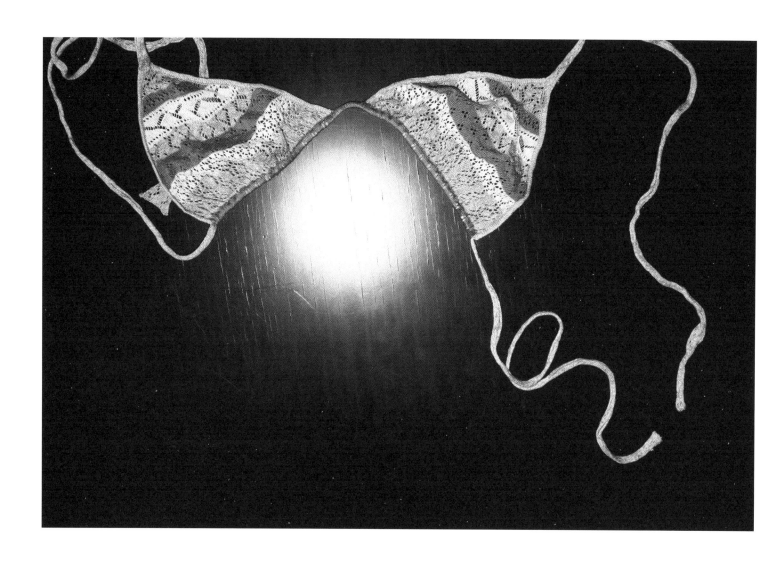

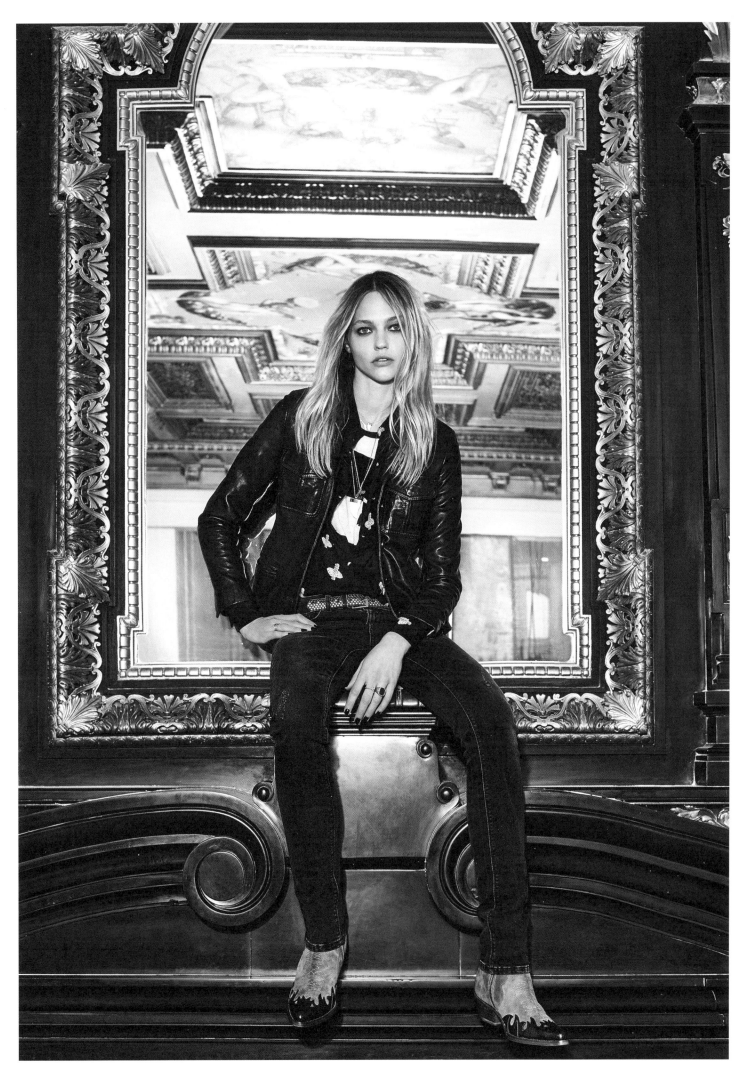

SPRING-SUMMER 2015 AD CAMPAIGN

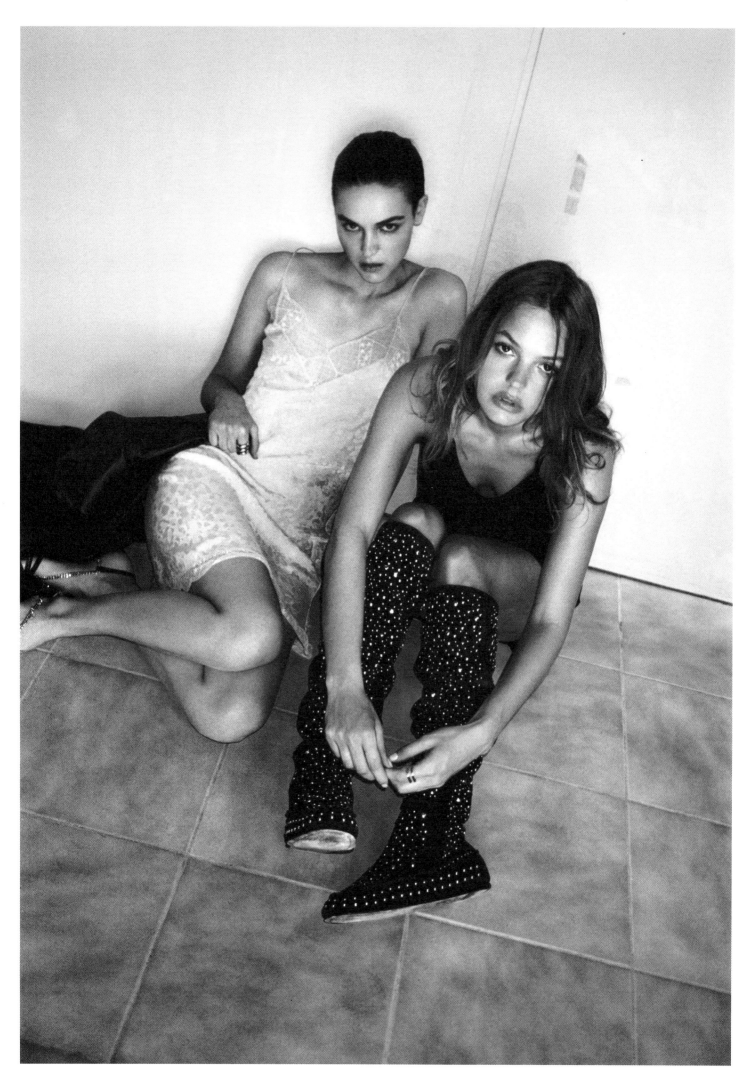

TUNISIAN T-SHIRT, ICONIC PIECE

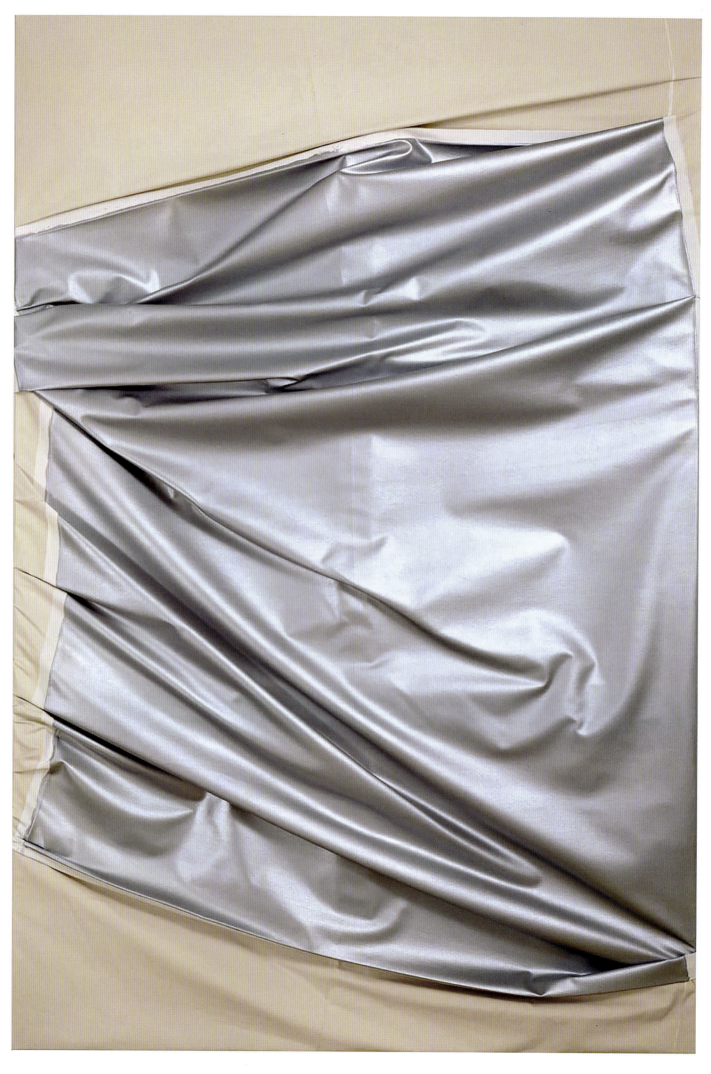

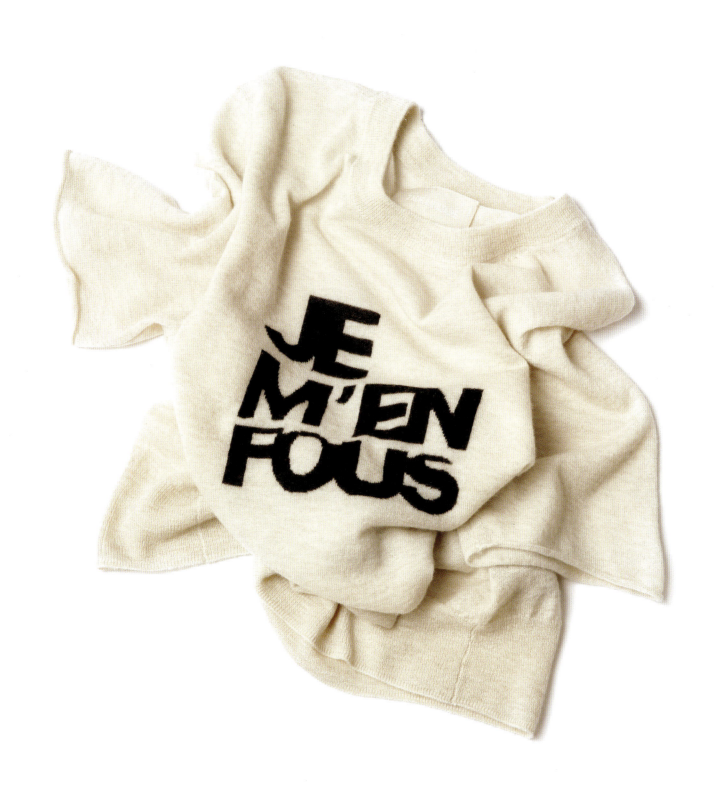

IDA SWEATER, FALL-WINTER 2022

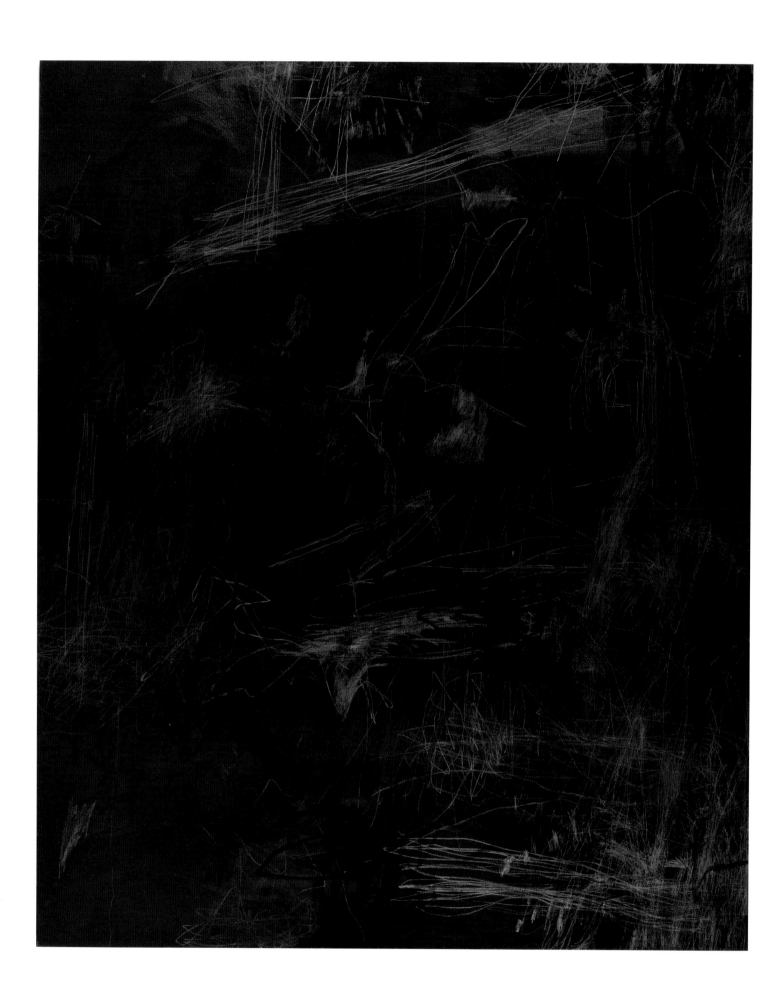

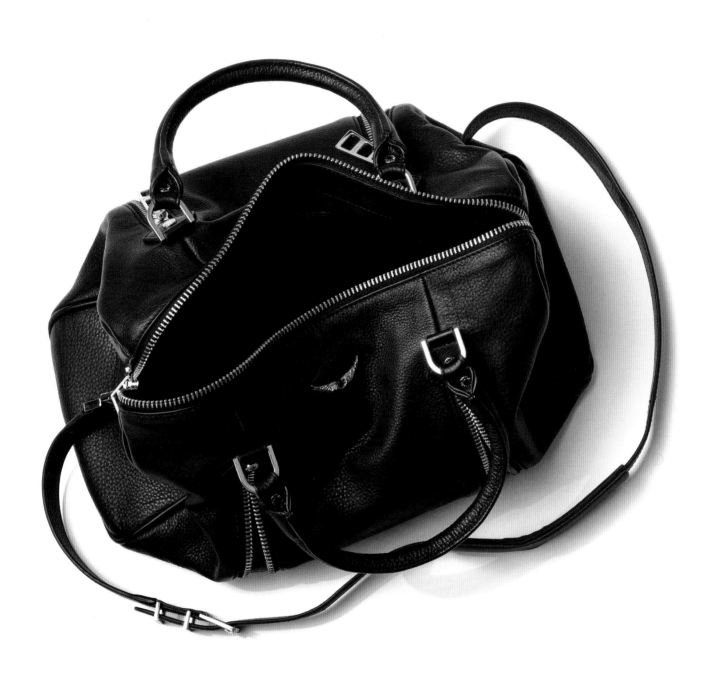

SUNNY BAG, MEDIUM SIZE, ICONIC PIECE

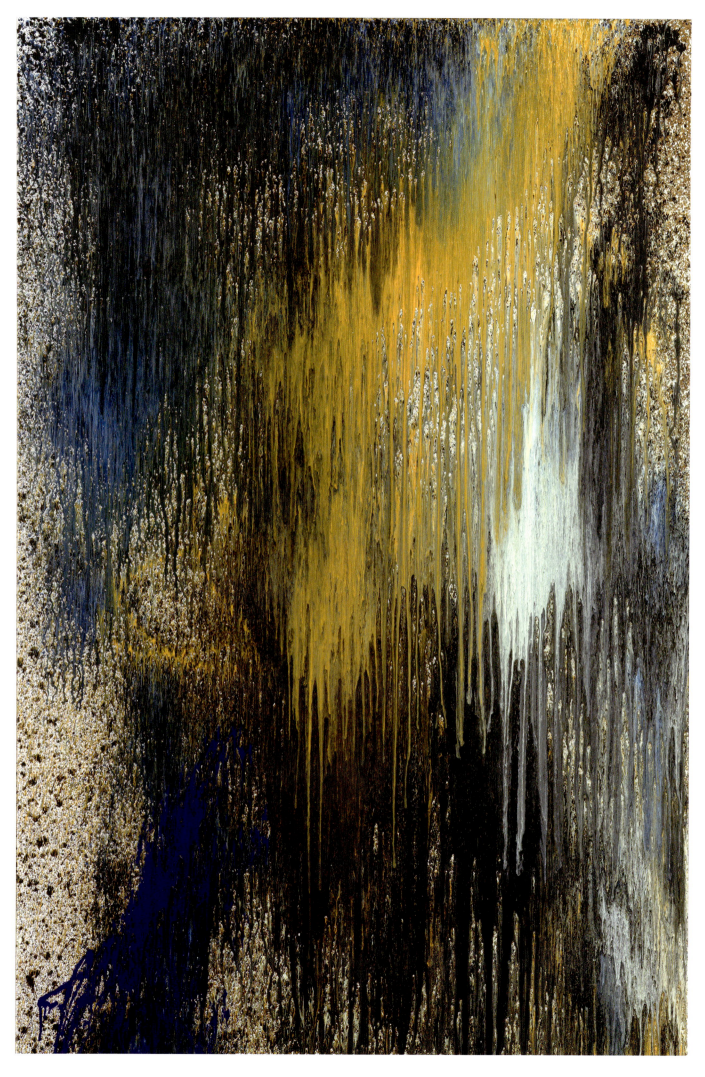

HANS HARTUNG, *T1989-E16*, 1989

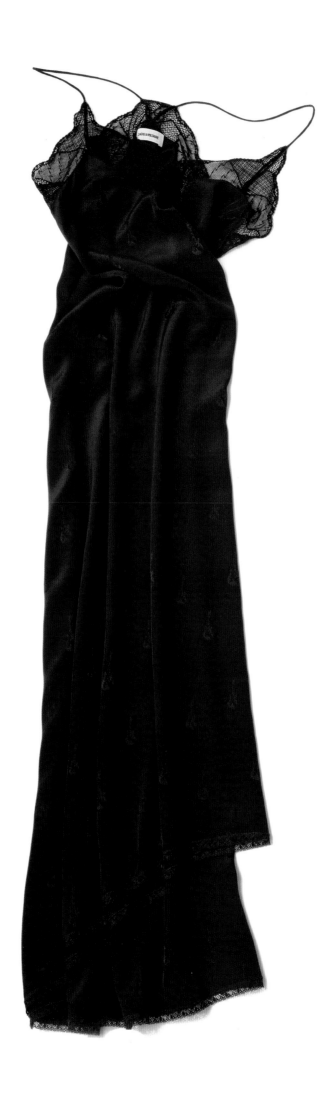

RISTY GUITAR DRESS, ICONIC PIECE

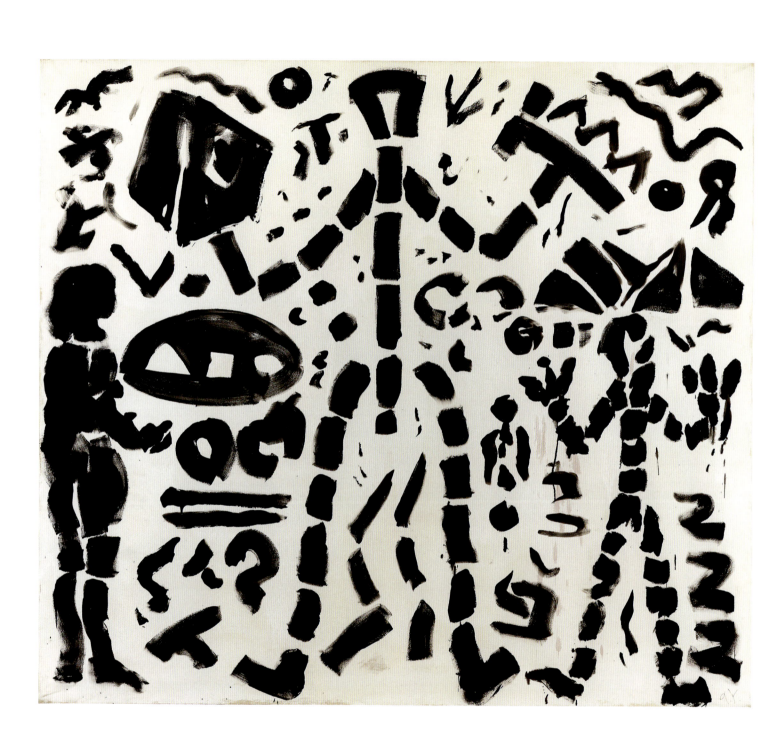
56 A.R. PENCK, *ÜBERGANG (TRANSITION)*, 1981

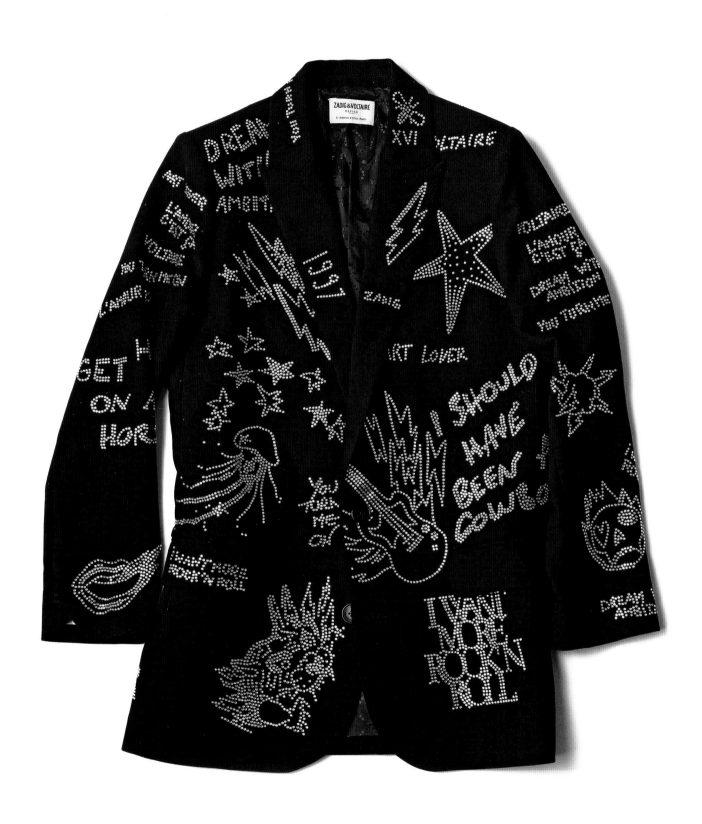

VIVA STRASS CARROUSEL JACKET, SPRING-SUMMER 2022

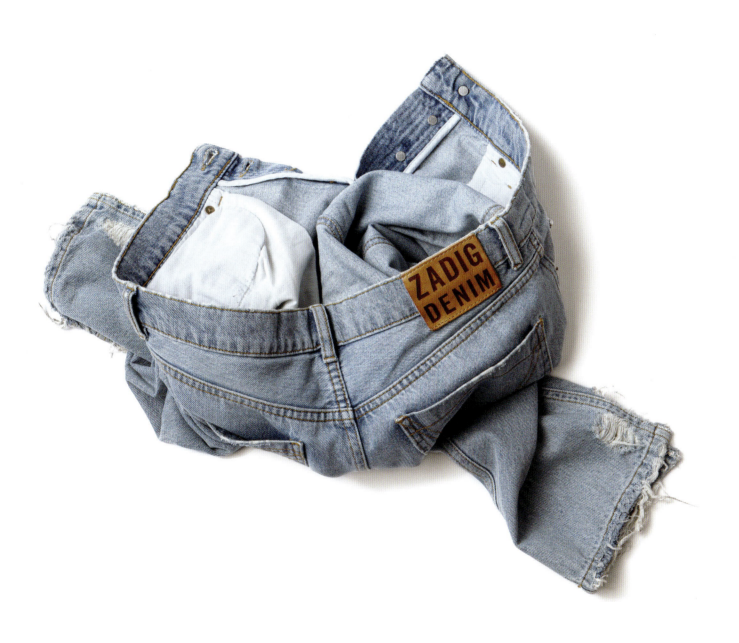

ERINI DENIM, ECO-FRIENDLY CAPSULE COLLECTION, SPRING-SUMMER 2021

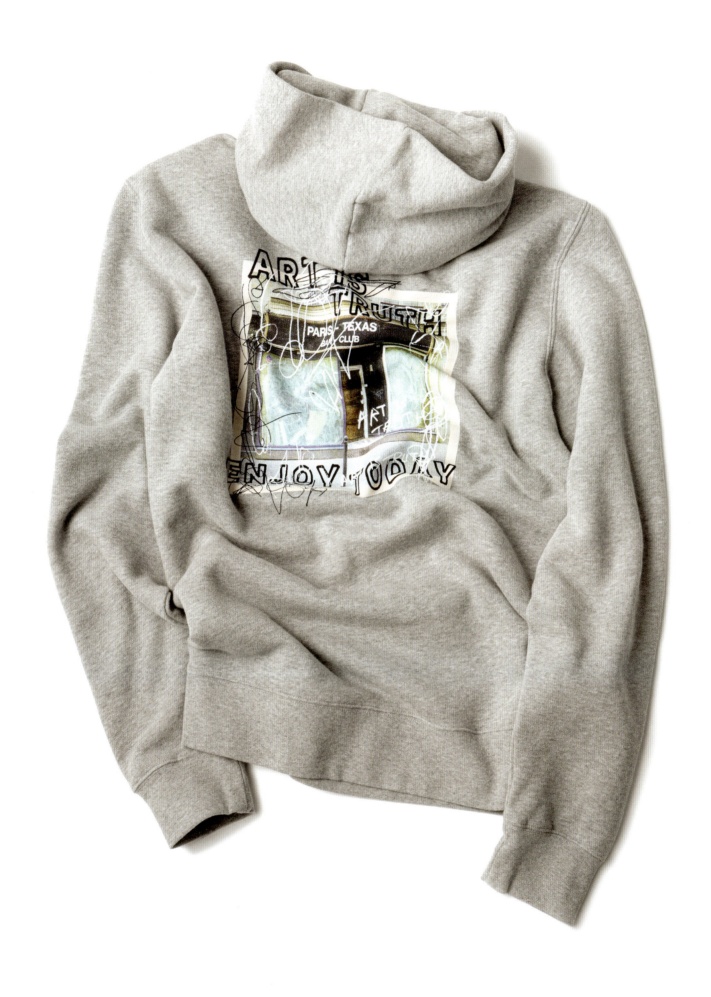

SANCHI PARIS TEXAS SWEATSHIRT, FALL-WINTER 2022

CHRISTY CARACO, ICONIC PIECE

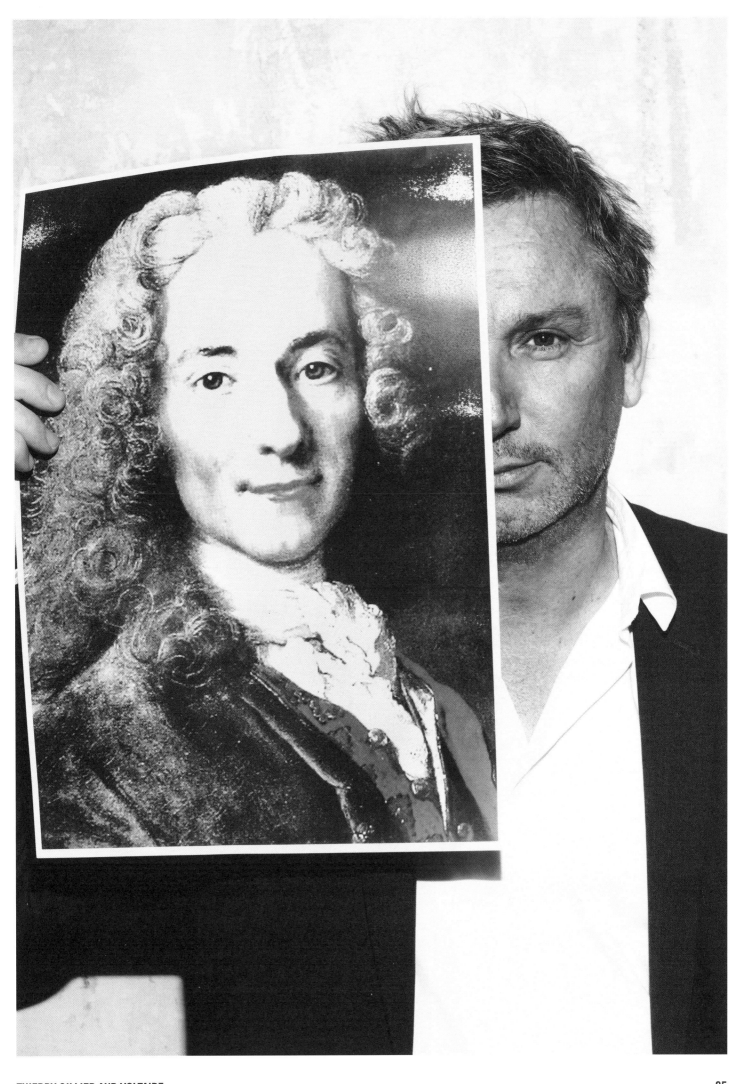

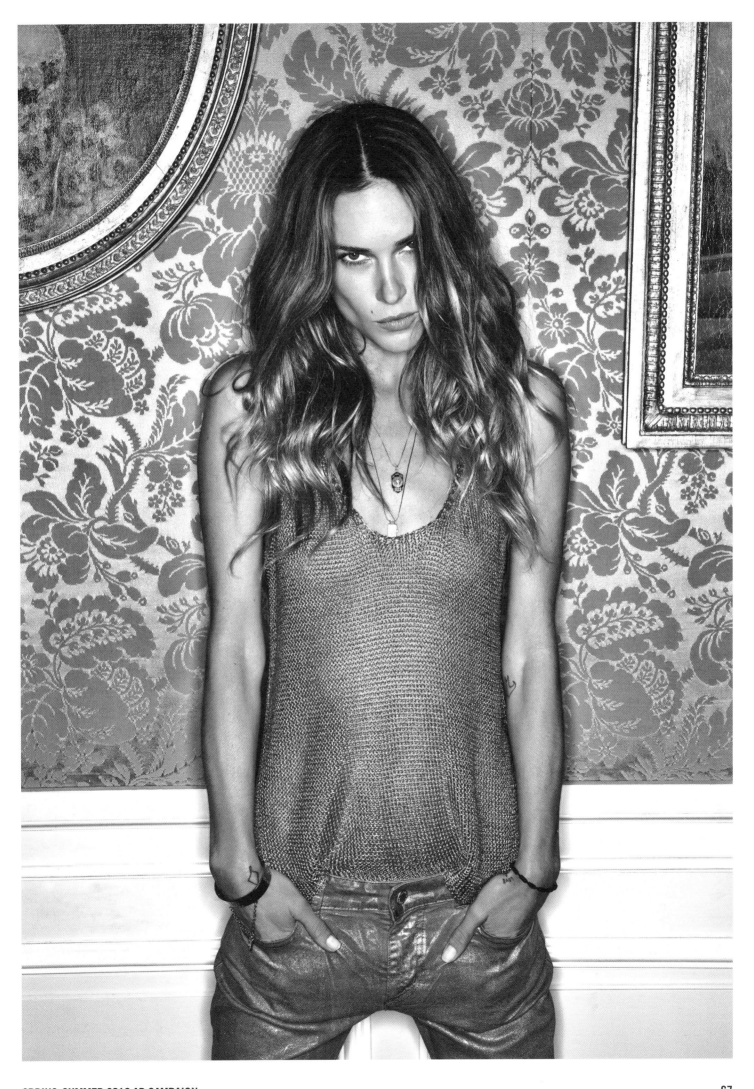

SPRING-SUMMER 2012 AD CAMPAIGN

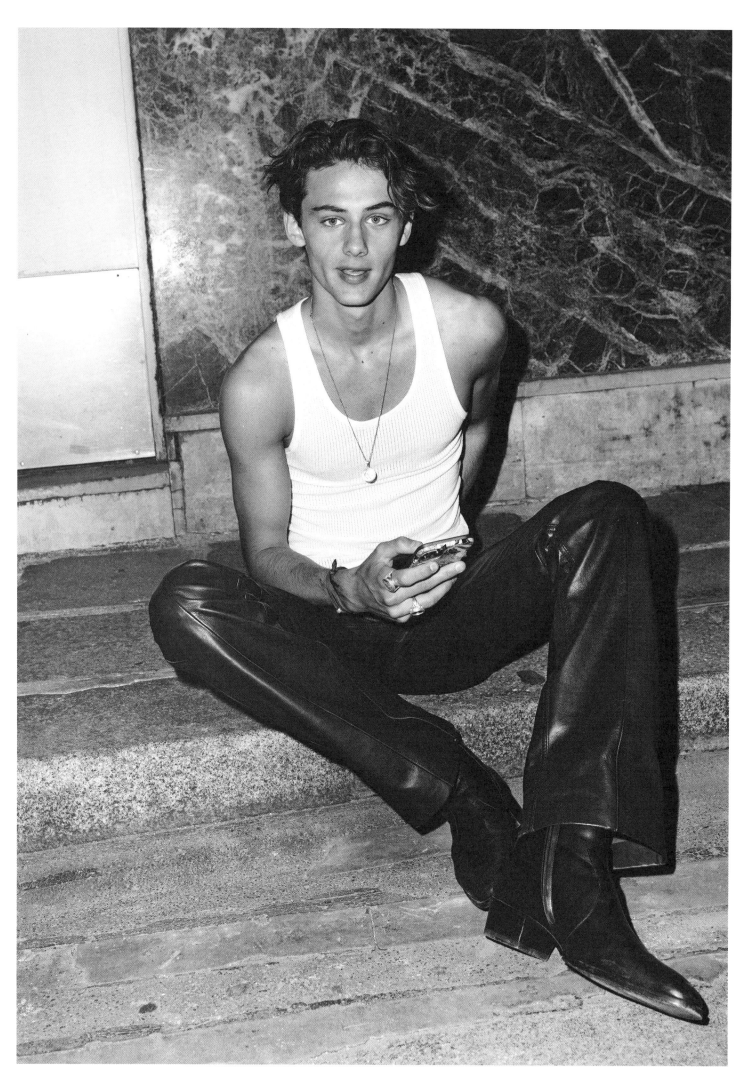

AFTER-PARTY, FALL-WINTER 2022 SHOW, PARIS

FLAGSHIP STORE, 2 RUE CAMBON, PARIS

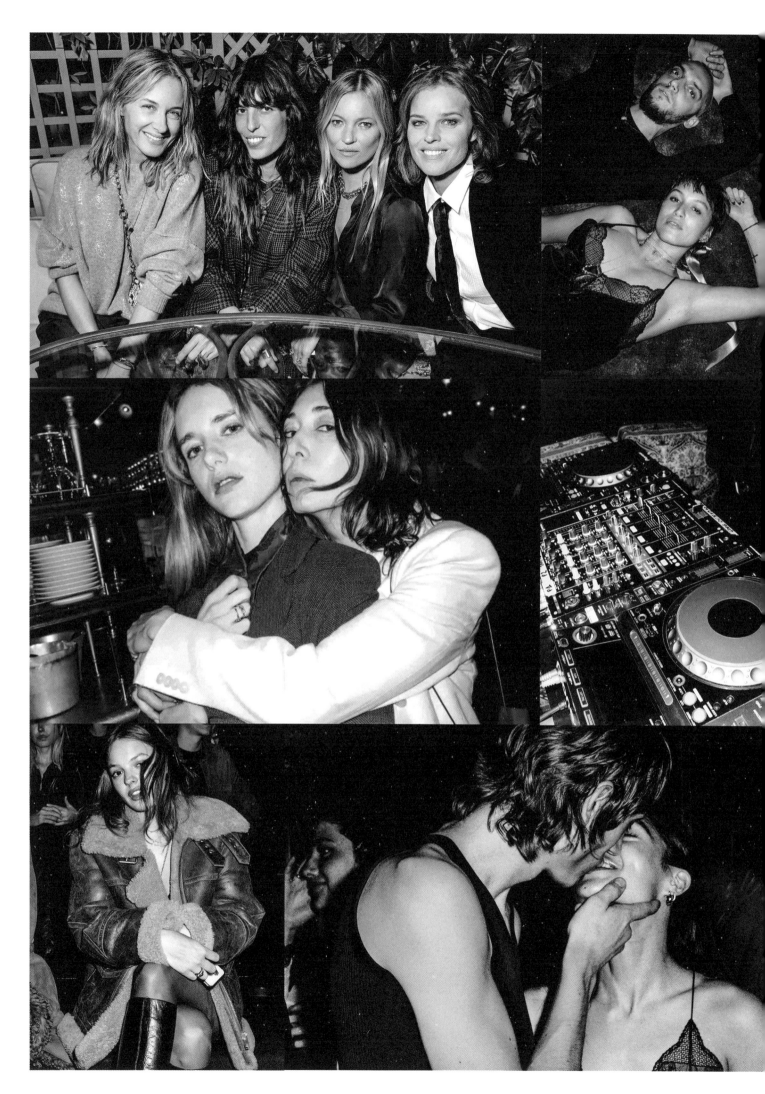

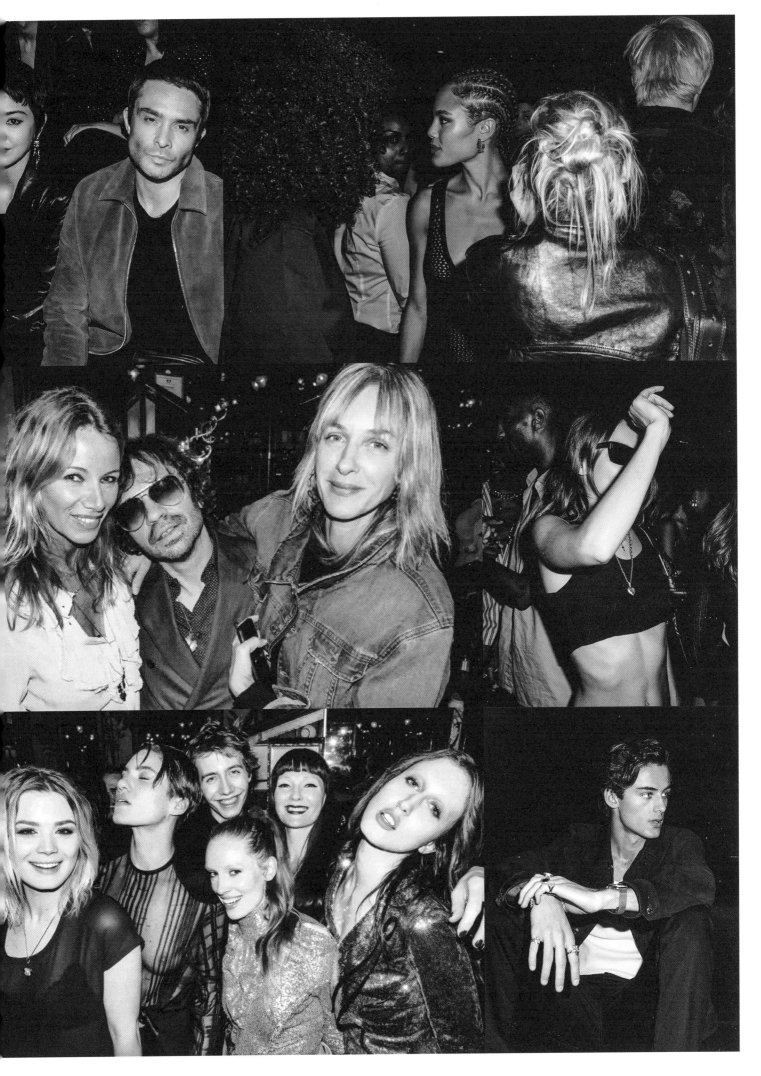

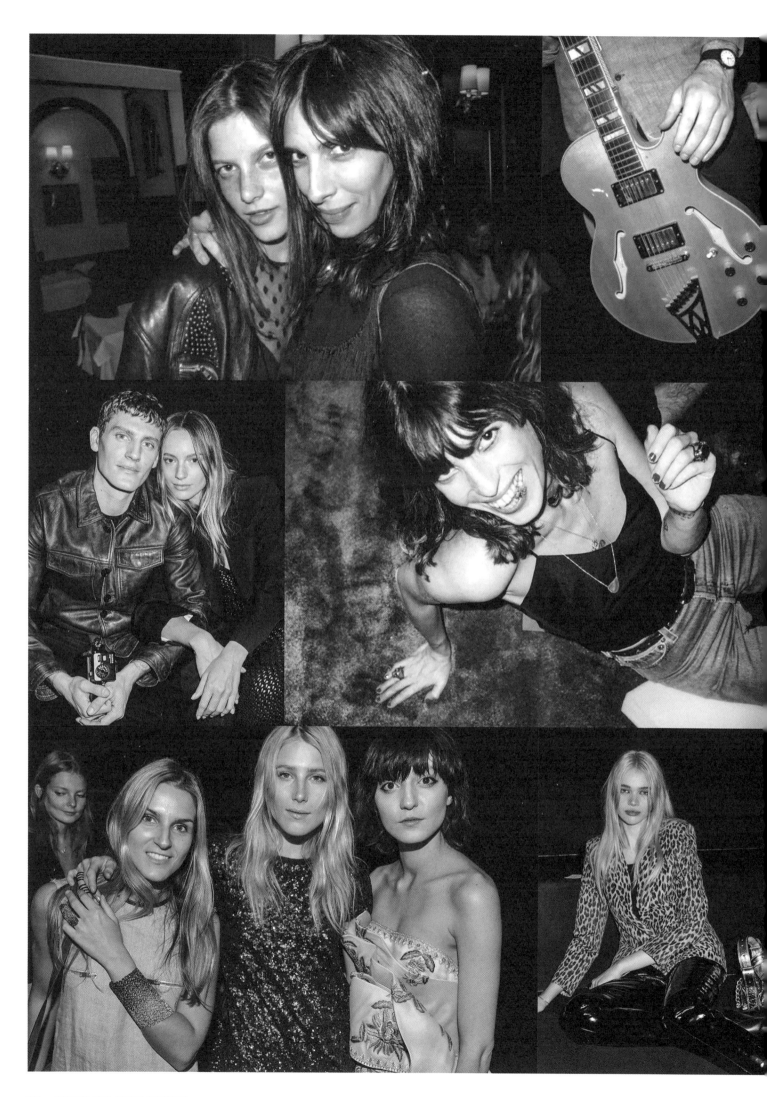

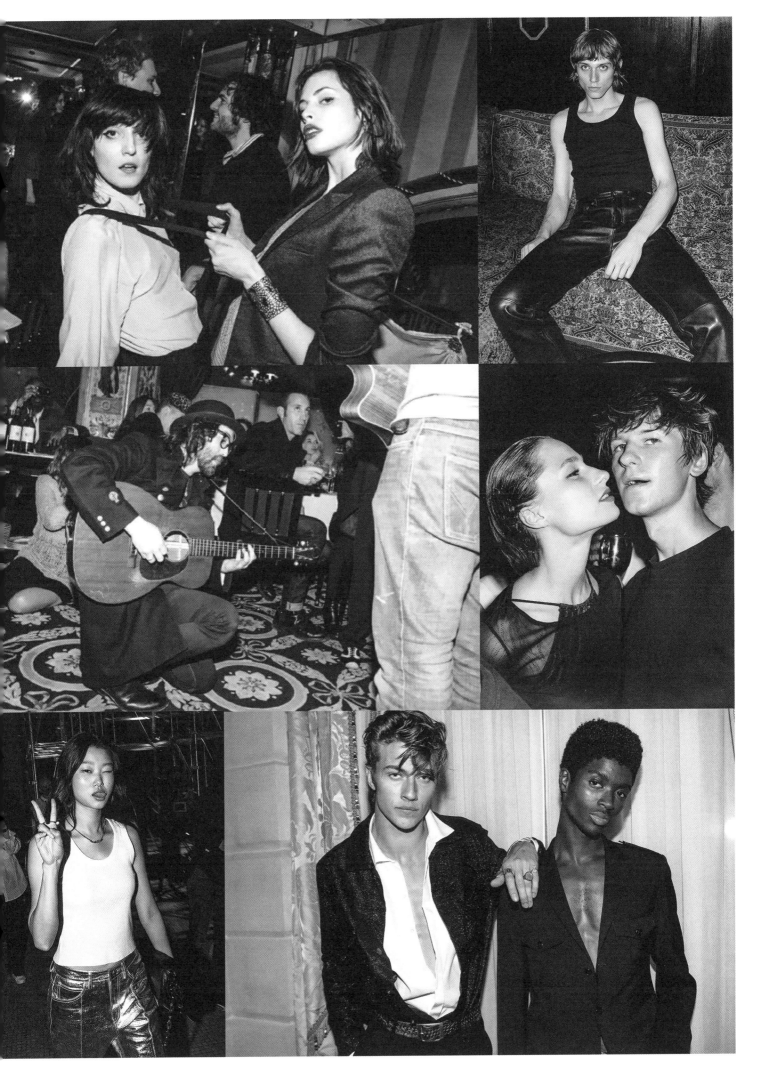

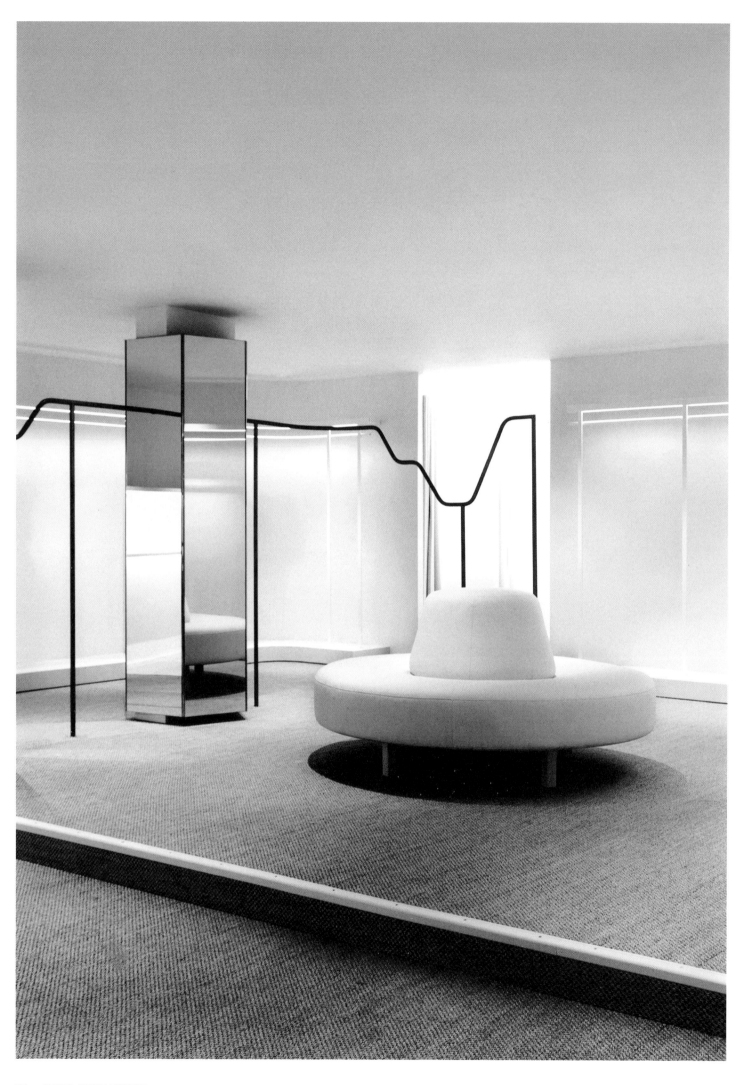

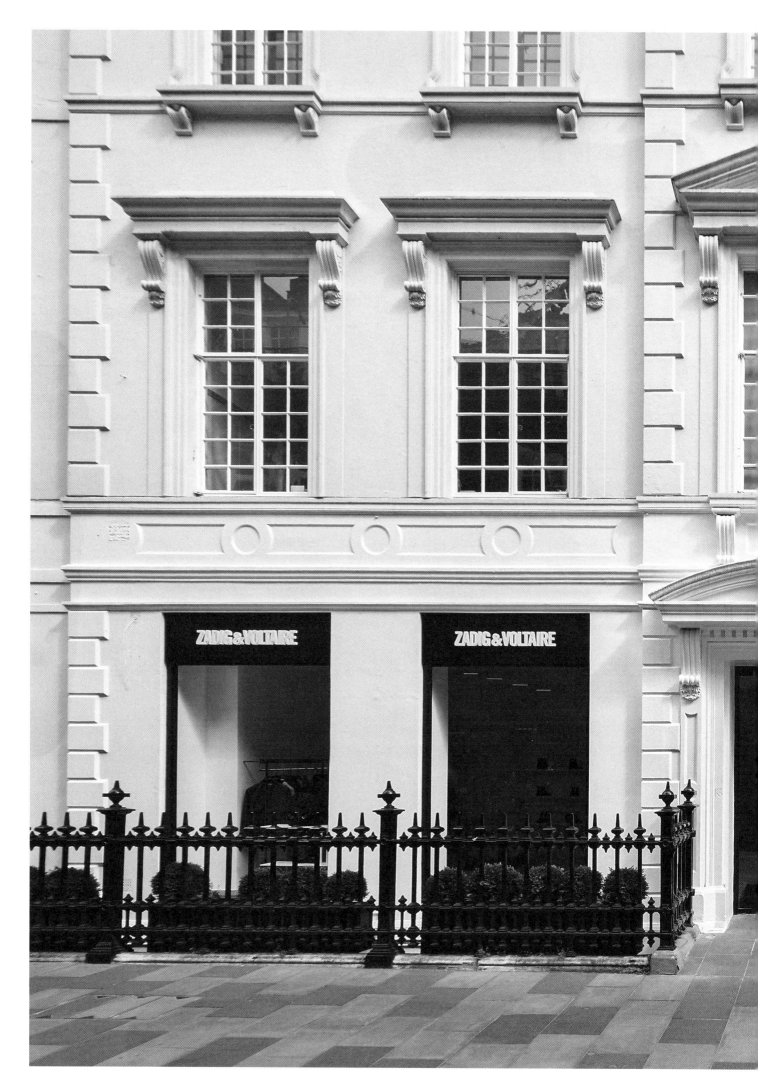

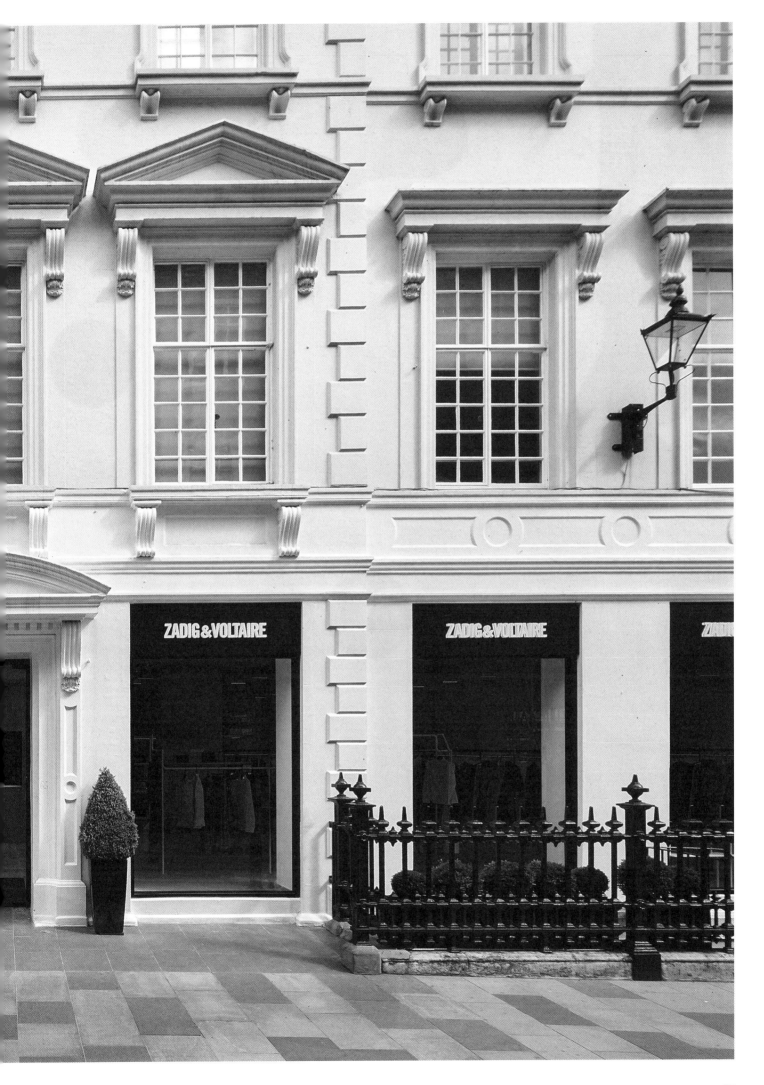

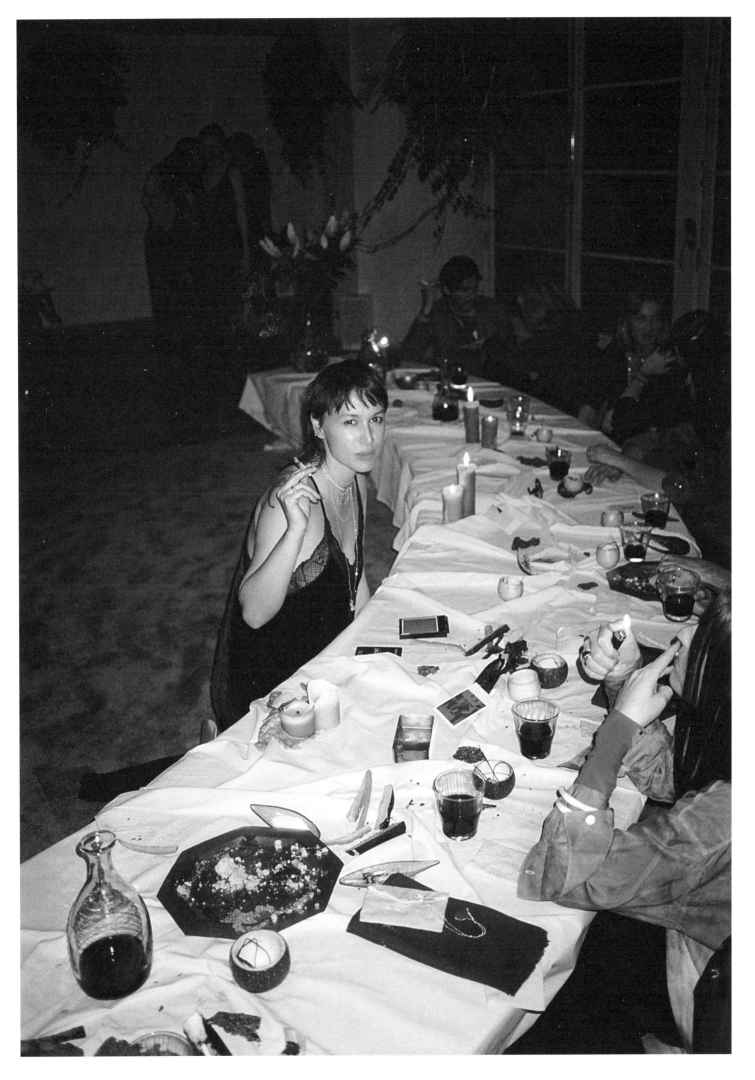

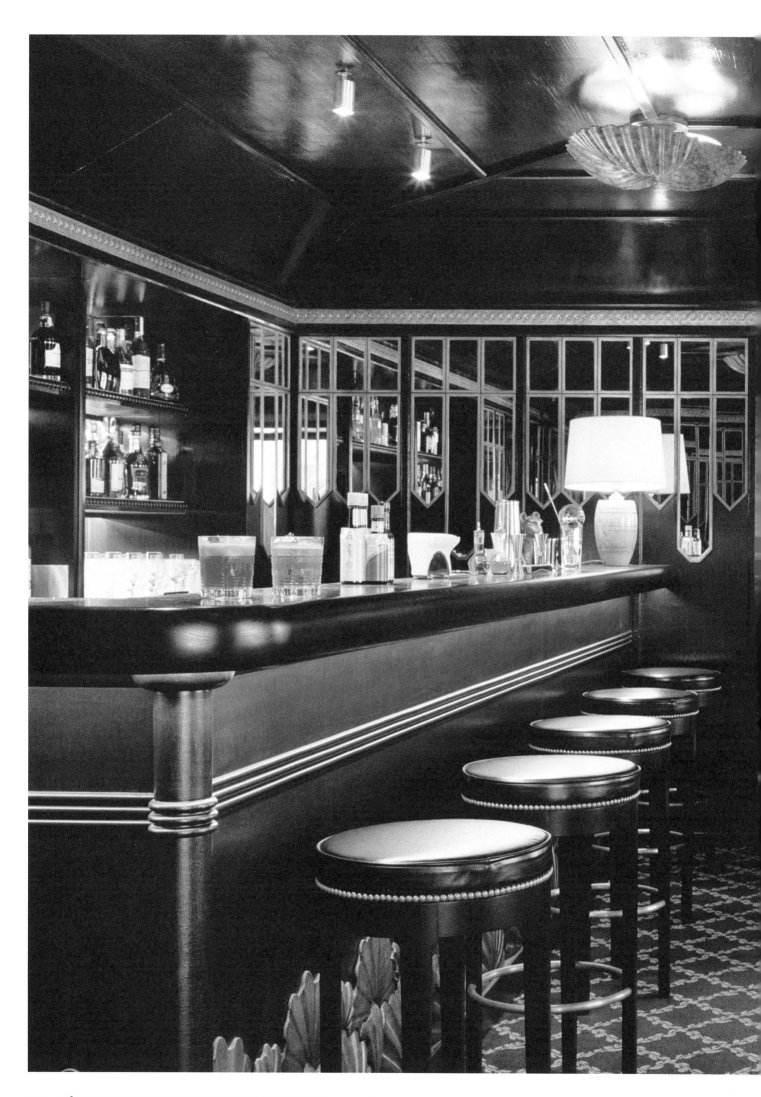

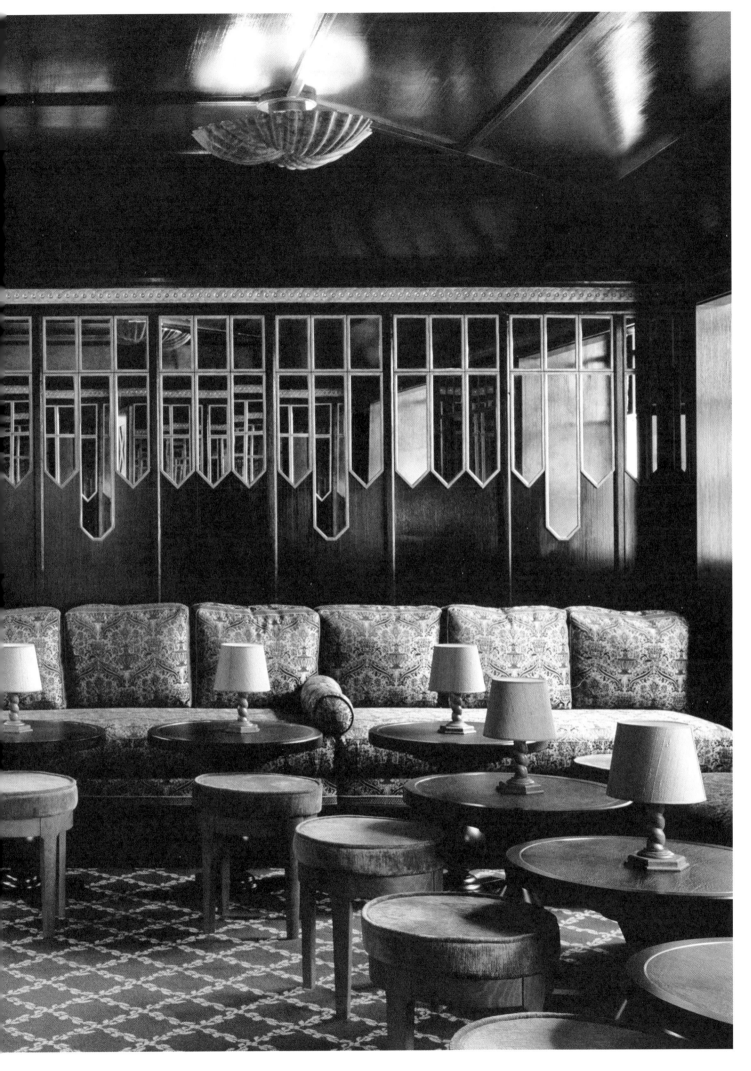

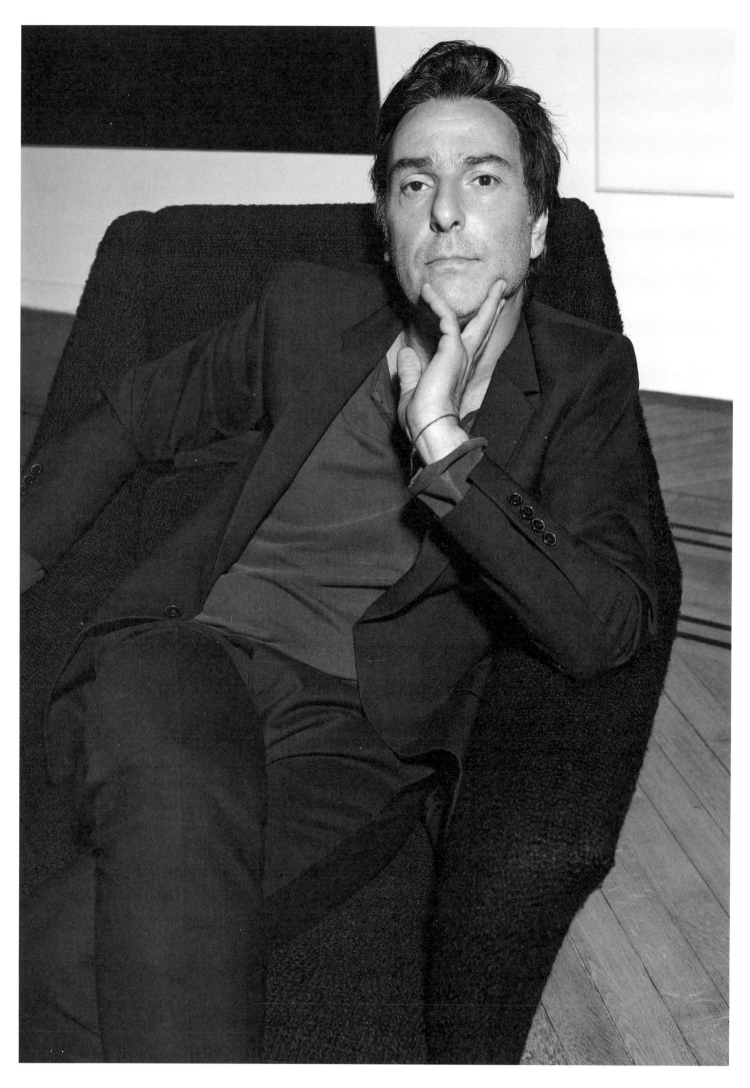

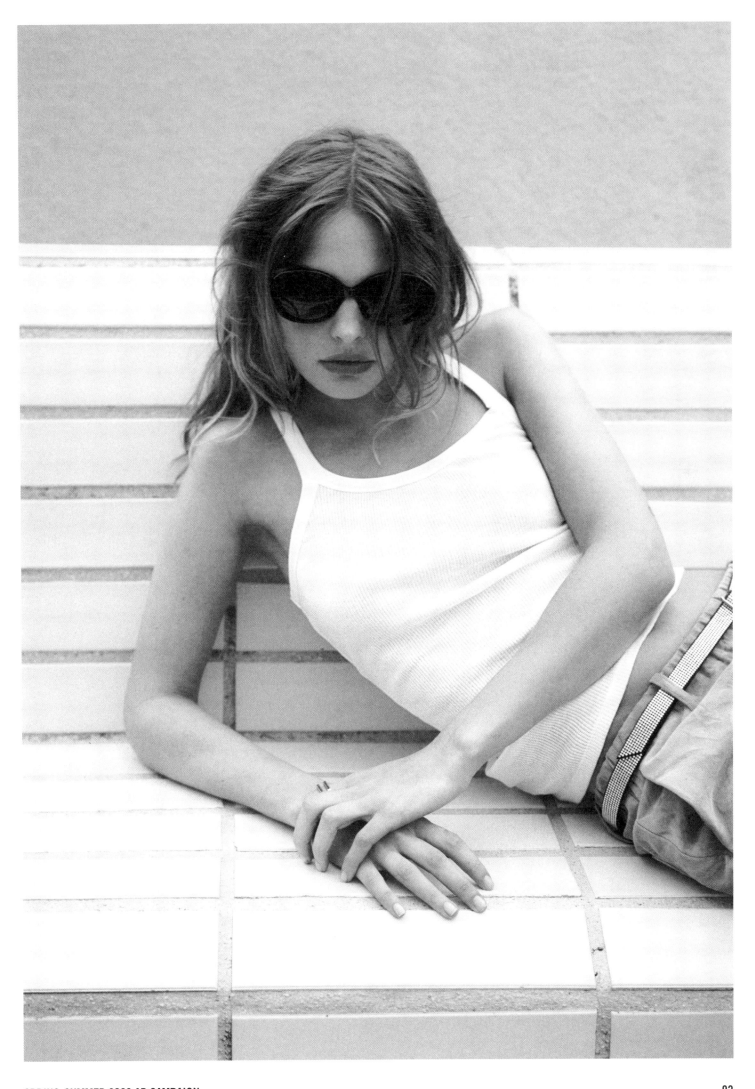

SPRING-SUMMER 2023 AD CAMPAIGN

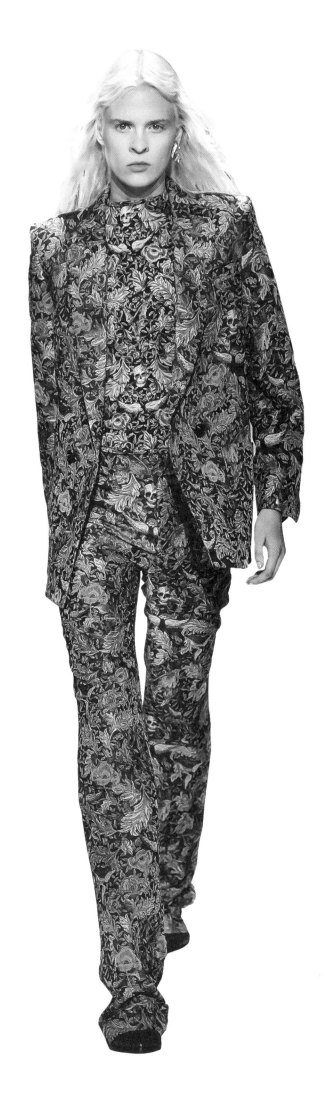

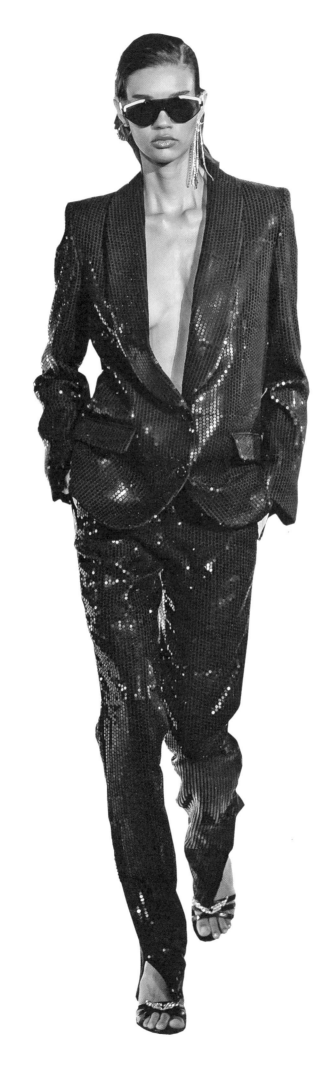

FALL-WINTER 2023 SHOW, PARIS

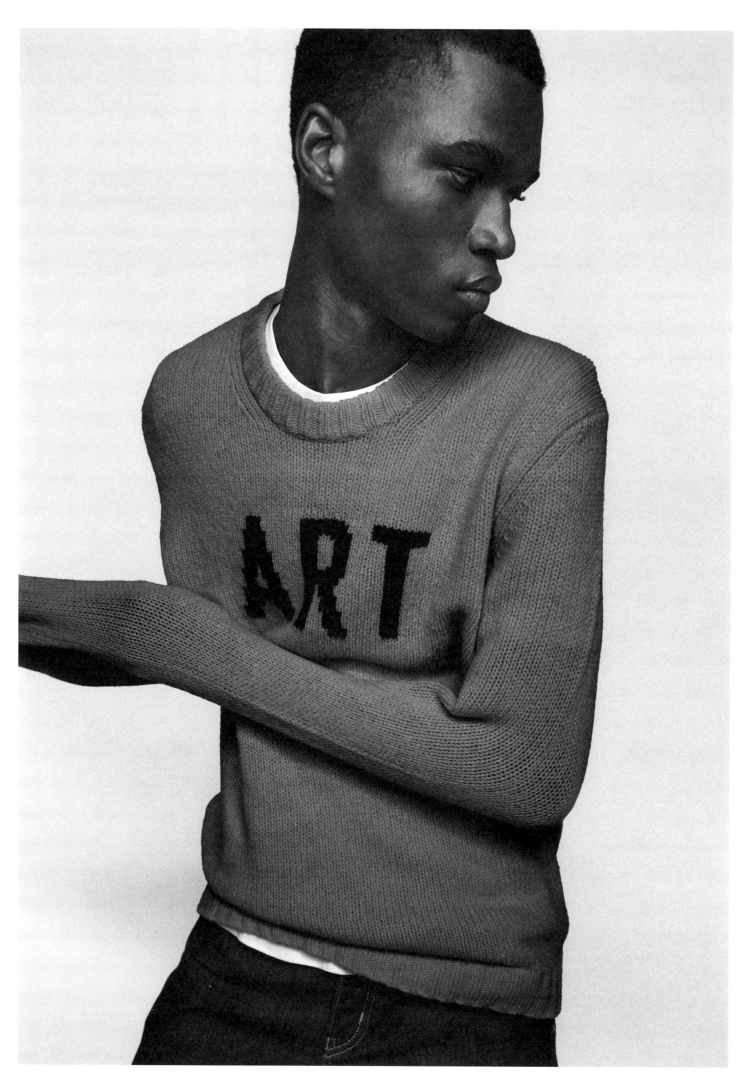

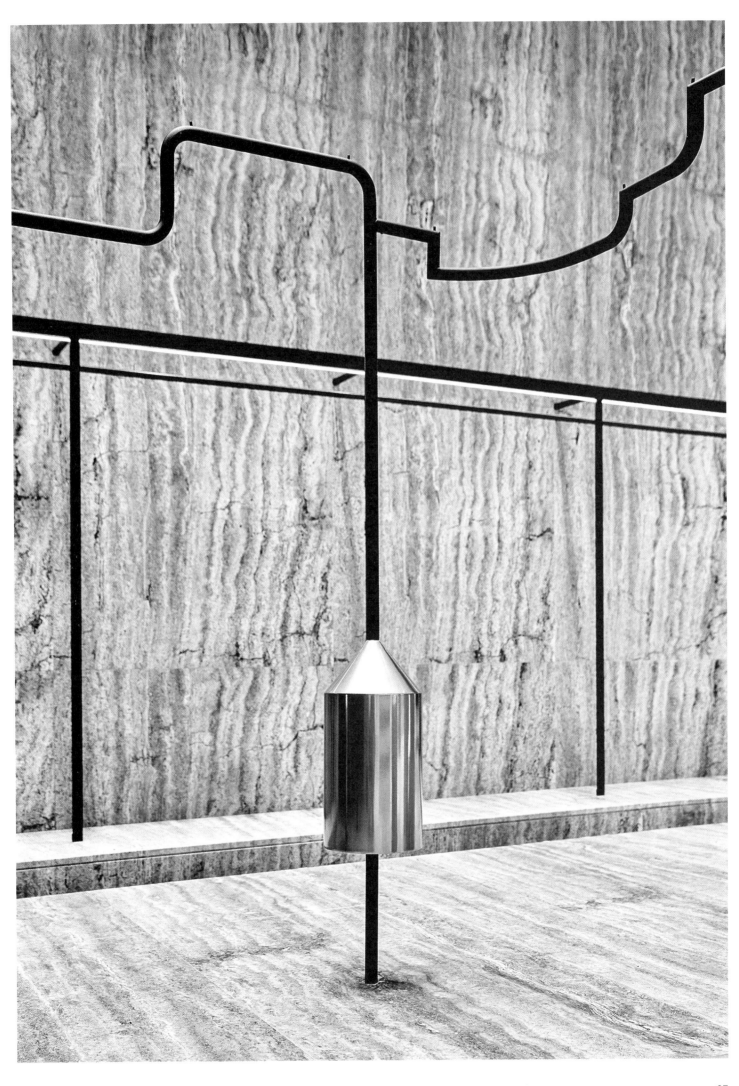

88 AFTER-PARTY, SPRING-SUMMER 2020 SHOW, RITZ, PARIS

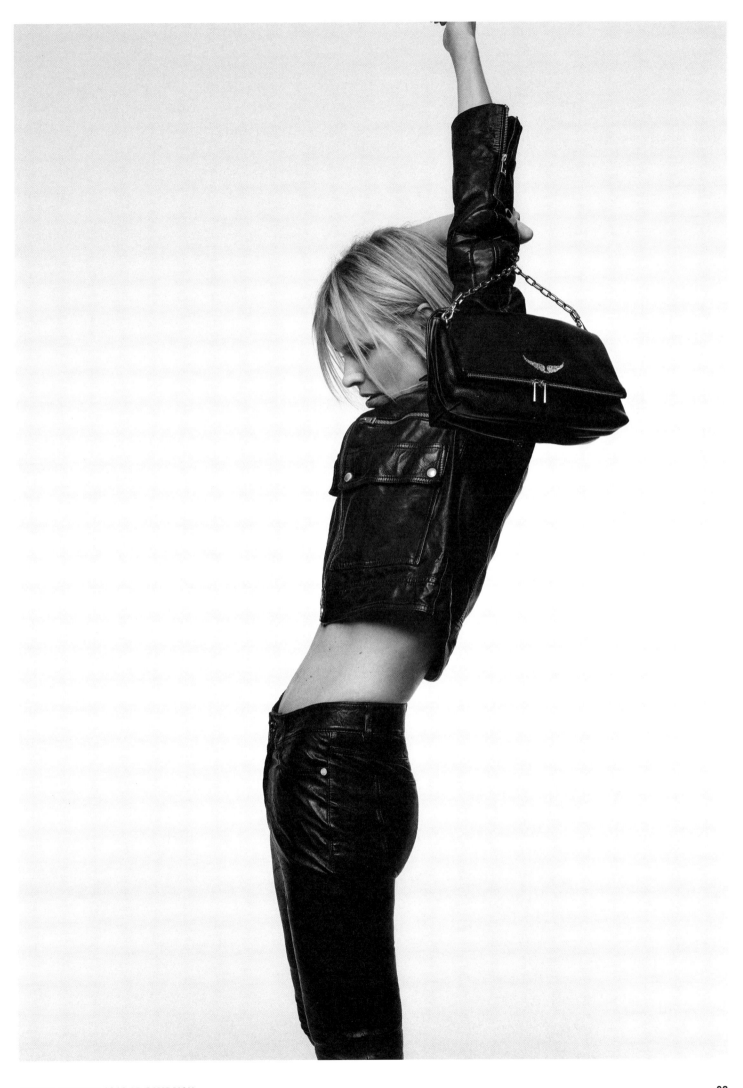
SPRING-SUMMER 2019 AD CAMPAIGN

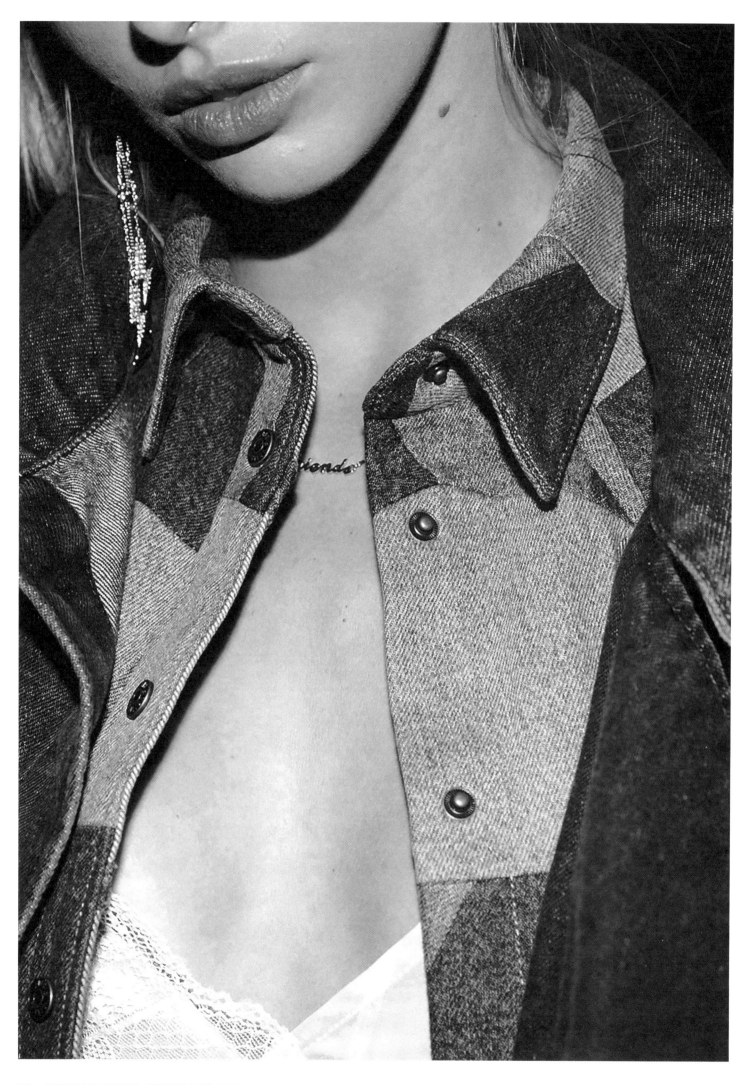

90 BACKSTAGE, SPRING-SUMMER 2019 SHOW, PARIS

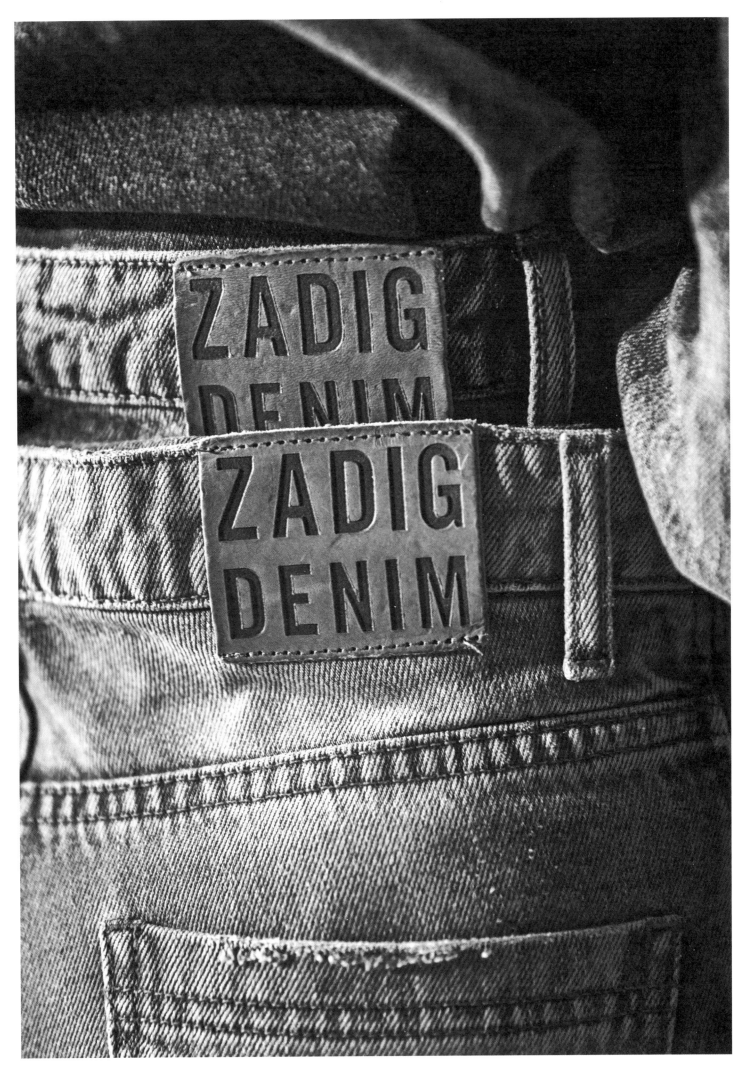

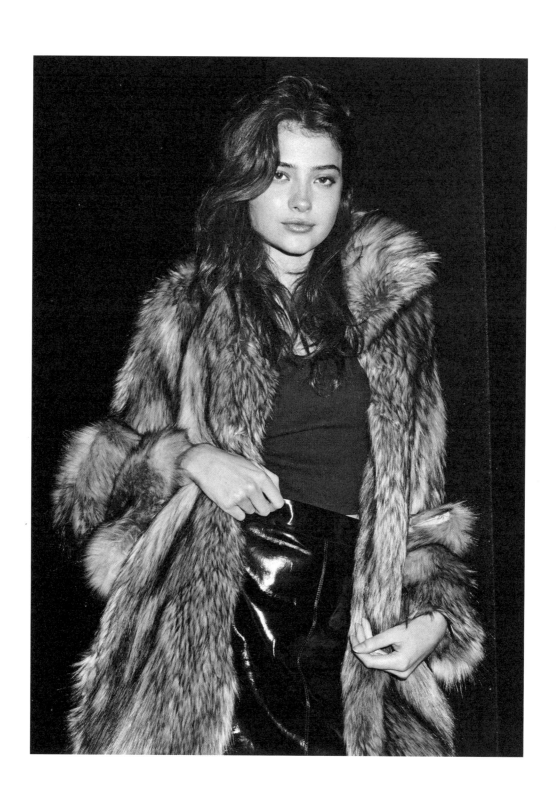

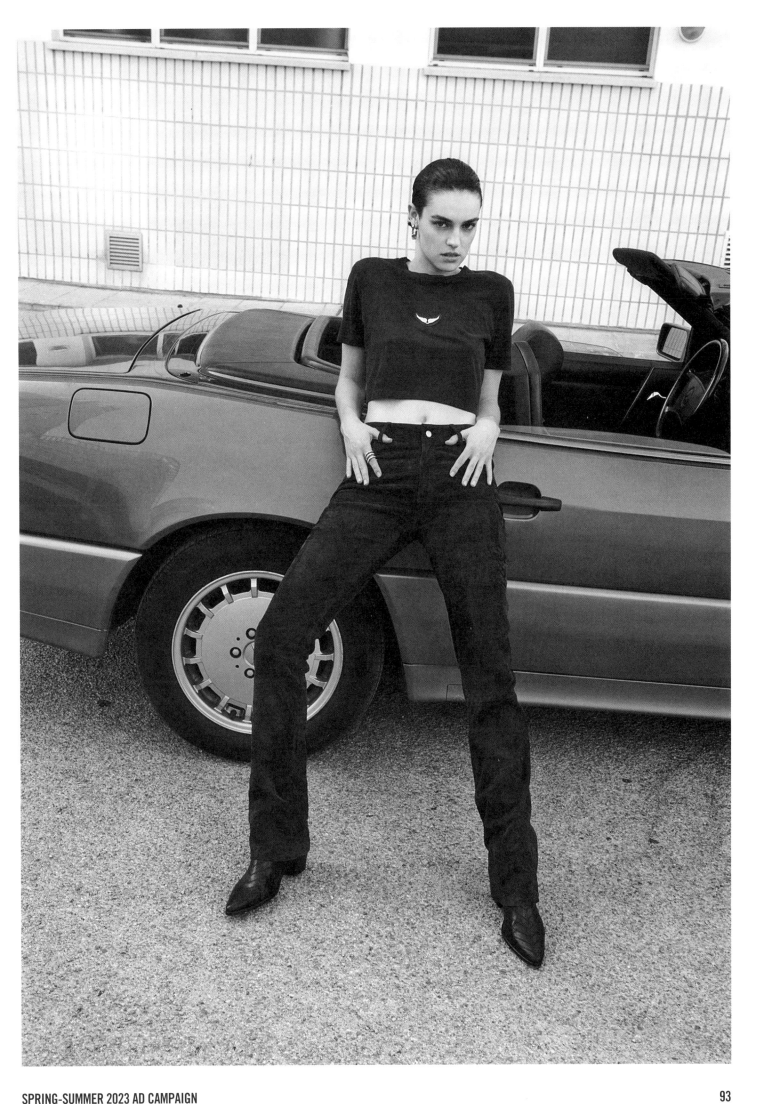

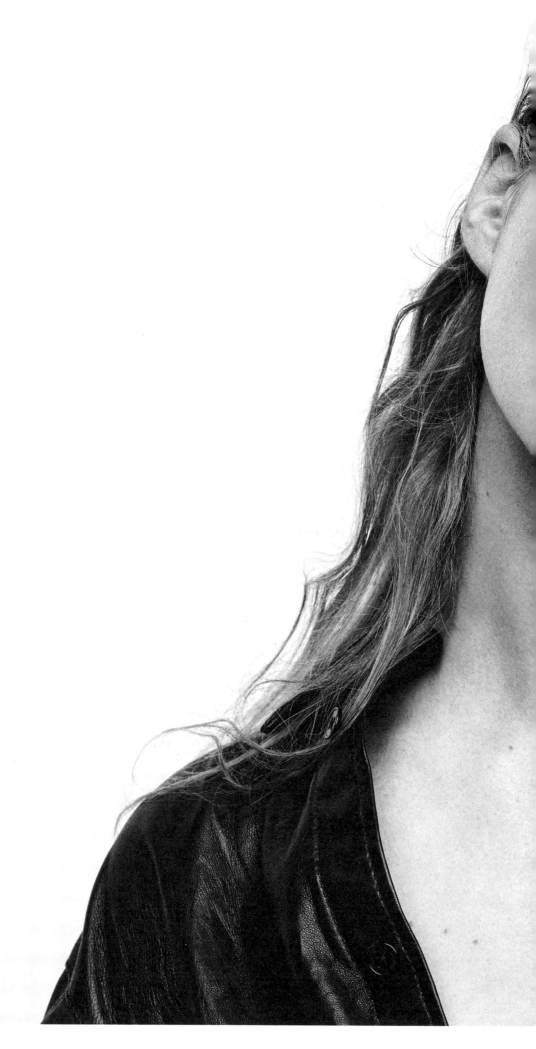

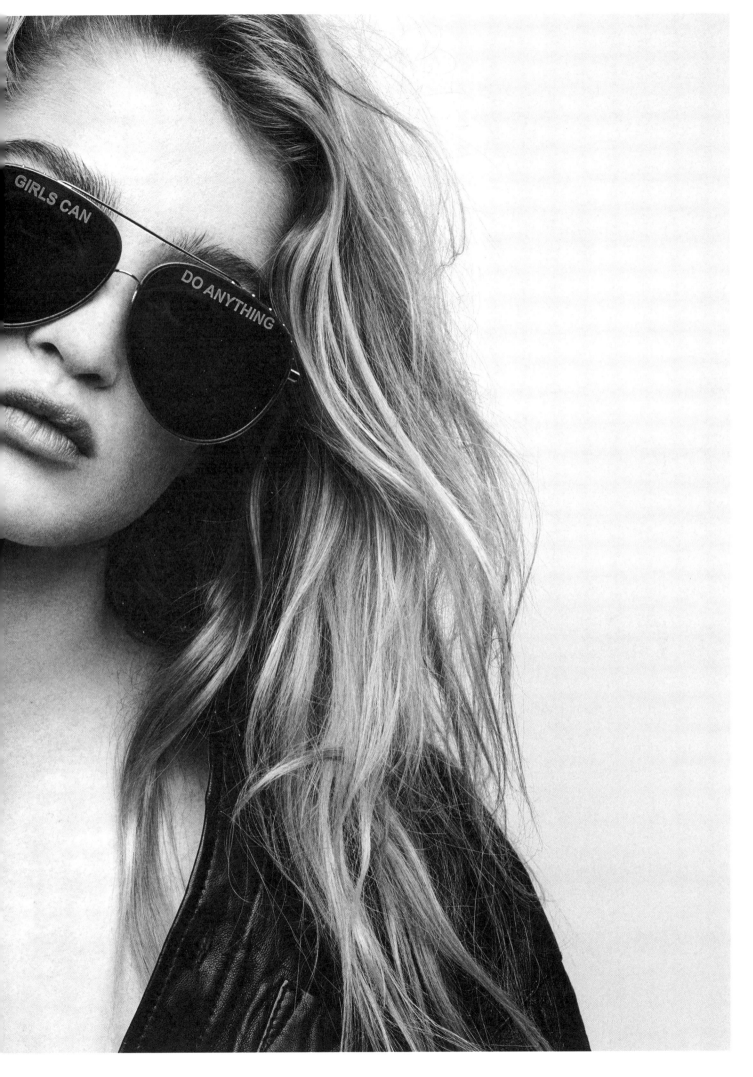

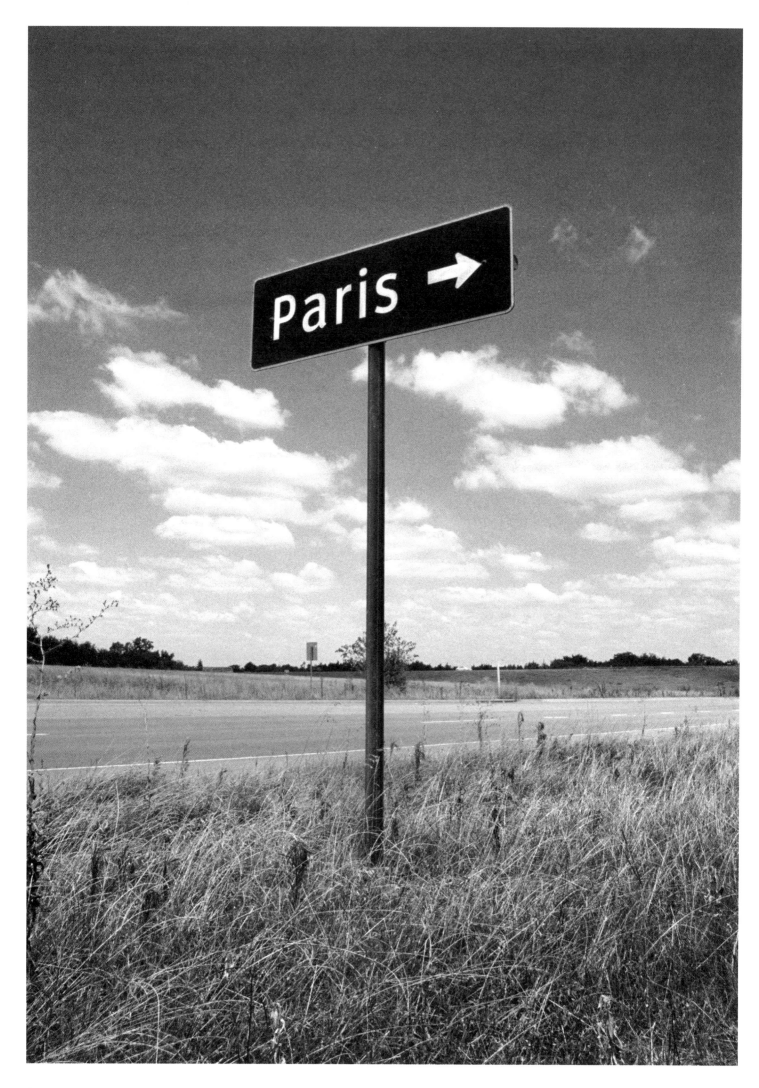

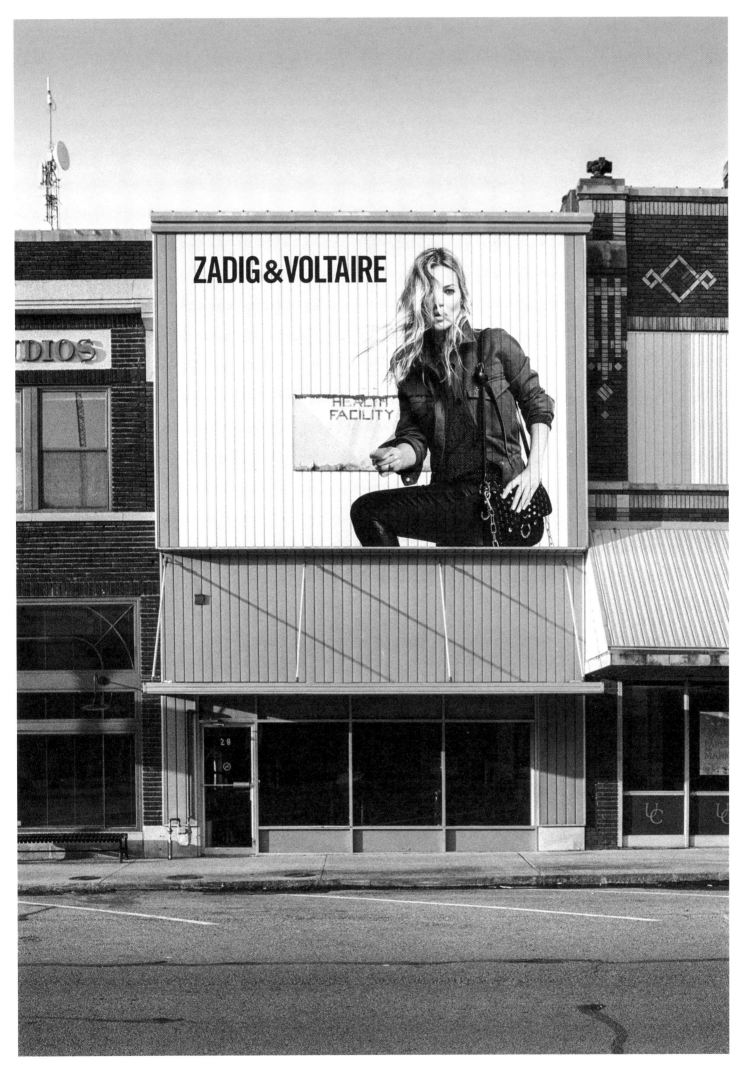

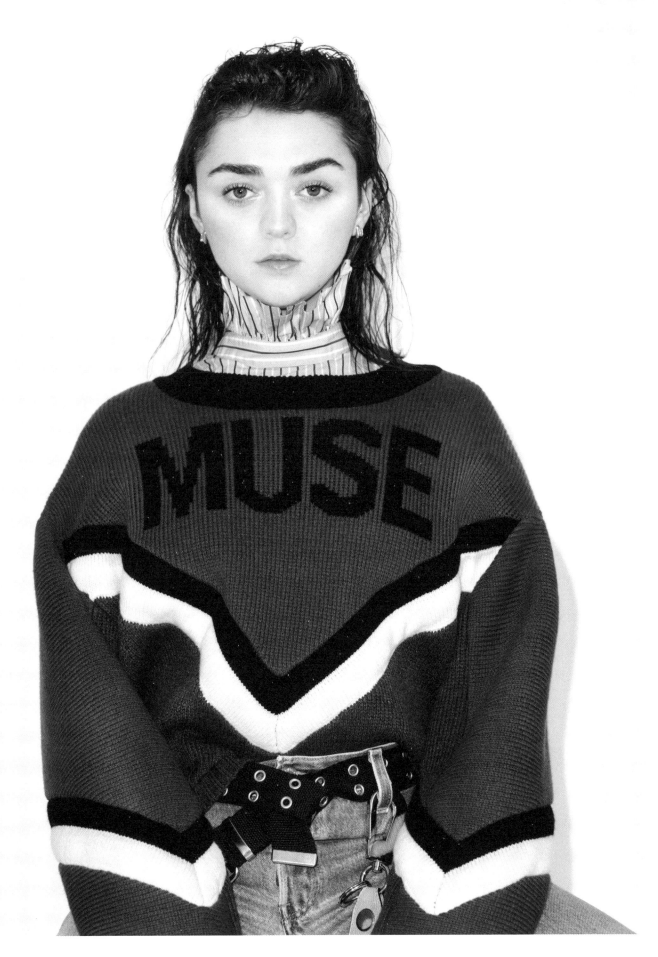

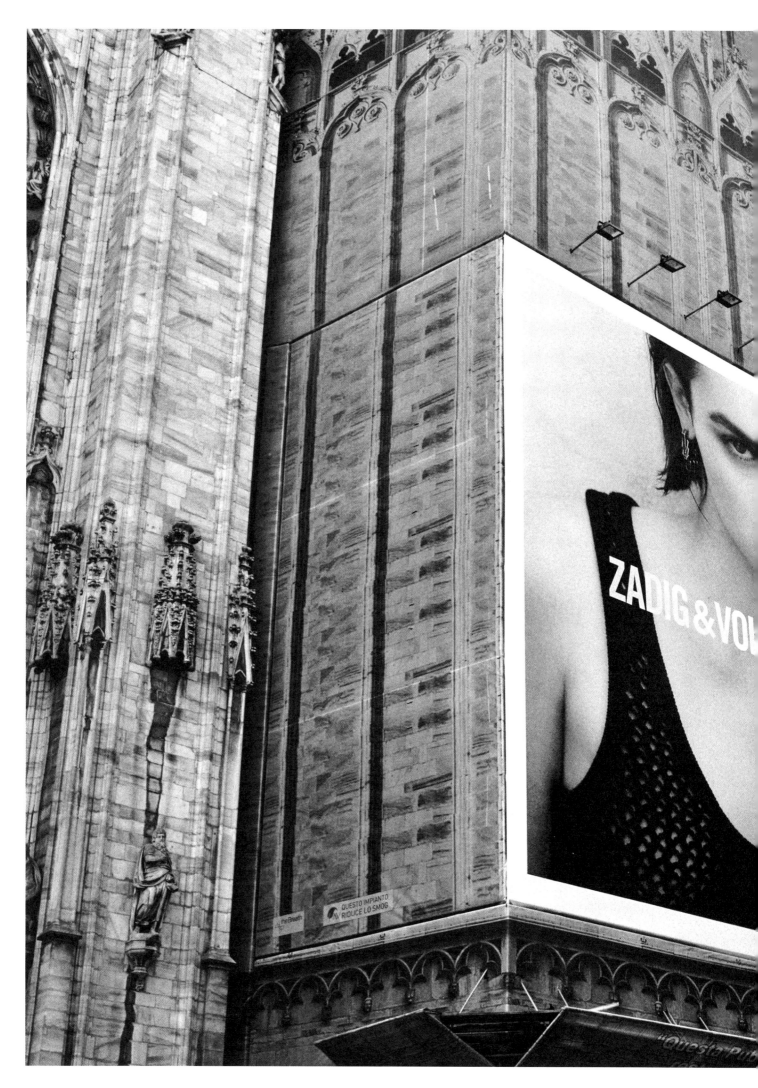

100 SPRING-SUMMER 2023 AD CAMPAIGN, DUOMO, MILAN

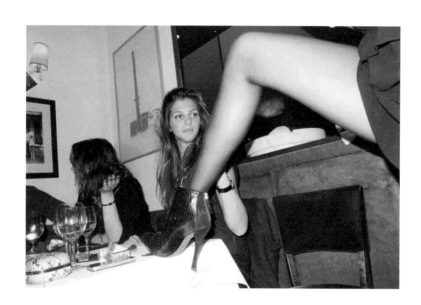

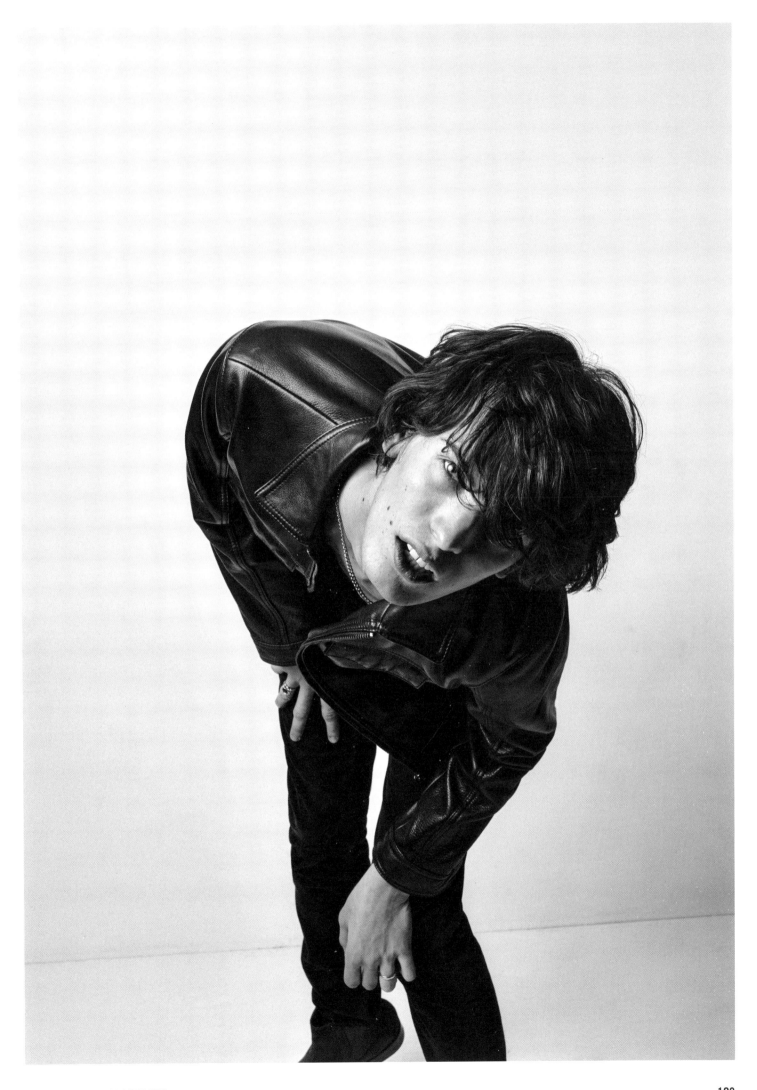

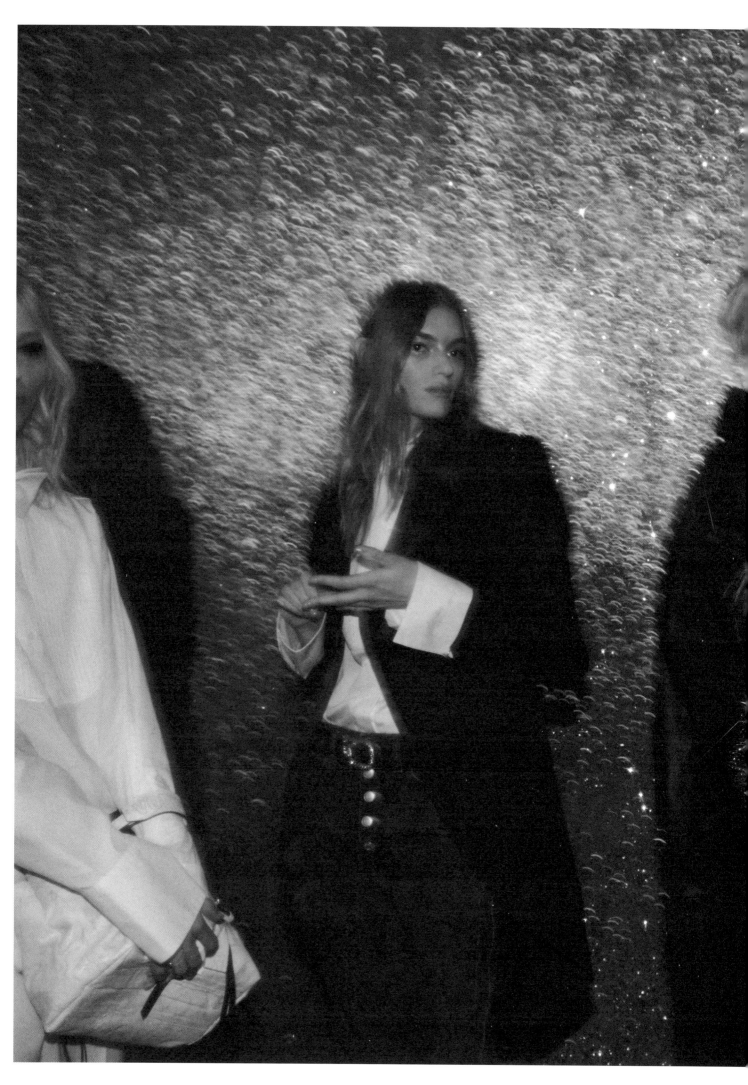

104 BACKSTAGE, FALL-WINTER 2019 SHOW, NEW YORK

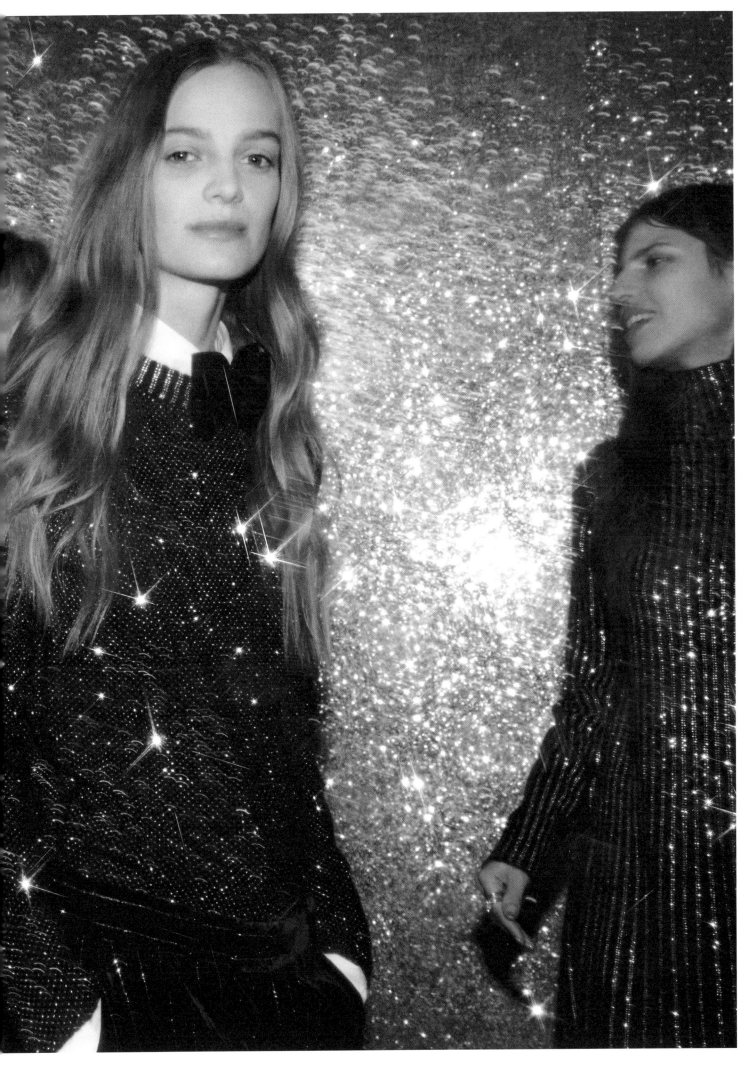

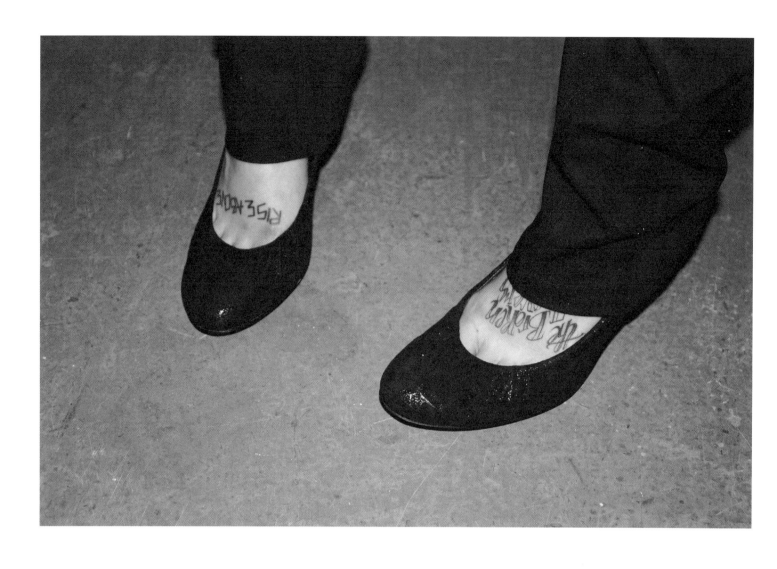

106 BACKSTAGE, FALL-WINTER 2017 SHOW, NEW YORK

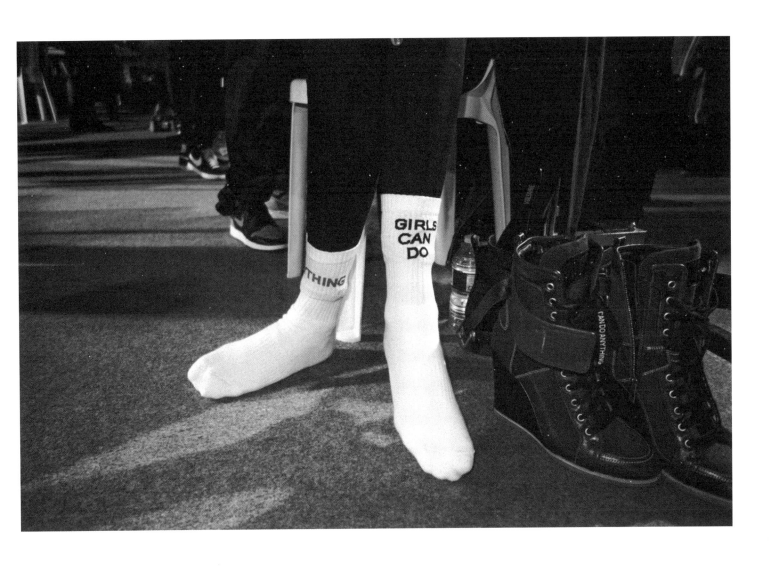

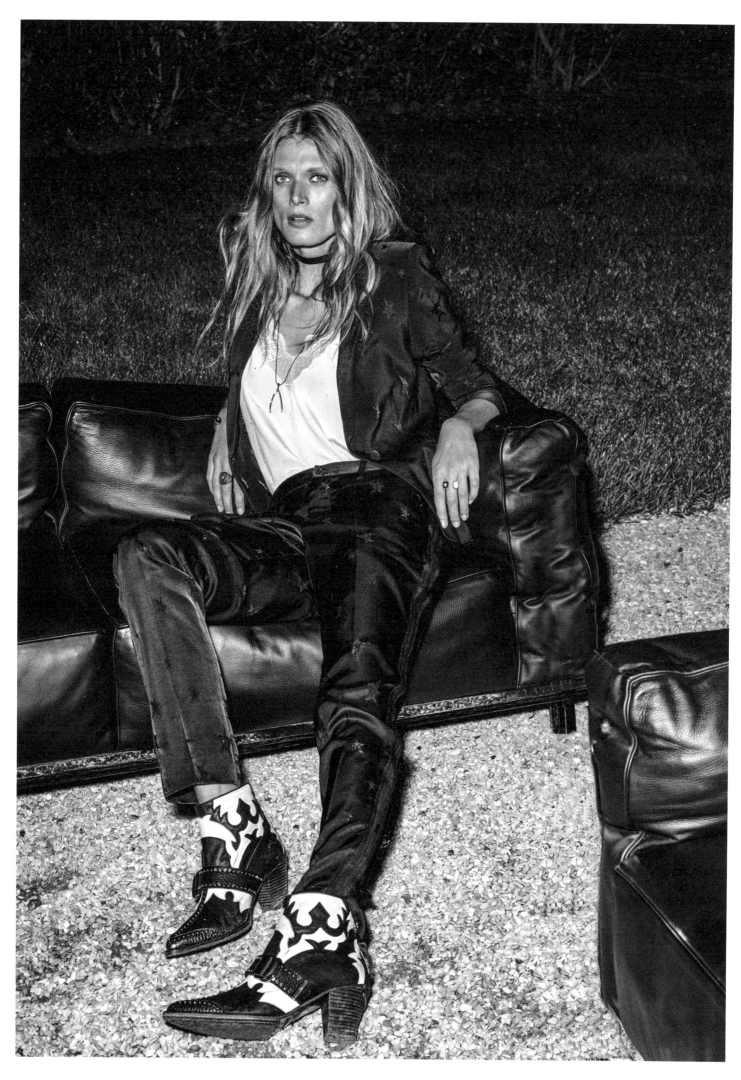

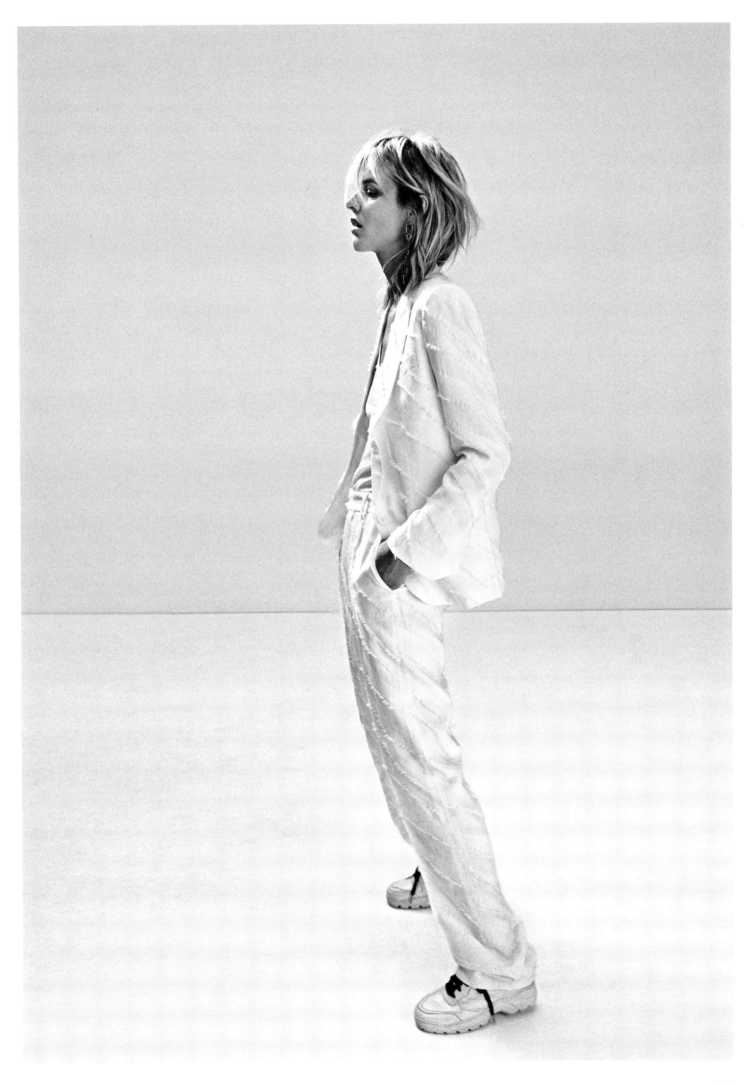

SPRING-SUMMER 2019 AD CAMPAIGN

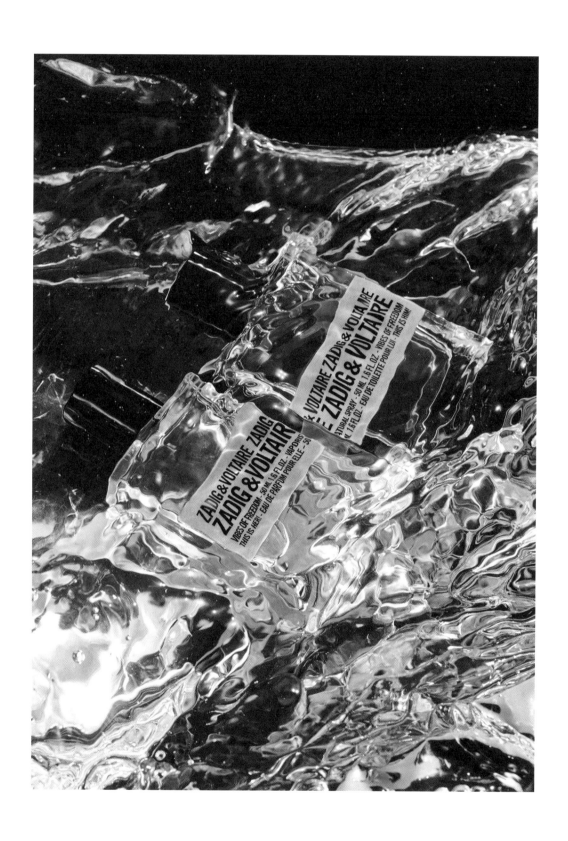

110 *THIS IS HER!* AND *THIS IS HIM! – VIBES OF FREEDOM*, FRAGRANCE AD CAMPAIGN 2022

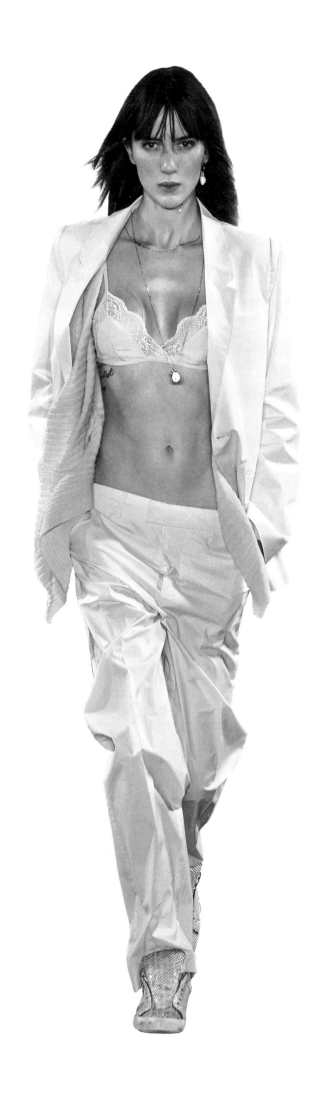

SPRING-SUMMER 2019 SHOW, PARIS

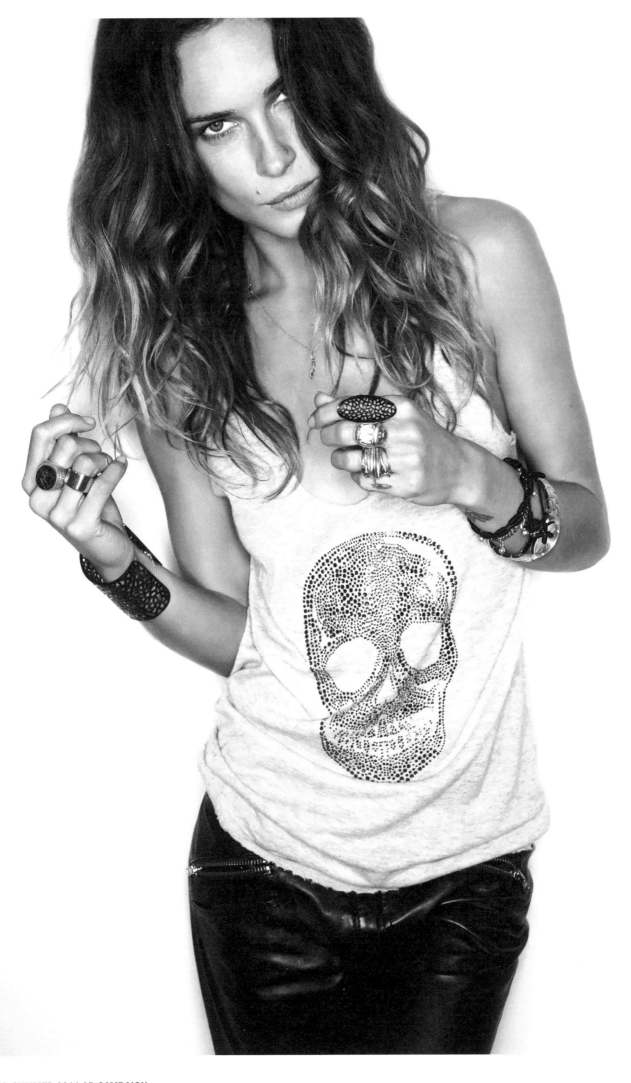

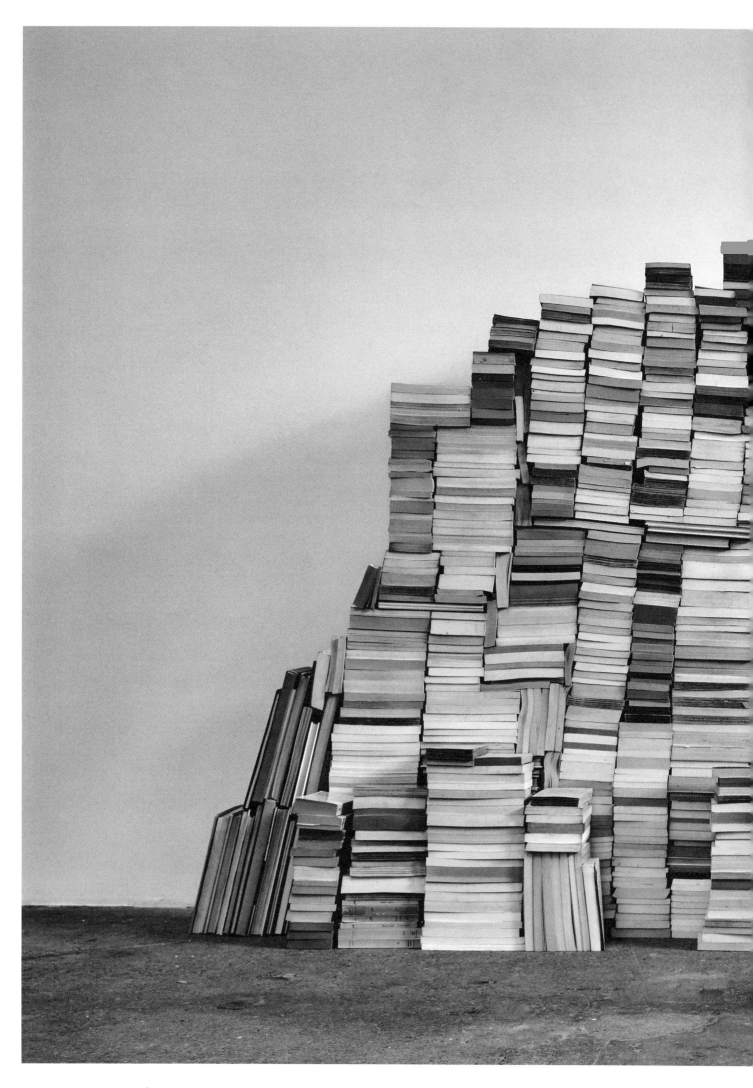

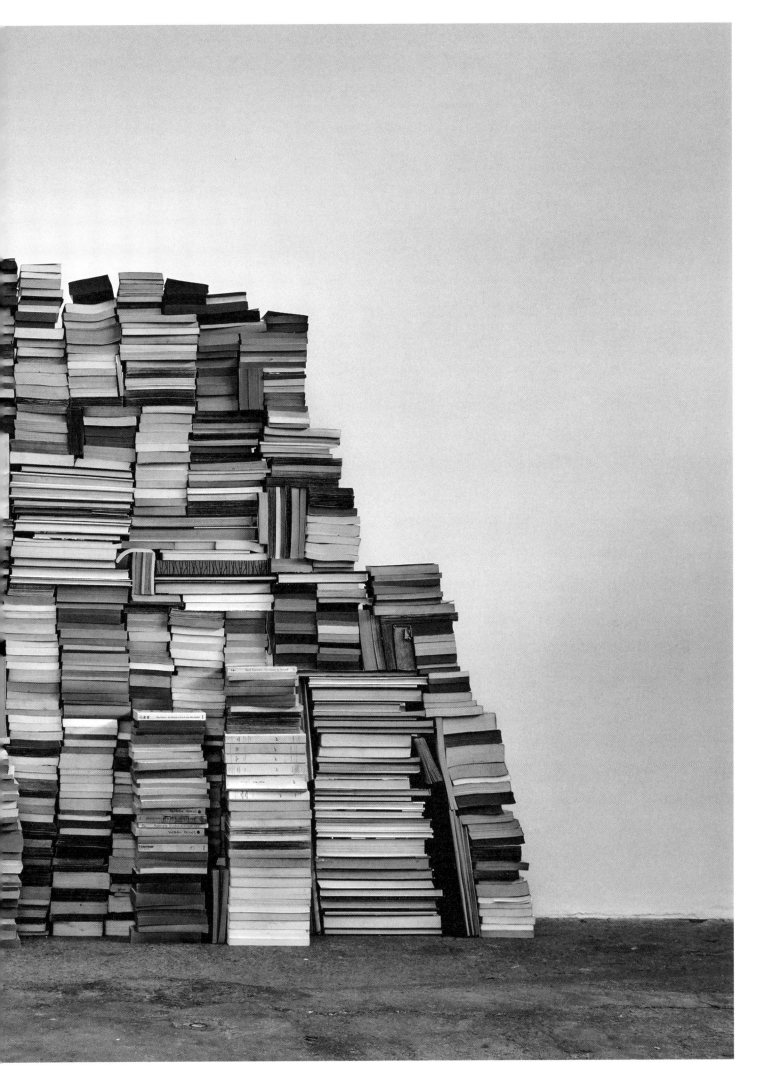

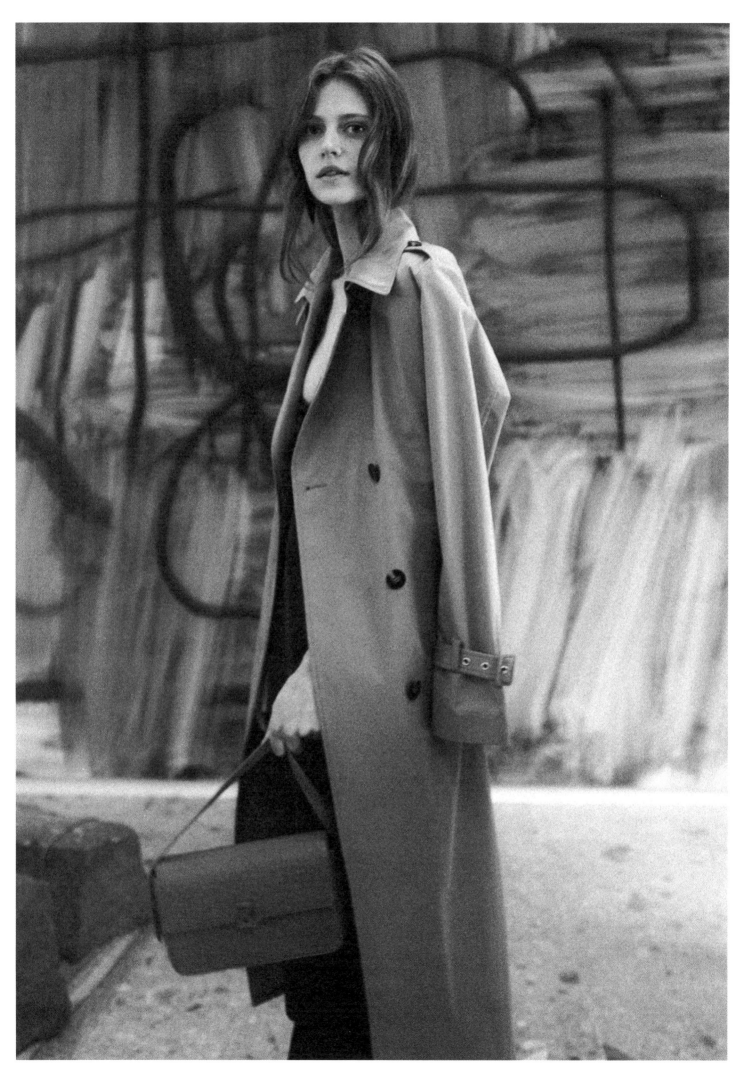

116 ECO-FRIENDLY CAPSULE COLLECTION, SPRING-SUMMER 2021

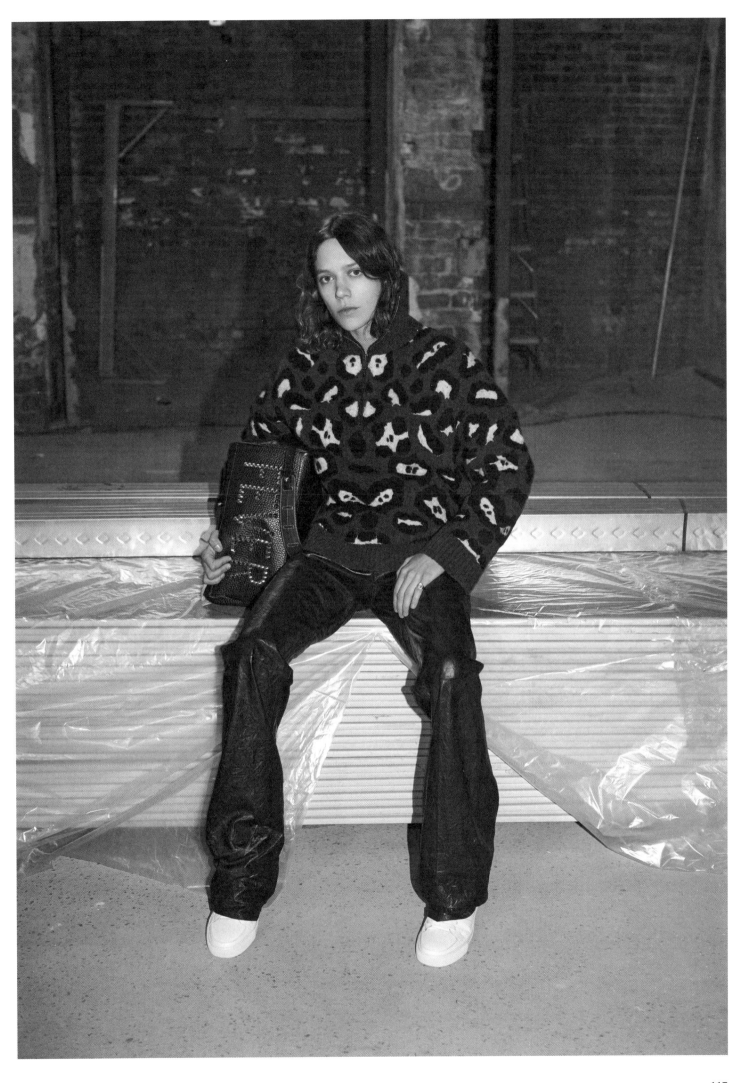

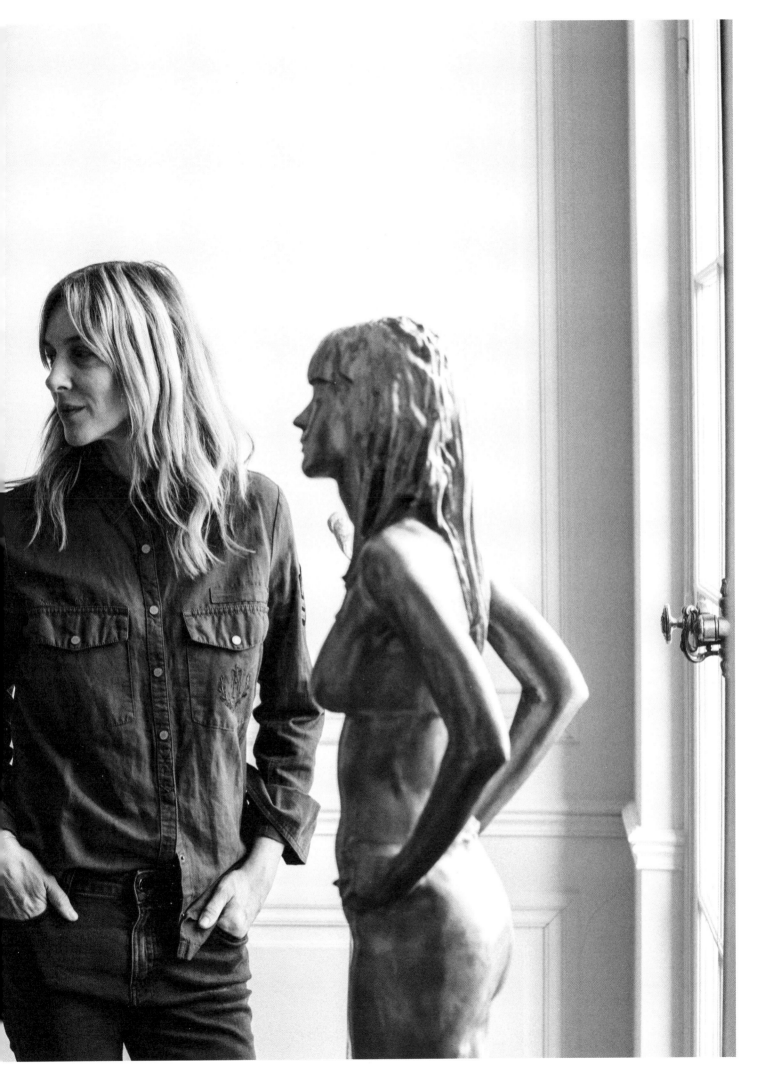

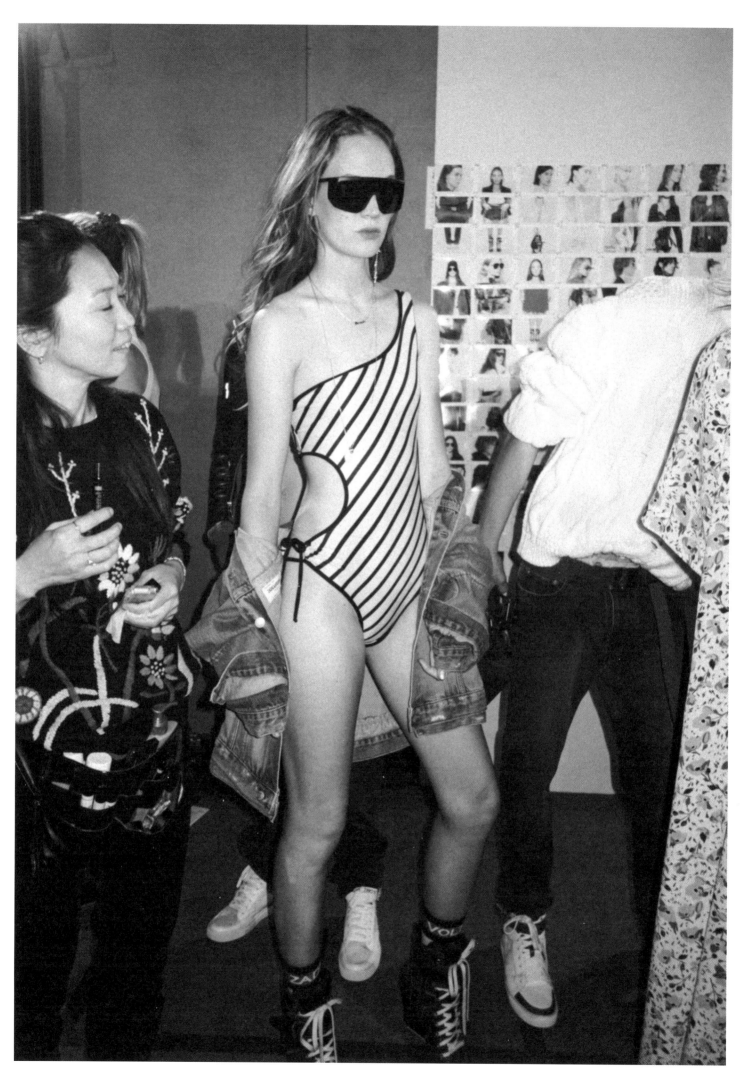

120 BACKSTAGE, SPRING-SUMMER 2019 SHOW, PARIS

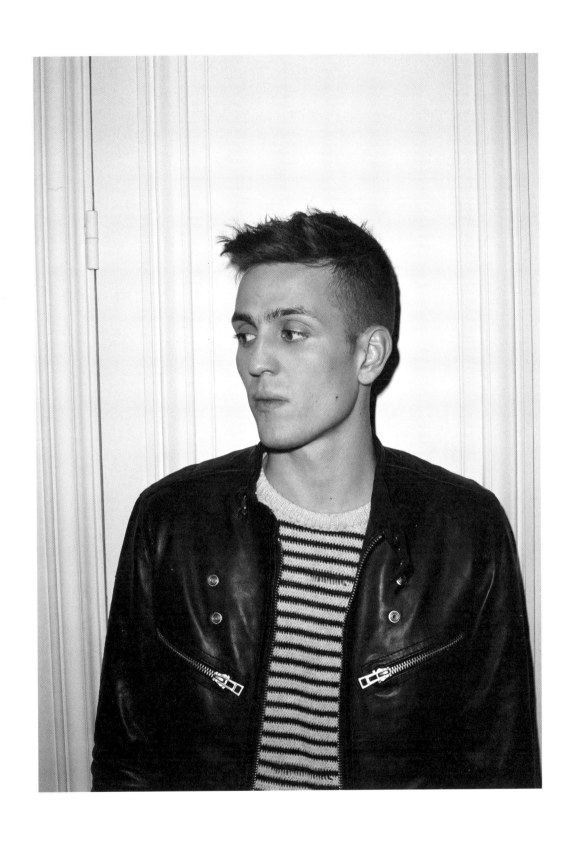

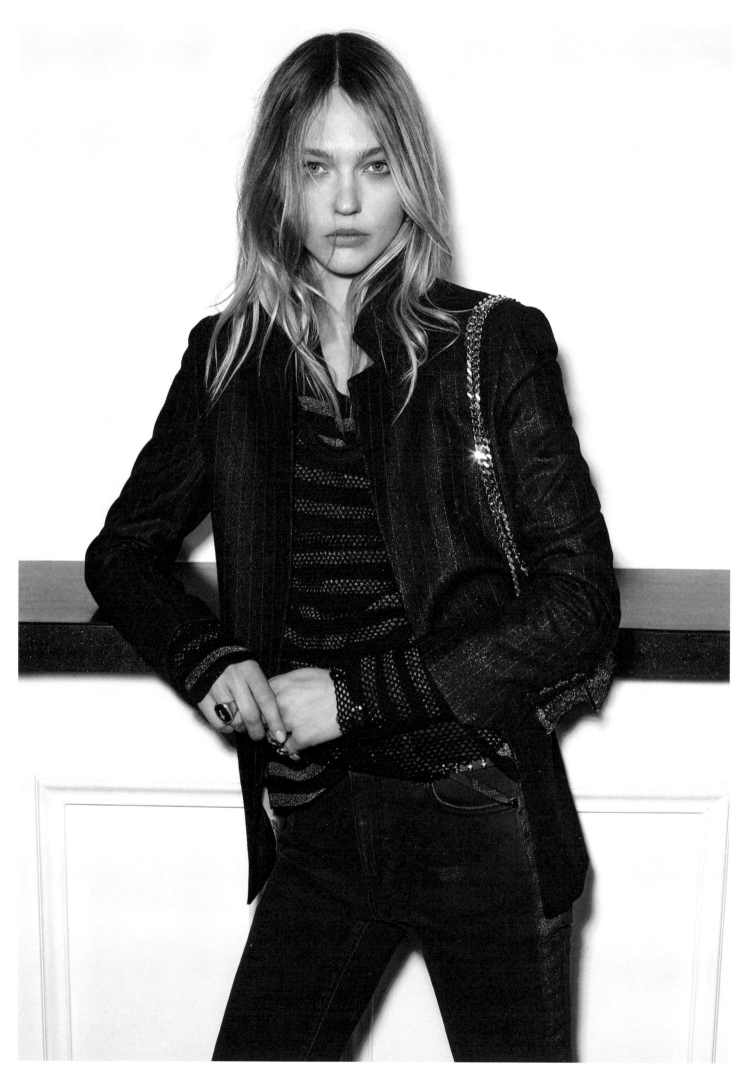

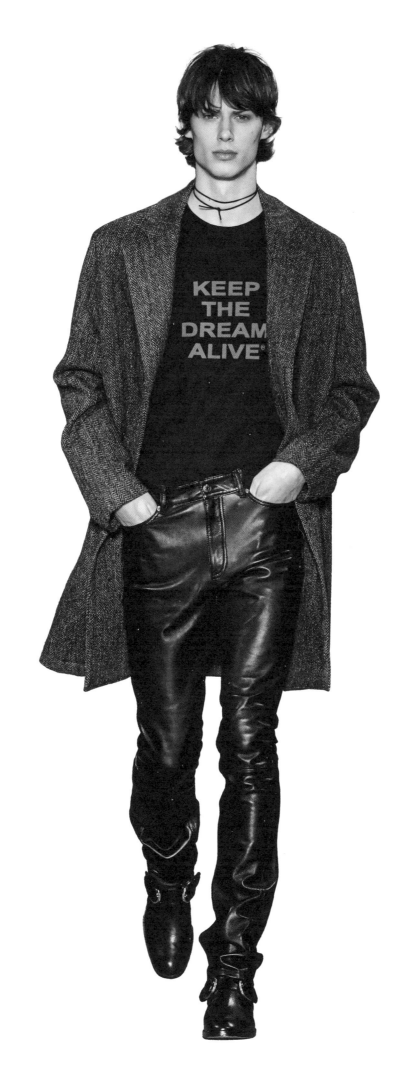

FALL-WINTER 2020 SHOW, NEW YORK

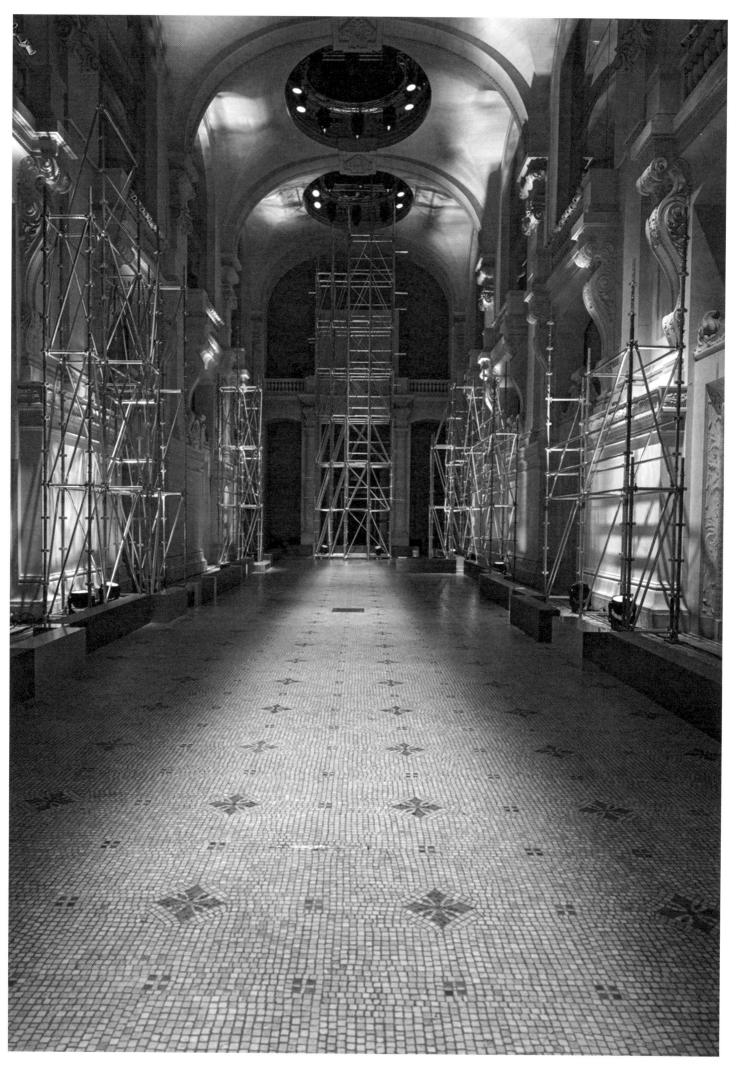

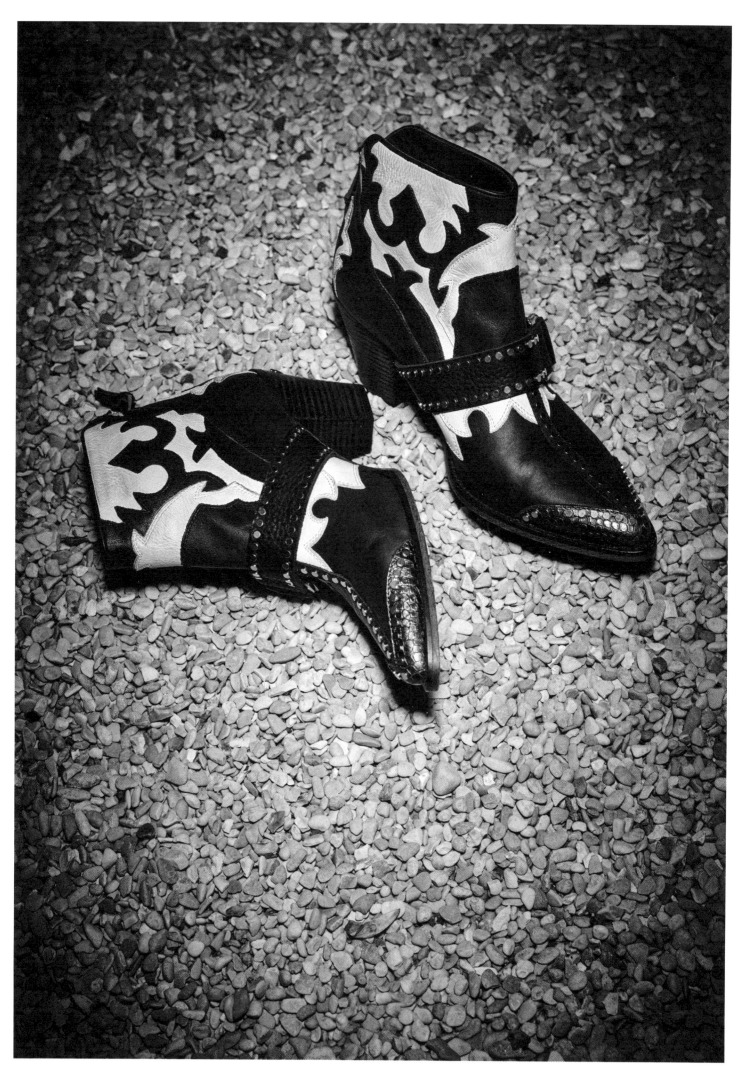

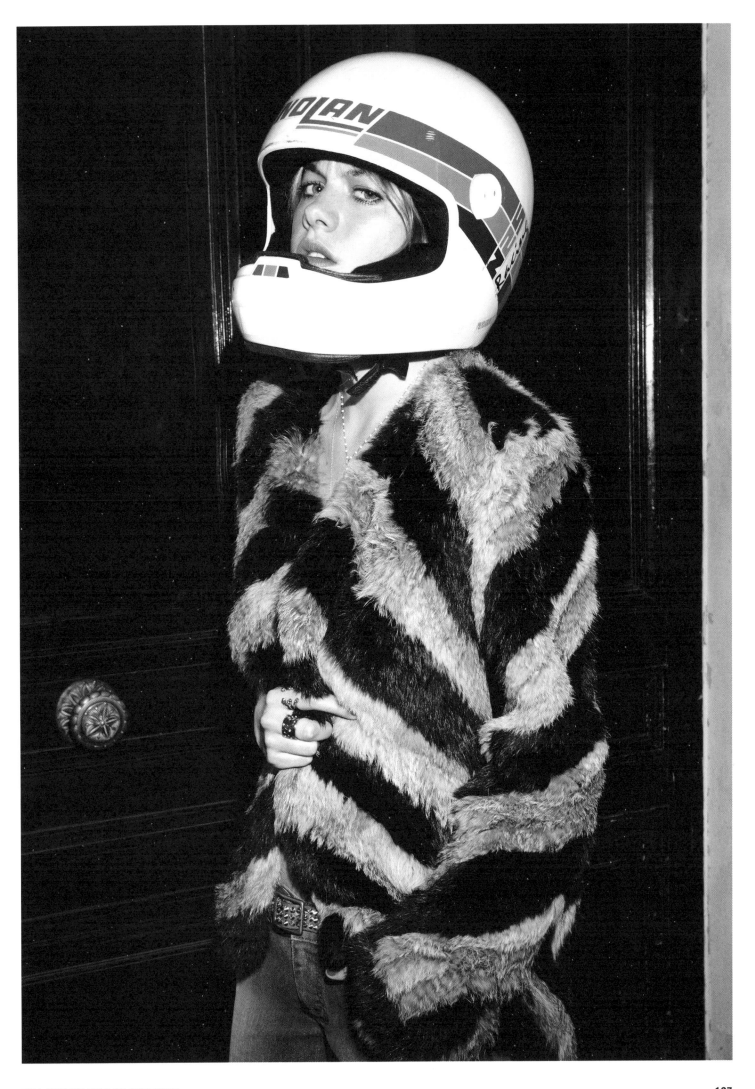

FALL-WINTER 2012 AD CAMPAIGN

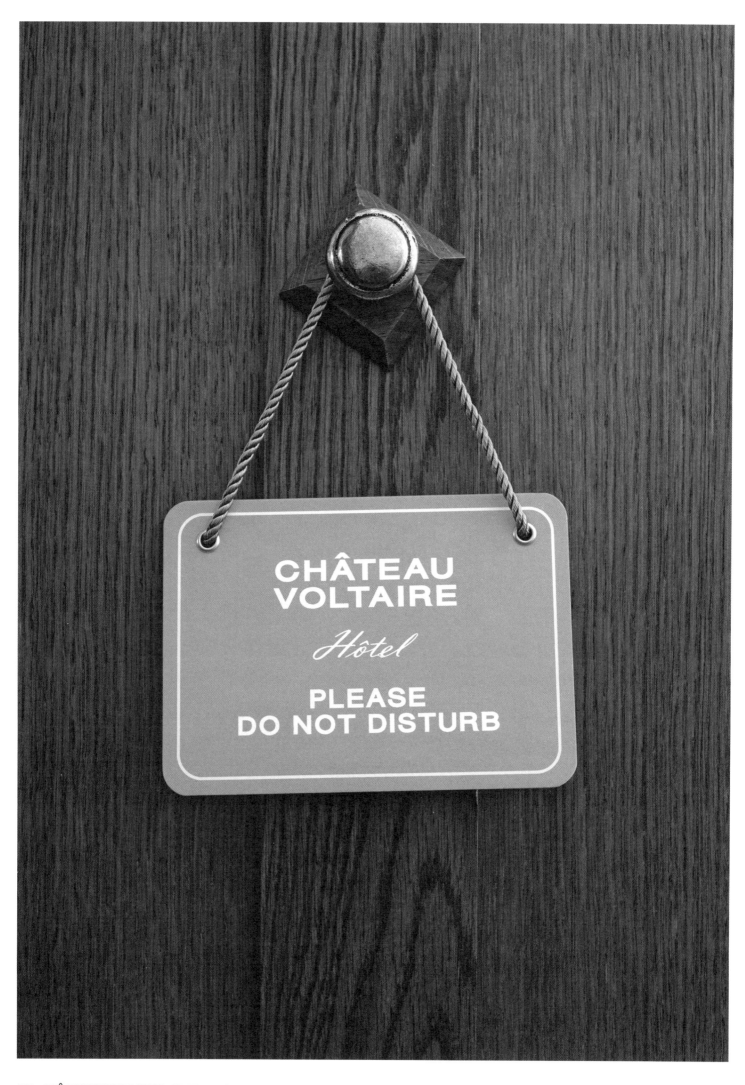

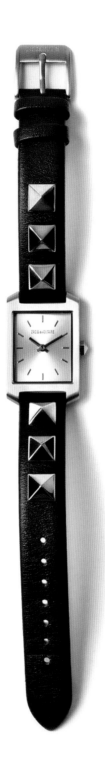

TIMELINE WATCH, 2022

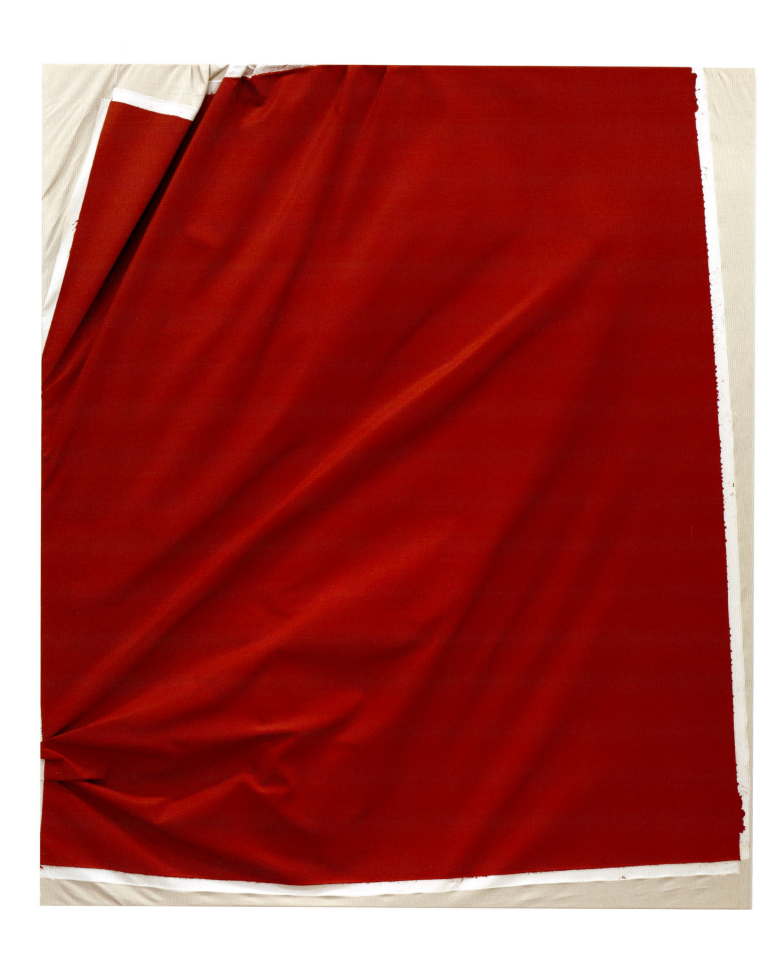

130 STEVEN PARRINO, *FOR PIERRE HUBER*, 1990

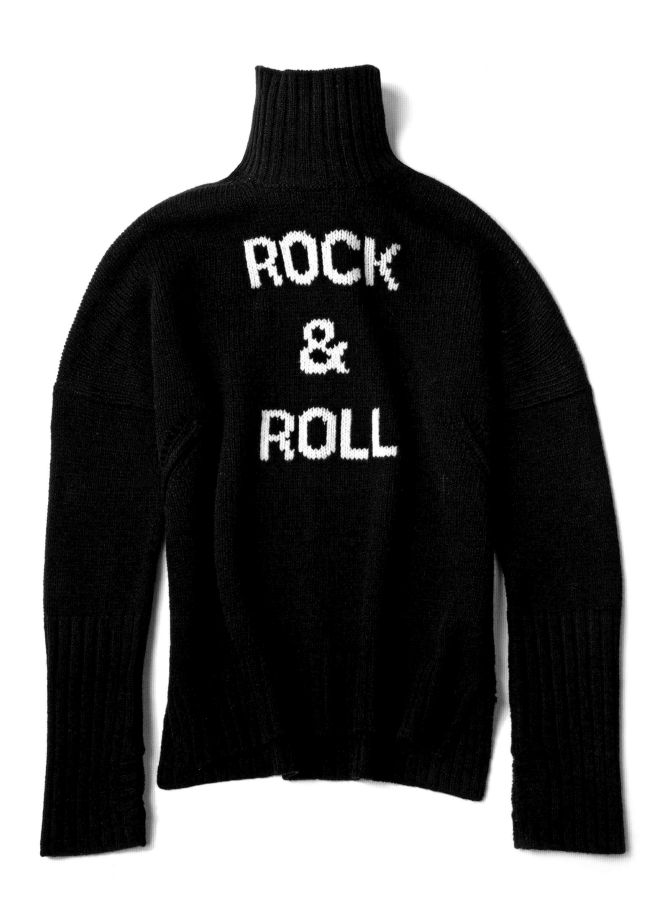

ALMA ROCK SWEATER, ICONIC PIECE

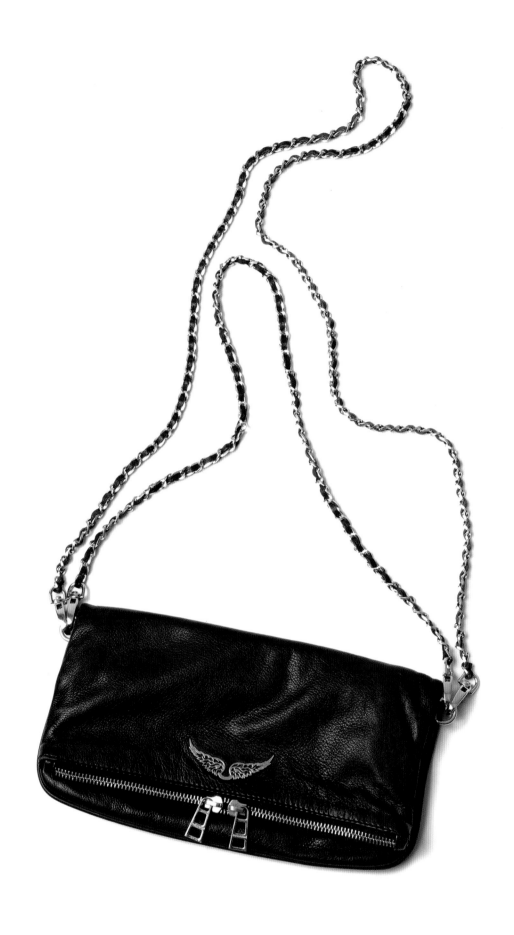

ROCK CLUTCH, ICONIC PIECE

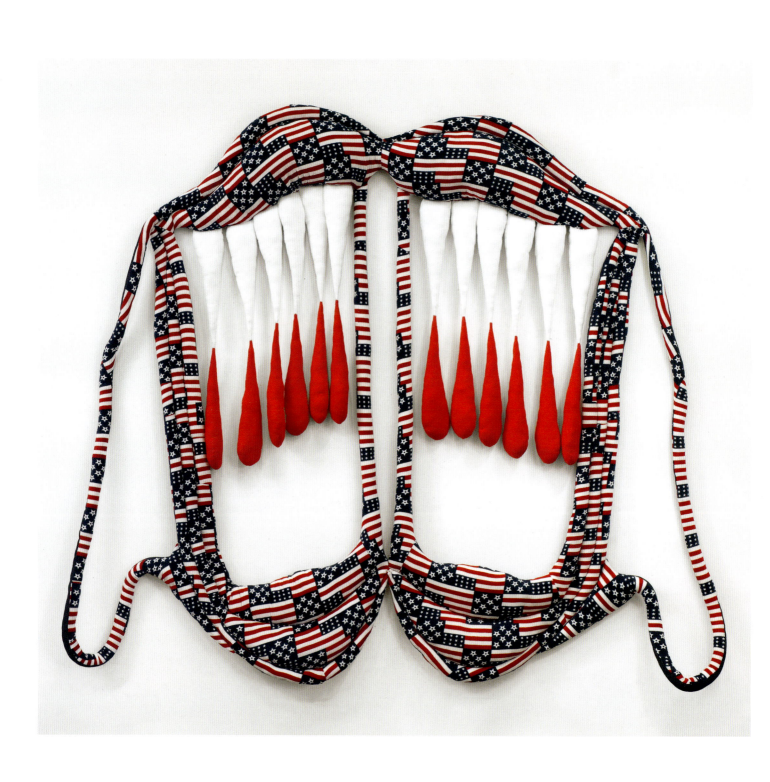

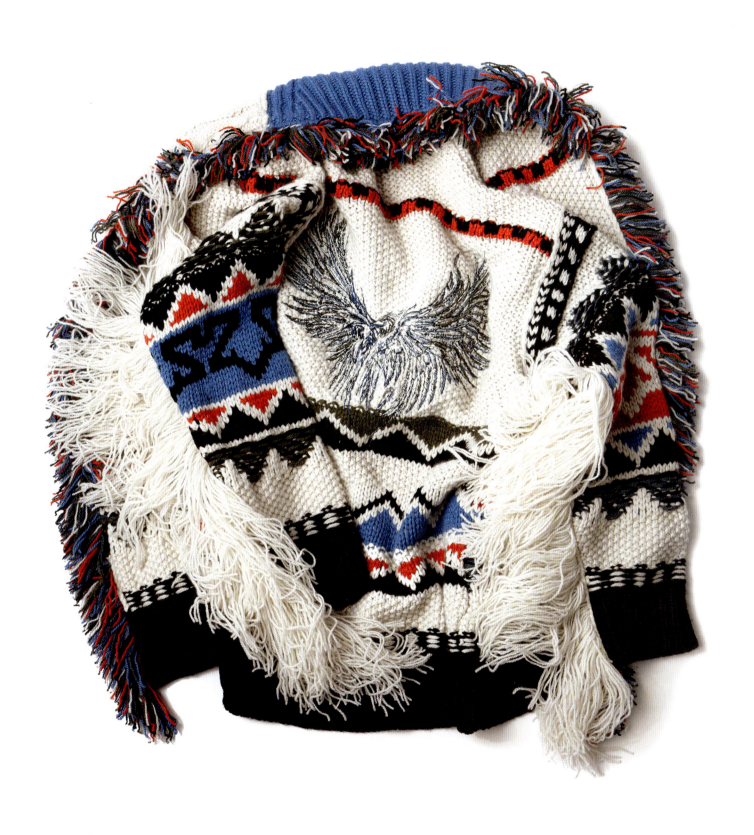

ELLA JACKET, SPRING-SUMMER 2022

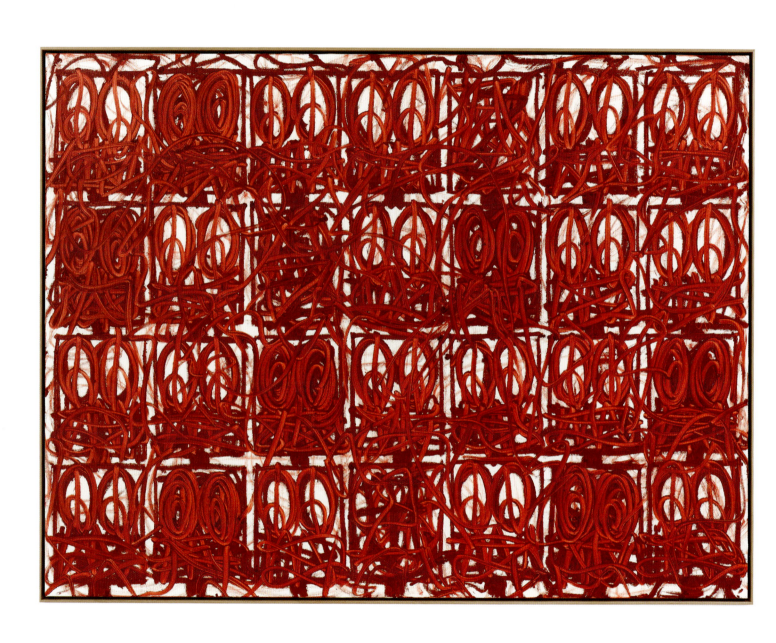

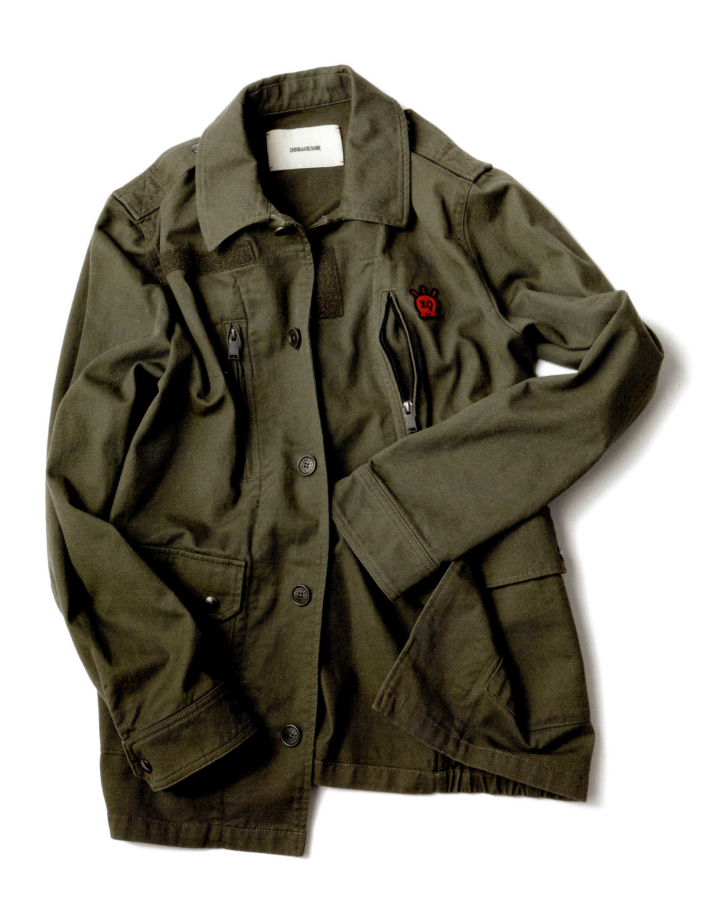

KIDO SKULL JACKET, FALL-WINTER 2022

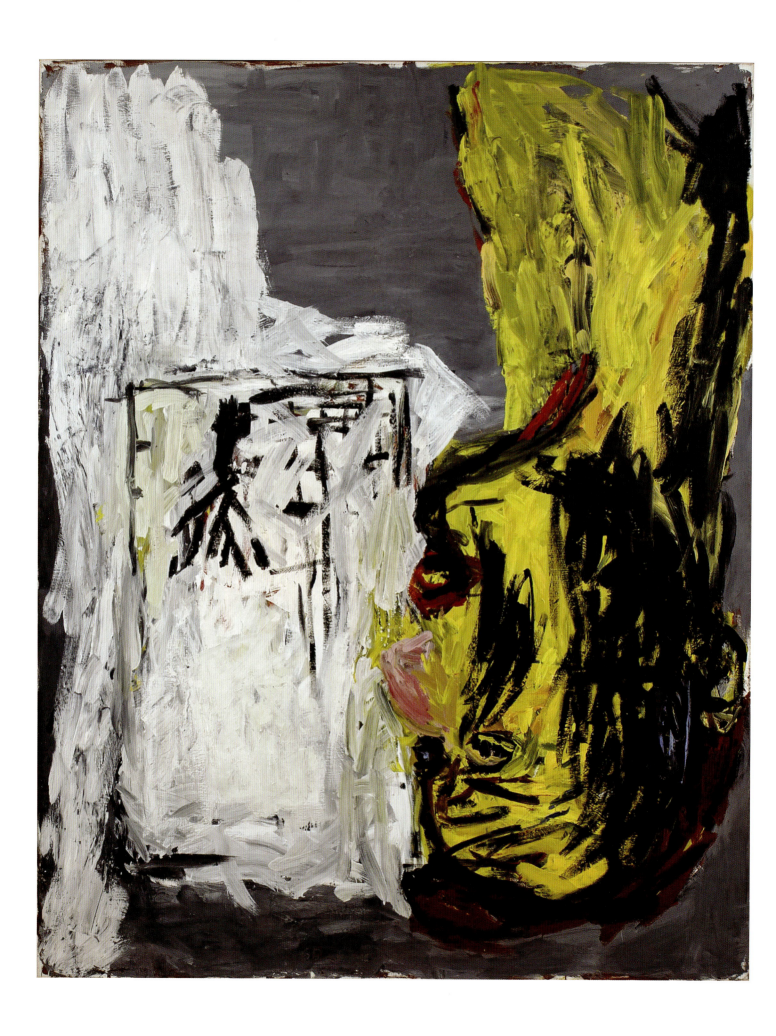

138 GEORG BASELITZ, *KOPF IN DER SONNE*, 1982

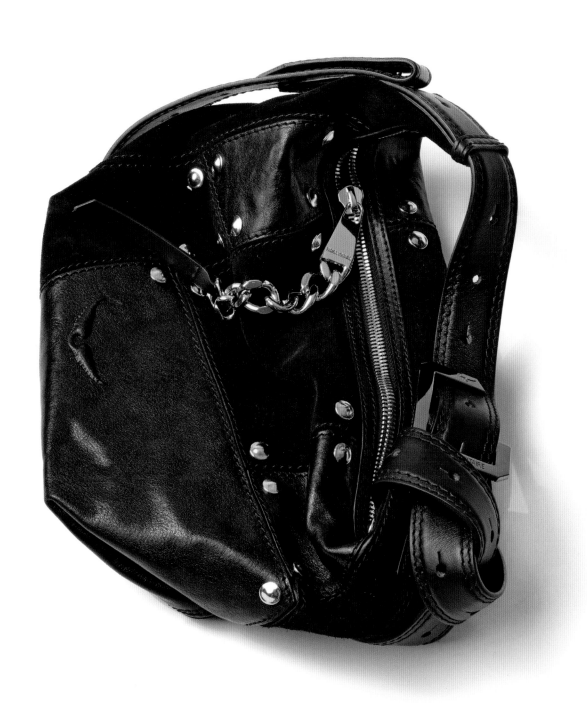

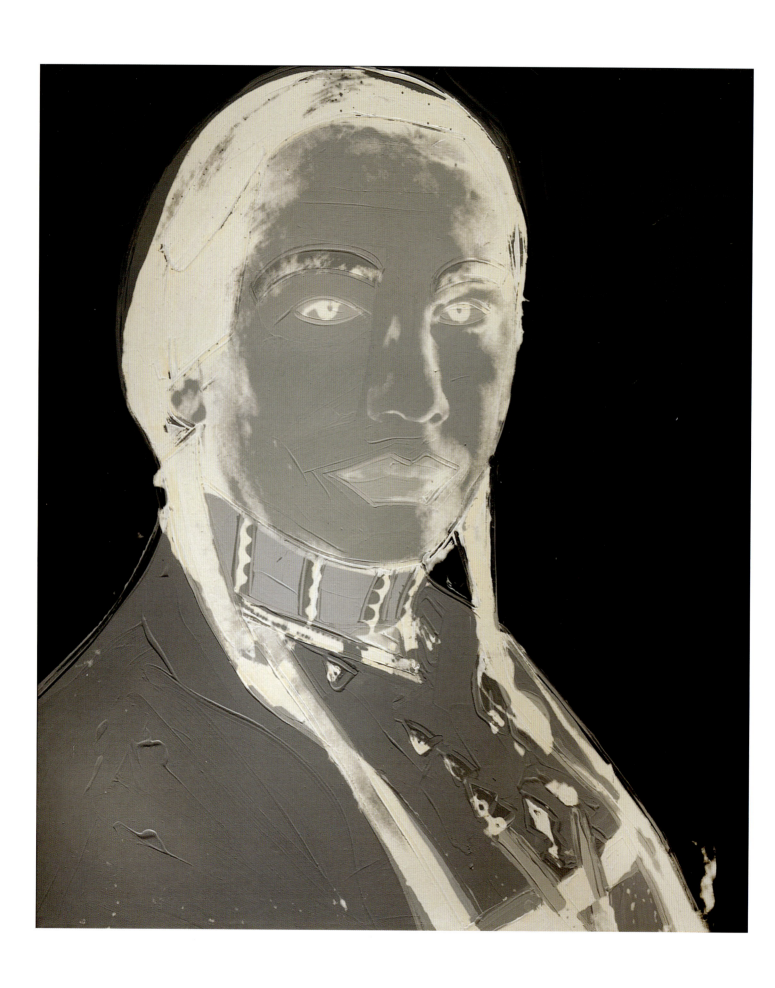

140 ANDY WARHOL, *THE AMERICAN INDIAN (RUSSELL MEANS)*, 1976

PHLAME PANTS, ICONIC PIECE

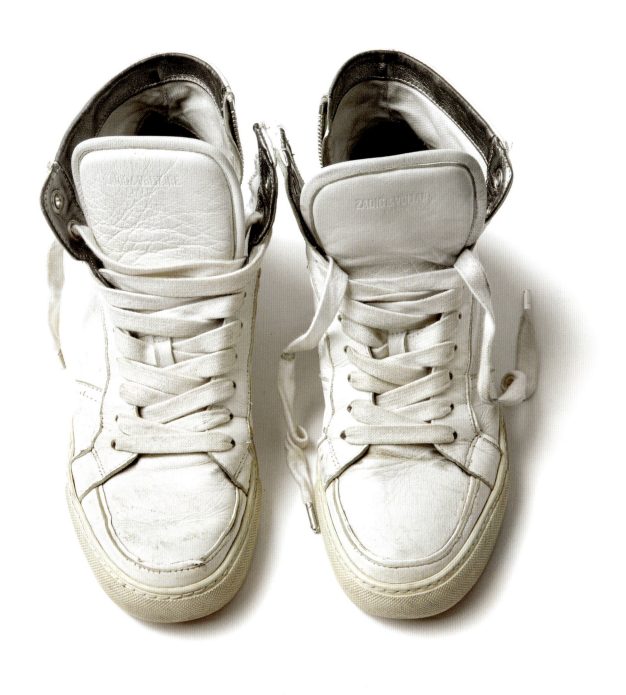

But, replied *Zadig*, Reason is of more antient Date than the Custom you plead for. Do you communicate these Sentiments to the Sovereigns of your Tribes, and in the mean while I'll go, and sound the Widow's Inclinations.

Accordingly he paid her a Visit, and having insinuated himself into her Favour, by a few Compliments on her Beauty, after urging what a pity it was, that a young Widow, Mistress of so many Charms, should make away with herself for no other reason but to mingle her Ashes with a Husband that was dead; he, notwithstanding, applauded her for her heroic Constancy and Courage. I perceive, Madam, said he, you was excessively fond of your deceased Spouse. Not I truly, reply'd the young *Arabian* Devotee. He was a Brute, infected with a groundless Jealousy of my Virtue; and, in short, a perfect Tyrant. But, notwithstanding all this, I am determin'd to comply with our Custom. Surely then, Madam, there's a Sort of secret Pleasure in being burnt alive. Alas! with a Sigh, cried *Almona*, 'tis a Shock indeed to Nature; but must be complied with for all that. I am a profess'd Devotee, and should I shew the least Reluctance, my Reputation would be lost for ever; all the World would laugh at me, should I not burn myself on this Occasion: *Zadig* having forc'd her ingenuously to confess, that she parted with her Life more out of Regard to what the World would say of her, and out of Pride and Ostentation, than any real Love for the deceas'd, he talk'd to her for some considerable Time so rationally, and us'd so many prevailing Arguments with her to justify her due Regard for the Life which she was going to throw away, that she began to wave the Thought, and entertain a secret Affection for her friendly Monitor. Pray, Madam, tell me, said *Zadig*, how would you dispose of yourself, upon the Supposition, that you could shake off this vain and barbarous Notion? Why, said Dame, with an amorous Glance, I think verily I should accept of yourself for a second Bed-fellow.

The Memory of *Astarte* had made too strong an Impression on his Mind, to close with this warm Declaration: He took his leave, however, that Moment, and waited on the Chiefs. He communicated to them the Substance of their private Conversation, and prevailed with them to make it a Law for the future, that no Widow should be allow'd to fall a Victim to a deceased Husband, till after she had admitted some young Man to converse with her in private for a whole Hour together. The Law was pass'd accordingly, and not one Widow in all *Arabia*, from that Day to this, ever observ'd the Custom. 'Twas to *Zadig* alone that the *Arabian* Dames were indebted for the Abolition, in one Hour, of a Custom so very inhuman, that had been practis'd for such a Number of Ages. *Zadig*, therefore, with the strictest Justice, was look'd upon by all the Fair Sex in *Arabia*, as their most bountiful Benefactor.

CHAPTER XI

THE EVENING'S ENTERTAINMENT

SETOC, who would never stir out without his Bosom-Friend (in whom alone, as he thought, all Wisdom center'd) resolv'd to take him with him to *Balzora* Fair, whither the richest Merchants round the whole habitable Globe, us'd annually to resort. *Zadig* was delighted to see such a Concourse of substantial Tradesmen from all Countries, assembled together in one Place. It appear'd to him, as if the whole Universe was but one large Family, and all happily met together at *Balzora*. On the second Day of the Fair, he sat down to Table with an *Egyptian*, an *Indian*, that liv'd on the Banks of the River *Ganges*, an Inhabitant of *Cathay*, a *Grecian*, a *Celt*, and several other Foreigners, who by their frequent Voyages towards the *Arabian* Gulf, were so far conversant with the *Arabic* Language, as to be able to discourse freely, and be mutually understood. The *Egyptian* began to fly into a Passion; what a scandalous Place is this *Balzora*, said he, where they refuse to lend me a thousand Ounces of Gold, upon the best Security that can possibly be offer'd. Pray, said *Setoc*, what may the Commodity be that you would deposit as a Pledge for the Sum you mention. Why, the Corpse of my deceased Aunt, said he, who was one of the finest Women in all *Egypt*. She was my constant Companion; but unhappily died upon the Road. I have taken so much Care, that no Mummy whatever can equal it: And was I in my own Country, I could be furnish'd with what Sum soever I pleas'd, were I dispos'd to mortgage it. 'Tis a strange Thing that Nobody here will advance so small a Sum upon so valuable a Commodity. No sooner had he express'd his Resentment, but he was going to cut up a fine boil'd Pullet, in order to make a Meal on't, when an *Indian* laid hold of his Hand, and with deep Concern, cried out, For God's Sake what are you about? Why, said the *Egyptian*, I design to make a Wing of this Fowl one Part of my Supper. Pray, good Sir, consider what you are doing, said the *Indian*. 'Tis very possible, that the Soul of the deceas'd Lady may have taken its Residence in that Fowl. And you wouldn't surely run the Risque of eating up your Aunt? To boil a Fowl is, doubtless, a most shameful Outrage done to Nature. Pshaw! What a Pother you make about the boiling of a Fowl, and flying in the Face of Nature, replied the *Egyptian* in a Pet; tho' we *Egyptians* pay divine Adoration to the Ox; yet we can make a hearty Meal of a Piece of roast Beef for all that. Is it possible, Sir, that your Country-men should act so absurdly, as to pay an Ox the Tribute of divine Worship, said the *Indian*? Absurd as you think it, said the other, the Ox has been the principal Object of Adoration all over *Egypt*, for these hundred and thirty five thousand Years, and the most abandon'd *Egyptian* has never been as yet so impious as to gain-say it. Ay, Sir, an hundred thirty five thousand Years, say you, surely you must be out a

little in your Calculation. 'Tis but about fourscore thousand Years, since *India* was first inhabited. Sure I am, we are a more antient People than you are, and our *Brama* prohibited the eating of Beef long before your Nation ever erected an Altar in Honour of the Ox, or ever put one upon a Spit. What a Racket you make about your *Brama*! Is he able to stand the least in Competition with our *Apis*, said the *Egyptian*? Let us hear, pray, what mighty Feats have been done by your boasted *Brama*? Why, replied the *Bramin*, he first taught his Votaries to write and read; and 'tis to him alone, all the World is indebted for the Invention of the noble Game of Chess. You are quite out, Sir, in your Notion, said a *Chaldean*, who sat within Hearing: All these invaluable Blessings were deriv'd from the Fish *Oannés*; and 'tis that alone to which the Tribute of divine Adoration is justly due. All the World will tell you, that 'twas a divine Being whose Tail was pure Gold, whose Head resembled that of a Man, tho' indeed the Features were much more beautiful; and that he condescended to visit the Earth three Hours every Day, for the Instruction of Mankind. He had a numerous Issue, as is very well known, and all of them were powerful Monarchs. I have a Picture of it at Home, to which, as in Duty I ought, I Say my Prayers at Night before I go to Bed, and every Morning that I rise. There is no Harm, Sir, as I can conceive, in partaking of a Piece of roast Beef; but, doubtless, 'tis a mortal Sin, a Crime of the blackest Dye, to touch a Piece of Fish. Besides, you cannot justly boast of so illustrious an Origin, and you are both of you mere Moderns, in Comparison to us *Chaldeans*, You *Egyptians* lay claim to no more than 135,000 Years, and you *Indians*, but of 80,000. Whereas we have Almanacks that are dated 4000 Centuries backwards. Take my Word for it; I speak nothing but Truth; renounce your Errors, and I'll make each of you a Present of a fine Portrait of our *Oannés*.

A Native of *Cambalu*, entring into the Debate, said, I have a very great Veneration, not only for the *Egyptians*, *Chaldeans*, *Greeks*, and *Celtæ*; but for *Brama*, *Apis*, and the *Oannés*, but in my humble Opinion, the Li^2, or as 'tis by some call'd, the *Tien*, is an Object more deserving of divine Adoration than any Ox, or Fish, how much soever you may boast of their respective Perfections. All I shall say, in regard to my native Country, 'tis of much greater Extent, than all *Egypt*, *Chaldea*, and the *Indies* put together. I shall lay no Stress on the Antiquity of my Country; for I imagine 'tis of much greater Importance to be the happiest People, than the most antient under the Sun. However, since you were talking of the Almanacks, I must beg the Liberty to tell you, that ours are look'd upon to be the best all over *Asia*; and that we had several very correct ones before the Art of Arithmetick was ever heard of in *Chaldea*.

2 *The* Chinese *Term,* Li, *signifies, properly speaking, natural Light, or Reason; and* Tien, *the Heavens, or the supreme Being.*

You are all of you a Parcel of illiterate, ignorant Bigots, cry'd a *Grecian*: 'Tis plain, you know nothing of the Chaos, and that the World, as it now stands, is owing wholly to *Matter* and *Form*. The *Greek* ran on for a considerable Time; but was at last interrupted by a *Celt*, who having drank deep, during the whole Time of this Debate, thought himself ten Times wiser than any of his Antagonists; and wrapping out a great Oath, insisted, that all their Gods were nothing, if set in Competition with the *Teutath* or the Misletoe on the Oak. As for my part, said he, I carry some of it always in my Pocket: As to my Ancestors, they were *Scythians*, and the only Men worth talking of in the whole World: 'Tis true, indeed, they would now and then make a Meal of their Countrymen, but that ought not to be urg'd as any Objection to his Country; and, in short, if any one of you, or all of you, shall dare to say any thing disrespectful of *Teutath*, I'll defend its Cause to the last Drop of my Blood. The Quarrel grew warmer and warmer, and *Setoc* expected that the Table would be overset, and that Blood-shed would ensue. *Zadig*, who hadn't once open'd his Lips during the whole Controversy, at last rose up, and address'd himself to the *Celt*, in the first Place, as being the most noisy and outrageous. Sir, said he, Your Notions in this Affair are very just: Good Sir, oblige me with a Bit of your Misletoe. Then turning about, he expatiated on the Eloquence of the *Grecian*, and in a Word, soften'd in the most artful Manner all the contending Parties. He said but little indeed to the *Cathayian*; because he was more cool, and sedate than any of the others. To conclude, he address'd them all in general Terms, to this or the like Effect: My dear Friends, You have been contesting all this while about an important Topick, in which 'tis evident, you are all unanimously agreed. Agreed, quotha! they all cried, in an angry Tone, How so, pray? Why said he to the hot, testy *Celt*, is it not true, that you do not in effect adore this Misletoe, but that Being who created that Misletoe and the Oak, to which it is so closely united? Doubtless, Sir, reply'd the *Celt*. And you, Sir, said he, to the *Egyptian*, You revere, thro' your venerable *Apis*, the great Author of every Ox's Being. We do so, said the *Egyptian*. The mighty *Oannés*, tho' the Sovereign of the Sea, continued he, must give Precedence to that Power, who made both the Sea, and every Fish that dwells therein. We allow it, said the *Chaldean*. The *Indian*, adds he, and the *Cathayan*, acknowledge one supreme Being, or first Cause, as well as you. As to what that profound worthy Gentleman the *Grecian* has advanc'd, is, I must own, a little above my weak Comprehension, but I am fully persuaded, that he will allow there is a supreme Being on whom his favourite Matter and Form are entirely dependent. The *Grecian*, who was look'd upon as a Sage amongst them, said, with Abundance of Gravity, that *Zadig*, had made a very just Construction of his Meaning. Now, Gentlemen, I appeal to you all, said *Zadig*, whether you are not unanimous to a Man, in the Debate upon the Carpet, and whether there are any just Grounds for the

least Divisions or Animosities amongst you. The whole Company, cool at once, caress'd him; and *Setoc*, after he had sold off all his Goods and Merchandize at a round Price, took his Friend *Zadig* Home with him to the Land of *Horeb*. *Zadig*, upon his first Arrival was inform'd, that a Prosecution had been carried on against him during his Absence, and that the Sentence pronounc'd against him was, that he should be burnt alive before a slow Fire.

CHAPTER XII

THE RENDEZVOUS

WHILST *Zadig* attended his Friend *Setoc* to *Balzora*, the Priests of the Stars were determin'd to punish him. As all the costly Jewels, and other valuable Decorations, in which every young Widow that sacrificed her self on her Husband's Funeral-pile, were their customary Fees, 'tis no great Wonder, indeed, that they were inclin'd to burn poor *Zadig*, for playing them such a scurvy Trick. *Zadig* therefore, was accus'd of holding heretical and damnable Tenets, in regard to the Celestial Host: They depos'd, and swore point-blank, that he had been heard to aver, that the Stars never sat in the Sea. This horrid blasphemous Declaration thunder-struck all the Judges, and they were ready to rend their Mantles at the Sound of such an impious Assertion; and they would have made *Zadig*, had he been a Man of Substance, paid very severely for his heretical Notions. But in the Height of their Pity and Compassion for even such an Infidel, they would lay no Fine upon him; but content themselves with seeing him roasted alive before a slow Fire. *Setoc*, tho' without Hopes of Success, us'd all the Interest he had to save his bosom Friend from so shocking a Death; but they turn'd a deaf Ear to all his Remonstrances, and oblig'd him to hold his Tongue. The young Widow *Almona*, who by this Time was not only reconcil'd to living a little longer, but had some Taste for the Pleasures of Life, and knew that she was entirely indebted to *Zadig* for it, resolv'd, if possible, to free her Benefactor from being burnt, as he had before convinc'd her of the Folly of it in her Case. She ponder'd upon this weighty Affair very seriously; but said nothing to any one whomsoever. *Zadig* was to be executed the next Day; and she had only a few Hours left to carry her Project into Execution. Now the Reader shall hear with how much Benevolence and Discretion this amiable Widow behav'd on this emergent Occasion.

In the first Place, she made use of the most costly Perfumes; and drest herself to the utmost Advantage to render her Charms as conspicuous as possible; And thus gaily attir'd, demanded a private Audience of the High Priest of the Stars. Upon her first Admittance into his august and venerable Presence, she address'd herself in the following Terms.

O thou first-born and well-beloved Son of the Great Bear, Brother of the Bull, and first Cousin to the Dog, (these you must know were the Pontiff's high Titles) I come to confess myself before you: My Conscience is my Accuser, and I am terribly afraid I have been guilty of a mortal Sin, by declining the stated Custom of burning myself on my Husband's Funeral-pile? What could tempt me, in short, to a Prolongation of my Life, I can't imagine, I, who am grown a perfect Skeleton, all wrinkled and deform'd. She paus'd, and pulling off, with a negligent but artful Air, her long silk Gloves; She display'd a soft, plump, naked Arm, and white as Snow: You see, Sir, said she, that all my Charms are blasted. Blasted, Madam, said the luscious Pontiff; No! Your Charms are still resistless: His Eyes, and his Mouth, with which he kiss'd her Hand, confirm'd their Power: Such an Arm, Madam, by the Great *Orasmades*, I never saw before. Alas! said the Widow, with a modest Blush; my Arm Sir, 'tis probable, may have the Advantage of any hidden Part; but see, good Father, what a Neck is here; as yellow as Saffron, an Object not worth regarding. Then she display'd such a snowy, panting Bosom, that Nature could not mend it. A Rose-Bud on an Ivory Apple, would, if set in Competition with her spotless Whiteness, make no better Appearance than common Madder upon a Shrub; and the whitest Wool, just out of the Laver, were she but by, would seem but of a light-brown Hue.

Her Neck, her large black, sparkling Eyes, that languishingly roll'd, and seem'd as 'twere, on Fire; her lovely Cheeks, glowing with White and Red, her Nose, that was not unlike the Tower of Mount *Lebanon*, her Lips, which were like two Borders of Coral, inclosing two Rows of the best Pearls in the *Arabian* Sea; such a Combination, I say, of Charms, made the old Pontiff judge she was scarce twenty Years of Age; and in a kind of Flutter, to make her a Declaration of his tender Regard for her. *Almona*, perceiving him enamour'd, begg'd his Interest in Favour of *Zadig*. Alas! my dear Charmer, my Interest alone, when you request the Favour, would be but a poor Compliment; I'll take care his Acquittance shall be signed by three more of my Brother Priests. Do you sign first, however, said *Almona*. With all my Soul, said the amorous Pontiff, provided—you'll be kind, my dearest. You do me too much Honour, said *Almona*; but should you give yourself the Trouble to pay me a Visit after Sunset, and as soon as the Star *Sheat* twinkles on the Horizon, you shall find me, most venerable Father, repos'd upon a rosy-colour'd silver Sopha, where you shall use your Pleasure with your humble Servant. With that she made him a low Courtesy; took up *Zadig*'s general Release as soon as duely sign'd, and left the old Doatard all over Love, tho' somewhat diffident of his own Abilities. The Residue of the Day he spent in his Bagnio; he drank large enlivening Draughts of a Water distill'd from the Cinnamon of *Ceilan*, and the costly Spices of *Tidor* and *Ternate*, and waited with the utmost Impatience for the up-rising of the brilliant *Sheat*.

In the mean time *Almona* went to the second Pontiff. He assur'd her that the Sun, Moon, and all the starry Host of Heav'n, were but languid Fires to her bright Eyes. He put the Question to her, in short, at once, and agreed to sign upon her Compliance. She suffer'd herself to be over-persuaded, and made an Assignation to meet him at a certain Place, as soon as the Star *Algenib* should make its Appearance. From him she repair'd to the third and fourth Pontiff, taking care, wherever she went, to see *Zadig*'s Acquittance duely sign'd, and made fresh Appointments at the Rising of Star after Star.

When she had carried her Point thus far, she sent a proper Message to the Judges of the Court, who had condemn'd *Zadig*, requesting that they would come to her House, that she might advise with them upon an Affair of the last Importance. They waited on her accordingly; she produc'd *Zadig*'s Discharge duly sign'd by four several Hands, and told them the Definitive Treaty between all the contracting Parties. Each of the pontifical Gallants observ'd their Summons to a Moment. Each was startled at the Sight of his Rival; but perfectly thunderstruck to see the Judges, before whom the Widow had laid open her Case. *Zadig* procur'd an absolute Pardon, and *Setoc* was so charm'd with the artful Address of *Almona*, that he married her the next Day. *Zadig* went afterwards to throw himself at the Feet of his fair Benefactress. *Setoc* and he took their Leave of each other with Tears in their Eyes, and vowing that an eternal mutual Friendship should be preserv'd between them; and, in short, should Fortune at any Time afterwards prove more propitious than could well be expected to either Party; the other should partake of an equal Share of his Success.

Zadig steer'd his Course towards *Syria*; forever pondering on the hard Fate of the justly-admir'd *Astarte*, and reflecting on his own Stars that so obstinately darted down their malignant Rays, and continu'd daily to torment him. What, said he! to pay four hundred Ounces of Gold for only seeing a Bitch pass by me; to be condemn'd to be beheaded for four witless Verses in Praise of the King; to be strangled to Death, because a Queen was pleas'd to look upon me; to be made a Prisoner, and sold as a Slave for saving a young Lady from being sorely abus'd by a Brute rather than a Man; and to be upon the Brink of being roasted alive, for no other Offence than saving for the future all the Widows in *Arabia* from becoming idle Burnt-Offerings, and mingling their Ashes with those of their deceased worthless Husbands.

CHAPTER XIII

THE FREE-BOOTER

ZADIG, arriving at the Frontiers which separate *Arabia Petræa* from *Syria*, and passing by a very strong Castle, several arm'd *Arabians* rush'd

out upon him, and surrounding him, cried out: Whatever you have belonging to you is our Property, but as for your Person, that is entirely at our Sovereign's Disposal. *Zadig*, instead of making any Reply, drew his Sword, and as his Attendant was a very couragious Fellow, he drew likewise. Those who laid hold on them, first fell a Sacrifice to their Fury: Their Numbers redoubled: Yet still, Both dauntless, determin'd to conquer or to die. When two Men defend themselves against a whole Gang, the Contest, doubtless, cannot last long. The Master of the Castle, one *Arbogad* by Name, having been an Eye-Witness from his Window, of the Intrepidity and surprising Exploits of *Zadig*, took a Fancy to him. He ran down therefore in Haste, and giving Orders himself to his Vassals to desist, deliver'd the two Travellers out of their Hands. Whatever Goods or Chattels, said he, come upon my Territories, are my Effects; and whatever I find likewise that is valuable upon the Premises of others, is my free Booty; but, as you appear, Sir, to me to be a Gentleman of uncommon Courage, you shall prove an Exception to my general Rule. Upon this, he invited *Zadig* into his magnificent Mansion, giving his inferior Officers strict Orders to use him with all due Respect; and at Night *Arbogad* was desirous of supping with *Zadig*. The Lord of the Mansion was one of those *Arabians*, that are call'd *Free-booters*; but a Man who now and then did good Actions amongst a Thousand bad ones. He plunder'd without Mercy; but was liberal in his Benefactions. When in Action, intrepid; but in Traffick, easy enough; a perfect *Epicure* in his Eating and Drinking, an absolute *Debauchee*, but very frank and open. *Zadig* pleas'd him extremely; his Conversation being very lively, prolong'd their Repast: At last, *Arbogad* said to him; I would advise you, Sir, to enlist yourself in my Troop; you cannot possibly do a better Thing: My Profession is none of the worst; and in Time, you may become perhaps as great a Man as myself. May I presume, Sir, to ask you one Question; how long may you have follow'd this honourable Calling? From my Youth upwards, replied his Host, I was only a *Valet* at first to an *Arabian*, who indeed was courteous enough; but Servitude was a State of Life I could not brook. It made me stark-mad to see, in a wide World, which ought to be divided fairly between Mankind, that Fate had reserv'd for me so scanty a Portion. I communicated my Grievance to an old Sage *Arabian*. Son, said he, never despair; once upon a Time, there was a Grain of Sand, that bemoan'd itself, as being nothing more than a worthless *Atom* of the Deserts. At the Expiration, however, of a few Years, it became that inestimable Diamond, which at this very Hour, is the richest, and most admir'd Ornament of the *Indian* Crown. The old Man's Discourse fir'd me with some Ambition; I was conscious to myself that I was at that Time the *Atom* he mention'd, but was determin'd, if possible, to become the *Diamond*. At my first setting out, I stole two Horses; then I got into a Gang; where we play'd at small Game, and stopp'd the small Caravans; thus I gradually lessen'd the wide Disproportion, which there was at first between me and the rest of Mankind:

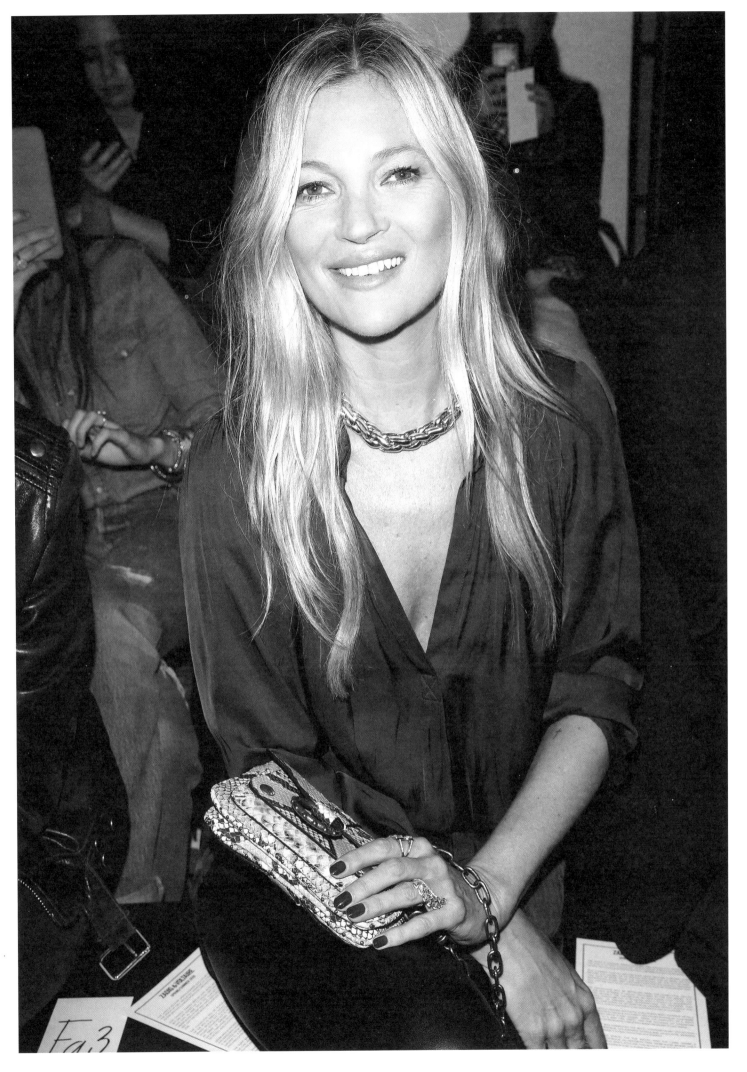

KATE MOSS, SPRING-SUMMER 2020 SHOW, RITZ, PARIS

146 BACKSTAGE, SPRING-SUMMER 2019 SHOW, PARIS

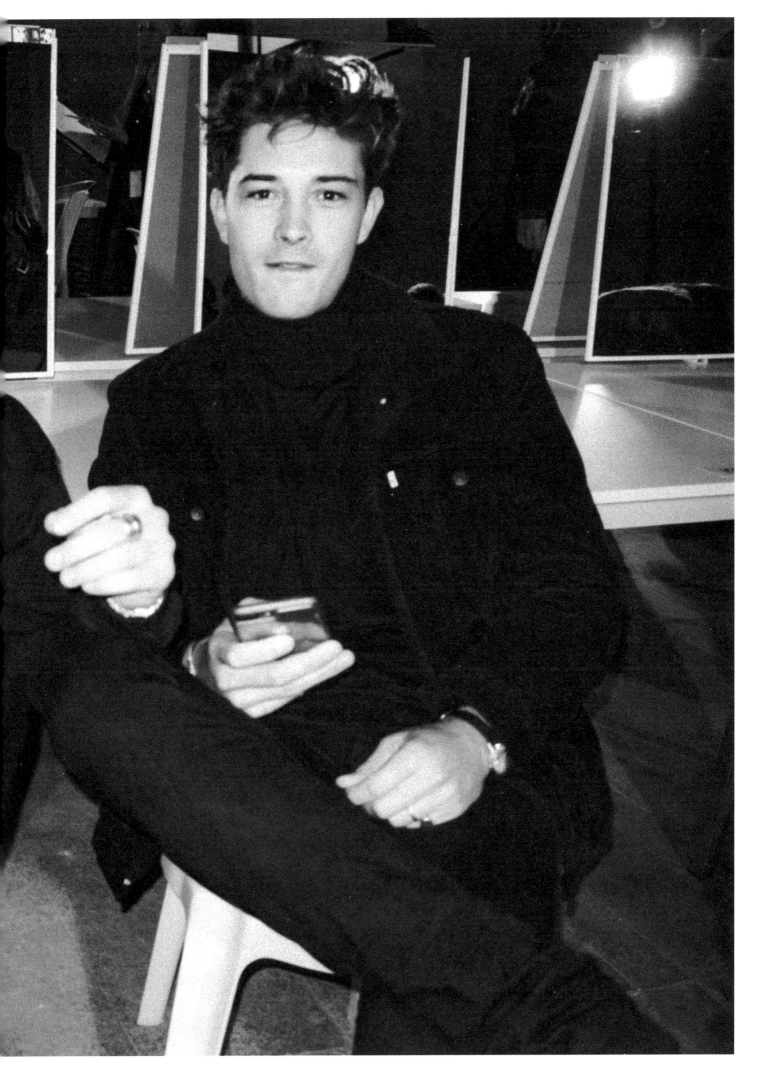

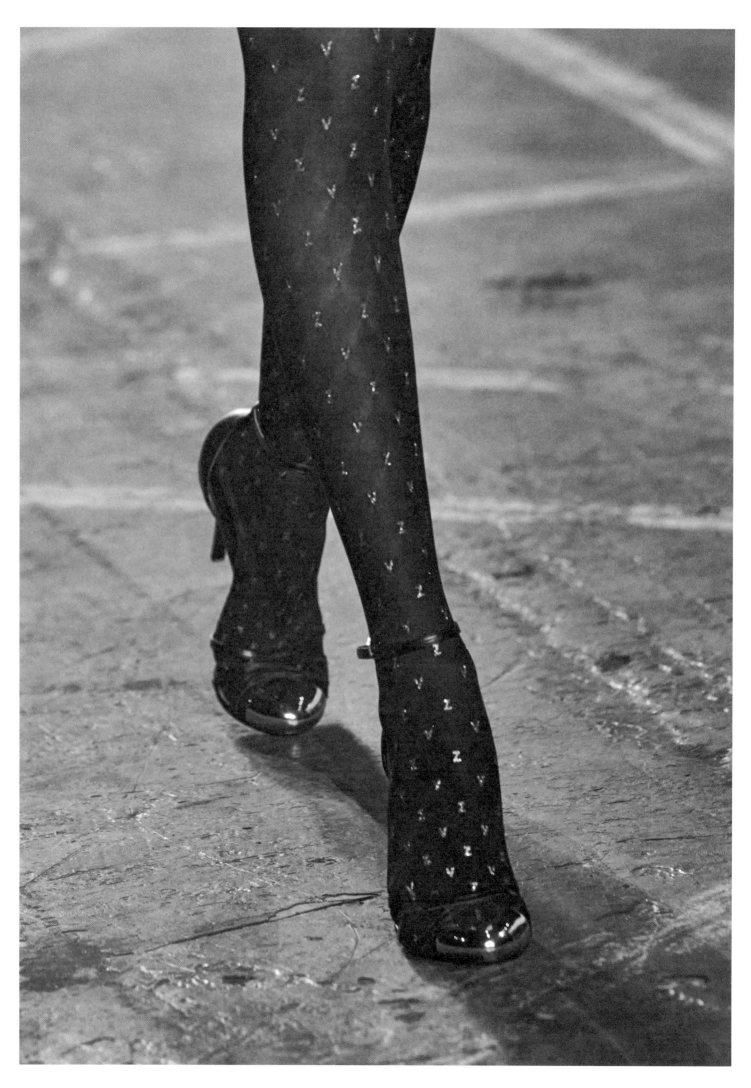

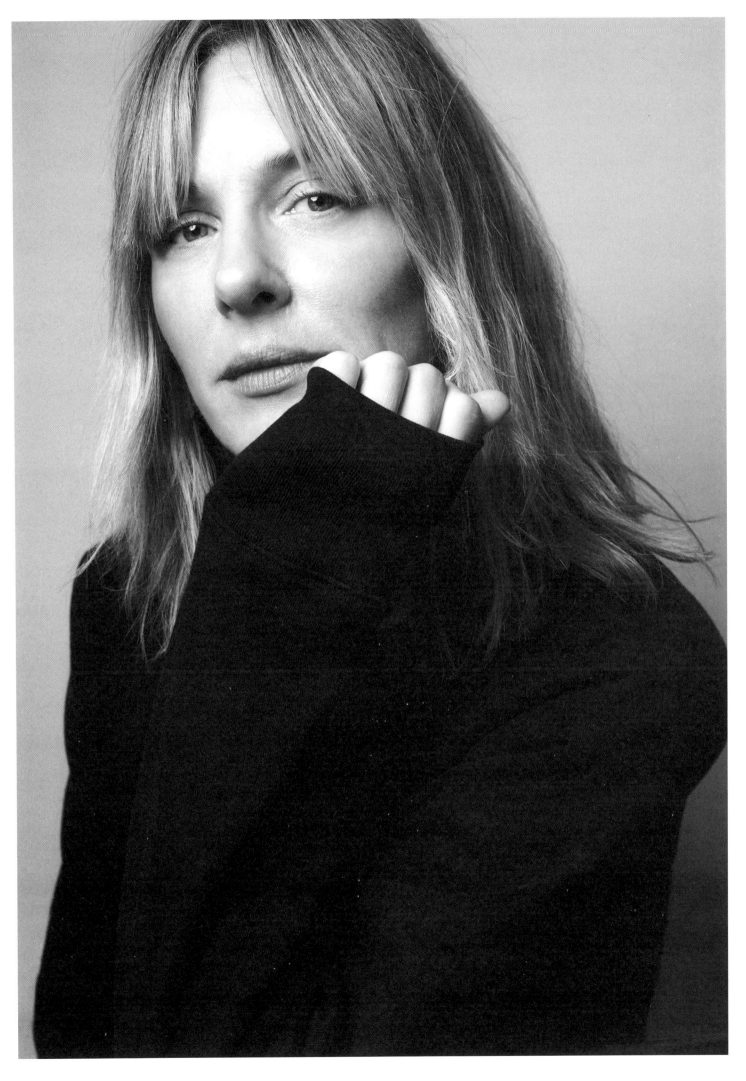

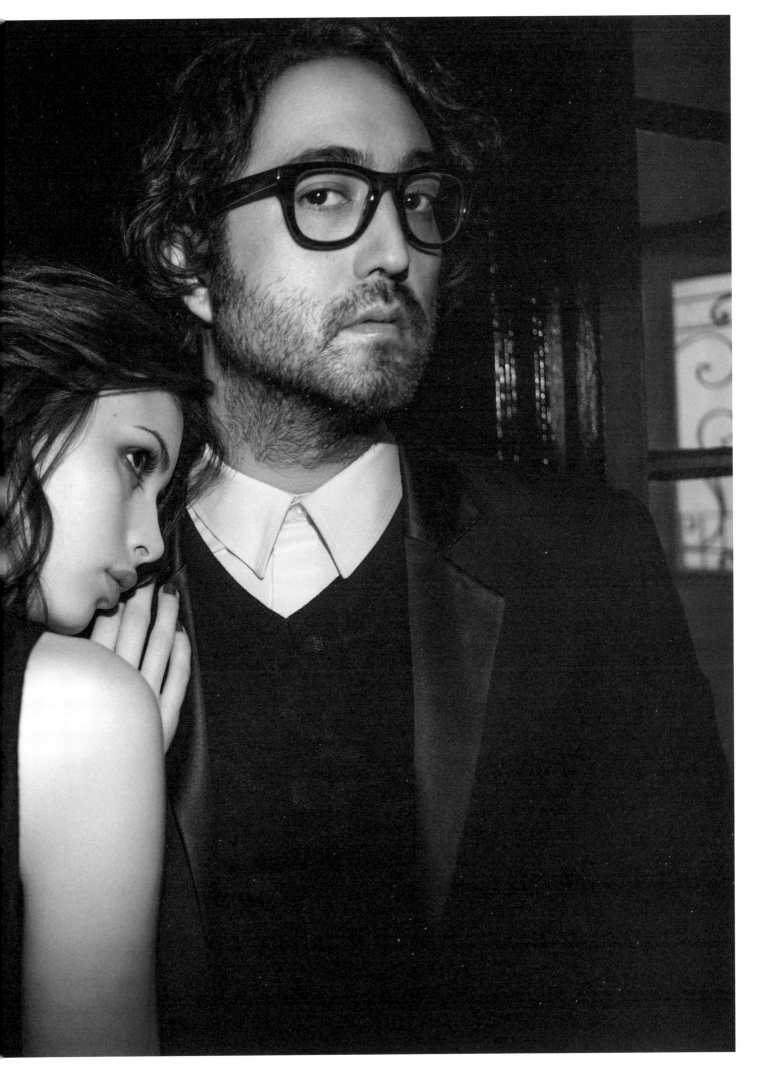

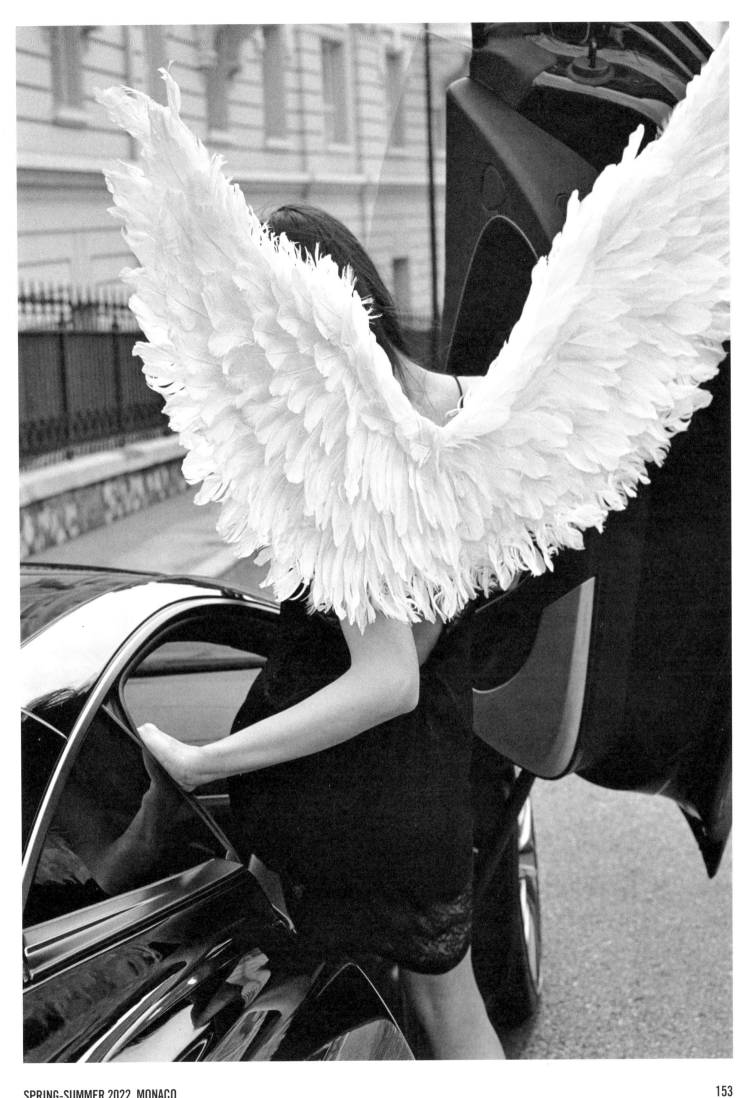

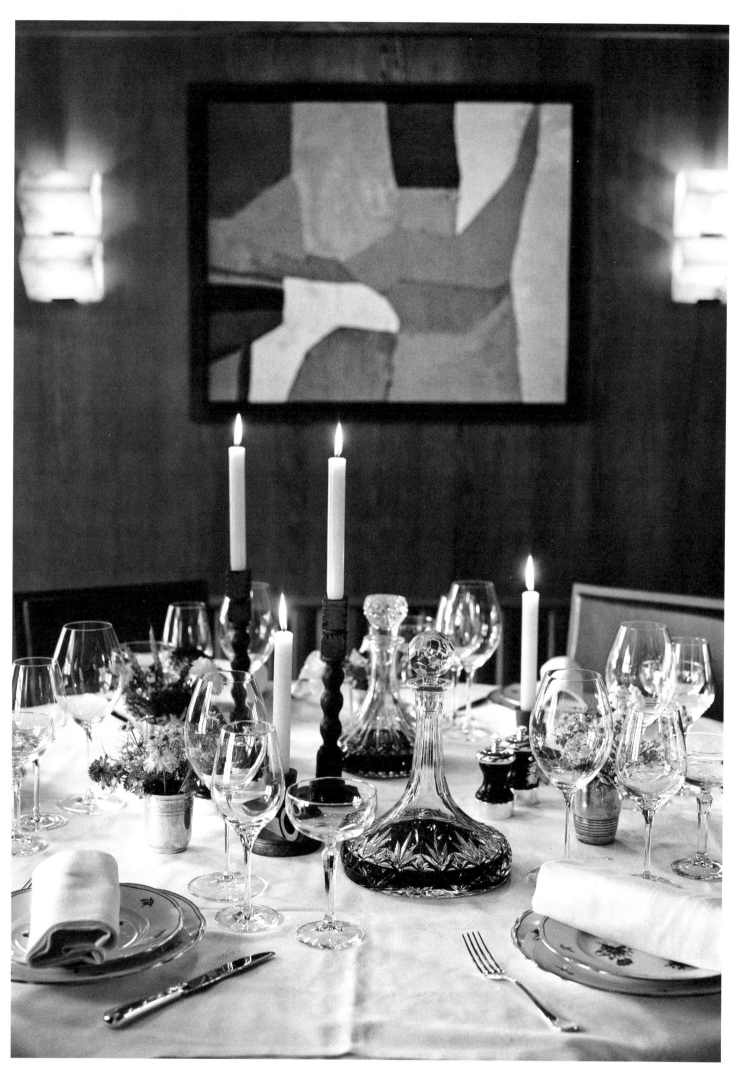

154 CHÂTEAU VOLTAIRE HOTEL, 55-57 RUE SAINT-ROCH, PARIS

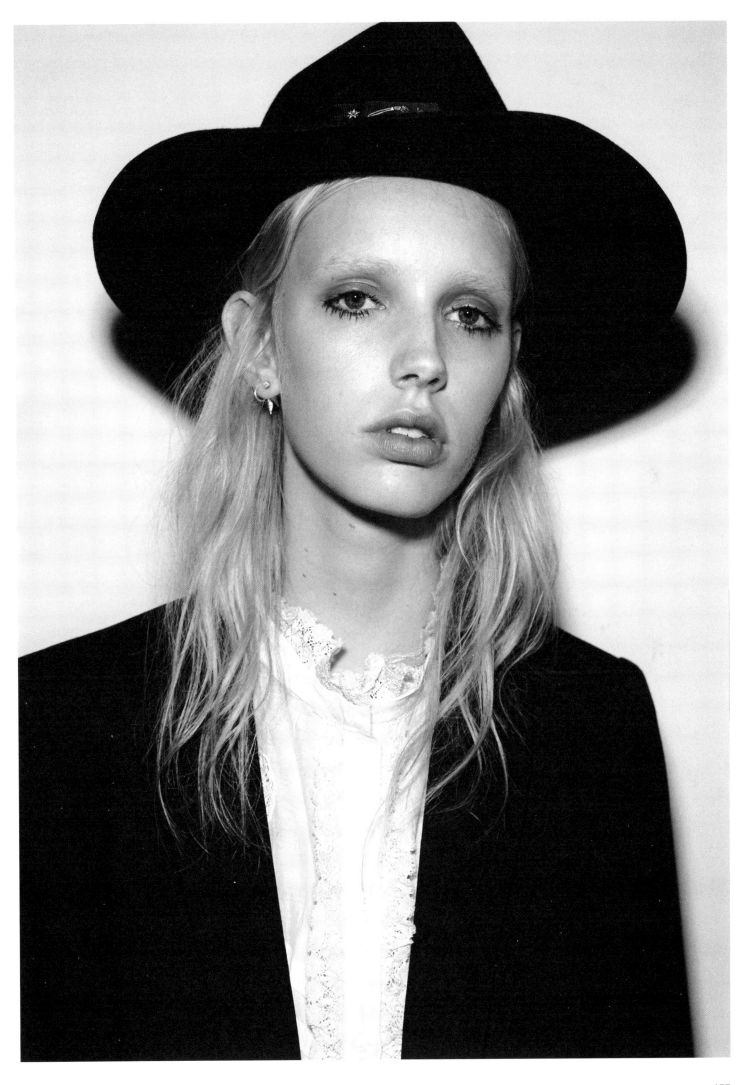

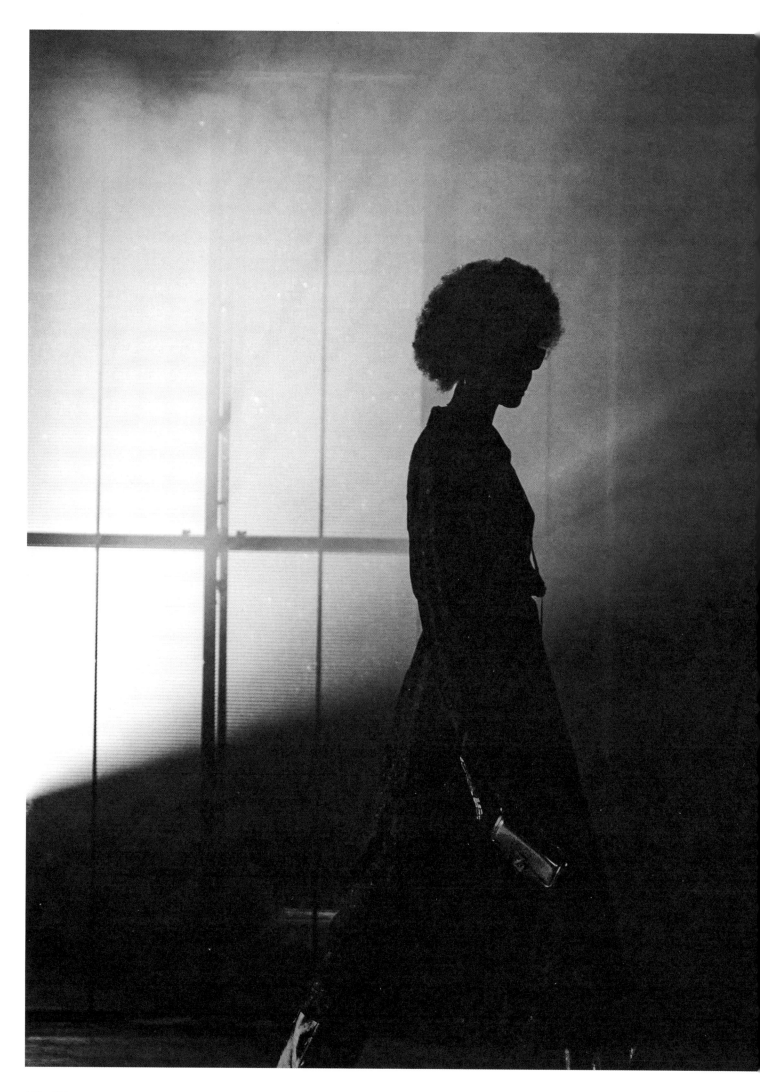

156 FALL-WINTER 2021 SHOW, PARIS

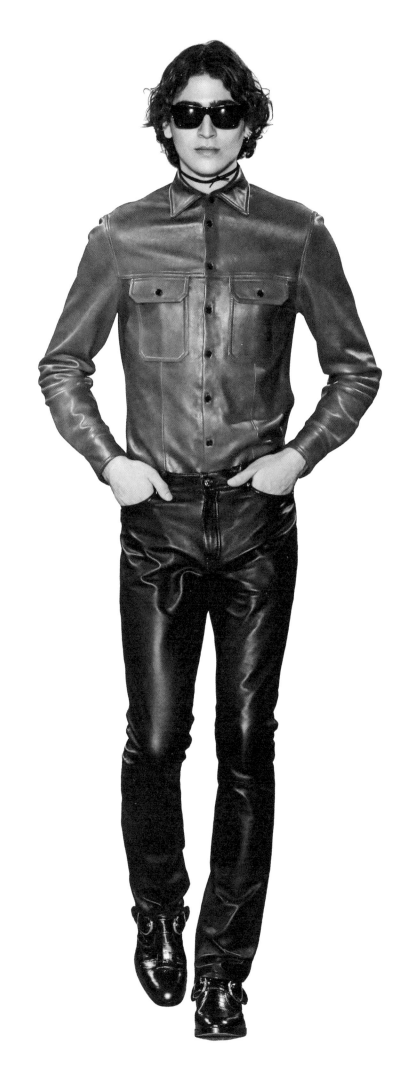

158 FALL-WINTER 2020 SHOW, NEW YORK

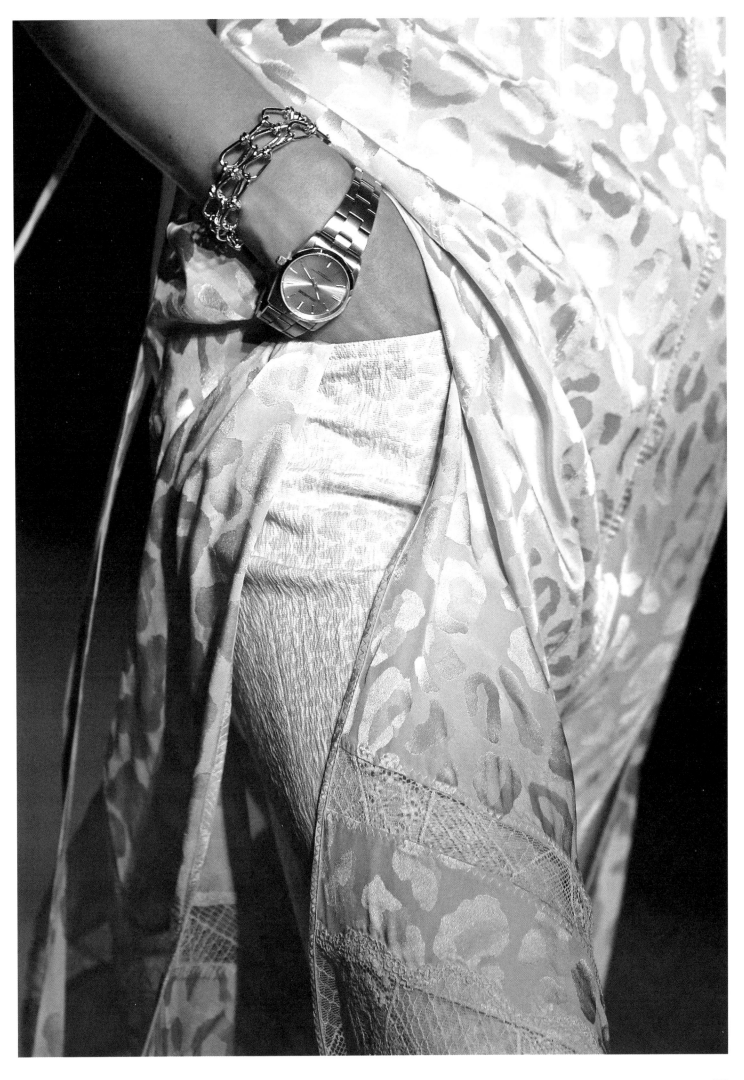

FALL-WINTER 2017 SHOW, NEW YORK

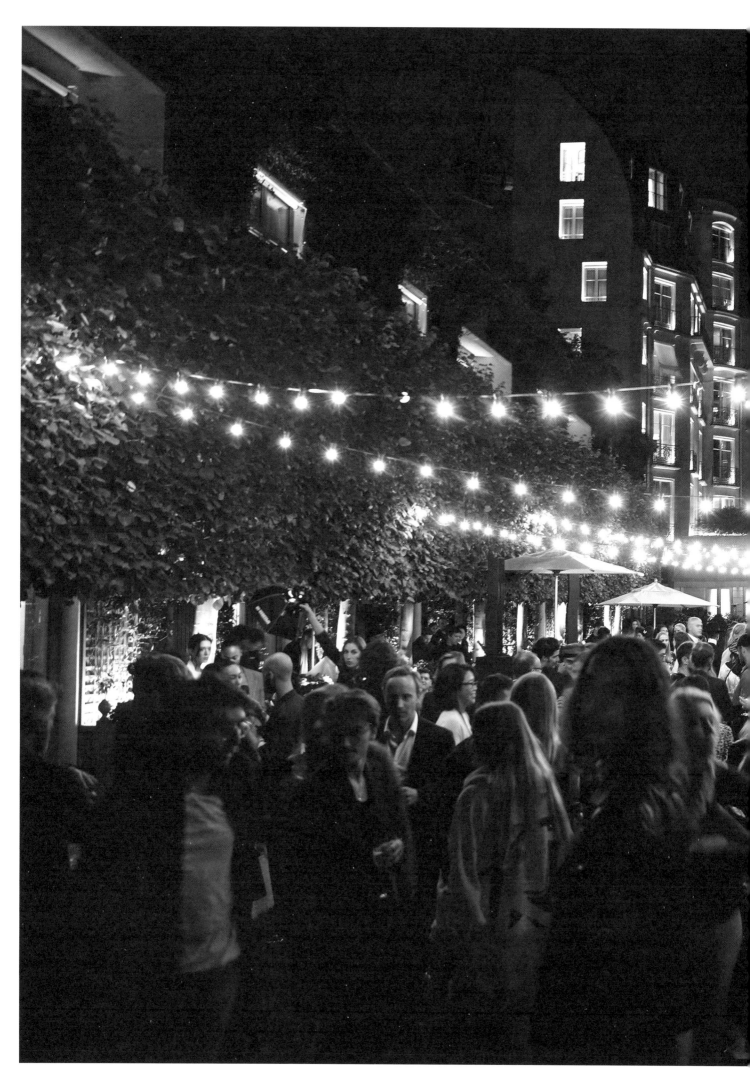

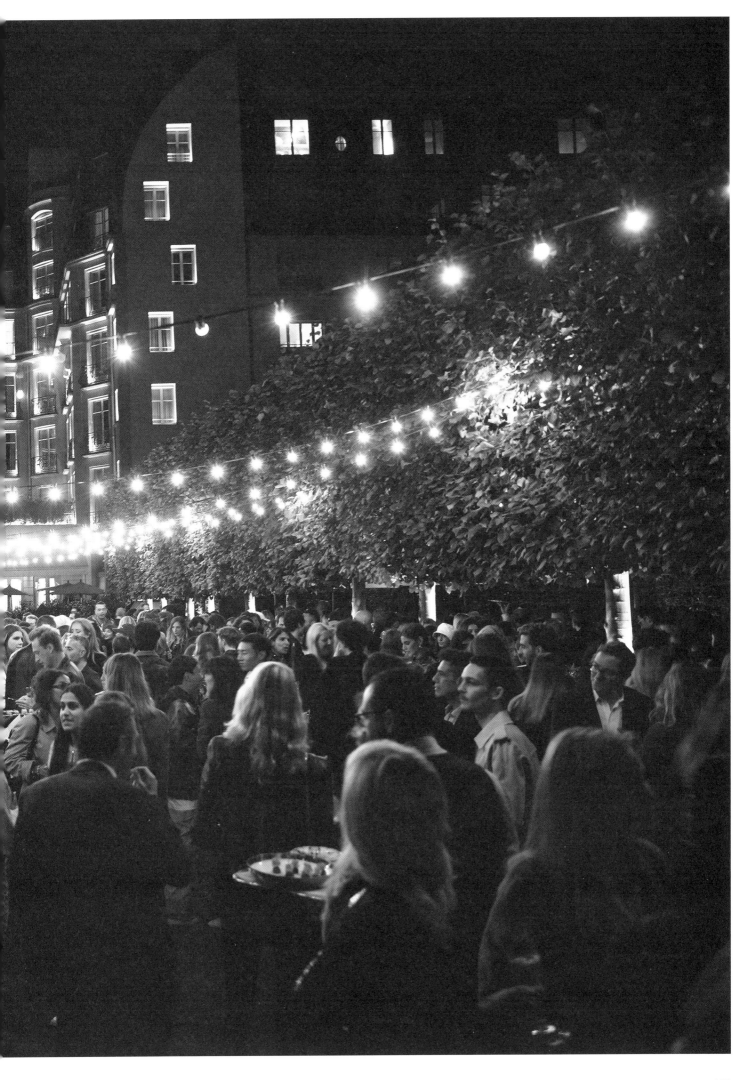

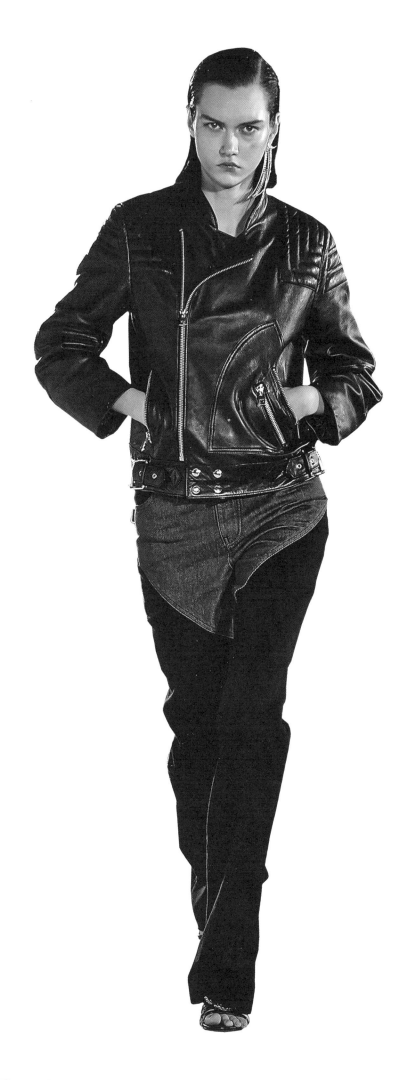

162 FALL-WINTER 2023 SHOW, PARIS

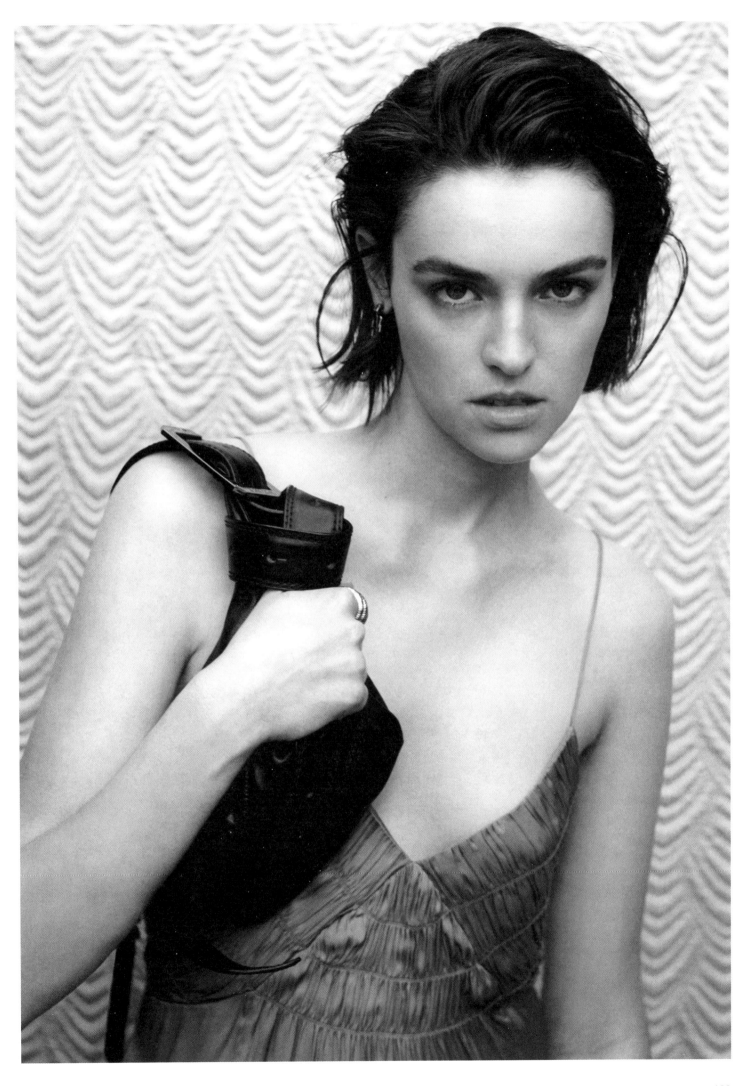

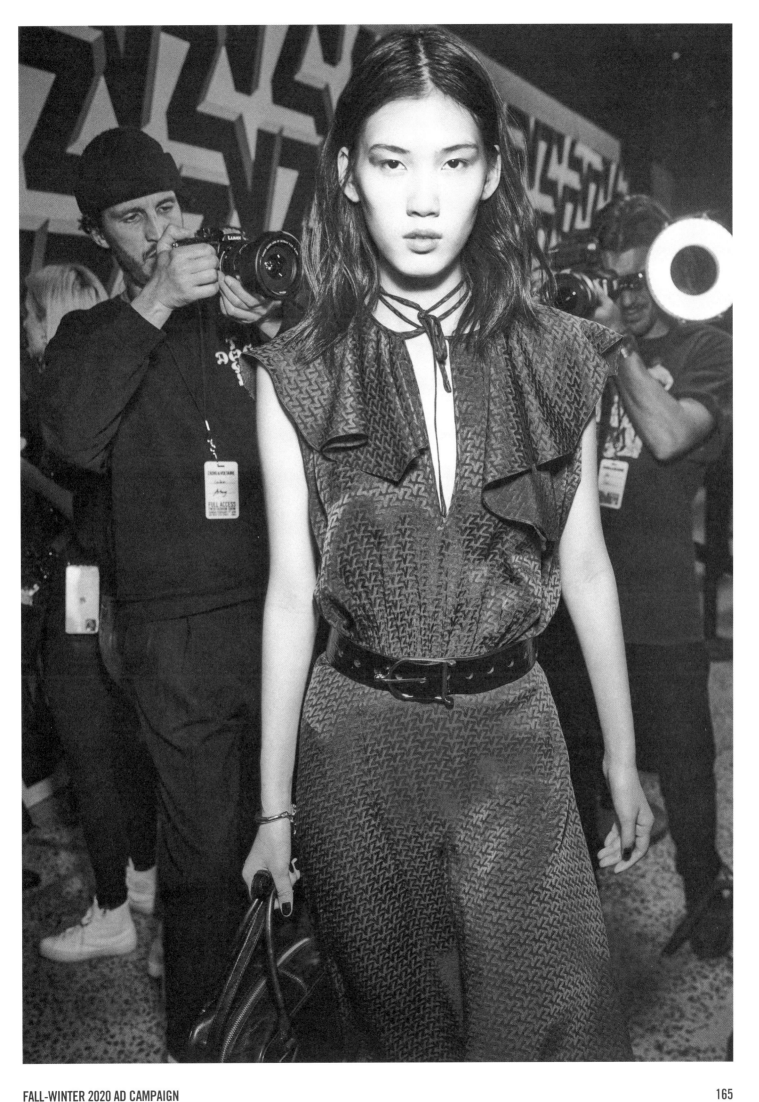

FALL-WINTER 2020 AD CAMPAIGN

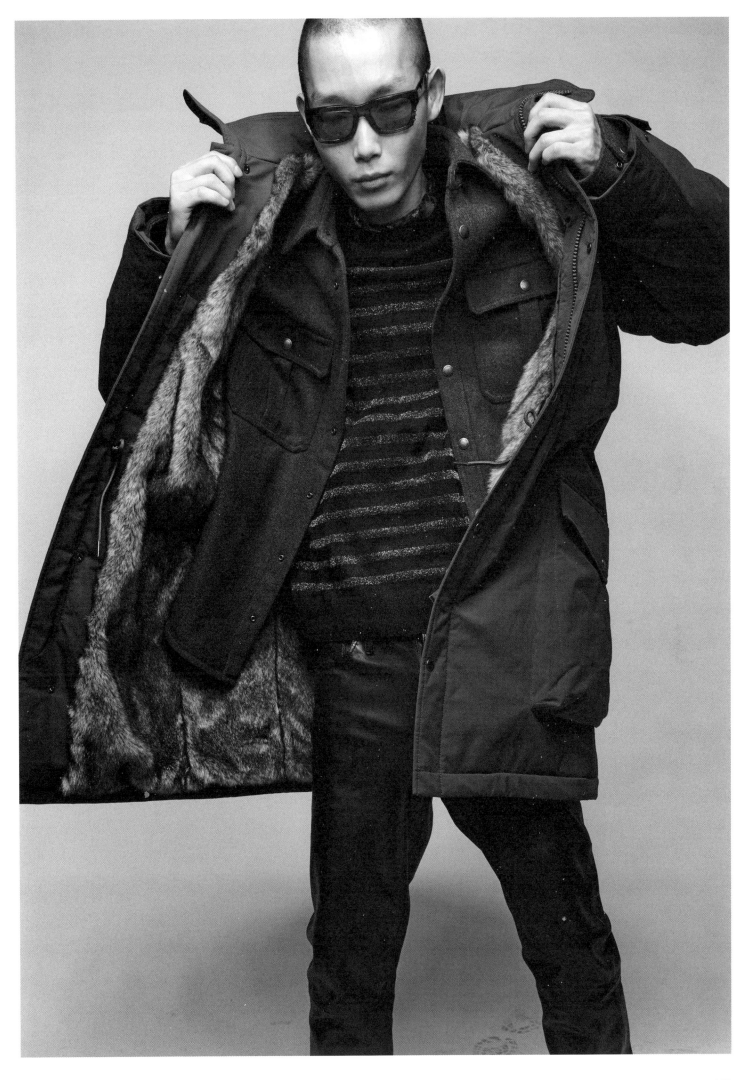

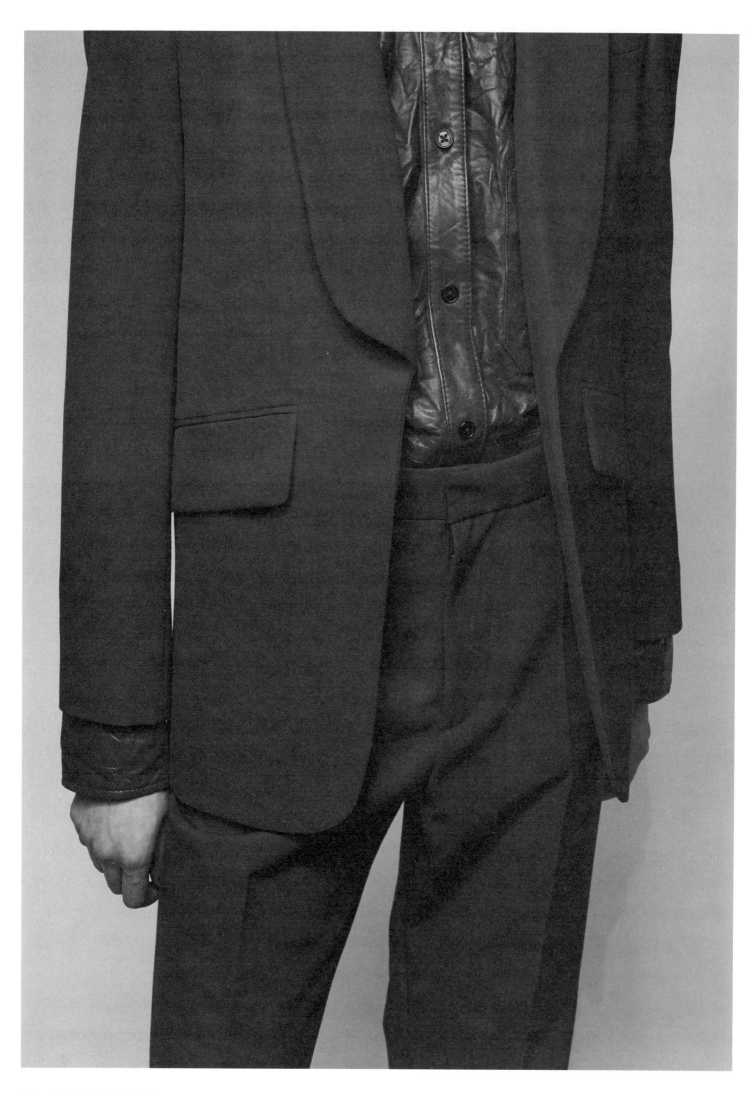

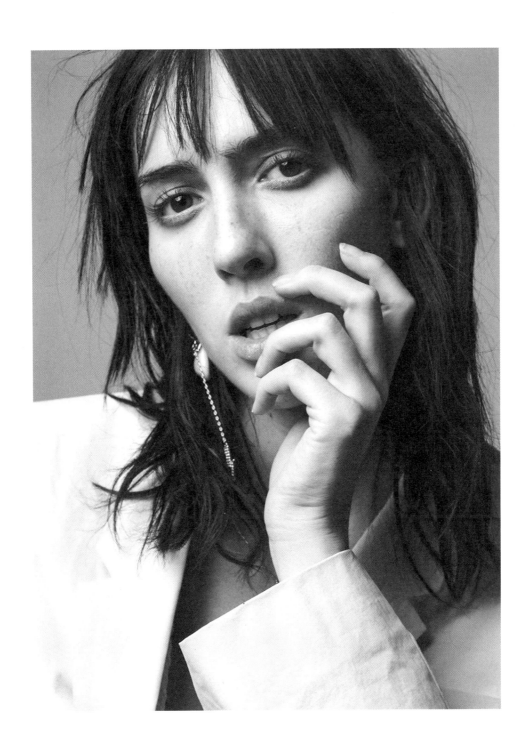

CASTING, SPRING-SUMMER 2019 SHOW, PARIS

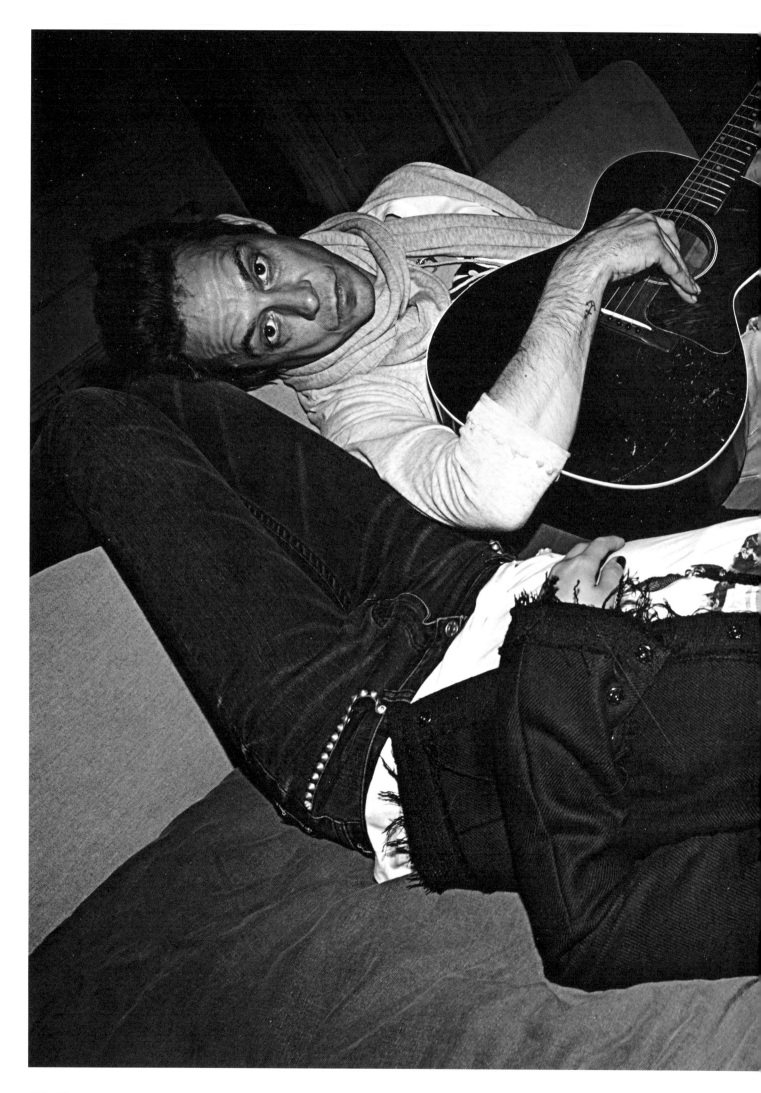

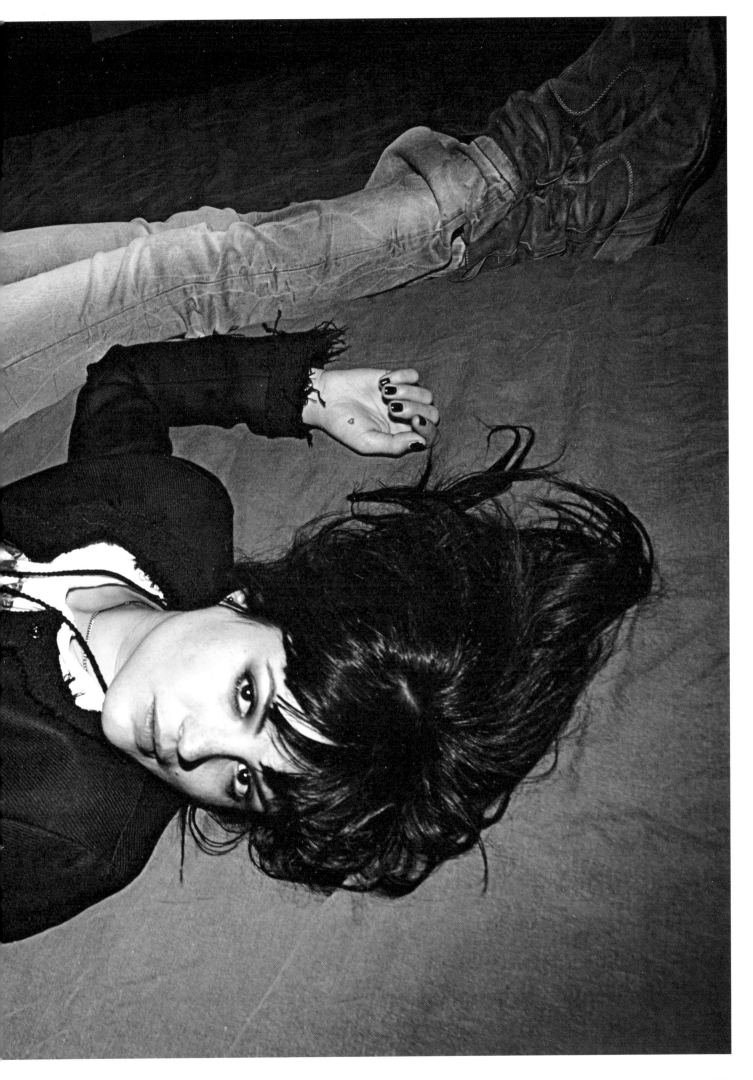

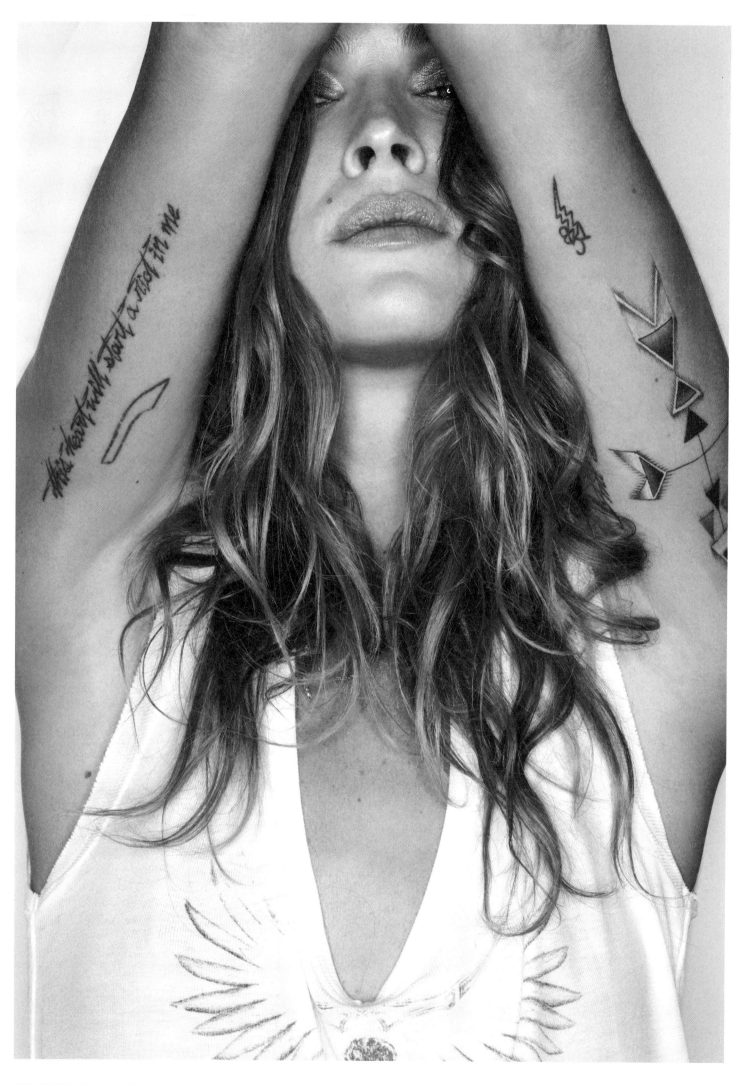

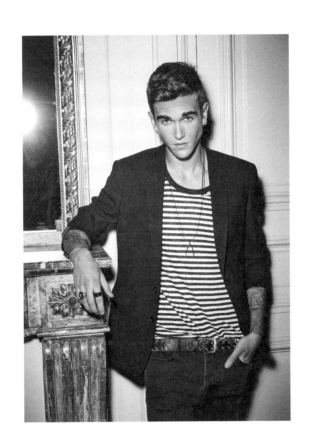

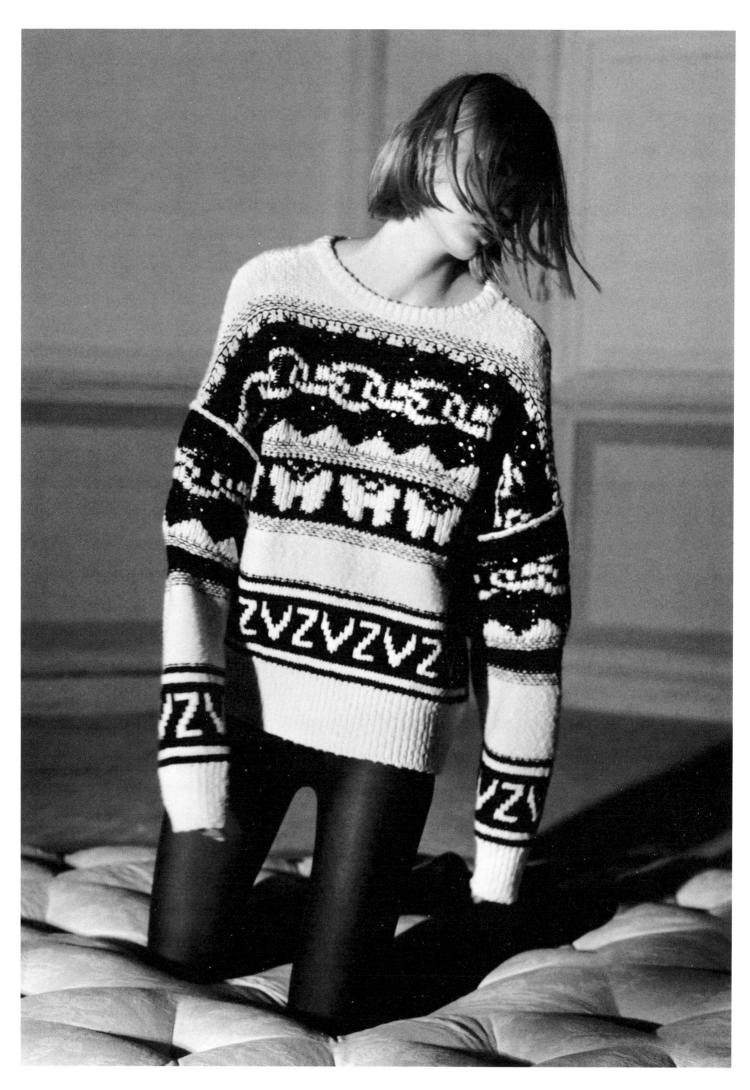

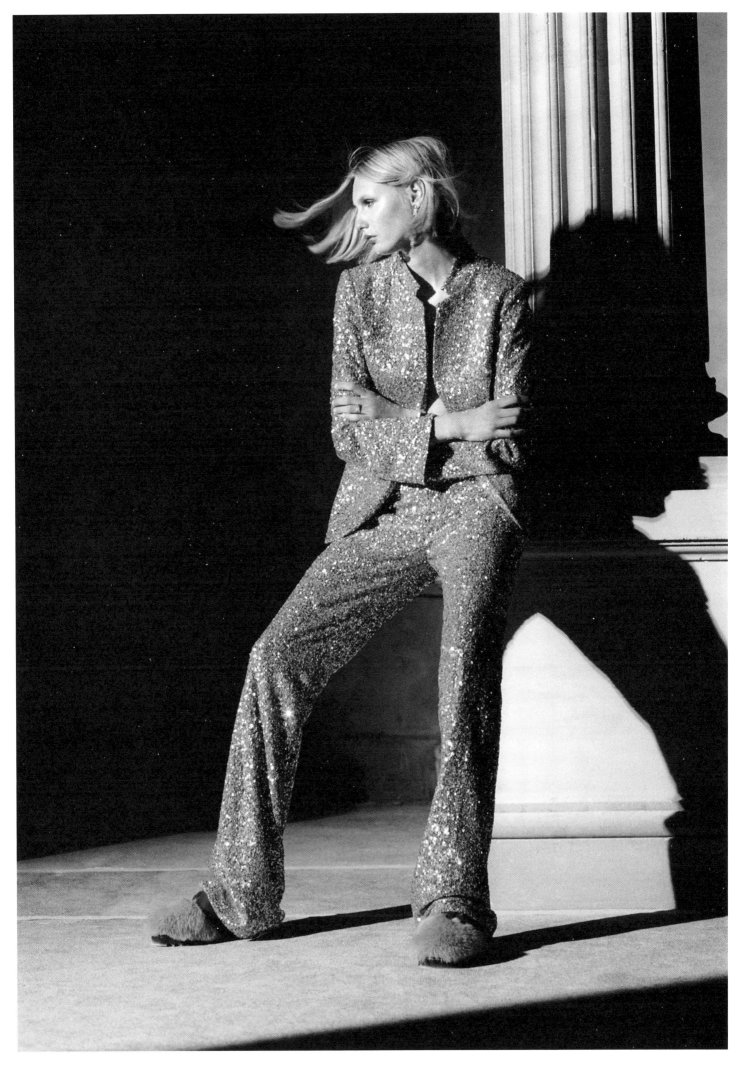

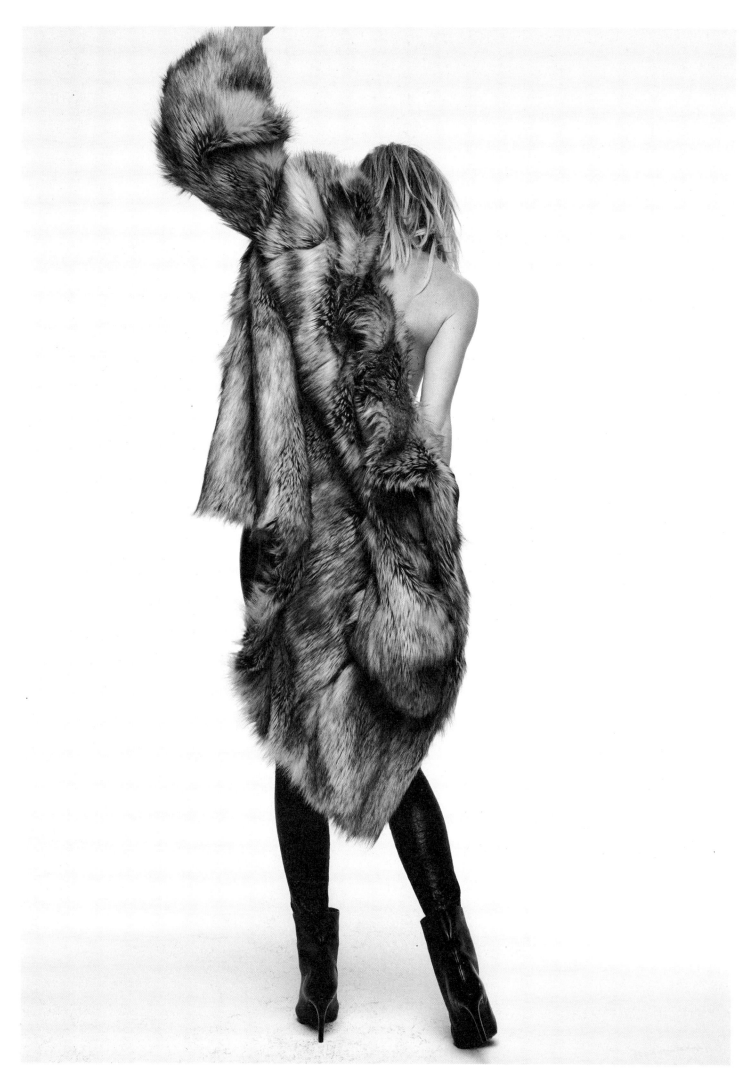

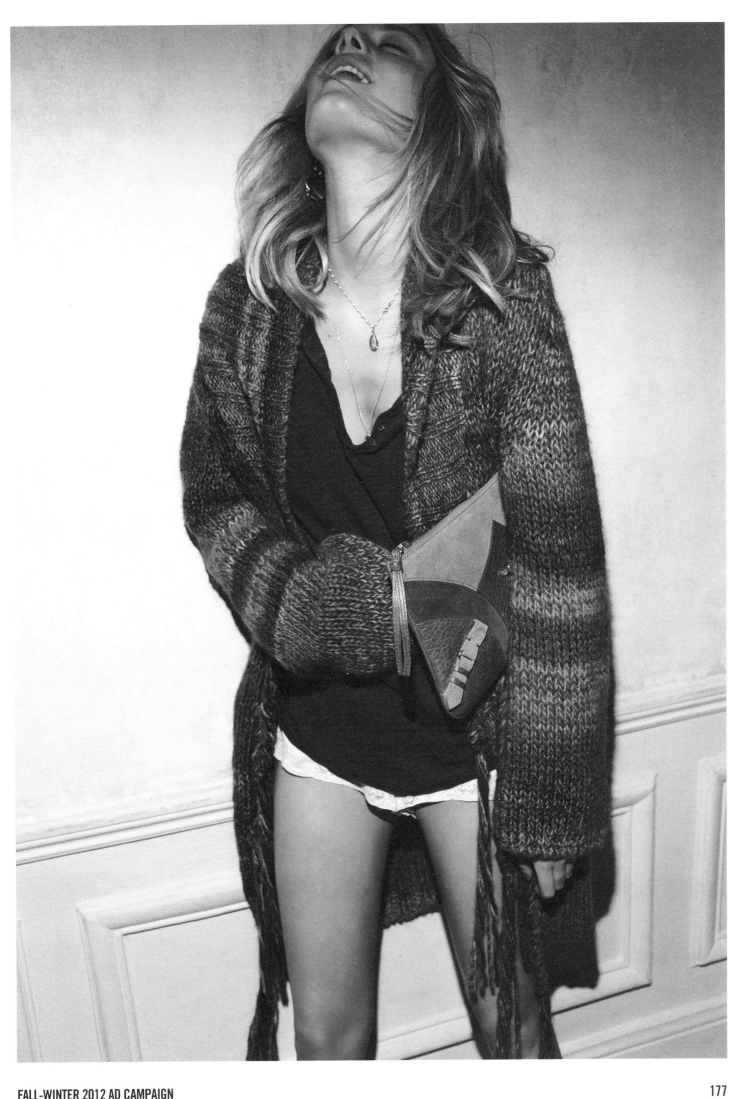

FALL-WINTER 2012 AD CAMPAIGN

178 AFTER-PARTY, SPRING-SUMMER 2013 SHOW, RUE DE GRENELLE, PARIS

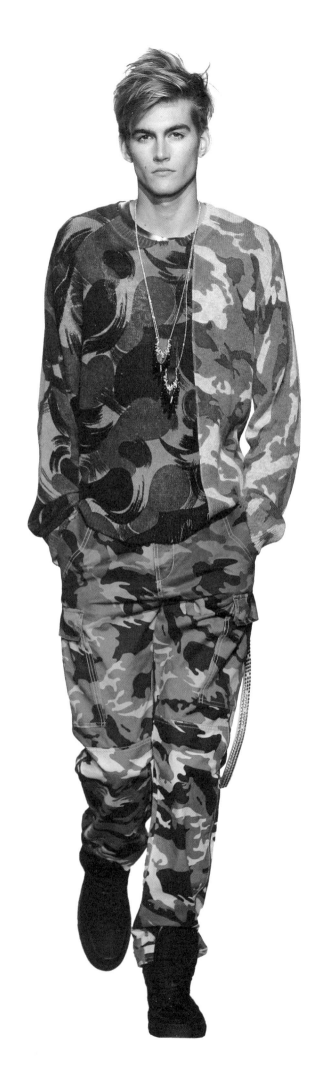

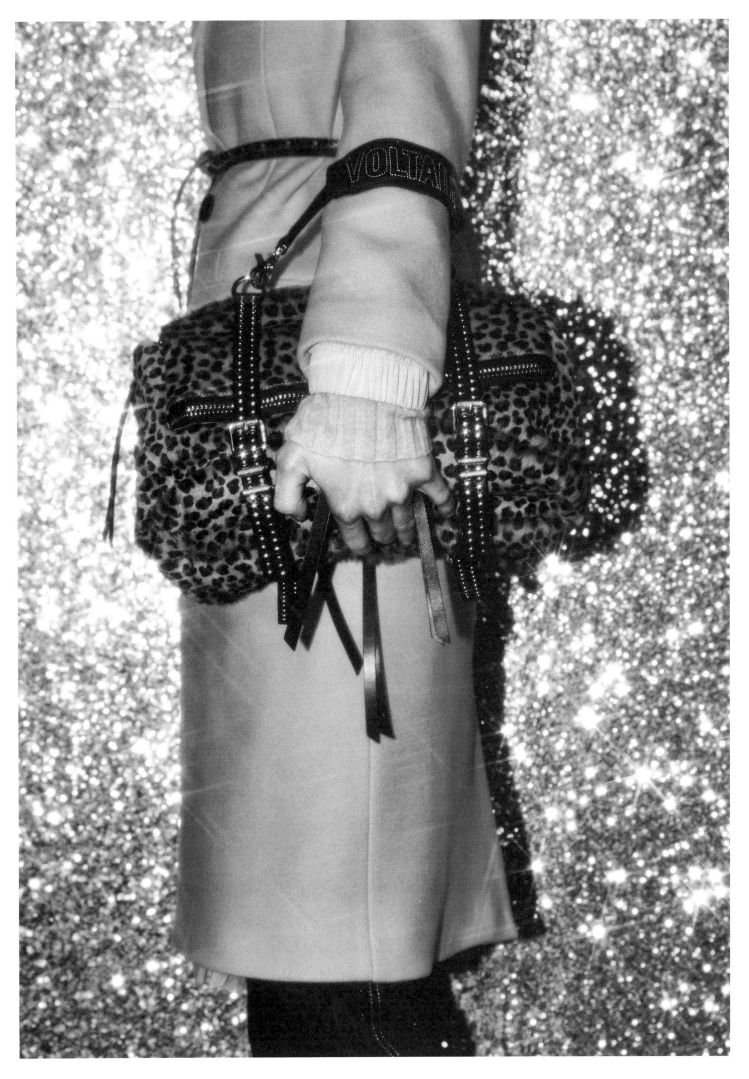

BACKSTAGE, FALL-WINTER 2019 SHOW, NEW YORK

182 AFTER-PARTY, SPRING-SUMMER 2013 SHOW, RUE DE GRENELLE, PARIS

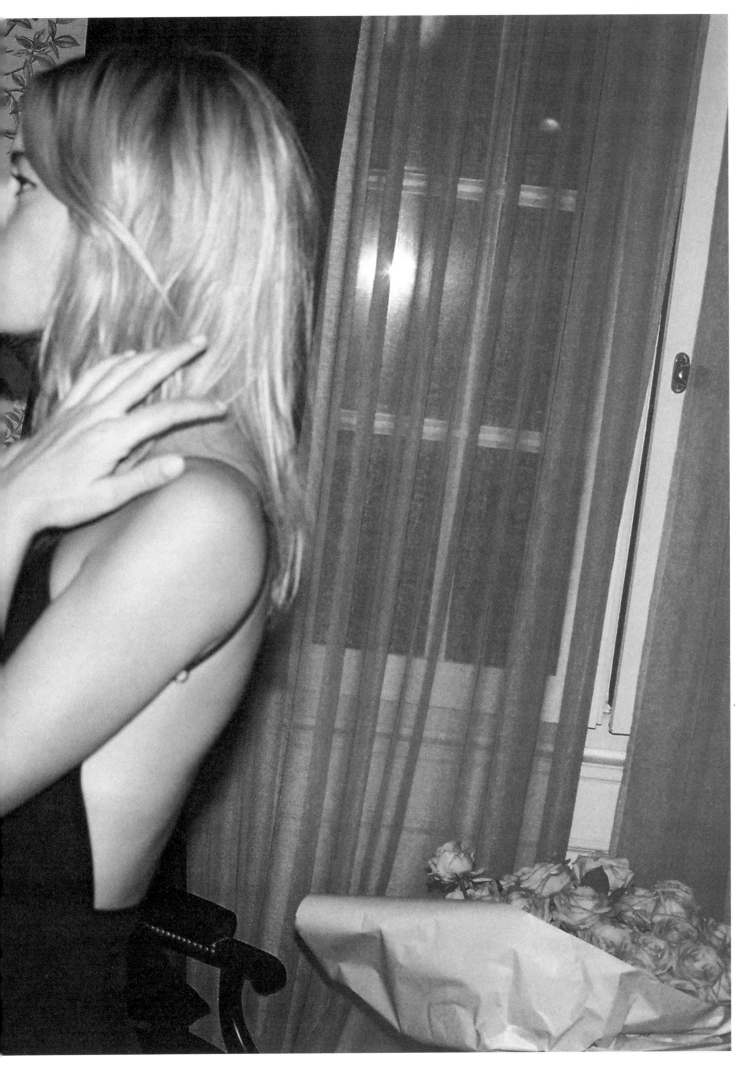

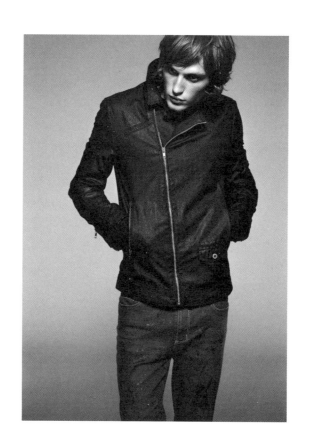

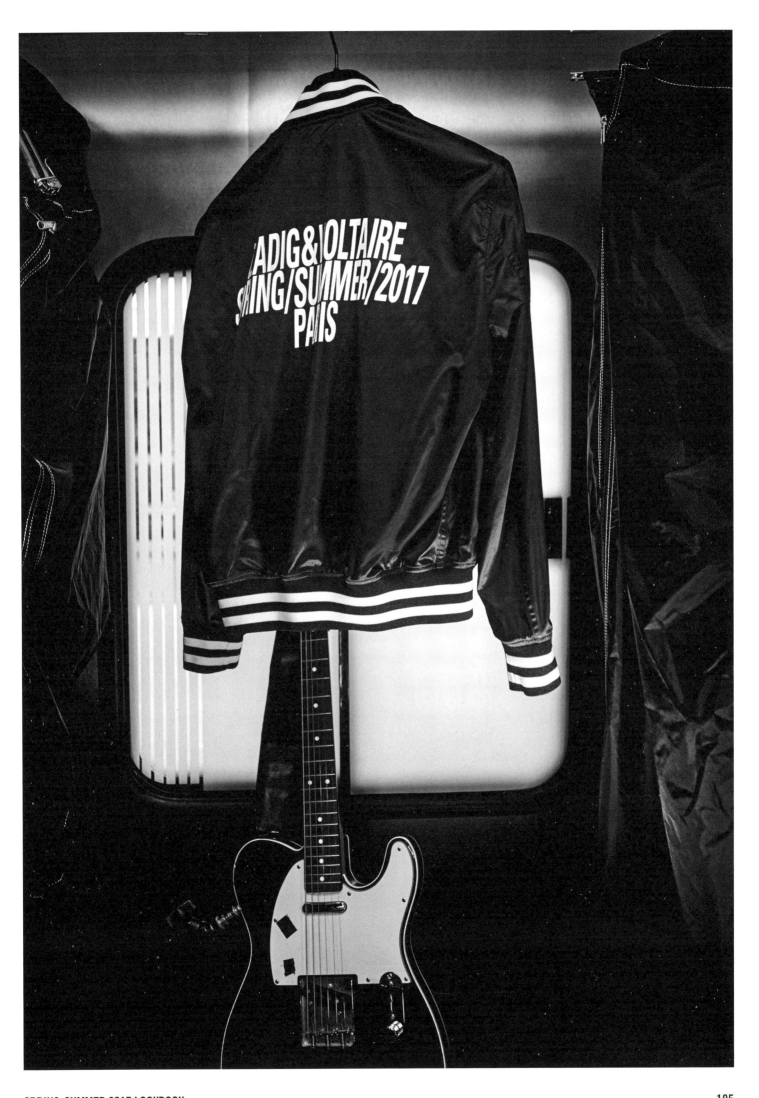

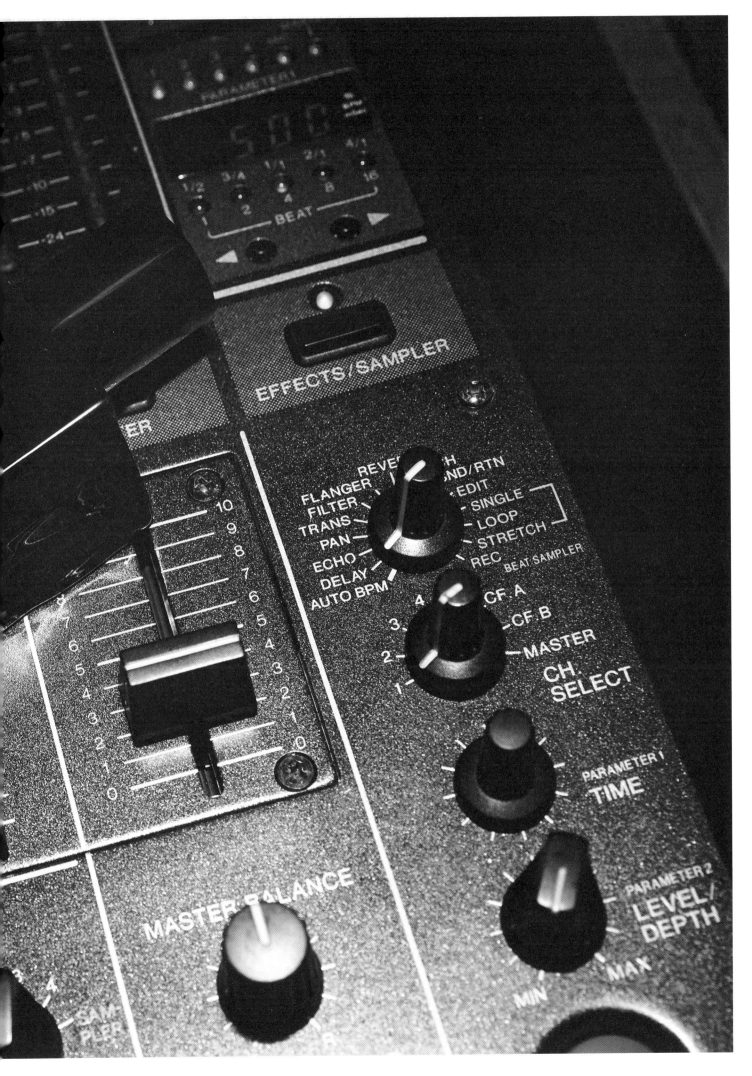

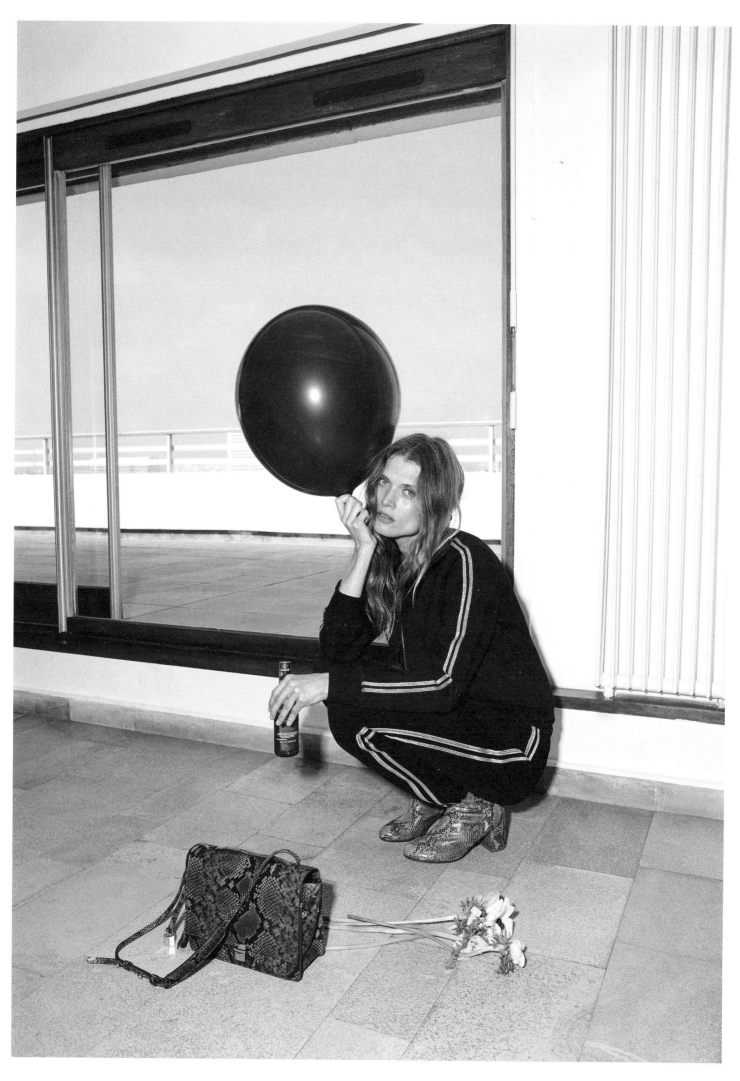

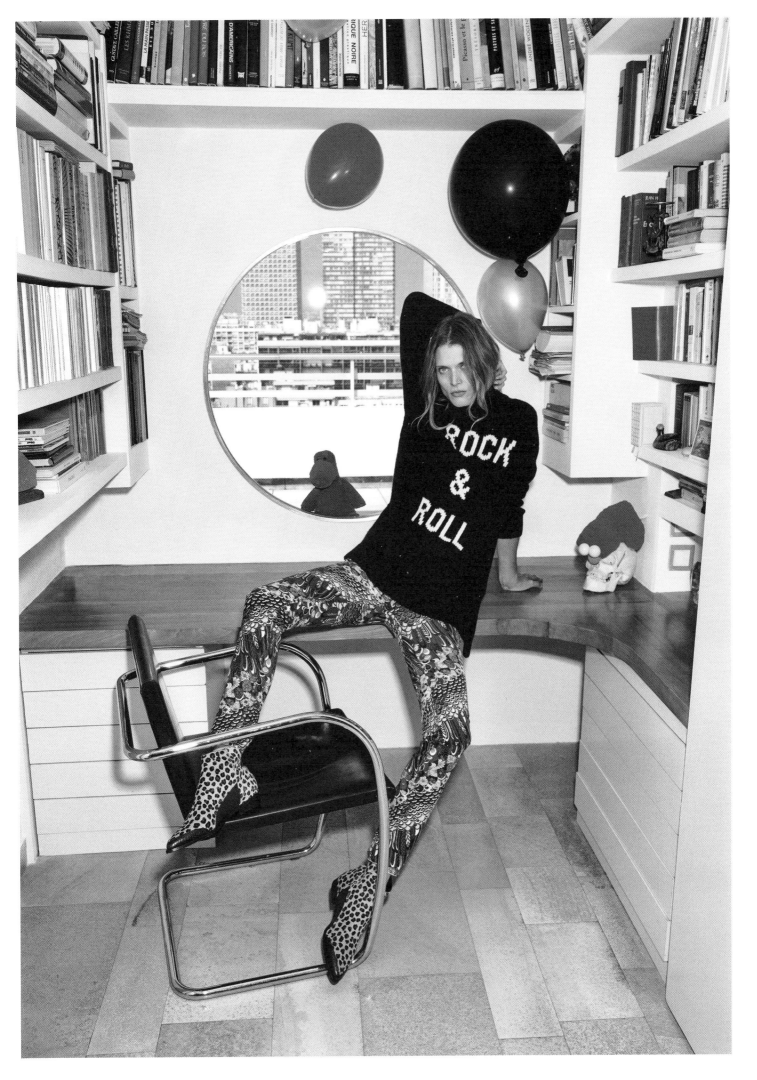

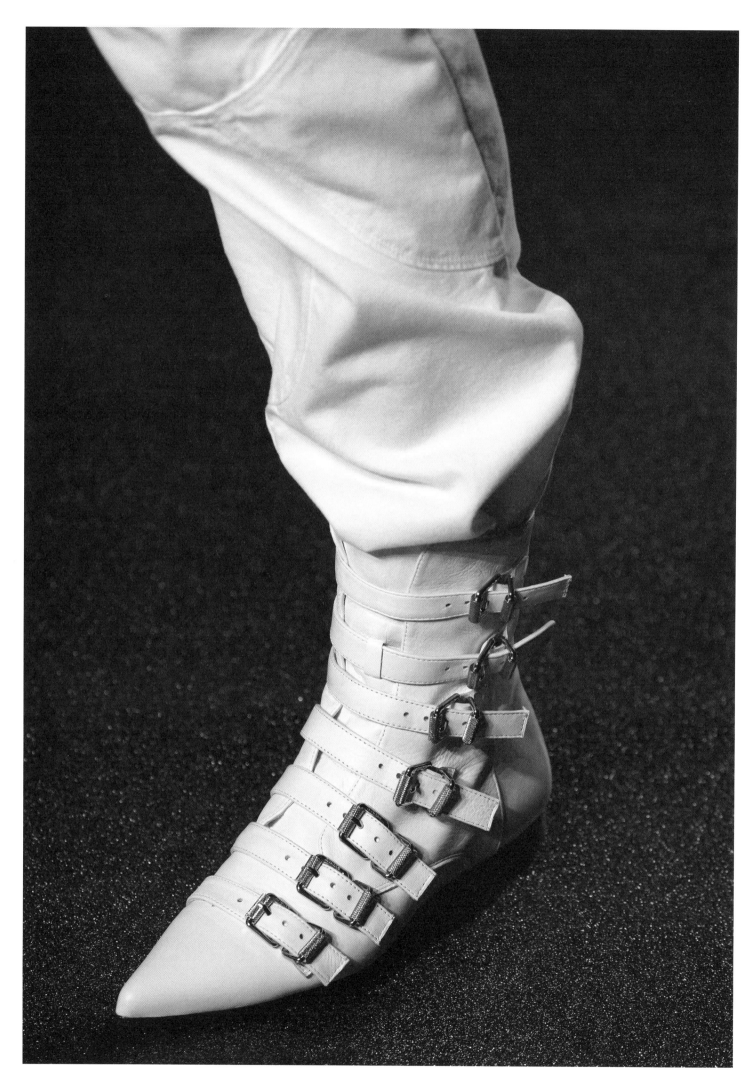

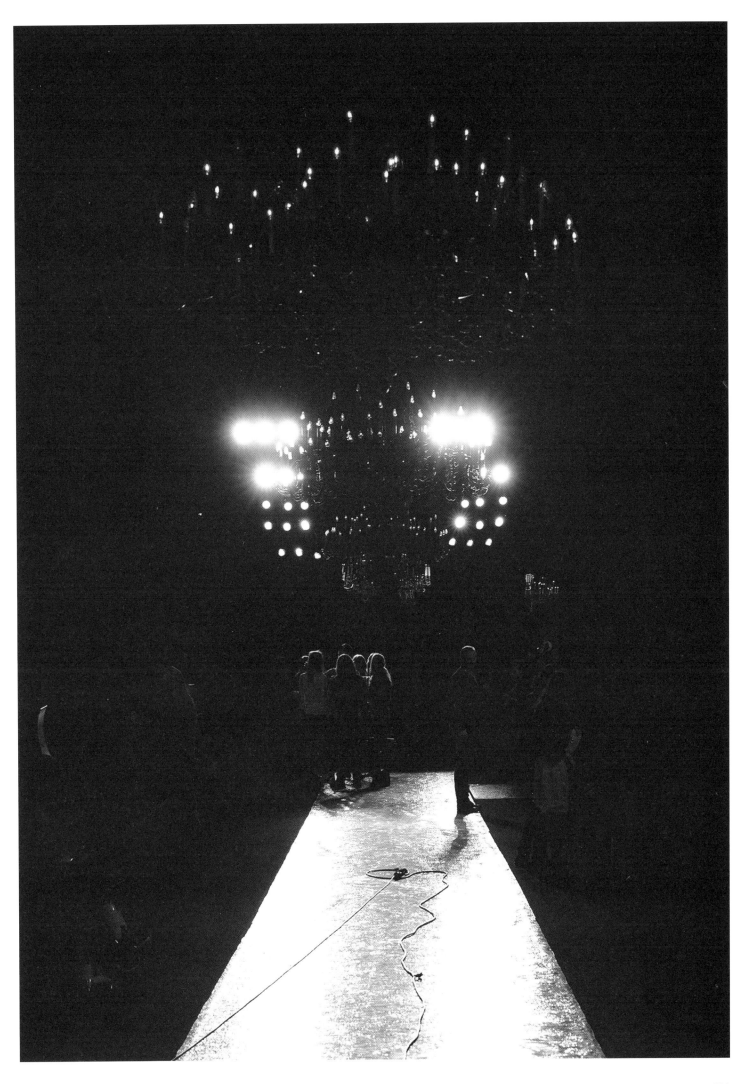

FALL-WINTER 2013 SHOW, PARIS

 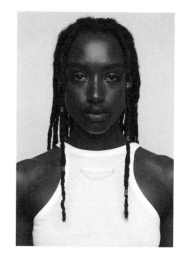
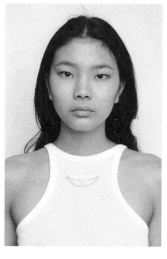 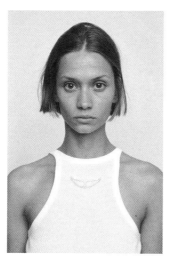 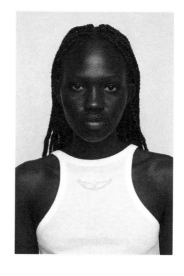 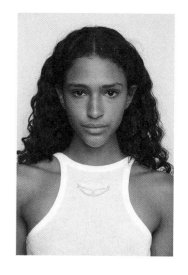
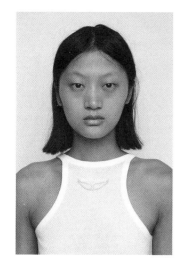 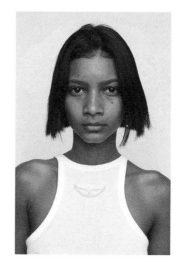 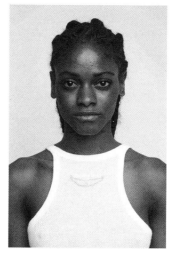 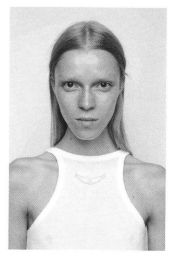
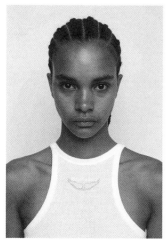 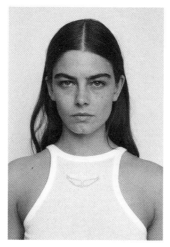 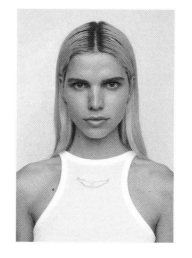 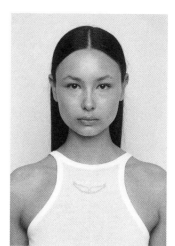

192 CASTING, FALL-WINTER 2022 SHOW, PARIS

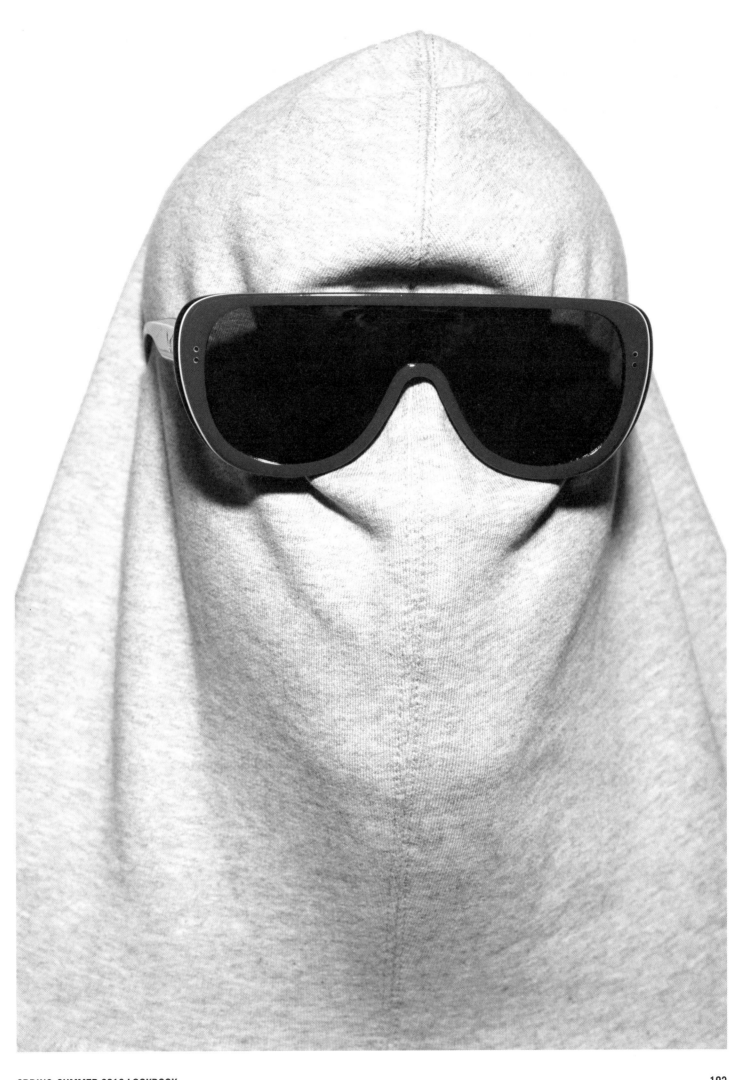

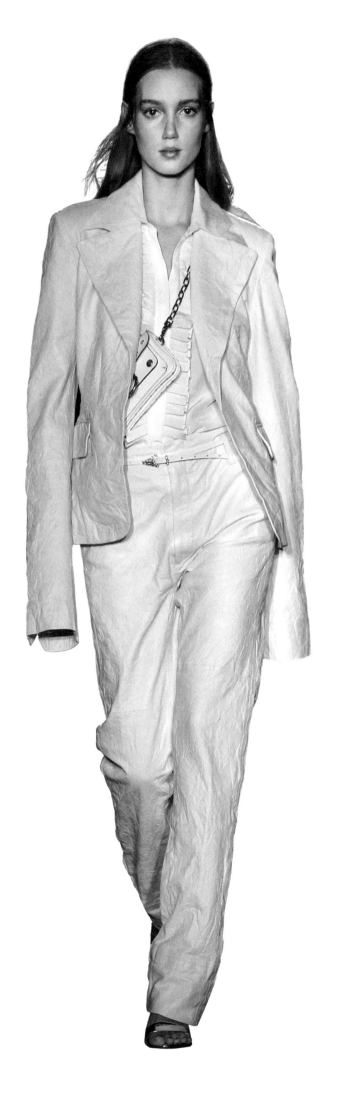

194 SPRING-SUMMER 2020 SHOW, PARIS

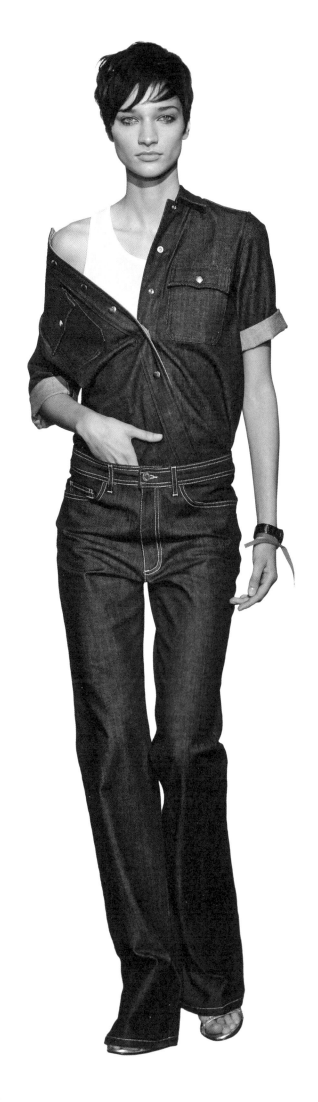

SPRING-SUMMER 2018 SHOW, NEW YORK

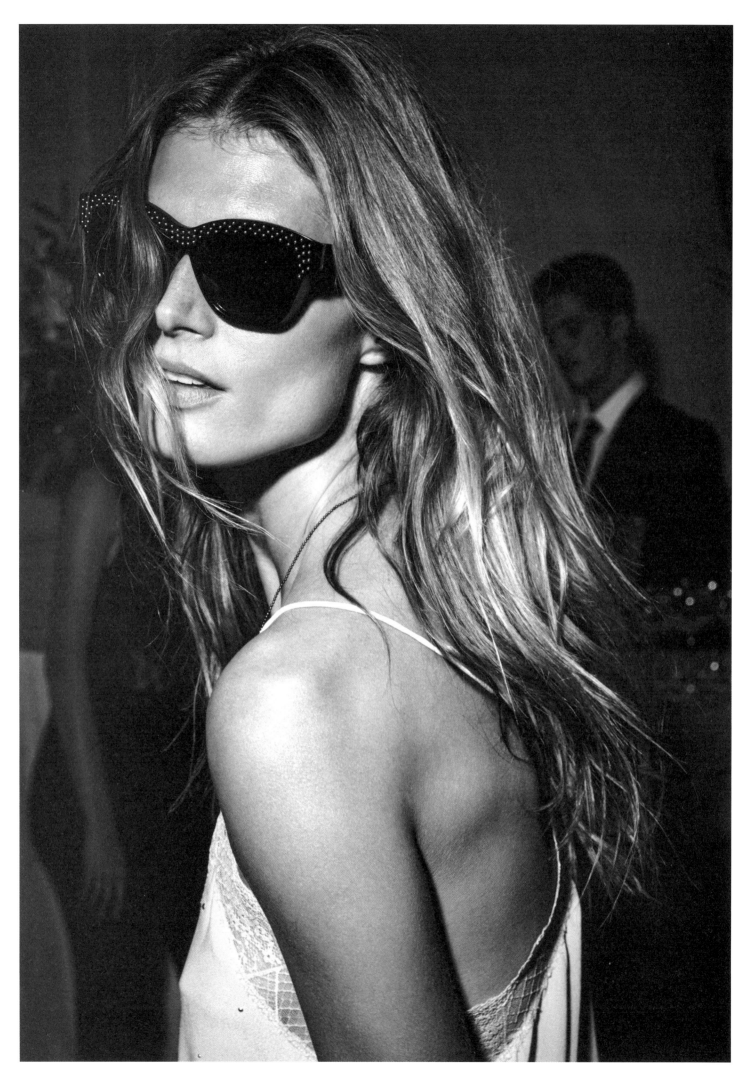

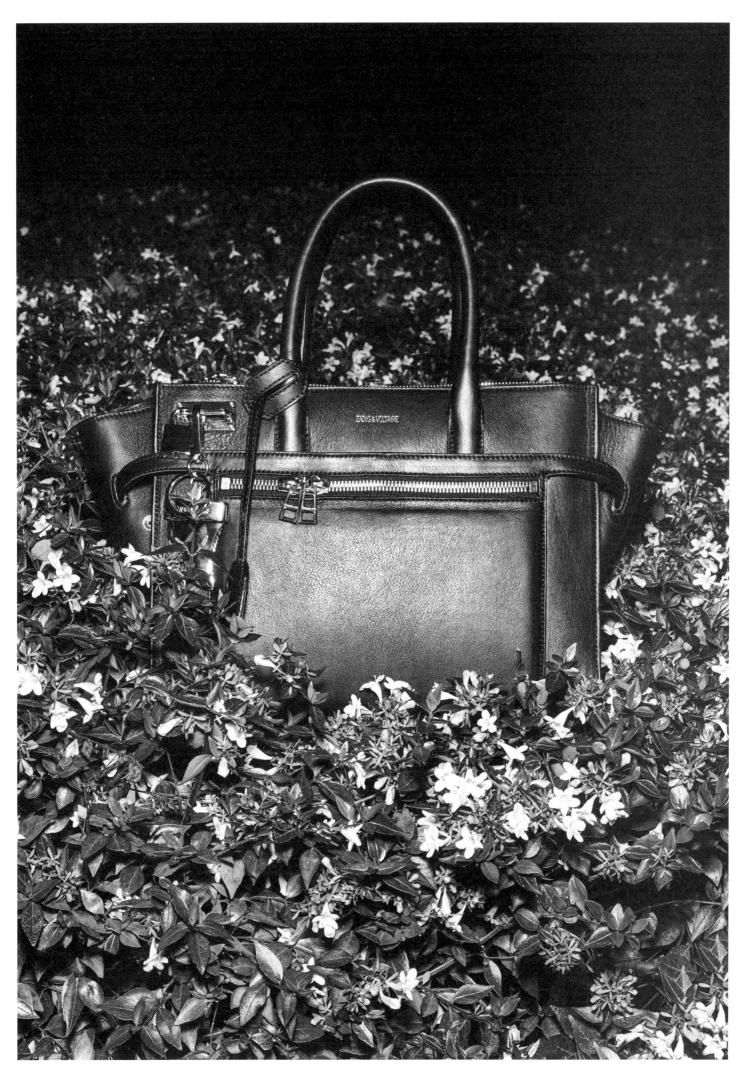

CANDIDE HANDBAG, SPRING-SUMMER 2016 AD CAMPAIGN

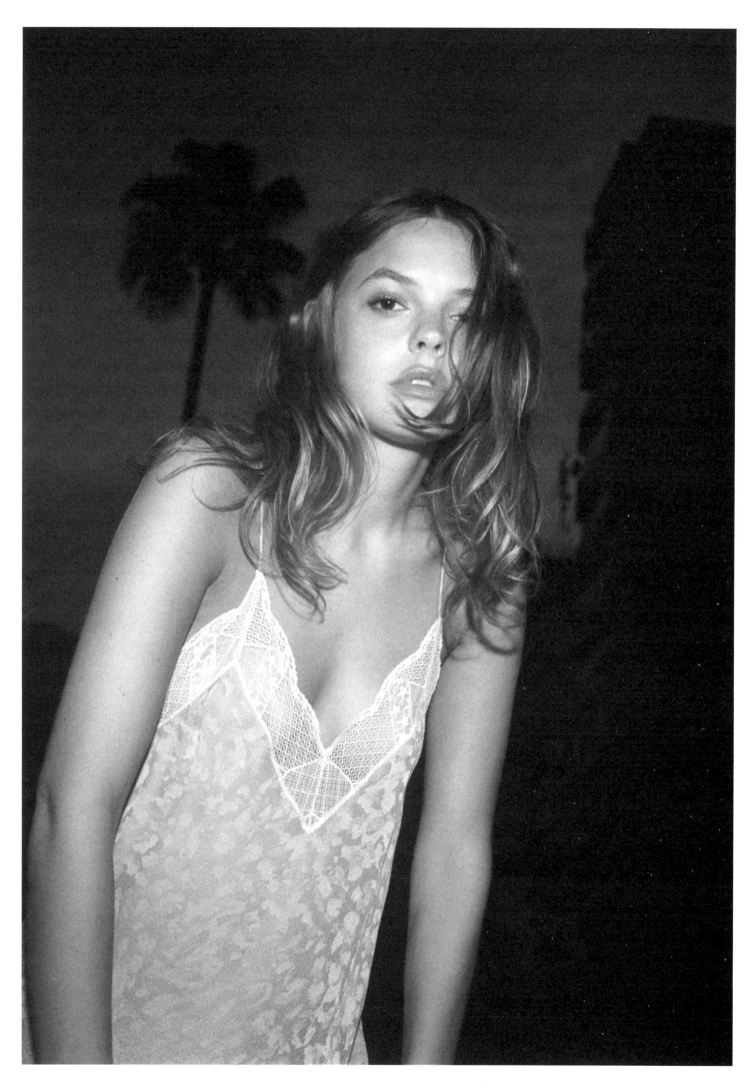

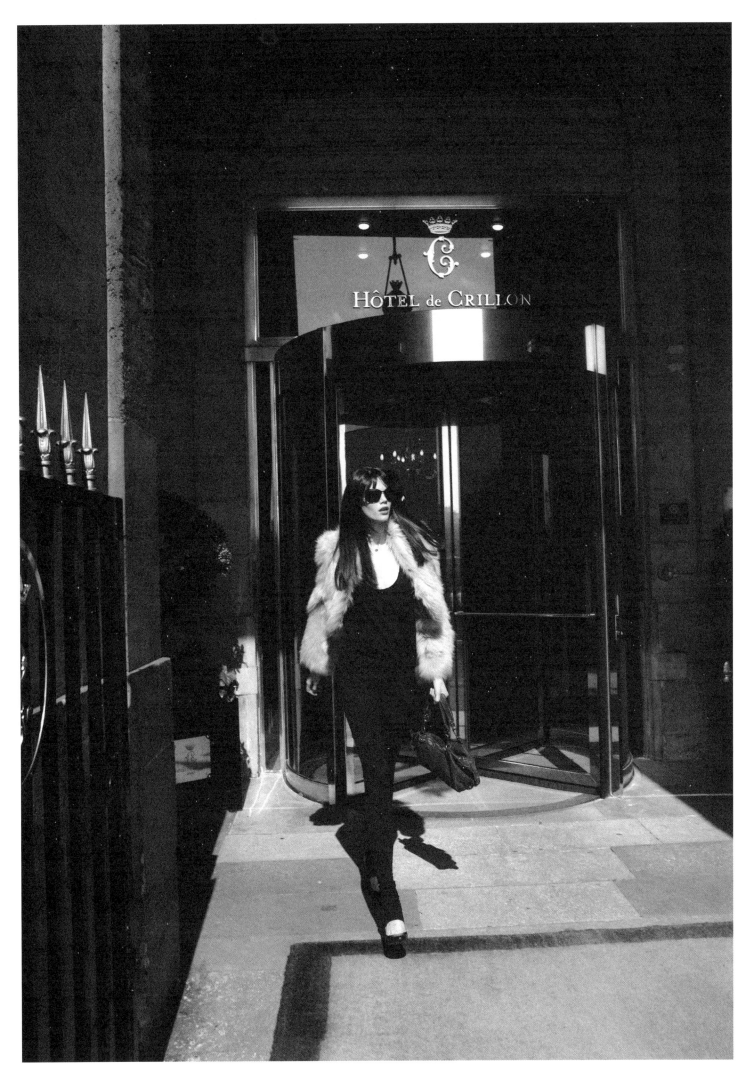

FALL-WINTER 2007 AD CAMPAIGN

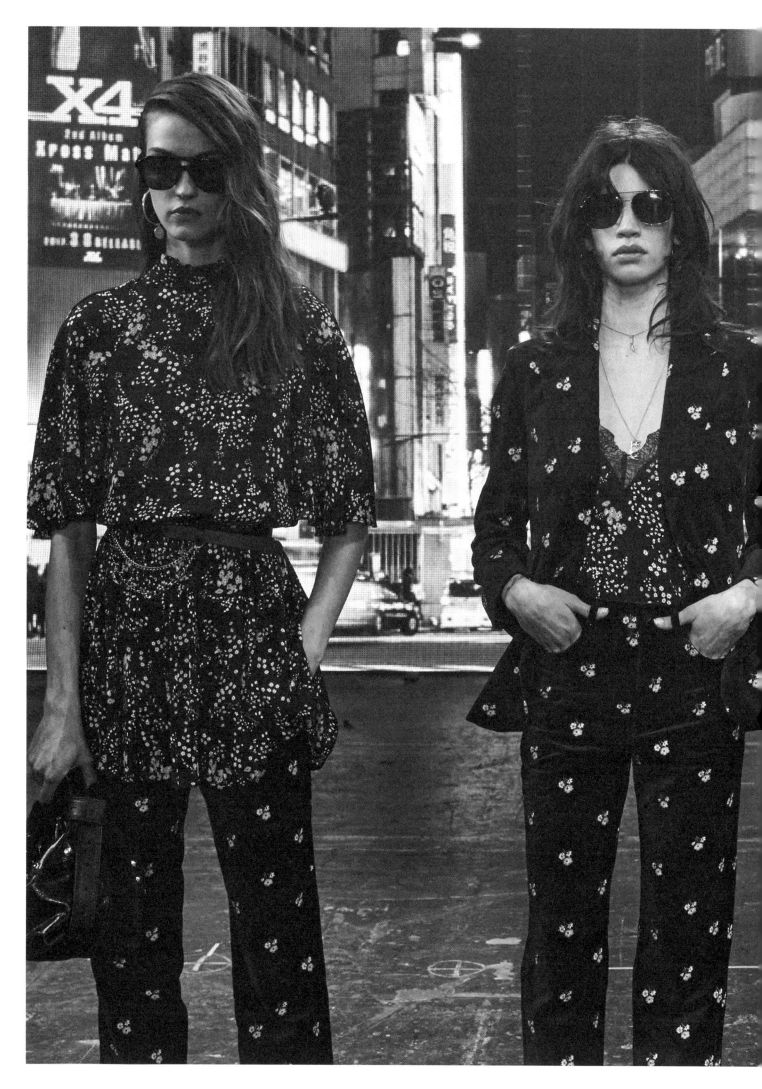

FALL-WINTER 2021 SHOW, PARIS

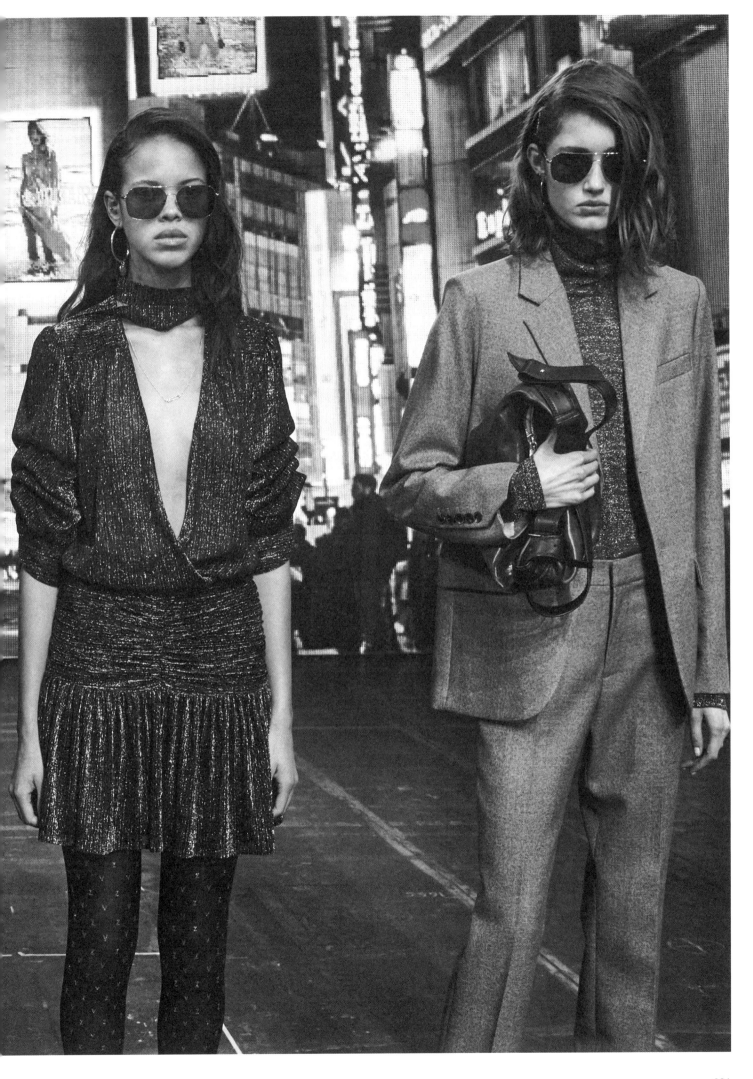

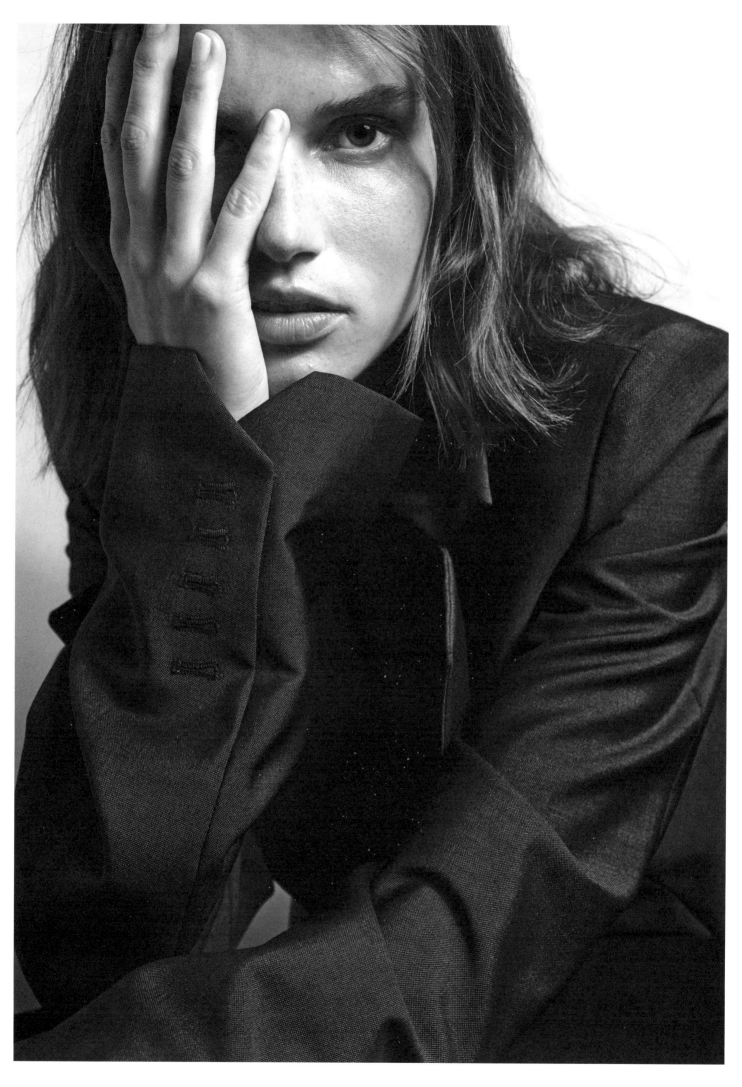

202 CASTING, SPRING-SUMMER 2020 SHOW, PARIS

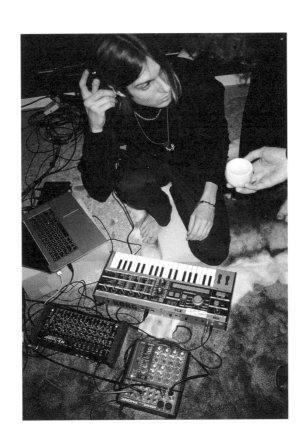

PARTY AT LE GRAND VÉFOUR, PARIS, 2011

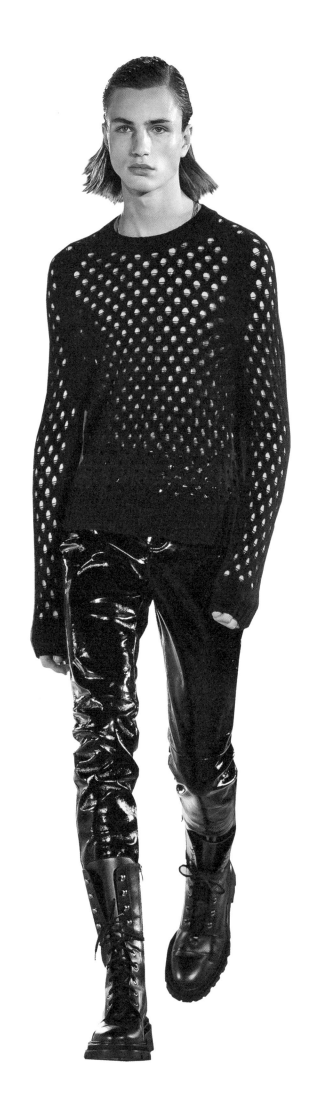

204 FALL-WINTER 2023 SHOW, PARIS

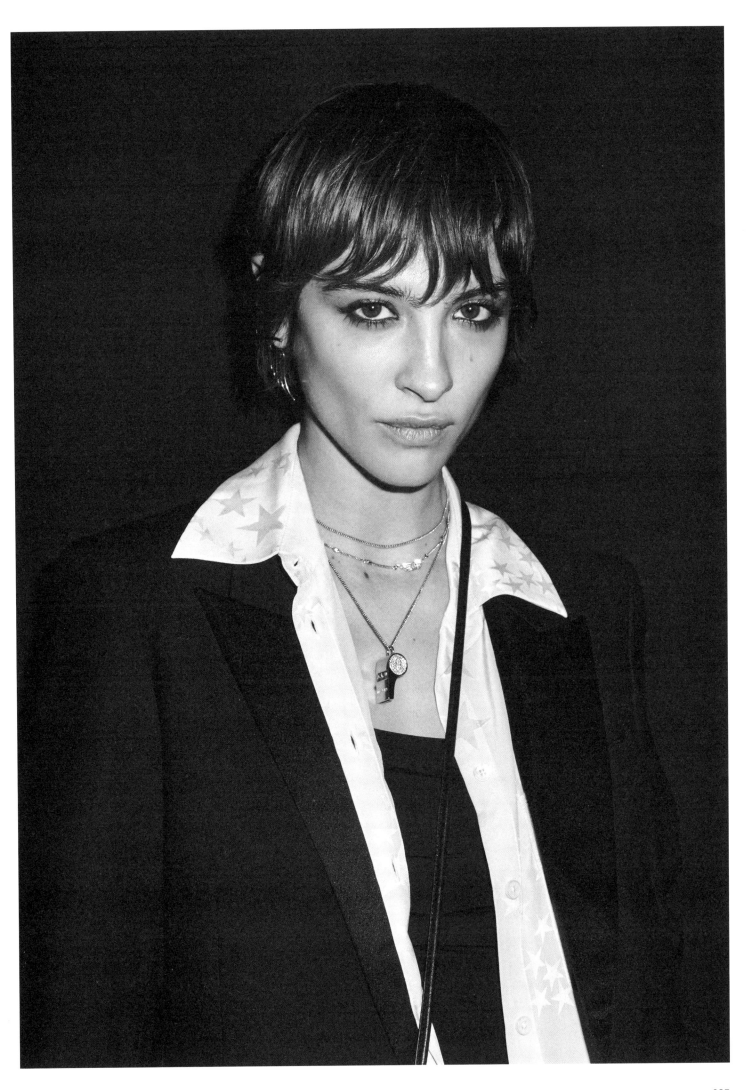

AFTER-PARTY, FALL-WINTER 2023 SHOW, PARIS

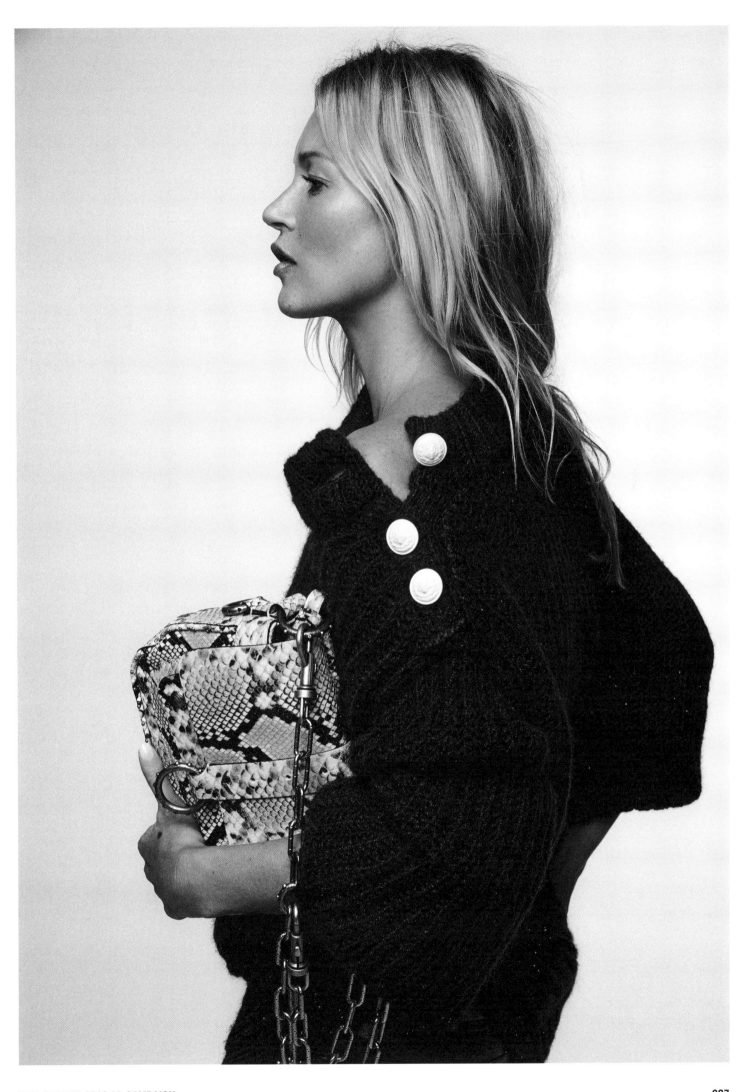

FALL-WINTER 2019 AD CAMPAIGN

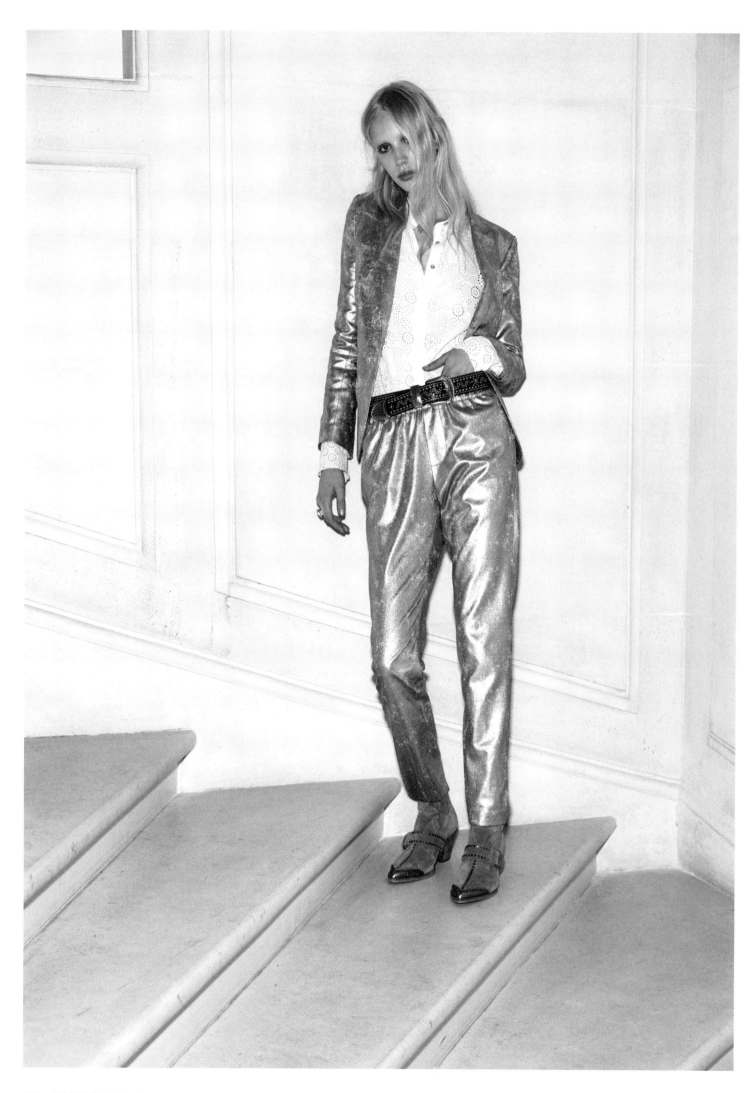

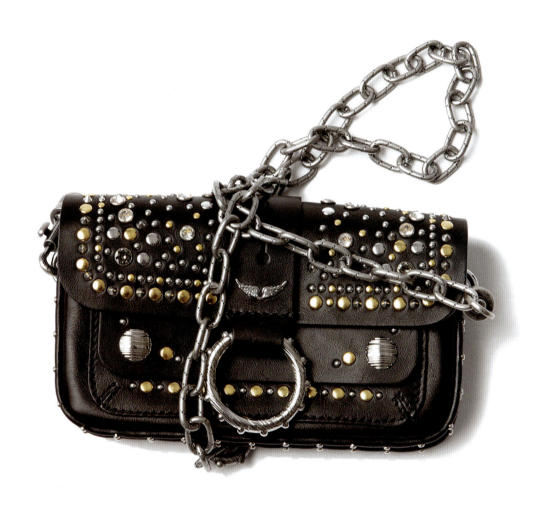

KATE WALLET BAG, SPRING-SUMMER 2023

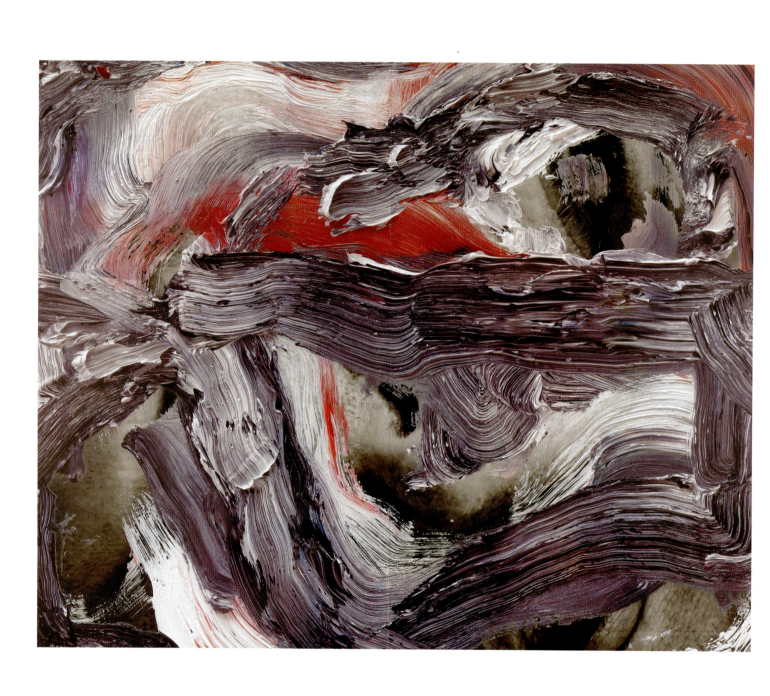

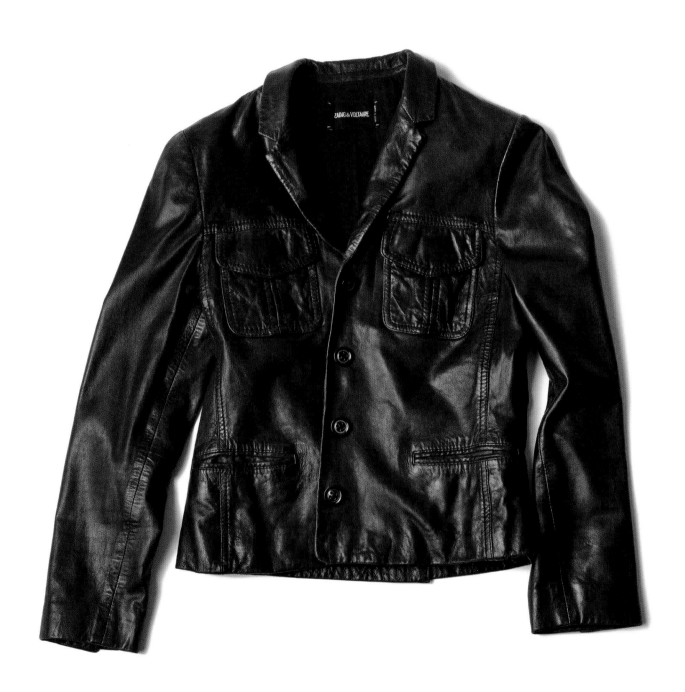

LIAM JACKET, ICONIC PIECE

212 STEVEN PARRINO, *SILVER SURFER*, 1987

ROZO DRESS, SPRING-SUMMER 2023

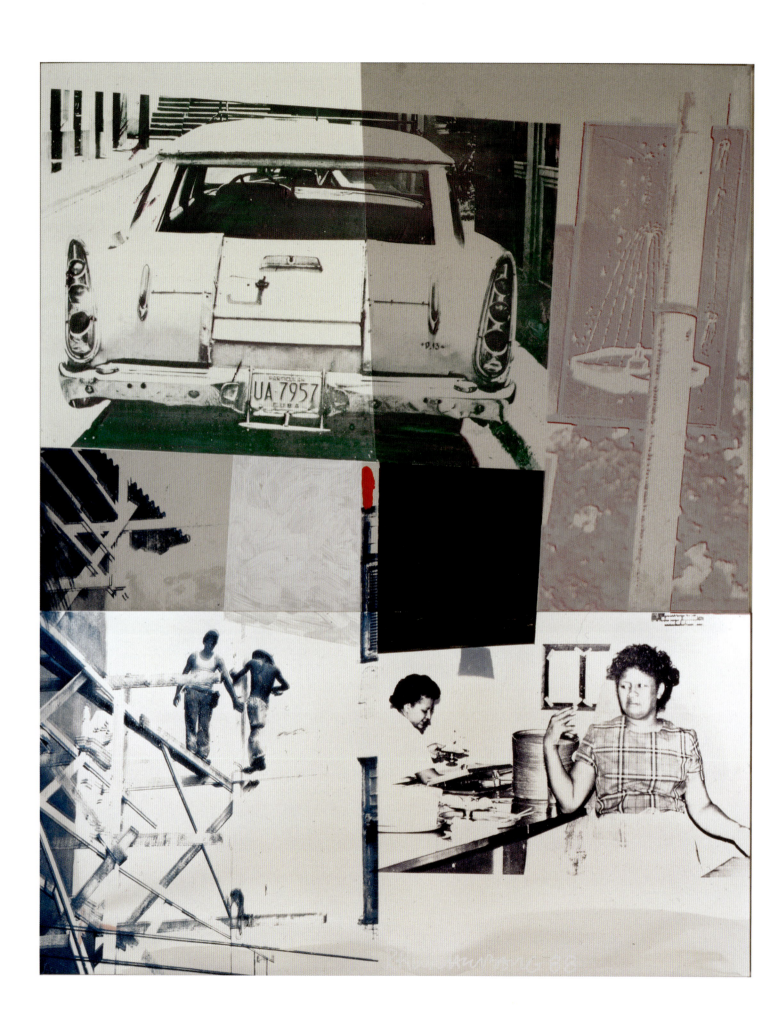

214 ROBERT RAUSCHENBERG, *NOON QUILT (COLCHA DE MEDIODIA) / ROCI CUBA*, 1988

KIOKI DENIM JACKET, ICONIC PIECE

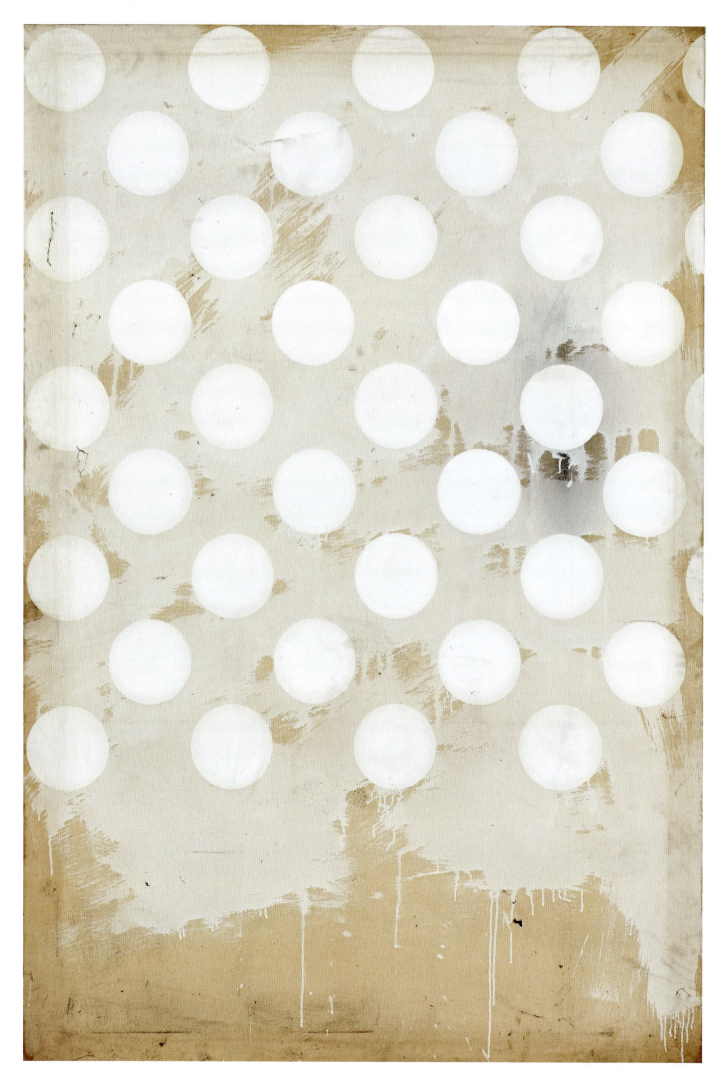

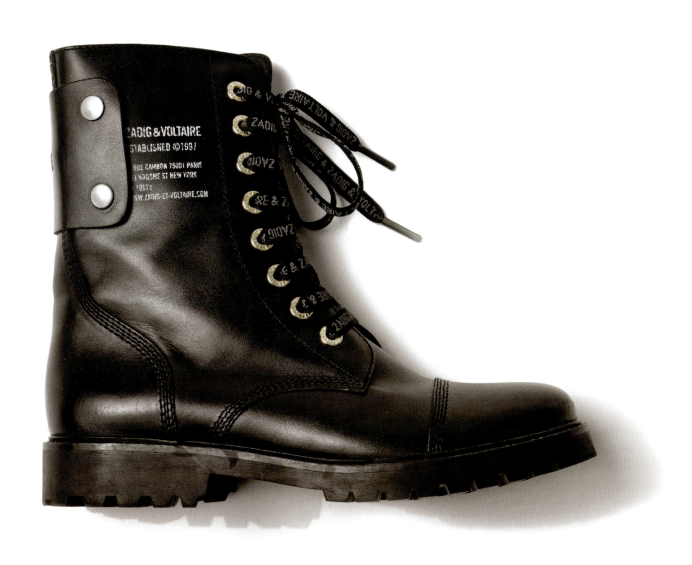

JOE BOOTS, ICONIC PIECE

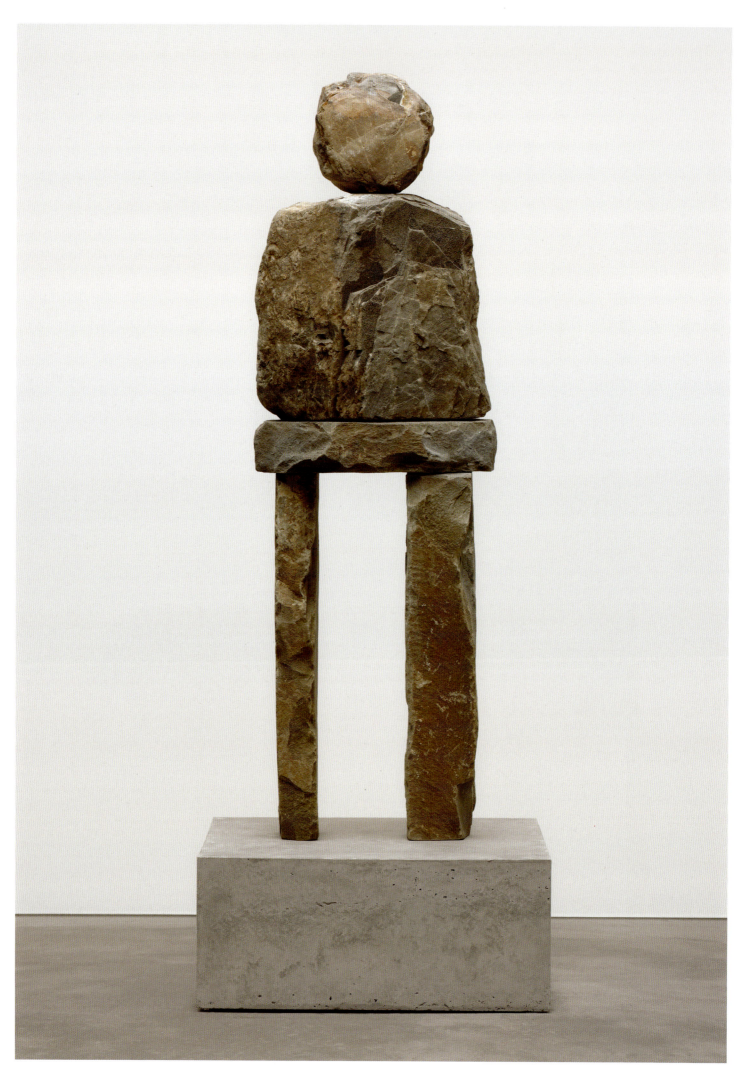

218 UGO RONDINONE, *THE SPRY*, 2021

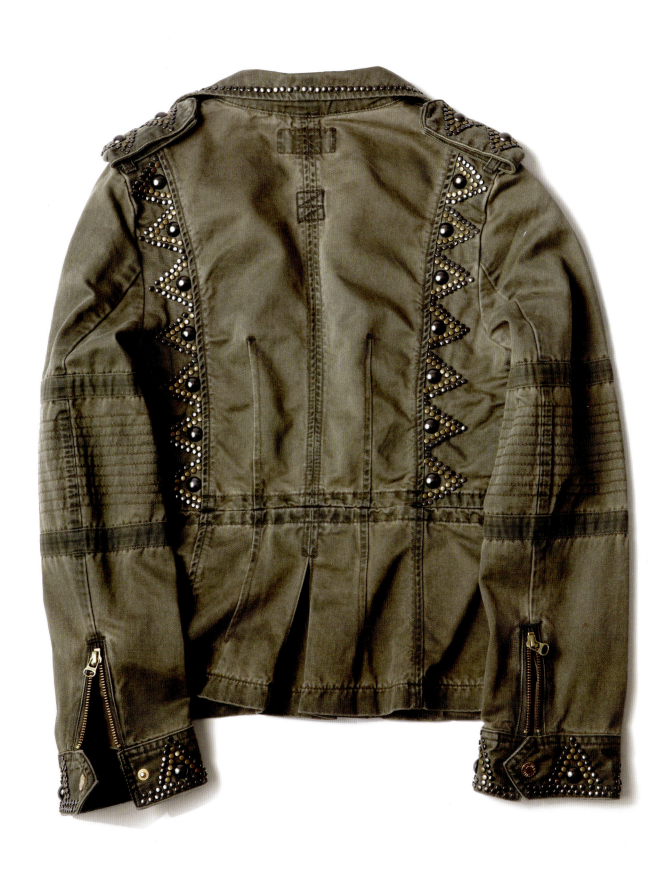

CECILIA'S JACKET, ICONIC PIECE

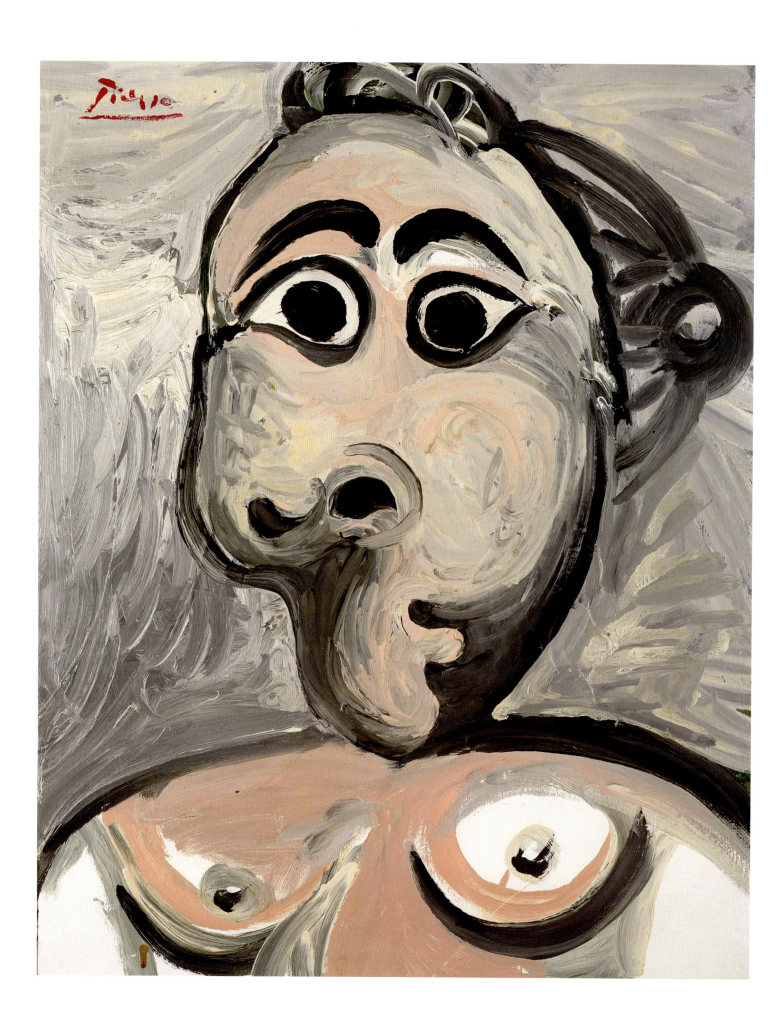

220 PABLO PICASSO, *BUSTE DE FEMME*, 1970

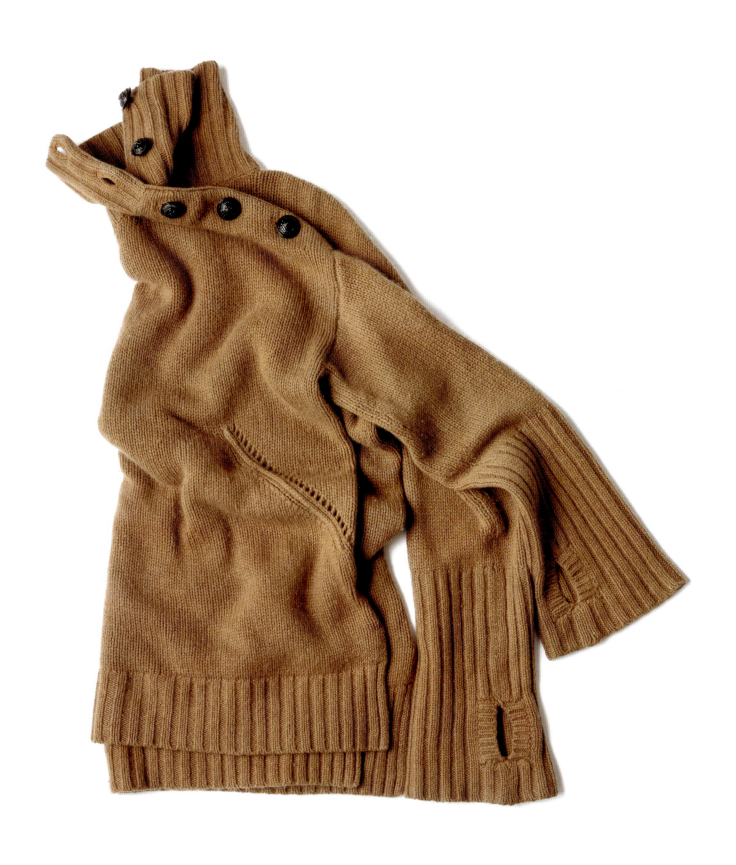

ALMA SWEATER, FALL-WINTER 2021

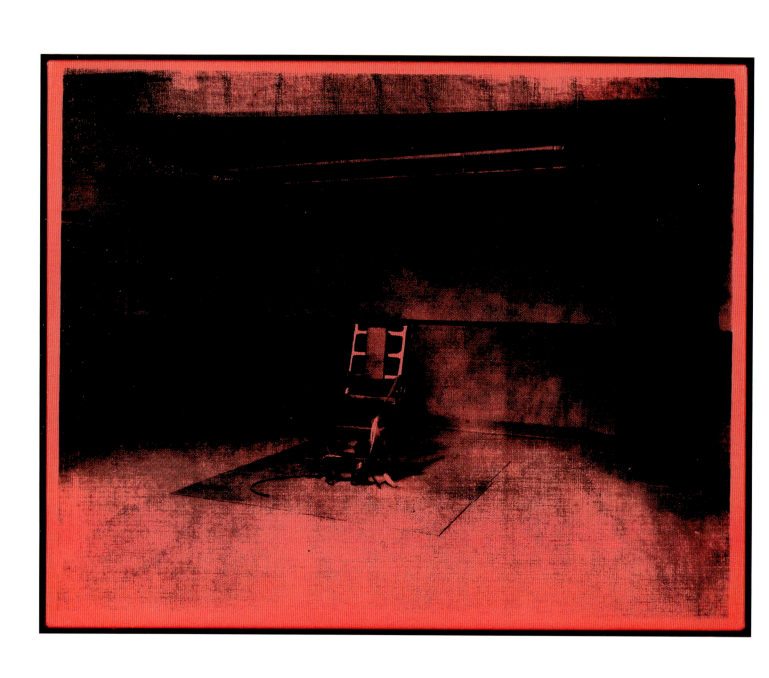

222 ANDY WARHOL, *LITTLE ELECTRIC CHAIR*, 1964

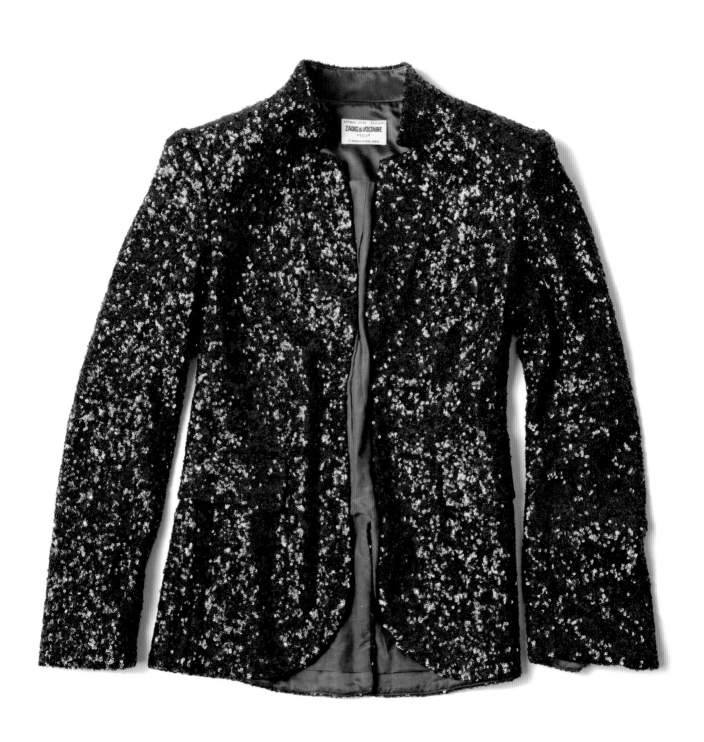

VERY SEQUINS JACKET, FALL-WINTER 2022

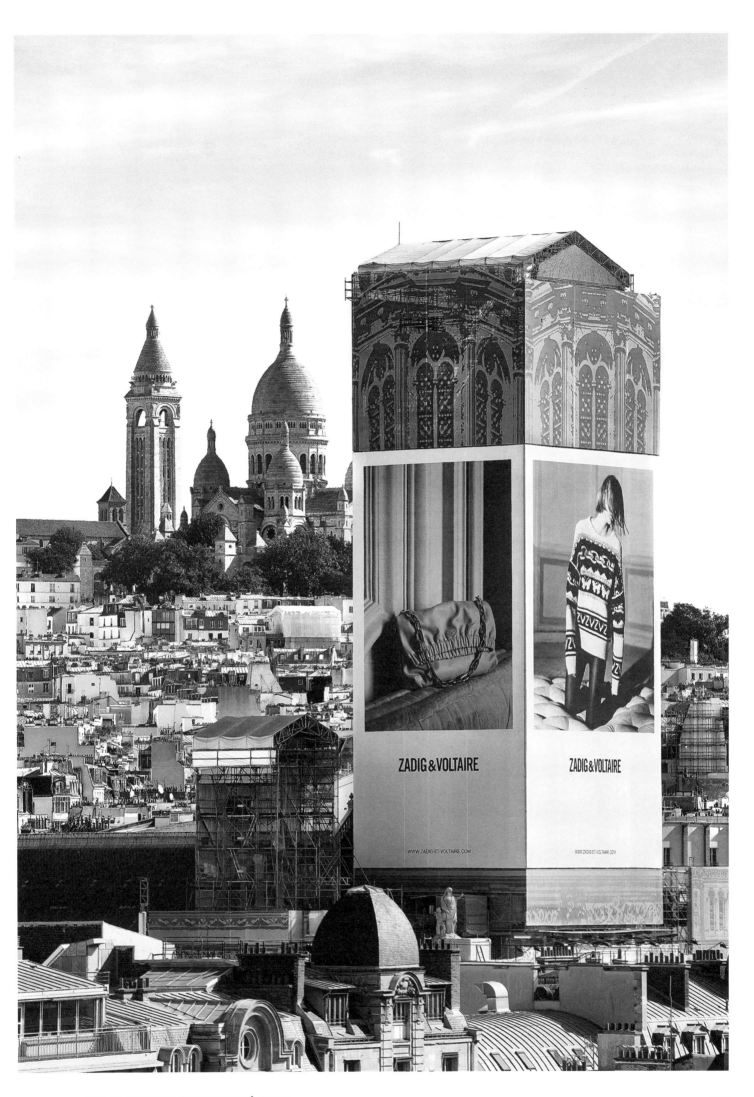

FALL-WINTER 2022 AD CAMPAIGN, SAINTE-TRINITÉ, PARIS

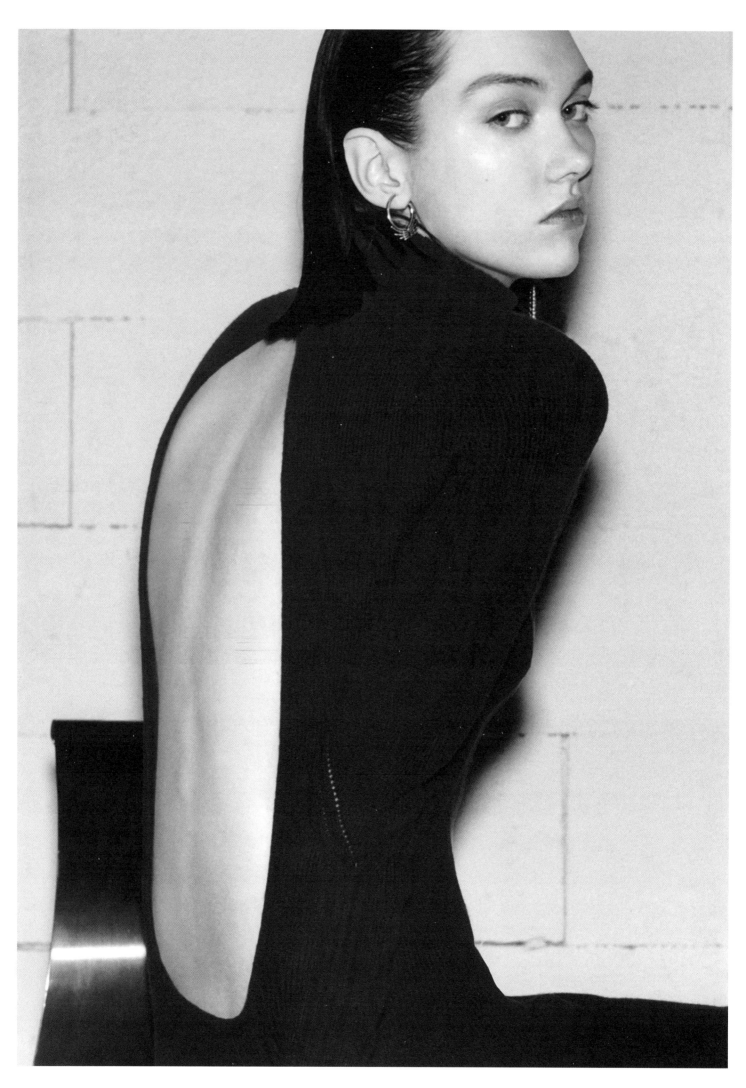

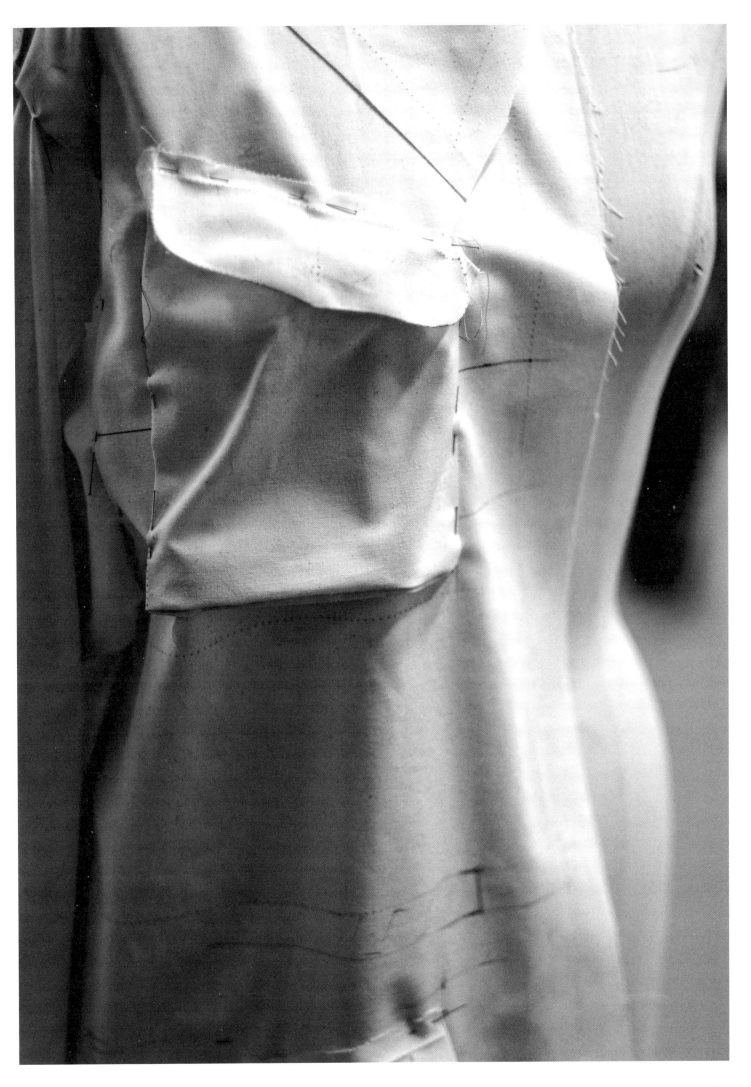

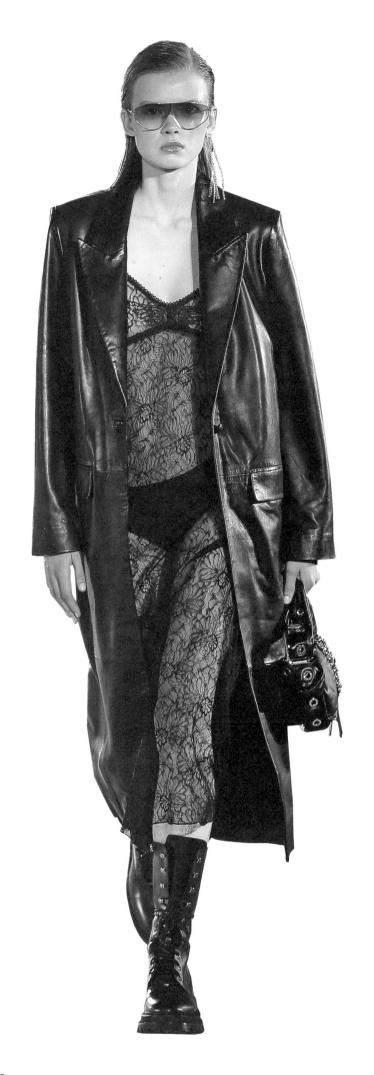

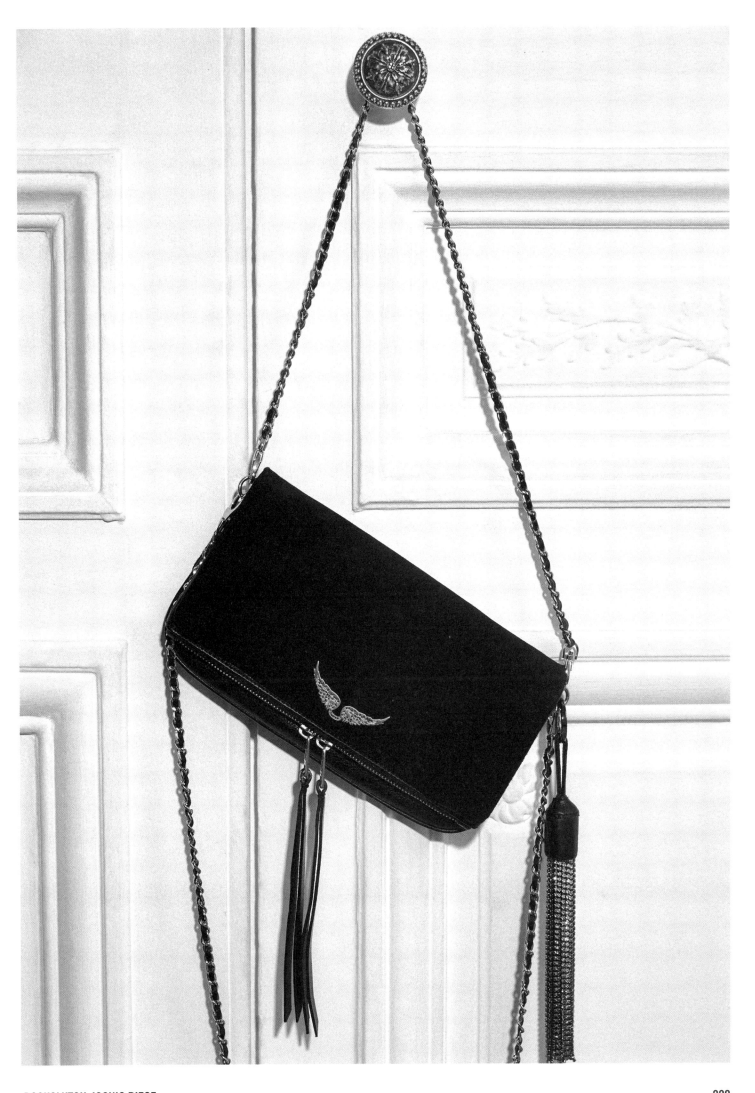

ROCK CLUTCH, ICONIC PIECE

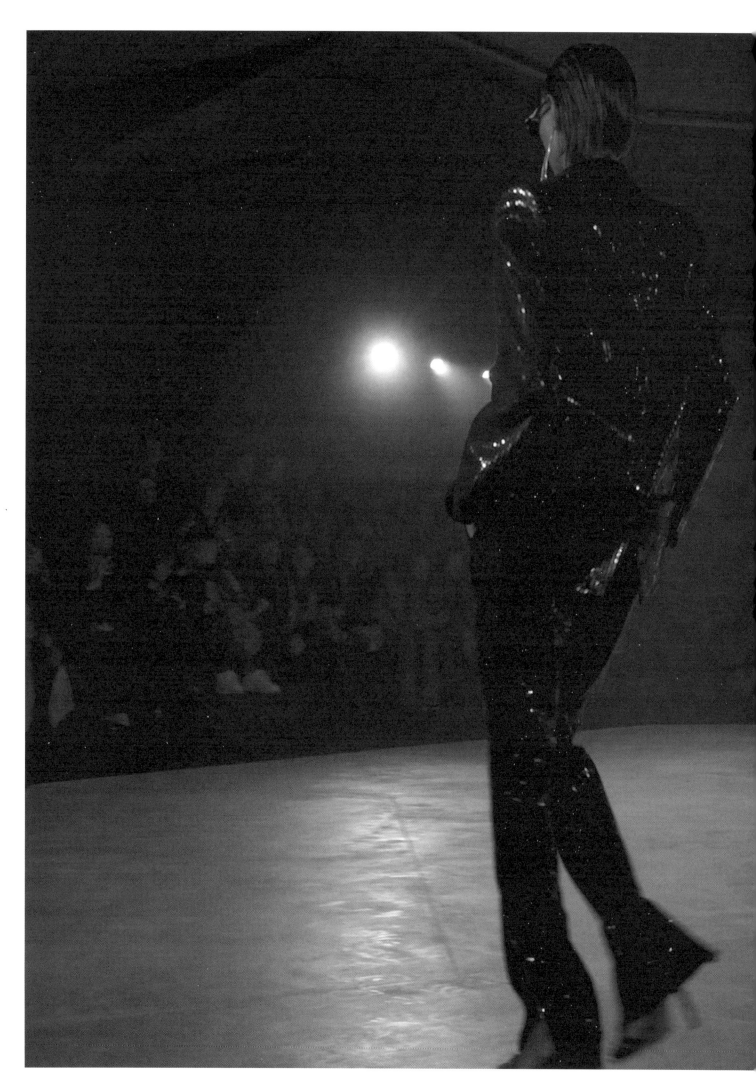

230 FALL-WINTER 2023 SHOW, PARIS

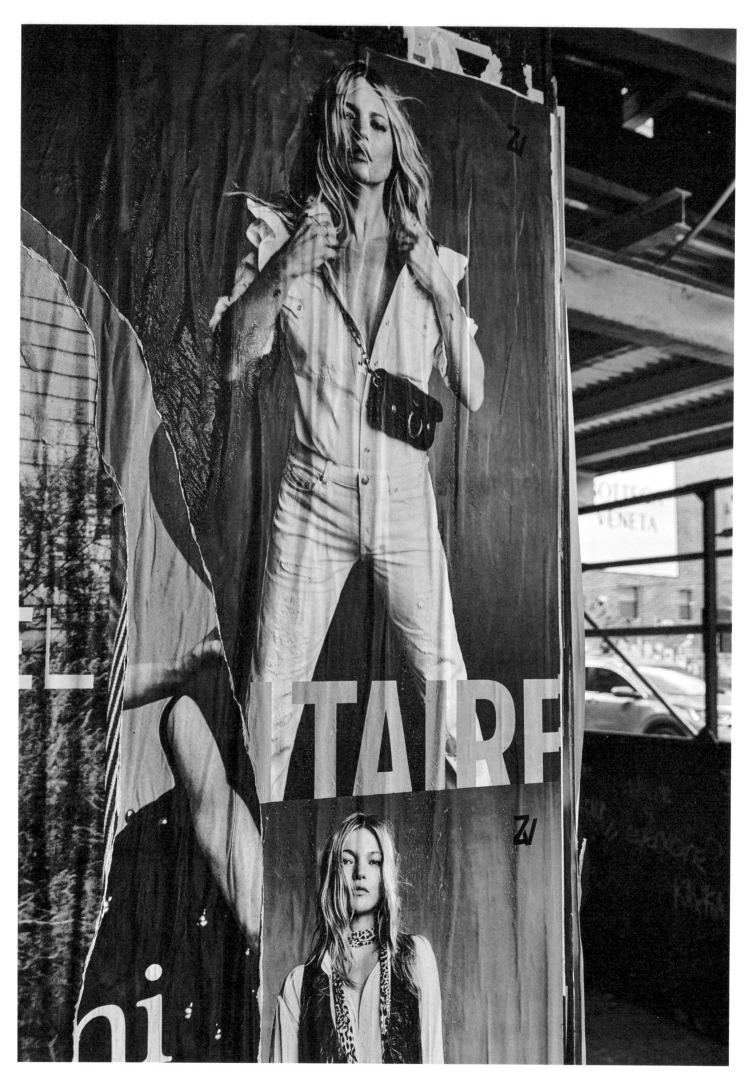

232 SPRING-SUMMER 2020 AD CAMPAIGN, NEW YORK

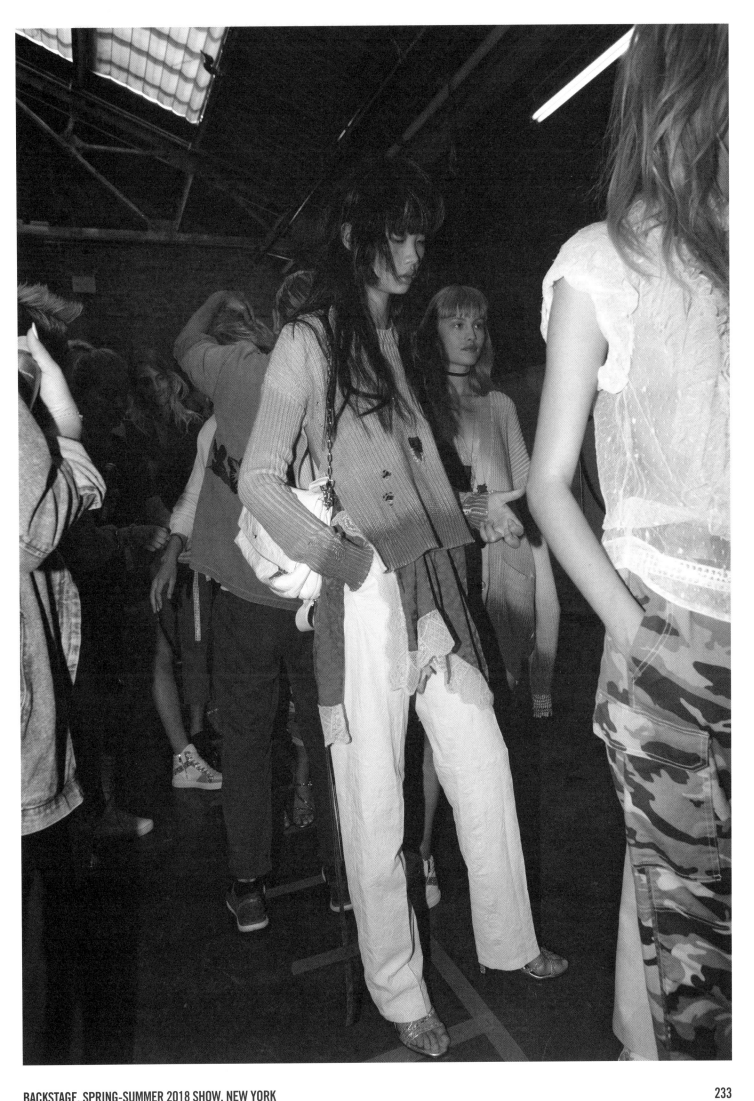

BACKSTAGE, SPRING-SUMMER 2018 SHOW, NEW YORK

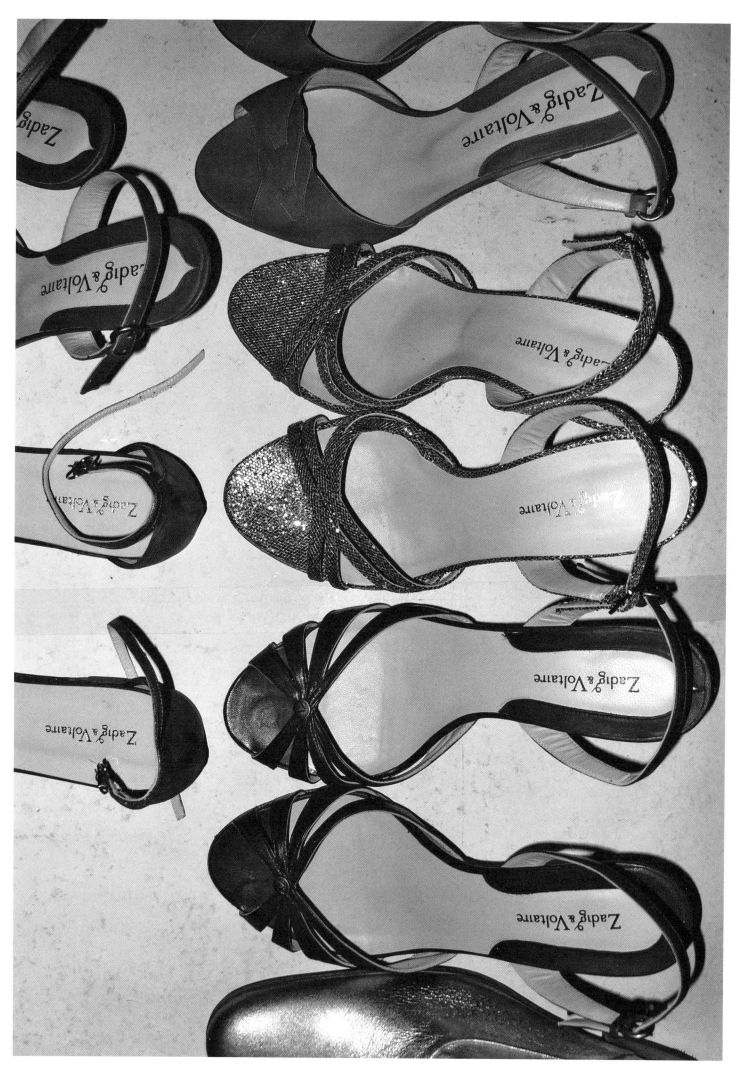

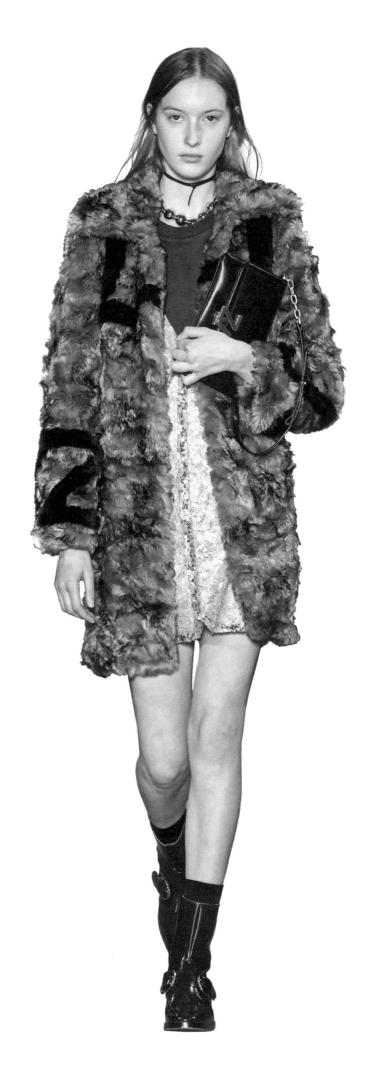

FALL-WINTER 2020 SHOW, NEW YORK

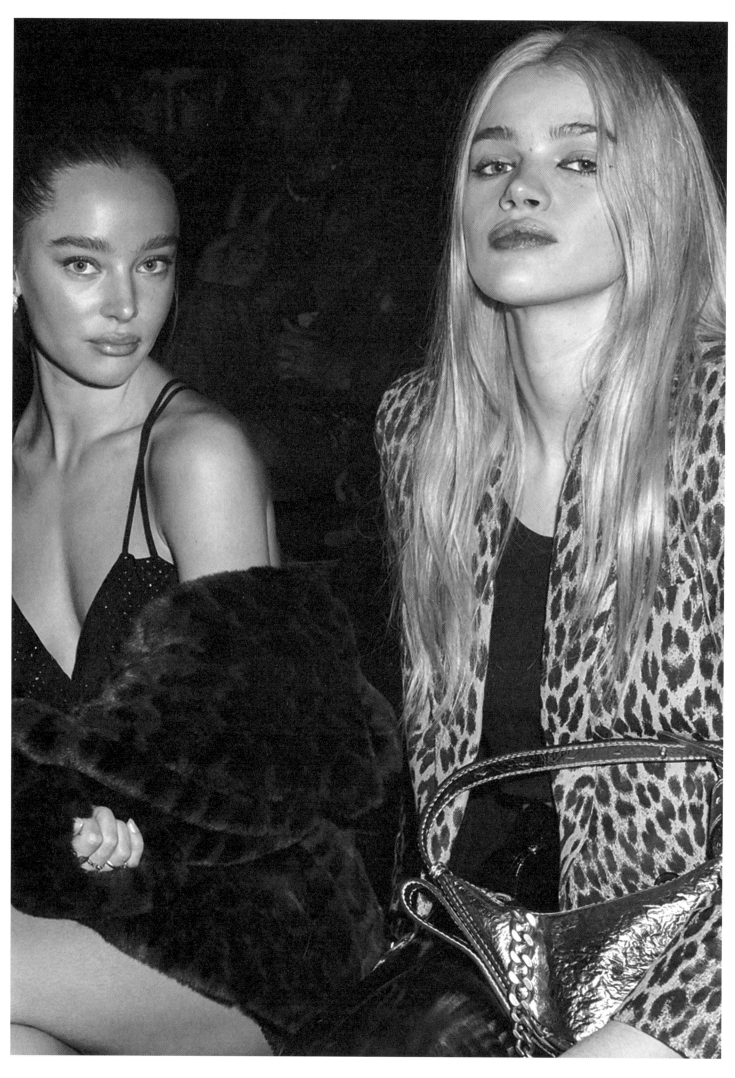

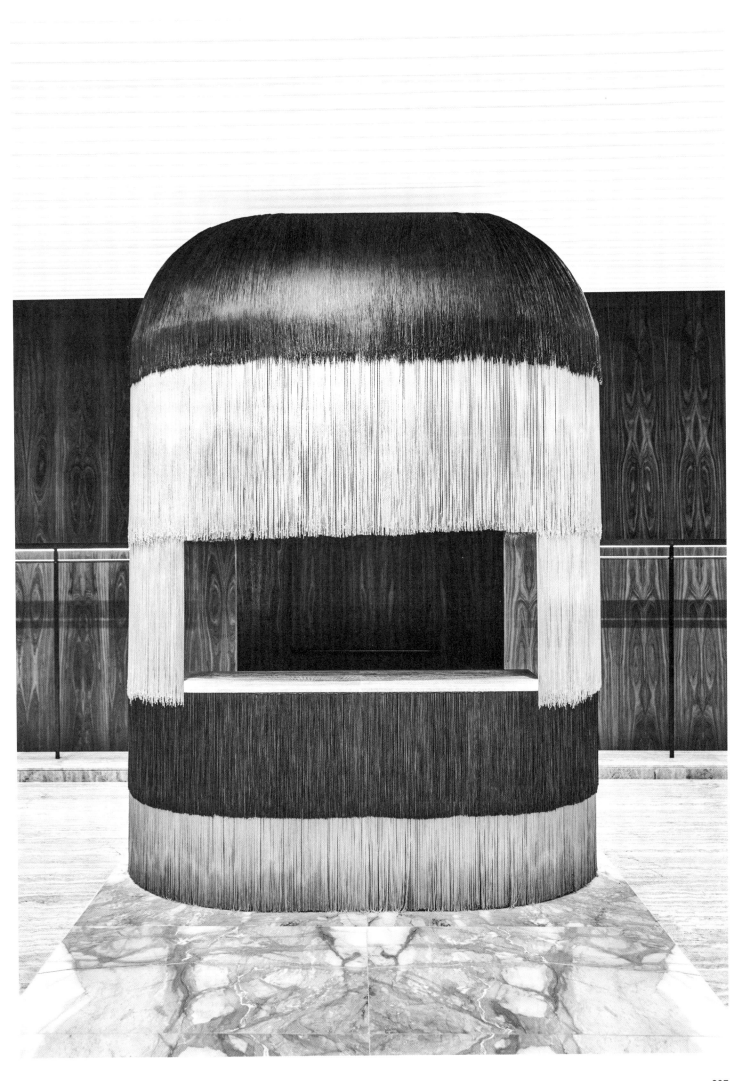

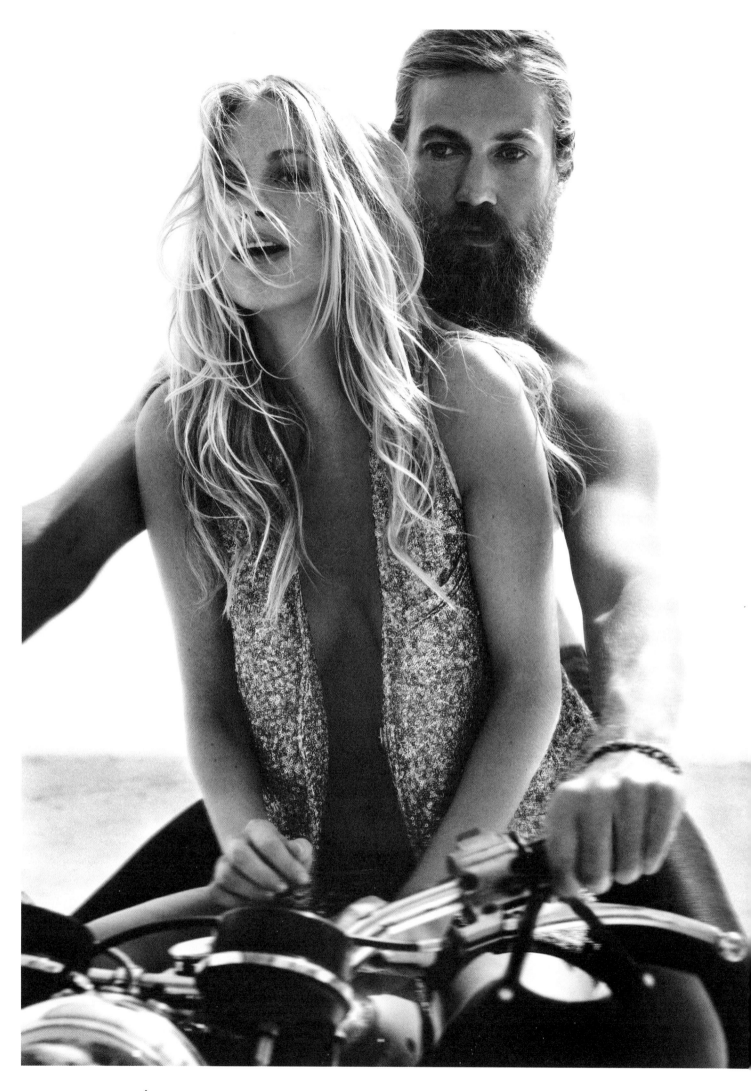

240 AFTER-PARTY, SPRING-SUMMER 2020 SHOW, RITZ, PARIS

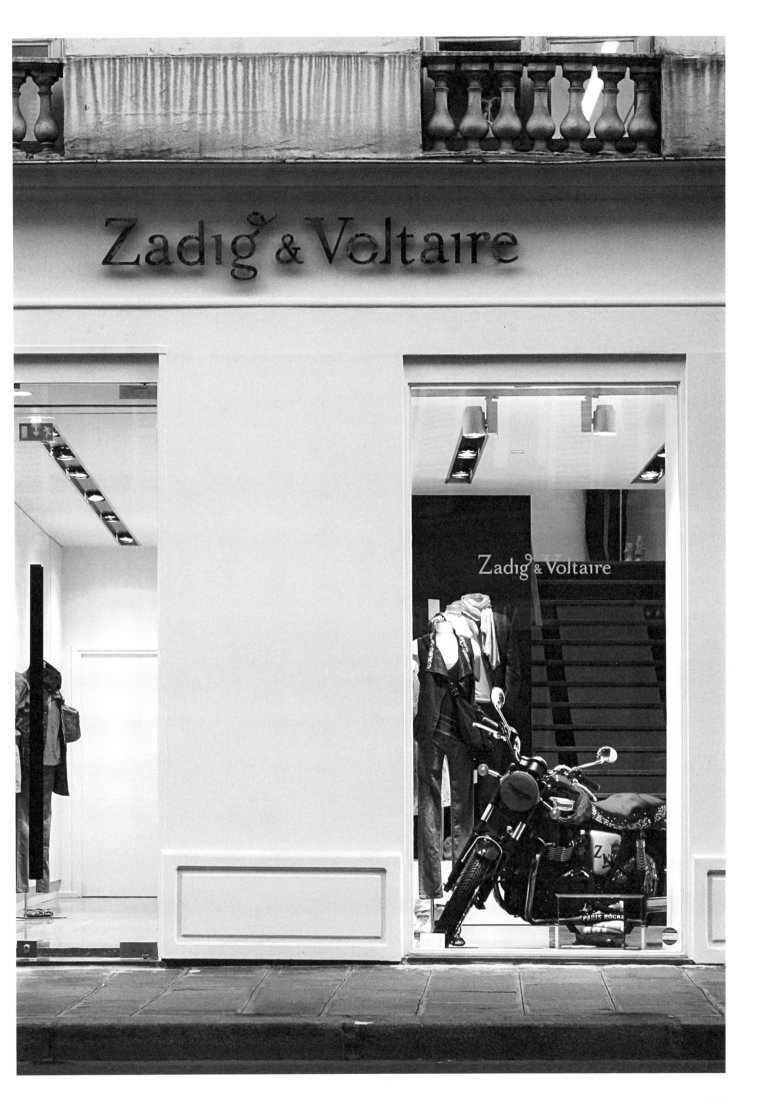

STORE, PARIS

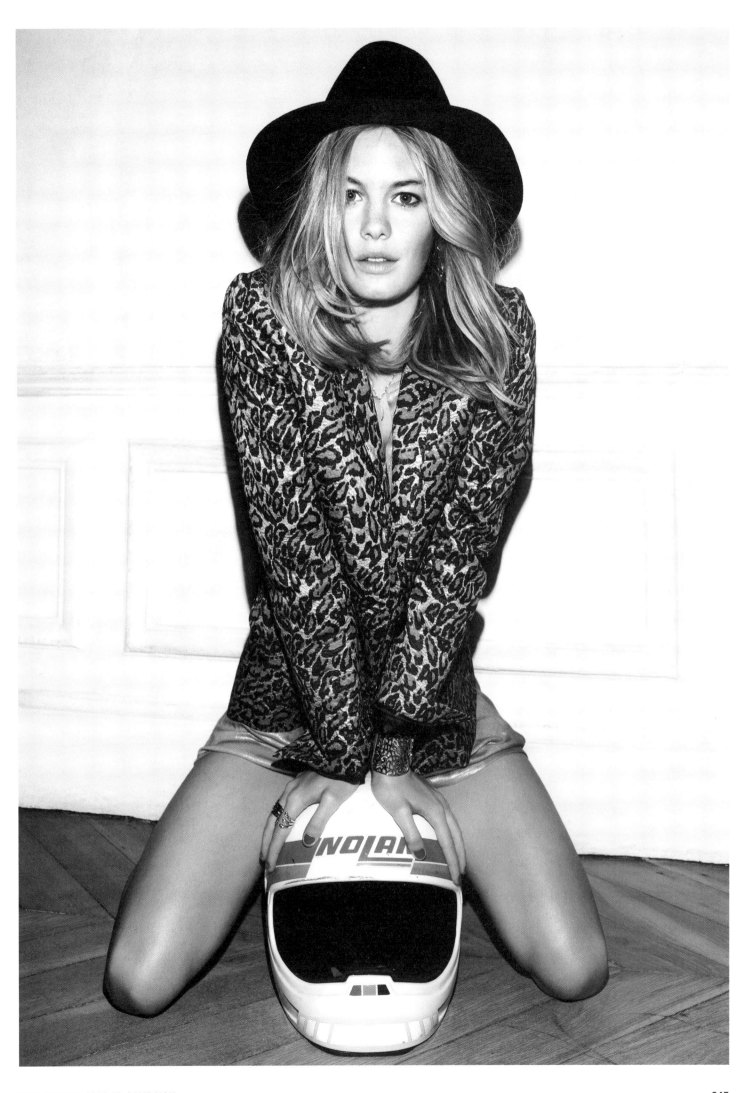

FALL-WINTER 2012 AD CAMPAIGN

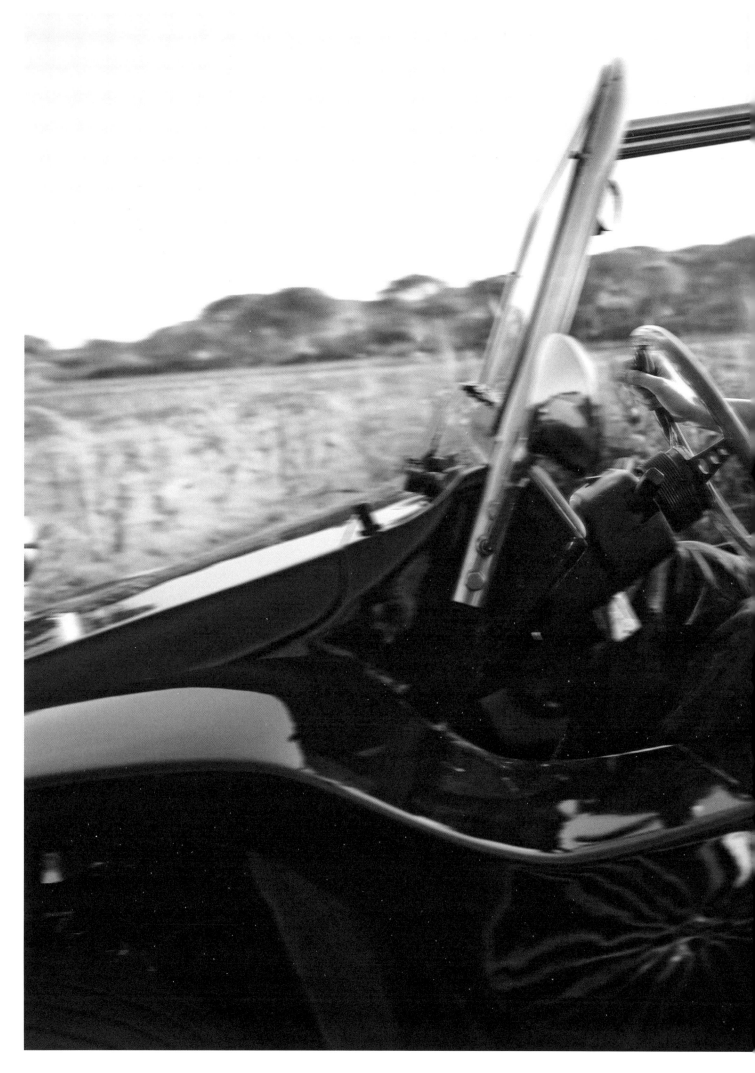

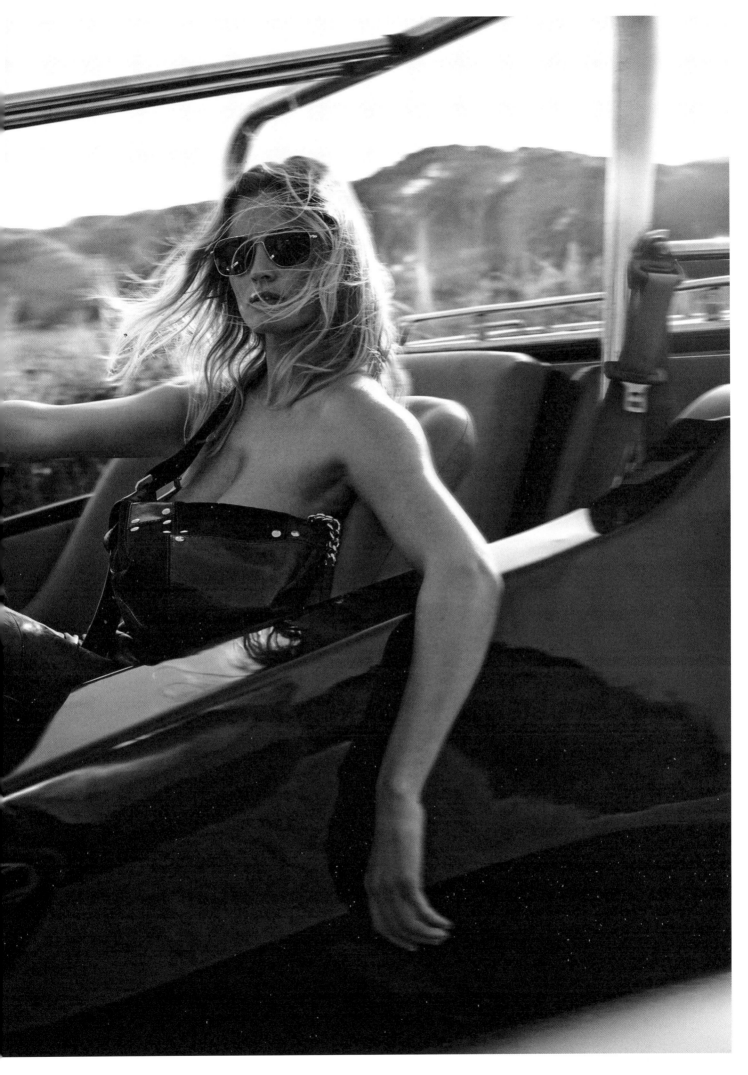

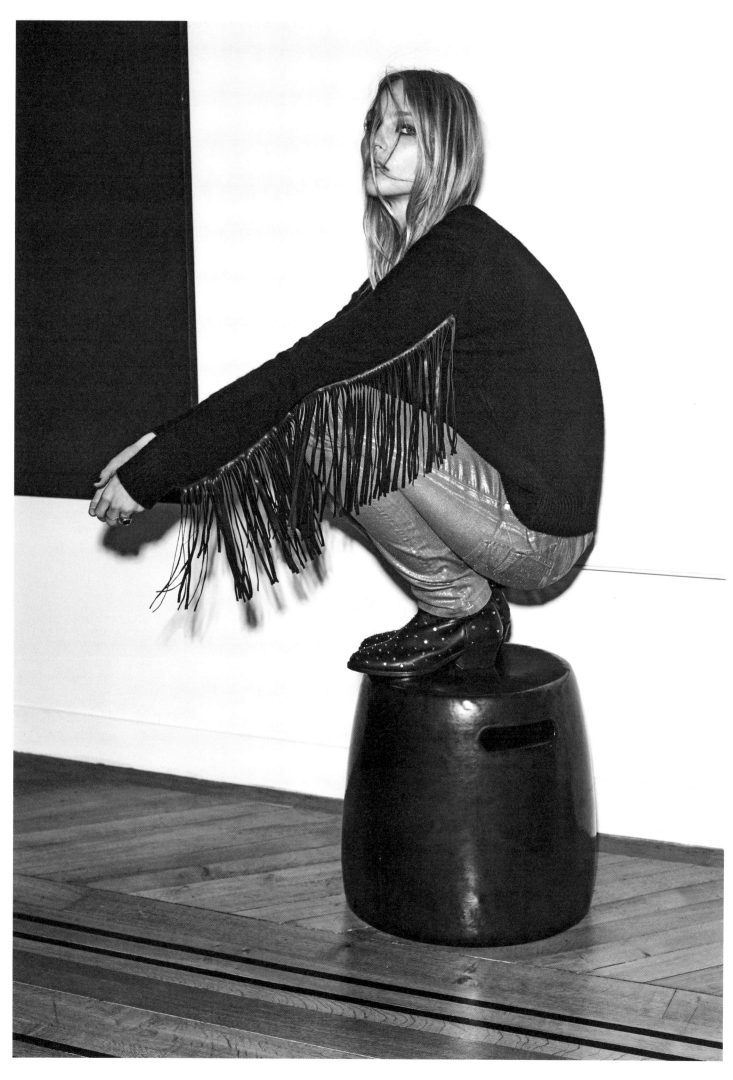

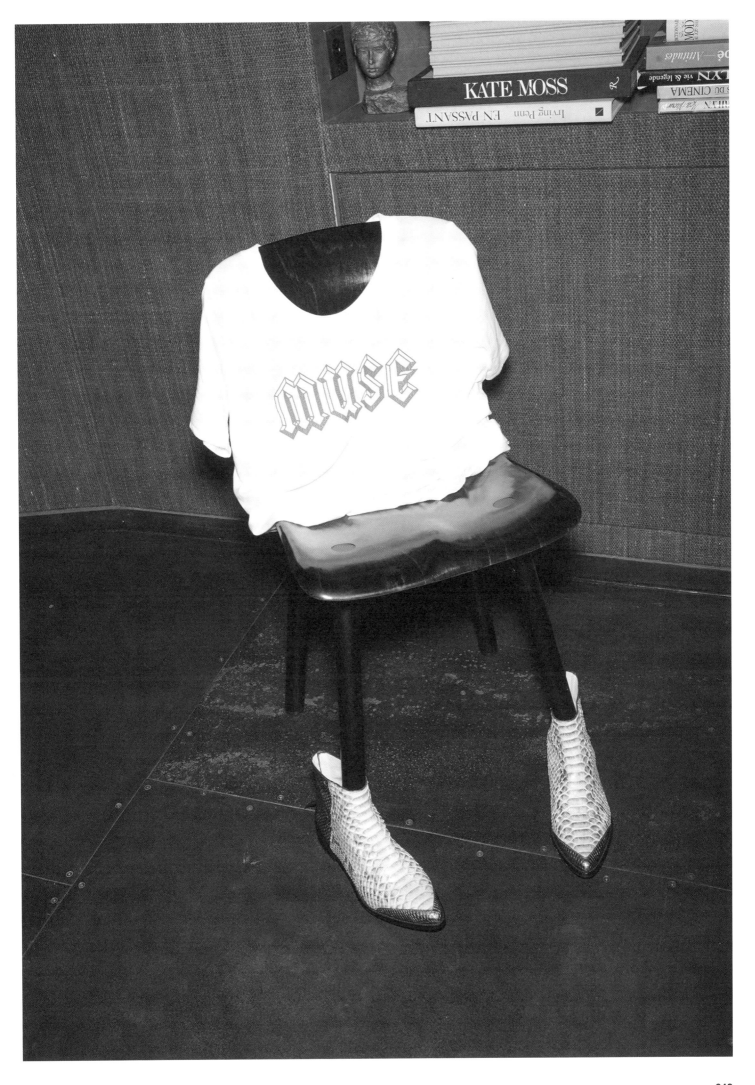

"CAROL'S WAY", 2017

250 *THIS IS HER!* AND *THIS IS HIM!*, FRAGRANCE AD CAMPAIGN 2016

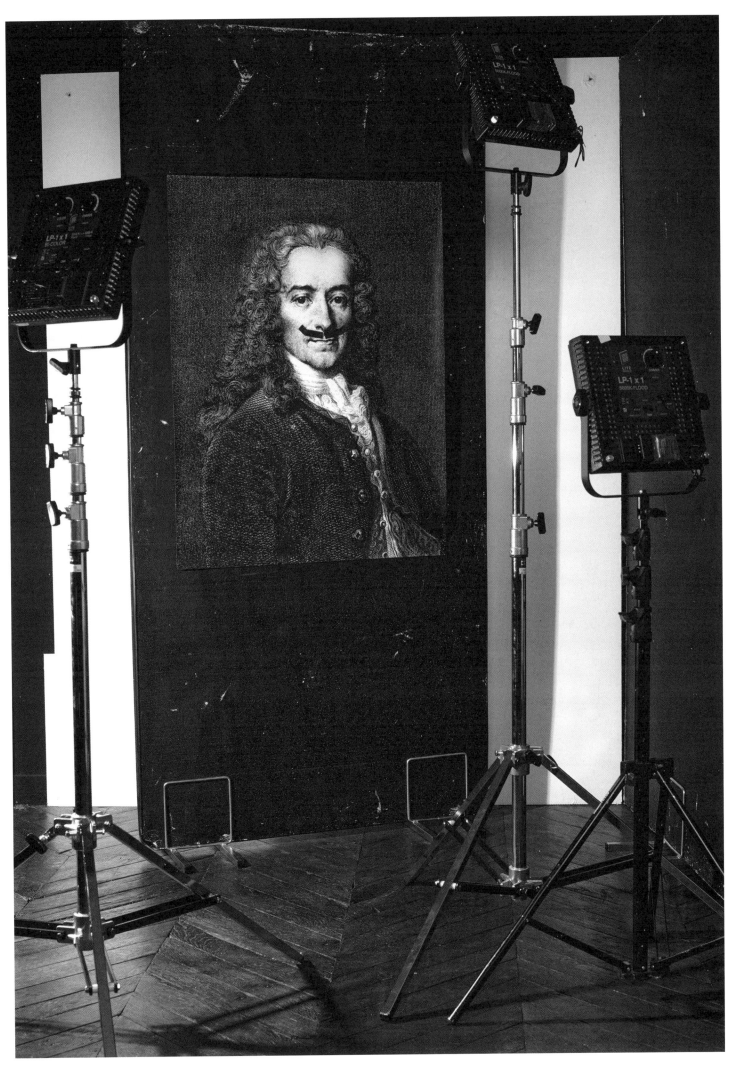

VOLTAIRE BY ZADIG&VOLTAIRE, 2016

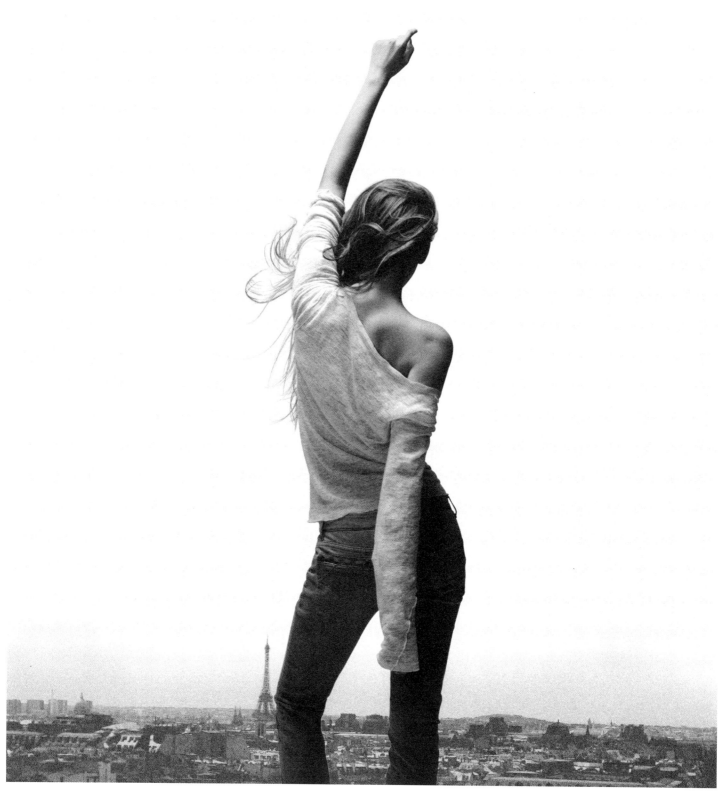

THANK YOU TO THE TEAMS WHO HAVE BEEN SUPPORTING ZADIG&VOLTAIRE FOR TWENTY-FIVE YEARS.

THANK YOU TO ALL THOSE WHO HAVE CONTRIBUTED TO THIS BOOK, TO THE ARTISTS, TO THE PHOTOGRAPHERS, AS WELL AS THEIR REPRESENTATIVES.

THANK YOU TO THE MODELS AND TALENTS
EM A (MIKAS), LERA ABOVA (2PM MODEL MANAGEMENT), MARCELO ALCAIDE, YVAN ATTAL (UBBA), JORDAN BARRETT (ELITE MODEL MANAGEMENT AGENCY), MALGOSIA BELA (VIVA), HAYETT BELARBI-MCCARTHY (TESS MANAGEMENT), CAMILLE BIDAULT WADDINGTON, JESSIE BLOEMENDAAL (WOMEN MANAGEMENT), LUCKY BLUE SMITH (IMG), JAMIE BOCHERT (THE LIONS), FLEUR BREIJER (SUPREME), ADRIEN BRUNIER, NATALIA BULYCHEVA (ELITE MODEL MANAGEMENT AGENCY), AVA CAPRI (THE GERSH AGENCY), CHARLOTTE CARDIN (CULT NATION), NATALIA CASTELLAR CALVANI (NEXT), ALANA CHAMPION (IMG), ANNA CLEVELAND (THE SQUAD), TATI COTLIAR, ELIBEIDY DANI (IMG), GABRIEL-KANE DAY-LEWIS (IMG), CHRIS DEL MORO, POPPY DELEVINGNE (IMG), DILONE (CREATIVE ARTISTS AGENCY), LOU DOILLON (ZZO IMAGE), GIEDRE DUKAUSKAITE (WOMEN MANAGEMENT), NAOMI EKINDI (UNIT MODEL), FARETTA (ELITE MODEL MANAGEMENT AGENCY), ADÈLE FARINE (EB AGENCY), WILLIAM FRANKLYN-MILLER (CHAPTER MANAGEMENT), NINA FRESNEAU (WOMEN MANAGEMENT), DIANA GÄRTNER (VIVA), CAROL GERLAND, AVERY GINSBERG (JOSEPH CHARLES VIOLA LLC), TAMY GLAUSER (MODEL MANAGEMENT), UNGHO GO (ELITE MODEL MANAGEMENT AGENCY), PANDORA GRAESSL, MIKKEL GREGERS JENSEN (IMG), IRENE GUARENAS (EB AGENCY), CATARINA GUEDES (VIVA), PAUL HAMELINE (SUCCESS MODELS), EVIE HARRIS (FORD MODELS), DREE HEMINGWAY (VIVA), EVA HERZIGOVA (ZZO IMAGE), JAMIE HINCE (DAWBELL), YILAN HUA (THE FACE), CAMILLE HUREL (WOMEN MANAGEMENT), COLIN JONES (W360), ADRIENNE JÜLIGER (VIVA), ELIZA KALLMANN (WOMEN MANAGEMENT), CHARLOTTE KEMP MUHL (CHIMERA MUSIC), AMBER KUO, FRANCISCO LACHOWSKI (MARYLIN), PRISCILLA DE LAFORCADE (AGENCE PLAN A), IRINA LAZAREANU (ELITE MODEL MANAGEMENT AGENCY), ZOË LE BER, MAMADOU LO (ELITE MODEL MANAGEMENT AGENCY), MARIE LORIDAN (W360), STELLA LUCIA (VIVA), ANOK MARIAL (SELECT MODEL), KALIXTE MASBERNARD (W360), ALTON MASON (IMG), XU MEEN (IMG), AMALIE MOOSGAARD (LE MANAGEMENT), CECILIE MOOSGAARD (LE MANAGEMENT), KATE MOSS (KATE MOSS AGENCY), ALISON MOSSHART, CONLAN MUNARI (CHADWICK MODEL), INE NEEFS (DOMINIQUE MODELS), ALISHA NESVAT (THE SOCIETY MANAGEMENT), ELISA NIJMAN (VIVA), AMELIE NSENGIYUMVA (NEW MADISON), BIANCA O'BRIEN (SUCCESS MODELS), EKATERINA OLESIK, SEAN ONO LENNON (CHIMERA MUSIC), BLESSING ORJI (METROPOLITAN MODEL), JULIA PACHA (WOMEN MANAGEMENT), LIV PARSONS (IMG), SASHA PIVOVAROVA (IMG), RUBEN POL (IMG), AMANDINE POUILLY (SUPREME), TEDDY QUINLIVAN (MAGGIE AGENCY), GAIA REPOSSI, DOMINIQUE RINDERKNECHT, MEGHAN ROCHE (IMG), CAMILLE ROWE (GIRL MANAGEMENT), JANETA SAMP, MERLIJNE SCHORREN (VIVA), SHERRY SHI (IMG), LOUIS SIMONON (MARYLIN), NATALIA SIROTINA (W360), BLANCA SOLER (UNO MODELS), STEINBERG (FORD MODELS), MAYA STEPPER (IMG), LORENZO SUTTO (MUTHA), SOFIA TESMENITSKAIA (DIRECT SCOUTING CENTER), ANASTASIJA TITKO (ELITE MODEL MANAGEMENT AGENCY), ANTON THIEMKE (SCOOP MODELS), BARBARA VALENTE (CANVAS MANAGEMENT), INDIANA EDEN VAN'T SLOT (REBEL MANAGEMENT), BETONY VERNON, TAÍS VIEIRA (IMG), VERONIKA VILIM (THE LIONS), EDITA VILKEVICIUTE (VIVA), PRESLEY WALKER GERBER (VIVA), ERIN WASSON (ELITE MODEL MANAGEMENT AGENCY), MADDI WATERHOUSE (JONATHAN SANDERS & CO), ED WESTWICK (EMPTAGE HALLETT), MAISIE WILLIAMS (OCEAN AVENUE), JIAYUN XIE (SMG MODEL), YOON YOUNG BAE (THE SOCIETY MANAGEMENT), OLIVIER ZAHM, HUAN ZHOU (ELITE MODEL MANAGEMENT AGENCY), VLAD ZORIN, KATERYNA ZUB (IMG), CLARA 3000.

CREDITS
COVER: © FRED MEYLAN; PP. 14–15, 16: © FRED MEYLAN; P. 17: © DEO SUVEERA AND PAMELA DIMITROV; P. 18: © FRED MEYLAN; P. 19: © EMMANUEL BRUNET, P. 20: © FRED MEYLAN; P. 21: © MAD AGENCY; P. 22: © DREW VICKERS, ART PARTNER INC.; PP. 23, 24–25: © FRED MEYLAN; P. 26, 27: © VALENTIN GIACOBETTI, ART BOARD; PP. 28–29: © MARIN LABORNE; PP. 30, 31, 32, 33, 34, 35: © ULRICH KNOBLAUCH; PP. 36, 37: © FRED MEYLAN; P. 38: © ALESSANDRO LUCIONI, LAUNCHMETRICS; P. 39: © FRED MEYLAN; P. 40: © DREW VICKERS, ART PARTNER INC.; P. 41: © CIHAN ÖNCÜ, ARCHITECT STUDIO HENRY; PP. 42–43: © MAD AGENCY; P. 44: © EMMANUEL BRUNET; P. 45: ALL RIGHTS RESERVED; P. 46: © EMMANUEL BRUNET; P. 47: © FRED MEYLAN; P. 48: © INDIGO LEWIN; P. 49: © STÉPHANE PASADO; P. 50: © STEVEN PARRINO, COURTESY ESTATE OF STEVEN PARRINO AND GAGOSIAN GALLERY, PHOTOGRAPH ROB MCKEEVER; P. 51: © STÉPHANE PASADO; P. 52: © WILLIAM ANASTASI, COURTESY GALERIE JOCELYN WOLFF; P. 53: © STÉPHANE PASADO; P. 54: HANS HARTUNG, *T1989–E16* (1989) © HANS HARTUNG / ADAGP, PARIS 2023; P. 55: © STÉPHANE PASADO; P. 56: A.R. PENCK © ADAGP, PARIS 2023, COURTESY GALERIE SUZANNE TARASIEVE, PARIS, COURTESY GALERIE MICHAEL WERNER, MÄRKISCH WILMERSDORF, KÖLN AND NEW YORK, PHOTOGRAPH THOMAS LANE; P. 57: © STÉPHANE PASADO; P. 58: © GLENN LIGON, COURTESY OF THE ARTIST AND HAUSER & WIRTH, NEW YORK, REGEN PROJECTS, LOS ANGELES, THOMAS DANE GALLERY, LONDON, AND GALERIE CHANTAL CROUSEL, PARIS, PHOTOGRAPH THOMAS BARRATT; P. 59: © STÉPHANE PASADO; P. 60: © RICHARD PRINCE, COURTESY OF THE ARTIST AND GLADSTONE GALLERY; P. 61: © STÉPHANE PASADO; P. 62: © RUDOLF STINGEL, COURTESY OF THE ARTIST AND GAGOSIAN GALLERY, PHOTOGRAPH ROB MCKEEVER; P. 63: © STÉPHANE PASADO; P. 65: © FRED MEYLAN; P. 66: © EMMANUEL BRUNET; P. 67: © FRED MEYLAN; P. 68: © P.A. HÜE DE FONTENAY, OPEN SPACE PARIS; P. 69: ALL RIGHTS RESERVED, ARCHITECT BERNARD DUBOIS; P. 70: TOP LEFT AND MIDDLE LEFT © STÉPHANE FEUGÈRE, TOP RIGHT © PIERRE-ANGE CARLOTTI, PHENOMENA, BOTTOM, ALL RIGHTS RESERVED; P. 71: TOP, MIDDLE RIGHT AND BOTTOM RIGHT, ALL RIGHTS RESERVED, MIDDLE LEFT AND BOTTOM LEFT © STÉPHANE FEUGÈRE; P. 72: TOP © OLIVIER ZAHM, MIDDLE

LEFT AND BOTTOM RIGHT, ALL RIGHTS RESERVED, MIDDLE RIGHT AND BOTTOM LEFT © STÉPHANE FEUGÈRE; P. 73: TOP LEFT AND MIDDLE LEFT © OLIVIER ZAHM, TOP RIGHT, MIDDLE RIGHT AND BOTTOM LEFT, ALL RIGHTS RESERVED, BOTTOM RIGHT © STÉPHANE FEUGÈRE; P. 74: ALL RIGHTS RESERVED; P. 75: © JEAN-MARIE BINET, CADENCE IMAGE; PP. 76–77: © FELIX FRIEDMANN; PP. 78, 79: © PIERRE-ANGE CARLOTTI, PHENOMENA; PP. 80–81: © FRANÇOIS HALARD; P. 82: © FRED MEYLAN; P. 83: © INDIGO LEWIN; PP. 84, 85: © GRÉGOIRE AVENEL; P. 86: © FRED MEYLAN; P. 87: © CIHAN ÖNCÜ, ARCHITECT STUDIO HENRY; P. 88: © VIRGILE GUINARD; P. 89: © FRED MEYLAN; P. 90: © ULRICH KNOBLAUCH; P. 91: © MARIN LABORNE; P. 92: ALL RIGHTS RESERVED; P. 93: © INDIGO LEWIN; PP. 94–95: © FRED MEYLAN; PP. 96, 97, 98: CREATIVE DIRECTOR, PLAYLAB, INC., PHOTOGRAPH AMANDA KRUEGER; P. 99: © KENNETH CAPPELLO; PP. 100–101: PHOTOGRAPH ALL RIGHTS RESERVED / © INDIGO LEWIN; P. 102: © STÉPHANE FEUGÈRE; P. 103: © FRED MEYLAN; PP. 104–105, 106, 107: © MARIN LABORNE; PP. 108, 109: © FRED MEYLAN; P. 110: © MARIN LABORNE; P. 111: EDWARD JAMES © INDIGITAL.TV; P. 112: © MAD AGENCY; PP. 113, 114–115: © FRED MEYLAN; P. 116: © VIRGILE GUINARD; P. 117: © PIERRE-ANGE CARLOTTI, PHENOMENA; PP. 118–119: XAVIER VEILHAN, *SANDRA* (2008) © VEILHAN / ADAGP, PARIS 2023, PHOTOGRAPH © EMMANUEL BRUNET; P. 120: © MAD AGENCY; P. 121: © TERRY RICHARDSON, ART PARTNER INC.; P. 122: © FRED MEYLAN; P. 123: © DANIELE OBERRAUCH, LAUNCHMETRICS; P. 124: © STÉPHANE DEROUSSENT; P. 125: © JAN WELTERS, OPEN SPACE PARIS; PP. 126, 127: © FRED MEYLAN; P. 128: © FRANÇOIS HALARD; P. 129: © STÉPHANE PASADO; P. 130: STEVEN PARRINO, COURTESY ESTATE OF STEVEN PARRINO, PHOTOGRAPH JOHN BERENS; P. 131: © STÉPHANE PASADO; P. 132: ALL RIGHTS RESERVED; P. 133: © STÉPHANE PASADO; P. 134: COURTESY STERLING RUBY STUDIO © STERLING RUBY; P. 135: © STÉPHANE PASADO; P. 136: © RASHID JOHNSON, COURTESY OF THE ARTIST AND HAUSER & WIRTH, NEW YORK, PHOTOGRAPH THOMAS BARRATT; P. 137: © STÉPHANE PASADO; P. 138: © GEORG BASELITZ 2023; P. 139: © STÉPHANE PASADO; P. 140: ANDY WARHOL, *THE AMERICAN INDIAN (RUSSELL MEANS)* (1976) © THE ANDY WARHOL FOUNDATION FOR THE VISUAL ARTS, INC. / LICENSED BY ADAGP, PARIS 2023; P. 141: © STÉPHANE PASADO; P. 142: FRANÇOIS MORELLET © ADAGP, PARIS 2023; P. 143: © STÉPHANE PASADO; P. 145: © STÉPHANE FEUGÈRE; PP. 146–147: © MAD AGENCY; P. 148: © MARIN LABORNE; P. 149: © ULRICH KNOBLAUCH; PP. 150–151: © OLIVIER ZAHM; P. 152: ALL RIGHTS RESERVED; P. 153: © TERESA CIOCIA; P. 154: © FRANÇOIS HALARD; P. 155: © FRED MEYLAN; PP. 156–157: © MARIN LABORNE; P. 158: © DANIELE OBERRAUCH, LAUNCHMETRICS; P. 159: © UMBERTO FRATINI, WWW.UMBERTOFRATINI.COM; PP. 160–161: © MAD AGENCY; P. 162: © GRÉGOIRE AVENEL; P. 163: © INDIGO LEWIN; P. 164: © FRANÇOIS HALARD; P. 165: © FRED MEYLAN; P. 166: ALL RIGHTS RESERVED; PP. 167, 168: © FRED MEYLAN; P. 169: © ULRICH KNOBLAUCH; PP. 170–171: © OLIVIER ZAHM; PP. 172, 173: © FRED MEYLAN; PP. 174, 175: © DREW VICKERS, ART PARTNER INC.; PP. 176, 177: © FRED MEYLAN; PP. 178–179: ALL RIGHTS RESERVED; P. 180: EDWARD JAMES © INDIGITAL.TV; P. 181: © MAD AGENCY; PP. 182–183: ALL RIGHTS RESERVED; P. 184: © JAN WELTERS, OPEN SPACE PARIS; P. 185: © RICARDO GOMES, 37.2; PP. 186–187, 188, 189: © FRED MEYLAN; P. 190: MARCUS TONDO © INDIGITAL.TV; P. 191: © UMBERTO FRATINI, WWW.UMBERTOFRATINI.COM; P. 192: © THOMAS MALYE REYNAUD; P. 193: ALL RIGHTS RESERVED; P. 194: © ALESSANDRO LUCIONI, LAUNCHMETRICS; P. 195: EDWARD JAMES © INDIGITAL.TV; PP. 196, 197: © FRED MEYLAN; P. 198: © INDIGO LEWIN; P. 199: © FRED MEYLAN; PP. 200–201: © MARIN LABORNE; P. 202: © ULRICH KNOBLAUCH; P. 203: © STÉPHANE FEUGÈRE; P. 204: © GRÉGOIRE AVENEL; P. 205: ALL RIGHTS RESERVED; P. 206: © MARIN LABORNE; PP. 207, 208: © FRED MEYLAN; P. 209: © STÉPHANE PASADO; P. 210: © URS FISCHER, COURTESY OF THE ARTIST AND GAGOSIAN GALLERY, PHOTOGRAPH MATS NORDMAN; P. 211: © STÉPHANE PASADO; P. 212: © STEVEN PARRINO, COURTESY ESTATE OF STEVEN PARRINO, PHOTOGRAPH JOHN BERENS; P. 213: © STÉPHANE PASADO; P. 214: ROBERT RAUSCHENBERG, *NOON QUILT (COLCHA DE MEDIODIA) / ROCI CUBA* (1988) © ROBERT RAUSCHENBERG FOUNDATION / ADAGP, PARIS 2023; P. 215: © STÉPHANE PASADO; P. 216: KIM YONG-IK, COURTESY OF THE ARTIST, PHOTOGRAPH KEITH PARK; P. 217: © STÉPHANE PASADO; P. 218: UGO RONDINONE, COURTESY OF THE ARTIST AND MENNOUR GALLERY, PARIS, PHOTOGRAPH STUDIO RONDINONE; P. 219: © STÉPHANE PASADO; P. 220: © SUCCESSION PICASSO 2023; P. 221: © STÉPHANE PASADO; P. 222: ANDY WARHOL, *LITTLE ELECTRIC CHAIR* (1964) © THE ANDY WARHOL FOUNDATION FOR THE VISUAL ARTS, INC. / LICENSED BY ADAGP, PARIS 2023; P. 223: © STÉPHANE PASADO; P. 225: PHOTOGRAPH © SPELA KASAL / © DREW VICKERS, ART PARTNER INC.; P. 226: © LARISSA HOFMANN, THE GOOD COMPANY; P. 227: © EMMANUEL BRUNET; P. 228: © GRÉGOIRE AVENEL; P. 229: © FRED MEYLAN; PP. 230–231: ALL RIGHTS RESERVED; P. 232: © MARIN LABORNE; P. 233: ALL RIGHTS RESERVED; P. 234: © EMMANUEL BRUNET; P. 235: © DANIELE OBERRAUCH, LAUNCHMETRICS; P. 236: ALL RIGHTS RESERVED; P. 237: © CIHAN ÖNCÜ, ARCHITECT STUDIO HENRY; PP. 238–239: © FRED MEYLAN; P. 240: © MARIN LABORNE; P. 241: ALL RIGHTS RESERVED; PP. 242–243: © FRED MEYLAN; P. 244: ALL RIGHTS RESERVED; PP. 245, 246–247, 248: © FRED MEYLAN; P. 249: ALL RIGHTS RESERVED; PP. 250, 251: © FRED MEYLAN; P. 252: © DAVID BELLEMÈRE.

EVERY EFFORT HAS BEEN MADE TO CONTACT COPYRIGHT OWNERS TO OBTAIN PERMISSION TO REPRODUCE COPYRIGHTED MATERIAL. HOWEVER, IF ANY PERMISSIONS HAVE BEEN INADVERTENTLY OVERLOOKED, WE WILL BE PLEASED TO MAKE THE NECESSARY AND REASONABLE ARRANGEMENTS AT THE FIRST OPPORTUNITY.

ZADIG&VOLTAIRE

FIRST PUBLISHED IN THE UNITED STATES OF AMERICA IN 2023
BY RIZZOLI INTERNATIONAL PUBLICATIONS, INC.
300 PARK AVENUE SOUTH, NY 10010
WWW.RIZZOLIUSA.COM

© 2023 ZADIG&VOLTAIRE

TEXT: NICOLE PHELPS

PUBLISHER: CHARLES MIERS
EDITORIAL DIRECTOR: CATHERINE BONIFASSI
EDITOR: VICTORINE LAMOTHE
PRODUCTION DIRECTOR: MARIA PIA GRAMAGLIA
MANAGING EDITOR: LYNN SCRABIS

ARTISTIC DIRECTION: GIAN GISIGER
DESIGN: CHARLOTTE-MAËVA PERRET

EDITORIAL COORDINATION: CASSI EDITION
VANESSA BLONDEL, CANDICE GUILLAUME, BLANCHE URBAN
WITH THE CONTRIBUTION OF CAROL GERLAND

ALL RIGHTS RESERVED. NO PART OF THIS PUBLICATION MAY BE
REPRODUCED, STORED IN A RETRIEVAL SYSTEM, OR TRANSMITTED
IN ANY FORM OR BY ANY MEANS, ELECTRONIC, MECHANICAL,
PHOTOCOPYING, RECORDING, OR OTHERWISE, WITHOUT PRIOR
CONSENT OF THE PUBLISHER.

ISBN: 978-0-8478-7368-5
LIBRARY OF CONGRESS CONTROL NUMBER: 2023934495
2023 2024 2025 2026 / 10 9 8 7 6 5 4 3 2 1
PRINTED IN HONG KONG

VISIT US ONLINE:
FACEBOOK.COM/RIZZOLINEWYORK
TWITTER: @RIZZOLI_BOOKS
INSTAGRAM.COM/RIZZOLIBOOKS
PINTEREST.COM/RIZZOLIBOOKS
YOUTUBE.COM/USER/RIZZOLINY
ISSUU.COM/RIZZOLI